# Women

## and the
## Work of Benevolence

Morality, Politics, and Class in the
Nineteenth-Century United States

LORI D. GINZBERG

Yale University Press

New Haven and London

Published under the direction of the Department of History of Yale University with assistance from the income of the Frederick John Kingsbury Memorial Fund.

Designed by James J. Johnson.
Set in Monticello Roman types by The Composing Room of Michigan, Inc.
Printed in the United States of America by BookCrafters, Inc., Chelsea, Michigan.

*Library of Congress Cataloging-in-Publication Data*
Ginzberg, Lori D.
    Women and the work of benevolence : morality, politics, and class in the nineteenth-century
    United States / Lori D. Ginzberg.
        p.   cm. — (Yale historical publications)
    Includes bibliographical references.
        ISBN 0–300–04704–5 (cloth)
            0–300–05254–5 (pbk.)
        1. Women social reformers—United States—History—19th century. 2. Women in char-
    itable work—United States—History—19th century. 3. Middle class women—United
    States—History—19th century. 4. United States—Moral conditions. I. Title. II.
    Series.
HQ1418.G56 1990
305.4'0973–dc20                                                                                      89–24930
                                                                                                          CIP

A catalogue record for this book is available
from the British Library.

*The paper in this book meets the guidelines for permanence and durability of the Committee on Production Guidelines for Book Longevity of the Council on Library Resources.*

10   9   8   7   6   5   4   3   2

*For my parents*

Shirley Ginzberg, who gave me the room to go against her grain and find an art of my own

and

David Ginzberg, who taught me always to ask "why," which is a central question in this book.

# Contents

◄§ ℰ►

# Acknowledgments

A glance at the acknowledgments of most feminist scholars should lay to rest the notion that women's history writing is a solitary venture. No author can have been more fortunate than I in the company of wise and patient people who saw this book through its many stages. My adviser, Nancy F. Cott, consistently encouraged me to focus on the big questions in women's history; I wish especially to thank her for her willingness to be challenged, as well as challenging. I am also indebted to David Brion Davis for combining supportive criticism with the enthusiasm that every graduate student needs. A number of people read all or part of this manuscript in its various incarnations, some of them more than once. For their enthusiasm in doing so, and for their inspiration, ideas, and proddings I wish to thank Jean-Christophe Agnew, Anne Boylan, Ellen DuBois, Matthew Gallman, Nancy Hewitt, Ann Firor Scott, Amy Stanley, Susan Yohn, and those who, after seminars and presentations, have promised an ongoing dialogue by asking, "So when will we get to *see* this book?" I thank Joy Newmann, Donna Rilling, Alexandra Franklin, and Harv Von Lonkhuyzen for aiding in the otherwise thankless task of proofreading and Donna Wilke for applying her skill and insight to the index. At Yale University Press, Chuck Grench has guided and supported this project since its earliest stages; Alexander Metro made its final production an education and a pleasure.

I am grateful to the Charlotte Newcombe Foundation, the American Historical Society and Library of Congress J. Franklin Jameson Fellowship, and the American Council of Learned Societies for the breathing space afforded by financial support during different periods of research and writing. Librarians, archivists, staffs, and trustees of nu-

merous libraries aided me greatly, and I want to thank those at the Boston Public Library, the Butler Library at Columbia University, the Historical Society of Pennsylvania, the Library of Congress, the New-York Historical Society, the New York Public Library, the Schlesinger Library at Radcliffe College, the Sophia Smith Collection at Smith College, Sterling Memorial and Beinecke libraries at Yale University; and the State Historical Society of Wisconsin.

Friends, family, and colleagues too numerous to mention individually have cared for, listened to, and cooked for me throughout the process of completing this project. In addition to my parents, to whom this book is dedicated, I wish to thank my family for keeping me at least tenuously grounded in the twentieth century: Janet Ginzberg, for her research assistance and her continued membership in our mutual admiration society; Steven Ginzberg, for his unfailingly gracious computer advice and crisis management; Robert Ginzberg, for his humor and his wonder that I could still be rewriting "the same paper"; Kate Ilana Steiker-Ginzberg, born during the final proofreading, for sleeping through the night; and the Steikers—Francine, Eugene, Ellen, and Jason—for their frequent displays of confidence. Numerous co-workers, past and present, at the University of Rhode Island and Penn State University helped make this commuter's life relatively sane. I am also grateful to an extraordinary community of (now former) graduate students in history and American studies at Yale University, who provided the intellectual and emotional support that is all too rarely enjoyed by the "dissertating." In addition, several communities of activists—ultraists all—who did not directly assist with this book helped remind me that one's professional and political lives are not necessarily at odds.

My greatest debts are to four people whose meticulous editing and gentle criticisms have improved every page of this book. Perhaps more important, their friendship made it possible, even enjoyable, to live with those pages. Carol Karlsen has been a model as a scholar and a teacher, giving me the gift of standards to be achieved in our studies of women and in our own lives. Ileen DeVault has shared the broad challenges and petty anxieties of writing a dissertation and then turning it into a book. I thank her for her reminders that ideas are inseparable from the very real people who held them. Jeanne Boydston has lived and labored with the words in these pages as if they were her own; quite a few of them are. Without her collaboration and her enthusiasm for meandering together through the nineteenth century I would long ago have forgotten why

this book was important to write. Finally, over the past twelve years I have become daily more grateful for Joel Steiker's seemingly limitless insight, patience, and respect for me and my work. Above all, he has been a living reminder of a central tenet of this book: that true benevolence is not after all a trait ordained by gender.

# Abbreviations

| | |
|---|---|
| Antislavery | Antislavery Collection, Rare Books and Manuscripts Division, Boston Public Library |
| Blackwell | Blackwell Family Collection, Manuscript Division, Library of Congress |
| Garrison | Garrison Family Papers, Sophia Smith Collection, Smith College |
| Gay | Sydney Howard Gay Papers, Rare Book and Manuscript Library, Columbia University |
| Griffing | Josephine Sophia White Griffing Papers, Rare Book and Manuscript Library, Columbia University |
| Post | Angelina Post Papers, Misc. Mss., Manuscripts Division, New-York Historical Society |
| Schuyler | Louisa Lee Schuyler Papers, Misc. Mss., Manuscripts Division, New-York Historical Society |
| Tappan | Lewis Tappan Papers, Manuscript Division, Library of Congress |
| USSC | United States Sanitary Commission Records, Rare Books and Manuscripts Division, New York Public Library, Astor, Lenox, and Tilden Foundations |
| Wead | Mary K. Wead Papers, Sophia Smith Collection, Smith College |
| Wright | Elizur Wright Papers, Manuscript Division, Library of Congress |

# Introduction

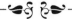

"It is to female influence and exertion that many of our best schemes of charity are due," stated the Reverend C. Gayton Pickman approvingly in 1836.[1] Few of Pickman's audience would have argued with this observation. Throughout the early nineteenth century, paeans to women's benevolent influence rang from books, newspapers, and pulpits, as did celebrations of women's moral excellence and their predisposition to religious faith. Directed primarily to the Protestant women who participated in a wide range of charitable and reform causes, these sentiments reflected an ideology that conflated ideas about femininity with ideas about morality itself. In turn, this ideology underpinned much of women's social activism in the antebellum years.

To a degree astonishing to our pluralistic and secular way of thinking about social change, middle- and upper-middle-class women of the antebellum era shared a language that described their benevolent work as Christian, their means as fundamentally moral, and their mandate as uniquely female. Some used the ideology of benevolence to attack liquor, some to fight lust, and some to eradicate slavery. Other women established training programs and shelters and bestowed tracts, clothing, and even employment on the poor, the foreign, and the "fallen." Abolitionists and Bible distributors, temperance activists and asylum builders, local relief givers and organizers of national charitable networks all expressed confidence that the language of Protestant be-

1. C. Gayton Pickman, "An Address Delivered Before the Ladies' Benevolent Society, at East Cambridge (1836)," in *An Address before the East Cambridge Temperance Society* (Boston: C. C. Little and J. Brown, 1845), p. 30.

nevolence accurately described their efforts at bringing about social change.

Until very recently, historians who studied early nineteenth-century benevolent activity viewed it as an assertion of social control, an attempt to impose class-specific values on the poor and foreign. They were, however, reluctant to grant much import to women in this effort at cultural domination, except to describe them as "an indispensible source of educated hands to [do] the work."[2] Apparently presuming class to be a "male" issue—a category both defined and disputed by males only—historians of the benevolent empire assumed that women played no role in shaping the particular causes which asserted a class identity.

Recent explorations in women's history have transformed the study of antebellum benevolent women. Nancy Cott, Kathryn Kish Sklar, and Carroll Smith-Rosenberg, in their studies of antebellum middle-class women's identities, have underscored both the ambiguities and the richness of the concept of "woman's sphere" and its impact on white middle-class women's self-understanding. By looking at women's own writings, Cott in particular has explicated the tensions between women's subordinate status and the sense of self worth gained from womanhood's "bonds"—the tensions, that is, between the conservative im-

2. Anthony F. C. Wallace, *Rockdale: The Growth of an American Village in the Early Industrial Revolution* (New York: Alfred A. Knopf, 1972), p. 313. Standard works on the early benevolent empire are Clifford S. Griffin, *Their Brothers' Keepers: Moral Stewardship in the United States, 1800–1860* (New Brunswick: Rutgers University Press, 1960) and Charles I. Foster, *An Errand of Mercy: The Evangelical United Front, 1790–1837* (Chapel Hill: University of North Carolina Press, 1960). On the revivals and their connection to reform see Paul E. Johnson, *A Shopkeeper's Millennium: Society and Revivals in Rochester, New York, 1815–1837* (New York: Hill and Wang, 1978); Timothy L. Smith, *Revivalism and Social Reform: American Protestantism on the Eve of the Civil War* (Baltimore: Johns Hopkins University Press, 1980); William G. McLoughlin, *Revivals, Awakenings, and Reform: An Essay on Religion and Social Change in America, 1607–1977* (Chicago: University of Chicago Press, 1978); and Donald G. Mathews, "The Second Great Awakening as an Organizing Process, 1780–1830," *American Quarterly* 21 (Spring 1969): 23–43. On the status deprivation theory of American reformers see Joseph R. Gusfield, *Symbolic Crusade: Status Politics and the American Temperance Movement* (Urbana: University of Illinois Press, 1963); and David Donald, *Lincoln Reconsidered: Essays on the Civil War Era* (New York: Vintage Books, 1961), especially chap. 2, "Toward a Reconsideration of Abolitionists," which argues that abolitionists were "an elite without function, a displaced class in American society" (p. 33). For studies that put these issues in a specifically urban context see Paul S. Boyer, *Urban Masses and Moral Order in America, 1820–1920* (Cambridge: Harvard University Press, 1978) and Carroll Smith-Rosenberg, *Religion and the Rise of the American City: The New York City Mission Movement, 1812–1870* (Ithaca: Cornell University Press, 1971). For an overview of antebellum reform see Ronald G. Walters, *American Reformers, 1815–1860* (New York: Hill and Wang, 1978).

plications of relegating women to a separate sphere and the potentially radical sense of solidarity gained from that experience.[3]

Building on these insights, Barbara Berg, Estelle Freedman, and others in their studies of nineteenth-century religion and reform have explored how, through the assertion of a shared female identity, middle-class women sought to transcend class differences between themselves and their less privileged "sisters." Barbara Epstein has illuminated the conflicts that evangelical religion ignited between women and men.[4] Women's historians have thus elucidated both the individual and the societal importance of the ideology of gender. They have at the same time given us a greater understanding of white Protestant women as active participants in nineteenth-century society and as shapers of benevolence itself. We still know little about why the ideology of "woman's sphere" emerged when it did and what large cultural implications it had, but we do know that many middle-class Protestant women incorporated its tenets into their own self image, that they used it to justify a wide range of social activities, and that it provided at least some basis for a consciousness based on the shared experience of being women.[5]

3. Carroll Smith-Rosenberg, "Beauty, the Beast, and the Militant Woman: A Case Study of Sex Roles and Social Stress in Jacksonian America," *American Quarterly* 23 (October 1971): 562–84, and "The Female World of Love and Ritual: Relations between Women in Nineteenth-Century America," *Signs* 1 (Fall 1975): 1-29; Nancy F. Cott, *The Bonds of Womanhood: "Woman's Sphere" in New England, 1780–1835* (New Haven: Yale University Press, 1977); Kathryn Kish Sklar, *Catharine Beecher: A Study in American Domesticity* (New York: W. W. Norton, 1976).

4. Barbara J. Berg, *The Remembered Gate: Origins of American Feminism: The Woman and the City, 1800–1860* (New York: Oxford University Press, 1978); Estelle B. Freedman, *Their Sisters' Keepers: Women's Prison Reform in America, 1830–1930* (Ann Arbor: University of Michigan Press, 1981); Barbara Leslie Epstein, *The Politics of Domesticity: Women, Evangelism, and Temperance in Nineteenth-Century America* (Middletown, Conn.: Wesleyan University Press, 1981). See also Mary P. Ryan, "A Women's Awakening: Evangelical Religion and the Families of Utica, N.Y., 1800–1840," in *Women and American Religion,* ed. Janet Wilson James (Philadelphia: University of Pennsylvania Press, 1980), pp. 89–110.

5. I frame the words "woman's sphere" in quotation marks intentionally. The concept of "spheres" is, after all, ideological, although it has too often come to represent historians' understanding of the actual experience of at least white middle-class Protestant women. What I have found in my work is that the reality of women's lives was quite different from the ideology which they themselves used and that, furthermore, the acceptance of the tenets of woman's sphere by historians has too often served to obscure that distinction, unwittingly preventing women from leaving the sphere itself. Several recent articles have grappled with these questions on a theoretical basis. Although several appeared after I had almost finished writing this book, they have helped me locate my own thinking in the changing historiography on women. See especially Nancy A. Hewitt, "Beyond the Search for Sisterhood: American Women's History in the 1980s," *Social History* 10 (October 1985): 299–321; Linda K. Kerber, "Separate Spheres, Female Worlds, Woman's Place: The Rhetoric of Women's History," *Journal of*

Even more recently, Mary Ryan and Nancy Hewitt have expanded the study of women's benevolent work by examining it not only from the perspective of an emerging gender identity but also in terms of the relationship between women's benevolent work and the emergence of middle-class culture and politics in the antebellum period. Hewitt's formulation of the styles and social bases of female activism is an especially significant challenge to previous historians' way of thinking about benevolence. In dividing the female activists of Rochester into three groups, "benevolent," "perfectionist," and "ultraist," Hewitt's schema begins to break down the presumed uniformity of women's reform work and provides categories for broadly conceptualizing the class and intellectual differences among those who called upon the shared language of morality to aid their various causes.[6] Similarly, Anne Boylan has identified three discrete traditions in antebellum women's organizing—benevolent, reform, and feminist—and has shown that both women's social backgrounds and their life cycle status affected their commitment to particular causes.[7]

Other scholars have carried the investigation of the connections between the ideology of domesticity and women's activism into the post–Civil War years; here, too, historians have shown, sometimes implicitly, that there were both radical and conservative possibilities inherent in that ideology and in its foundation in both gender and class identities. Karen Blair, in her study of clubwomen, has underscored the continued vitality of an ideology of domesticity and "ladydom" in justifying women's organizations; Ruth Bordin has argued that, through their demands that women act to "protect the home," female temperance activists "were caught up in feminist goals." Even native-born

---

*American History* 75 (June 1988): 9–39; Cécile Dauphin, Anette Farge, Geneviève Fraisse, Christiane Klapische-Zuber, Rose-Marie Lagrave, Michelle Perrot, Perrette Pfzerat, Yannick Ripa, Pauline Schmitt-Pantel, and Danièle Voldman, "Women's Culture and Women's Power: An Attempt at Historiography," *Journal of Women's History* 1:1 (Spring 1989): 63–88; and "Comment" on Dauphin et al., especially Lois Banner, "A Reply to 'Culture et Pouvoir' from the Perspective of United States Women's History," ibid., 101–07.

6. Mary P. Ryan, *Cradle of the Middle Class: The Family in Oneida County, New York, 1790–1865* (New York: Cambridge University Press, 1981); Nancy A. Hewitt, *Women's Activism and Social Change: Rochester, New York, 1822–1872* (Ithaca: Cornell University Press, 1984).

7. Anne M. Boylan, "Women in Groups: An Analysis of Women's Benevolent Organizations in New York and Boston, 1797–1840," *Journal of American History* 71 (December 1984): 497–523, and "Timid Girls, Venerable Widows and Dignified Matrons: Life Cycle Patterns among Organized Women in New York and Boston, 1797–1840," *American Quarterly* 38 (Winter 1986): 779–97.

socialist women, as Mari Jo Buhle has demonstrated, adhered to the tenets of universal sisterhood in justifying their commitment to—and, indeed, analysis of—broad social change.[8]

As much as previous studies have added to our understanding of the complex and even contradictory meanings of the ideology of female benevolence, for different groups of women, we have so far barely begun to explore the holding power of that ideology over a century of intense social and specifically class change. To the contrary, our dissections of the ideology of female benevolence have tended to be rather localized in time and, with the exception of Hewitt, have failed to illuminate the internal dynamics which rendered that ideology sufficiently malleable to continue to engage the passions of a middle class that was itself in a constant state of change. To fail to understand the source of this apparent potential for ongoing modification and transformation is, finally, to fail to understand the power of the ideology itself.

Indeed, what drew me to a study of female benevolence that would cross the Civil War period was my observation that the rhetoric of benevolence seemed to hold quite disparate meanings in different periods. Antebellum activists' moral language, which carried the assumption both that virtue was more pronounced in women than in men and that this virtue could be the force behind a moral transformation of society at large, distinguished these activists from later generations of American reformers. By the 1870s and 1880s, the rhetoric and the goals of reform had drastically altered. An entirely different context characterized wartime and postwar benevolence, and activists thus imparted different meanings to rhetoric about gender and reform. The heirs of antebellum benevolence had strikingly different perspectives and agendas than their predecessors—in some cases their actual parents—referring less to a mission of moral regeneration and far more to a responsibility to control the poor and "vagrant." Perhaps the most dramatic transformation in the history of nineteenth-century female benevolence and reform is the way in which the children and grandchildren of antebellum reformers adapted the work of benevolence to an increasingly class-stratified and class-conscious society—indeed, how they refashioned the ideology of benevolence itself from an analysis of gender to one of class.

8. Karen J. Blair, *The Clubwoman as Feminist: True Womanhood Redefined, 1868–1914* (New York: Holmes and Meier, 1980); Ruth Bordin, *Woman and Temperance: The Quest for Power and Liberty, 1873–1900* (Philadelphia: Temple University Press, 1981), p. 3; Mari Jo Buhle, *Women and American Socialism, 1870–1920* (Urbana: University of Illinois Press, 1981).

To answer questions about the connections between ideologies of gender and those of class, I extended this study back to the earliest decades of the nineteenth century. I soon discovered that the rhetoric of female benevolence bore little resemblance to women's actual organizational behavior—most notably to the behavior of the most socially prominent and conservative women. Before I could understand the changes in the language and meanings of benevolence, I needed to explain more clearly why the identification of women with morality had such a powerful hold on society—and on women themselves—in light of this seeming inconsistency. I found that by untangling the connections between rhetoric and women's actual benevolent work I could learn a great deal not only about what the ideology explained but what it obscured—most especially, what it obscured about women's role in the development of middle-class identity in the United States.

Self-identity is not of course the sole, nor perhaps the most important, indicator of class standing or class development; nor is self-definition the only measure of the status of women. This book is a piece of a larger dialogue among historians who are trying to untangle questions about the intersection of identity and material conditions in the antebellum United States. In particular, I am indebted to the insight of historians such as Hewitt and Boylan that even within the white Protestant middle and upper classes, women who adhered to the rhetoric of female morality expressed quite different interests and goals, that the ideology of "woman's sphere" only superficially unified women across even the middle classes. As these scholars have demonstrated, women's class and social backgrounds corresponded with the causes they were likely to enter: In general, conservative benevolent women were far more likely than abolitionists to be members of wealthy, locally influential family and community networks, and their benevolent goals and means reflected the economic and political privileges of their class.

Hewitt and Boylan have drawn to great advantage upon quantitative analyses in showing the class, ideological, and generational differences among women who were committed to very different styles of activism. I suspect, however, that the question of middle-class self-definition will not dissolve in an ever more sophisticated solution of quantification and categorization. The problem of self-identity especially plagues historians of the antebellum years, a time when the concept of, indeed, the phrase "middle class" was still emerging; the problem intrudes into the most meticulous analysis of the material bases of social class as well as into fictional accounts of "genteel poverty." This

6

was a time when declarations of class identity—or lack of one—contradicted or obscured the material realities of growing class divisions. *Women and the Work of Benevolence* is thus not a further distillation of these material conditions and their relationship to benevolent reform. Rather than approach the problem by describing precisely who belonged to which category within the middle and upper-middle classes, I have chosen to jump into that murky intersection between social and intellectual history at a point of changing class dynamics and ask what meanings people at the time found in those changes. The road to material comfort and class dominance was rocky in the antebellum years, and measurements of the scale of that transformation have not put to rest questions about the experience itself. We can only observe the tumult in hope of better understanding its impact on ideologies of class, gender, and benevolence.[9]

This book, then, reevaluates changes in the ideology and practice of a specifically female benevolent activism in light of the essentially class nature of benevolence. If early benevolent work and rhetoric were vehicles for the emergence of a new middle-class identity, later changes

9. Let me make this experience a bit more specific. At the uppermost end of society, the patterns of inheritance and kin that defined class were most rigid, as Edward Pessen has shown. Below these highest ranks, however, white people endured a great deal of turbulence in their economic standing, a turbulence underscored during the depression of 1837, when national benevolent societies as well as individuals suffered unprecedented dislocation. Even those members of the broadly defined antebellum middle- and upper-middle class who were quite well off (and, indeed, one can begin to speak of an upper-middle class in these years) experienced the vulnerabilities and insecurities that characterized their less prosperous co-workers. Individuals who joined antislavery societies, e.g., were not simply less well heeled than the founders of, say, the conservative American Bible Society; they were newer to their affluence and less certain of it. The wealthy Lewis Tappan, for instance, who eventually founded the credit agency that would become Dun and Bradstreet, experienced bankruptcy; so did the fathers of Susan B. Anthony and Elizabeth Blackwell (cotton and sugar mill owners, respectively), forcing their daughters to help to support the family. See Edward Pessen, *Riches, Class, and Power before the Civil War* (Lexington, Mass.: D. C. Heath, 1973); Bertram Wyatt-Brown, *Lewis Tappan and the Evangelical War against Slavery* (Cleveland: Press of Case Western Reserve University, 1969); and Frances E. Willard and Mary A. Livermore, *American Women: Fifteen Hundred Biographies,* rev. ed. (New York: Mast, Crowell and Kirkpatrick, 1897; repr. Detroit: Gale Research, 1973), 1:30, 91. A number of reformers, like Abby Hopper Gibbons, grew up in marginally middle-class families that used much of their income for reform purposes and later married men who were able to provide considerable economic security; others (Lydia Maria Child comes to mind) had precisely the opposite experience. In addition, many among this activist middle or upper-middle class were new to their cities of residence: Tappan, for instance, and reformers Joshua Leavitt, Mary Hawkins, Sarah Smith Martyn, and others were newly removed from farms when they arrived in Boston or New York; they, if not their children, faced older urban elites—and the city itself—with the insecurity of the newly arrived. This experience, as much as their actual accumulation of material wealth, continually reemerges as central to their own self-definition.

in that work and rhetoric signaled an important transformation in that class's culture and politics. Tracing this transformation can help us trace the historical development of class identity in the United States and of women's role in it. Gender and class identities and interests, I argue, were not simply simultaneous throughout this process, each acting in its own place, but inextricable. Thus the book asks throughout how the ideology of female benevolence was used differently by women of different social groups and in different settings. What privileges—indeed, what authority— did the conflation of femininity and morality obscure? How did women of different social groups benefit from their commitment to the ideology of benevolent femininity? How did the middle class employ the ideology of benevolence and of female moral superiority in its own process of self-definition? Specifically, what roles did middle- and upper-middle-class women themselves play in making the "language of virtue and vice," as Christine Stansell puts it, "a code of class"?[10]

Understanding the conflation of femaleness and morality in nineteenth-century ideology—and the history of that conflation—can also help us understand the changing nature of authority over the course of that century. Several layers of analysis must be peeled away from the rhetoric of benevolence in order to explain these changes. Certainly it is true, as some women's historians have pointed out, that the ideology of female moral influence granted some women more personal authority than they might otherwise have had, even as it demanded that they accede to their social subordination to men. It is also the case, as earlier historians of benevolence have argued, that the ideology of benevolence, and especially its insistence on specific standards of sexual, work, religious, and leisure behavior, underpinned the cultural authority of a multilayered middle class over the poor, the non-Protestant, and the fallen.

More surprising, perhaps, are the ways in which a reexamination of female benevolence and authority provides us with new insights into American political history. Antebellum political life reflected an important moment in the nation's struggle to balance democracy with the rule of dominant groups, a struggle too often viewed only in terms of an increasingly diverse electorate and party structure. Yet, although the extension of the franchise might mean the expansion and sharing of authority among Americans, it also meant that authority operated in

10. Christine Stansell, *City of Women: Sex and Class in New York, 1789–1860* (New York: Alfred A. Knopf, 1986), p. 66.

hidden ways in an ostensibly democratic society. If the ideology of benevolence carried within it both radical and conservative implications for the development of women's sense of sexual solidarity, so too did the growing centrality of electoral politics contain complex and even contradictory meanings about the possibilities for social change. This book thus examines a society and, especially, a class that proclaimed the transcendent authority of women's influence in light of the changing nature of—and debate about—authority in American political life. The answers to these questions will surely teach us something about ideology—ranging from that of the most conservative and socially prominent of benevolent women to the most radical of middle-class Protestants—but more important, about the nature of gender as a social construct and the historical relationship among women, benevolence, and class.

The book is chronologically arranged, although several themes distinguish each chapter. After exploring the basic tenets of the ideology of female benevolence, chapter 1 describes the radical and conservative possibilities of that ideology, focusing especially on the role of women's belief in "benevolent femininity" in creating an analysis of sisterhood which could undermine male dominance, in defining the middle class, and in guarding propriety. The book then explores the ways in which women of different social groups participated in undertakings that the ideology of femininity itself obscured—business and political activities, for example. Chapter 2 analyzes a broad spectrum of the business of benevolence, especially for women involved in traditional charitable and relief endeavors. It focuses in particular on women's participation in fund raising, wage paying, and legal incorporation, activities that the ideology of an intrinsically female nature so persistently obscured. Chapter 3 assesses the ideological separation of morality and politics in light of evidence that women participated in varied and extensive political activities. It also examines how the middle class's most radical—or "ultraist"—female reformers grappled with their own political identities in the face of profound changes in American political life.

Although I initially expected to find that the fulcrum for the major changes in benevolence was the Civil War, it became clear that by the 1840s and 1850s, women and men were increasingly adopting institutional and electoral means for change and that these changes signaled new opportunities—as well as limits—for benevolent activists. Chapter 4 examines the emergence of a new generation of women just prior to the Civil War and demonstrates how the final antebellum decade set the

stage for war's reevaluation of female benevolence, in terms of both the changing styles of benevolence and the more conservative focus of activists themselves. Chapter 5 discusses the war itself, a war that constituted for many young women a central experience, a "revival" to which they would refer time and again in their later careers. Having served apprenticeships in corporate benevolence in the 1850s, a cadre of young, well-to-do women joined the men of their class in declaring themselves the national elite best fitted to make benevolence "efficient" instead of "feminine." Chapter 6 follows the careers and rhetoric of benevolent and reform women into the postwar decades. Although the ideology of female benevolence—and thus of a uniquely female morality—persisted into this period, the emphasis on business skills and on an unsentimental analysis of social ills pervaded institutions established by younger reformers. The chapter examines the ideologies of gender sameness that emerged alongside that of gender difference in this period—ideologies which could support either a radical call for women's equal rights or a conservative alliance with the men in the emerging professional elite. The chapter focuses on the tension between "business principles," which many women had stressed during the war, and the older ideal of the feminine task of social redemption, which they rejected.

A brief afterword focuses on the persistence of the ideology of morally expressed gender differences in the face of new ideologies of gender sameness. It concludes by attempting to understand the persistence of the belief in morally expressed gender differences across a wide spectrum of political opinion.

# *One*

## "Her Strongest Moral Organ"

—————————— ❦ ❧ ——————————

"Alas for morality among men!" moaned John McDowall, the founder of the moral reform movement, in 1833. McDowall did not refer to a generic man; like many of his contemporaries, he believed that men were less moral than women. Similarly, to physician and reformer William Alcott, conscience was a She. A writer in the *American Phrenological Journal,* after studying the head of reformer Paulina Wright Davis, noted approvingly, "Her strongest moral organ is Benevolence."[1] To many nineteenth-century observers, women's presumably sheltered environment sustained their truer morality. And as long as a woman did not leave her sphere, God had ordained that she be protected by some degree of inherent goodness, a "moral organ" in her very being.

By the nineteenth century, piety and moral virtue had come to be associated with female qualities. Women had long dominated Protestant church congregations, participating in the process by which Christianity gradually recast an older image of women as lustful seducers of men.[2] *Godey's Lady's Book* editor Sarah Josepha Hale lifted Eve herself from the depths of Christian doctrine in pursuing evidence of women's

1. *McDowall's Journal* 1:2 (February 1833): 9; [William A. Alcott], "Female Attendance on the Sick," *American Ladies' Magazine* 7 (July 1834): 302; "Paulina Wright Davis: Phrenological Character," *American Phrenological Journal* 17 (July 1853): 11.

2. As early as 1692, Cotton Mather, the Puritan divine, noted that "[there] are far more *Godly Women* in the world, than there are *Godly Men.*" Mather guessed that "the *Curse* in the Difficulties both of *Subjection* and of *Child-bearing* which the *Female Sex* is doom'd unto" might explain their greater willingness to submit to God: Cotton Mather, *Ornaments for the Daughters of Zion* (Boston: S. G[reen] and B. G[reen], 1692), p. 42. On the transformation in ideas about women from the European to the Puritan view see Carol F. Karlsen, *The Devil in the Shape of a Woman: Witchcraft in Colonial New England* (New York: W. W. Norton, 1987), especially pp. 155–66.

greater virtue: "Though human nature in both sexes is rendered sinful or prone to sin by the 'fall,'" she wrote, "yet women's nature has never sunk to the brute sensuality of man's; this comparative purity has kept her mind, as regards morality, above the standard which even the most Christian men fix for their own sex." Women's adherence to, indeed identification with, traditional Christian virtues—humility, modesty, submission, piety—would "exalt [them] to an equal rank with man in all the felicities of the soul, in all the advantages of religious attainment, in all the prospects and hopes of immortality."[3] As even the most casual observer of Protestant churches and revivals could tell, nineteenth-century religion had in some sense been "feminized."

The ideology of female moral superiority was a central component of nineteenth-century domesticity, or the "cult of true womanhood." It was among women's duties to be religious, insisted Lydia Sigourney, who claimed women's greater fitness for guarding the morals of the home and society. Women, she wrote, were "sheltered from temptation"; this, added to "our physical weakness, our trials, and our inability to protect ourselves, prompt that trust in Heaven, that implicit leaning upon a Divine arm." Women both embodied and utilized "the highest natural faculty or element of the human soul . . . moral sense."[4] The message was clear: women were protected by their religious training from abandoning themselves to the lusts and corruptions of men; they were in turn duty bound to cling to religion as the only safeguard against vice.

The assumption that women would exhibit a higher virtue than men infused antebellum Protestants' descriptions of their society, as well as their prescriptions for its salvation. "As regards the sexes," observed Philadelphia reformer Matthew Carey, "there are, among the poor, twice as many worthless males as females—idle, dissipated, and intemperate."[5] Social and religious experience suggested that women rarely fell to the level of men. In prisons, for example, men far outnumbered

3. Sarah Josepha Hale, *Woman's Record; or, Sketches of All Distinguished Women, from the Creation to A.D. 1854,* 2nd ed. (New York: Harper and Brothers, 1855; repr. New York: Source Book Press, 1970), p. xlviii; Samuel Worcester, *Female Love to Christ* (1809), quoted in Nancy F. Cott, *The Bonds of Womanhood: "Woman's Sphere" in New England, 1780-1835* (New Haven: Yale University Press, 1977), p. 130. See also Cott's chapter on religion (pp. 126–59).

4. [Lydia Sigourney], *Letters to Young Ladies* (Hartford: P. Canfield, 1833), pp. 36, 37; Hale, *Woman's Record,* p. xlviii.

5. M[atthew] Carey, *Appeal to the Wealthy of the Land,* 2nd ed. (Philadelphia: L. Johnson, 1833), p. 12.

women. Historian Estelle Freedman notes that in 1831 the percentage of prisoners who were female ranged from 5.3 percent in New York to 16.7 percent in Maryland. By 1850, only 3.6 percent of the inmates in thirty-four state and county prisons were women, with New York having the highest proportion at 5.6 percent. That same year in Massachusetts county jails and houses of correction, where most female prisoners were sent, women constituted 19.5 percent of the inmates.[6] These statistics say as much about what was culturally visible as about what was socially true; although asylums for "immoral" women increased in number over the 1840s and 1850s, prescriptive writers continued to maintain that women's virtue—aided by their domestic circumstances—prevented them from succumbing to the worst excesses of men.

To some degree the ideology of women's higher standard of virtue was self-fulfilling, since authors defined virtue itself to conform to women's visible behavior. Still, women seemed to behave more morally than men. Excluded from the electoral process, women had little opportunity to behave as corruptly as male politicians who bought votes. Rarely achieving positions of economic power, they were not among the merchants who profited from faulty or frivolous goods. Nor did they abandon their families as frequently and freely as did countless fathers and husbands. Women were not prominent as perpetrators of violent crimes. And if they drank liquor, they did so largely in private; respectable women, writers agreed, did not gather in bars.

Actual women, of course, failed to live up to these unachievable standards: Abby Hopper Gibbons counted herself among the most consistent of reformers when she refused to take brandy as medicine; apparently, many of her acquaintances did not consider that using such "medicine" might well belie the public image of restraint and delicacy.[7] Yet when faced with evidence of genuine female "depravity," visitors from benevolent organizations expressed both surprise and betrayal and acted as if the offender were ever the exception. "Our feelings were shocked to see one of our own sex so sunk in degradation," reported Margaret Prior, missionary for the New York Female Moral Reform

6. Estelle B. Freedman, *Their Sisters' Keepers: Women's Prison Reform in America, 1830–1930* (Ann Arbor: University of Michigan Press, 1981), p. 11.

7. Abby Hopper Gibbons to Susan Hopper, 28 December 1848, in Sarah Hopper Emerson, ed., *Life of Abby Hopper Gibbons Told Chiefly through Her Correspondence* (New York: G. P. Putnam's Sons, 1897), 1:148. W. J. Rorabaugh estimates that women consumed ⅛ to ¼ of the nation's liquor: *The Alcoholic Republic: An American Tradition* (New York: Oxford University Press, 1979), p. 12.

Society. Drunken women in particular amazed reformers, since intemperance was assumed to be a male vice. Visitors for the Female Total Abstinence Society in Boston cried out against "the degraded state into which intemperance had placed so many, *even of our own sex.*"[8] Indeed, the belief in women's greater virtue—and in its consequences for American society—permeated the rhetoric of advocates of social change. In abolitionists' analysis of slave society, male lust doubly enslaved black women. Slaveowners had demeaned womankind by showing disrespect for their female slaves' virtue, by separating wives from their husbands, and, most of all, by keeping mothers from their children. Under even the worst conditions, however, women's inherent goodness could prevail over evil. From the earliest abolitionist literature to Harriet Beecher Stowe's *Uncle Tom's Cabin,* many writers agreed that "women are the only beings who have not been degraded by slavery."[9]

That women were less often discovered in a degraded condition fueled the belief that women bore a responsibility to teach virtue to others. Doing good, writers claimed, was "her task, her lot, her ministry, her special destination."[10] Indeed, the conviction that "WOMAN," as Sarah Hale put it, was "God's appointed agent of *morality*" cemented the ideology of women's individual morality with the mandate to act to transform the world. With the advent of voluntary associations in the late eighteenth century and, especially, of the Second Great Awakening of the 1820s, writers demanded with increasing conviction that women assume a unique responsibility to disseminate Christian virtues and counter the materialism and greed of the nineteenth-century male. Women, numerous observers insisted, could affect all aspects of life,

8. *Advocate of Moral Reform* 3:11 (15 June 1837): 275; Female Total Abstinence Society of the City of Boston, *Annual Report* (Boston, 1842), p. 7, my italics. See also Matthew Carey, *A Solemn Address to the Mothers, Wives, Sisters and Daughters of Philadelphia* (Philadelphia, 1837), p. 4.

9. "In bondage they are not sordid; under persecution, they are still generous; . . . in suffering they lose not benevolence; in the most afflictive trials, they possess magnanimity; . . . excluded from power, privilege and distinction, they have enthusiasm for every great design, for every splendid achievement; their affections are purified from selfishness; they rejoice in diffusing joy, and are grateful for blessings in which they are not allowed to participate": *Salem Gazette* 32: 3 (February 1818): 4. The belief of many Northerners that white Southern women were closet abolitionists helped to underscore the horror of Southern practices: Ronald G. Walters, *The Antislavery Appeal: American Abolitionism after 1830* (Baltimore: Johns Hopkins University Press, 1976), pp. 105–08.

10. Reverend Alexander Young, *The Beneficent Woman* (1852), quoted in Kathleen D. McCarthy, *Noblesse Oblige: Charity and Cultural Philanthropy in Chicago, 1849–1929* (Chicago: University of Chicago Press, 1982), p. 13.

from church attendance to drinking, from education to laws. "It is woman's womanhood, her instinctive femininity, her highest morality that society now needs to counteract the excess of masculinity that is everywhere to be found in our unjust and unequal laws," claimed Jane Frohock in 1856.[11]

The rhetoric of female benevolence thus articulated not only the rationale but the means by which women were to act on behalf of a moral cause. Far from entering the fields of male battle, women, asserted countless missives, would activate an influence that was very nearly divine in nature. In theory, the more invisible—that is to say, characteristically feminine—this influence was, the more effective. "Woman is to win every thing by peace and love," intoned Catharine Beecher. Indeed, women's agency was so gentle, pervasive, and unseen that the world would hardly know it was being subverted. A Michigan abolitionist explained that "woman's influence, distilling like the dew of Heaven, gentle, constant and no less effectual, fertilizes and refreshes where it goes, and steals over the heart with irresistless power, which prompts to action." Metaphors abounded; not only the dew of heaven, women's influence was yeast for the bread of social change, a prayer to authorities higher than themselves.[12]

Ideologues of women's heavenly influence did not hesitate in giving that influence an earthly content when they depicted how women were to wield their immense power. "There is a certain class of benevolent deeds," asserted Lydia Sigourney, "which fall so peculiarly within the province of females, as to have obtained the name of feminine charities. I allude to the relief of the famishing, and the care of the sick." William Alcott insisted that training women as caretakers of the ill would benefit the entire society. Since, according to Alcott, women required only "the pleasure and privilege of being employed, and . . . of bestowing a charity," a supply of female nurses would mean that there would always be someone who could care for a sick person without charge. "Is there any good work or benevolent enterprise to be carried forward, where

11. Hale, *Woman's Record*, p. xxxv; Jane Frohock, in *The Lily* 8:23 (1 December 1856): 150.

12. Catharine E. Beecher, "Essay on Slavery and Abolitionism" (1837), in Jeanne Boydston, Mary Kelley, and Anne Margolis, *The Limits of Sisterhood: The Beecher Sisters on Women's Rights and Woman's Sphere* (Chapel Hill: University of North Carolina Press, 1988), p. 127; *Signal of Liberty* (Ann Arbor, Mich.), 4 July 1846, p. 42. See also "Female Influence," *Ladies' Garland* (Philadelphia) 1:4 (3 June 1837): 55, and *Godey's Lady's Book* 49 (August 1854), quoted in McCarthy, *Noblesse Oblige*, p. 18.

[woman] may not labor?" asked "Oliva," a Lowell factory worker. "Is there any vice that she may not rebuke?"[13] To those who worried that benevolent activities would weaken women's effectiveness in the home, reformers replied that benevolent work merely extended the job of motherhood, that it would elevate woman "without removing her from her 'appropriate sphere.'"[14] Justified as an extension of their maternal duties, women's influence could be exerted over an entire nation.

Indeed, it was most fortunate for a society bent on accumulating material wealth, writers claimed, that women's actions countered men's greed and selfishness. Rich men built factories, contended minister and reformer Theodore Parker, "wherein the sweat and tears and blood of the poor turn the wheels . . . . The wives and daughters of the wealthy house go out to 'undo the heavy burdens, and let the oppressed go free;' to heal the sick and teach the ignorant, whom their fathers, their husbands, their lovers have made sick, oppressed and ignorant." Similarly, Matthew Carey urged women to ponder the lives of seamstresses and servants of their acquaintance, "who are ground to the earth by an inadequate remuneration for their painful labours. Let [the ladies] raise their voices, . . . and urge their male friends to enter the lists in the holy cause of suffering humanity." Woman's influence in that "holy cause" was as mighty as it was invisible, for it governed the world's future. "Yes, Christian females, it depends . . . upon you," warned the Rhode Island *Philanthropist*, "whether this country shall be wrecked by the flood of iniquity and death which now threatens its desolation and destruction, or whether it shall arise and come forth in the beauty of holiness."[15]

13. Sigourney, *Letters to Young Ladies,* p. 120; Alcott, "Female Attendance," p. 303; "Oliva," *The Voice of Industry,* in Philip Foner, ed., *The Factory Girls* (Urbana: University of Illinois Press, 1977), p. 302. Later, the Civil War would serve as a dramatic occasion for extolling women's particular fitness for benevolent services. See Mrs. C. B. W. Flanders, "Woman of the Times," in *Our Country, in Its Relation to the Past, Present and Future,* ed. Almira Lincoln Phelps (Baltimore: John D. Toy, 1864), p. 259.

14. Boston Female Moral Reform Society, *Second Annual Report* (Boston, 1837), p. 11. See also Boston Female Auxiliary Bible Society, *Annual Report* (Boston, 1823), p. 10. Mrs. A. J. Graves for one had serious doubts about the "anti-domestic" tendencies of benevolent activity: *Woman in America: Being an Examination into the Moral and Intellectual Condition of American Female Society* (New York: Harper and Brothers, 1855), pp. 138–43.

15. Theodore Parker, *The Public Function of Woman: A Sermon* (London: John Chapman, 1855), p. 11; Carey, *Appeal to the Wealthy,* p. 4; Rhode Island *Philanthropist* quoted in *McDowall's Journal* 1:9 (September 1833): 72. Parker, interestingly, thought that philanthropy, although it reflected well on the women themselves, did not go far enough: "We need the justice which removes causes, as well as the charity that palliates effects." For other paeans to the extent of this influence see John Todd, *The Daughter at School* (Northampton,

That women had a special responsibility to alleviate harsh conditions was an idea of long and respectable standing. But during the nineteenth century, the growth of both economic hardship and benevolent associations expanded the list of Protestant women's duties beyond recognition. In the rhetoric and then in fact, women's influence leapt across barriers, permitting them to enter all but the most protected male bastions. To the defenders of Republican motherhood, mothers had borne the responsibility to influence their children to be virtuous citizens; how much wider an impact might they have as teachers? Female churchgoers could persuade ministers to direct church funds toward local organizations; how far, it followed, could their "prayers" to legislators extend? Sunday schools, immigrant neighborhoods, prisons, hospitals, and wars were but a few of the situations that succumbed to the "maternal" force. "To [women], we must look for the advancement of all noble and philanthropic enterprises," wrote Linus Brockett and Mary Vaughan, "the lifting [of] vagrant and wayward childhood from the paths of ruin; the universal diffusion of education and culture; the succor and elevation of the poor, the weak, and the down-trodden; the rescue and reformation of the fallen sisterhood."[16] The rhetoric of Christian benevolence suggested not only that even the most oppressed women would aspire to a higher standard of virtue than that presumably exhibited by men but that women, acting together, would identify with and care for the poor and downtrodden.

The belief in the tenets of benevolent femininity—in a morality defined by "female" traits and in women's mandate to promote it—pervaded a broad spectrum of antebellum social movements, from the most conservative and prosperous evangelical organizations to the most "ultra" and more marginal abolitionist societies. In important respects these groups' analyses of social ills differed dramatically: whereas those who would form the American Bible Society and the American Tract Society constituted, in the words of one historian, "an evangelical counter-offensive to political and religious infidelity," moral reformers, temperance activists, and abolitionists reaffirmed essentially female values on behalf of far more radical causes. Reacting in part against the earlier, more elite endeavors, these later groups sought to eradicate the "sins" that they believed lay at the root of the nation's troubles; they

Mass.: Hopkins, Bridgman, 1854), p. 213, and Mr. Wells' "Address before the Moral Reform Society of Salem," in S.M.R.S., *First Annual Report* (Boston: John Ford, 1835), p. 15.

16. Linus P. Brockett and Mary C. Vaughan, *Woman's Work in the Civil War: A Record of Heroism, Patriotism and Patience* (Philadelphia: Zeigler, McCurdy, 1867), p. 77.

insisted that truly pervasive social change could only follow each individual's moral transformation. Yet across this broad spectrum, an ideology about morality and gender was central to a process by which an emerging middle and upper-middle class would identify its own social station. Women, often seen by historians as mere foot soldiers in causes that did not define a specifically female constituency and agenda, played an active role in shaping all these cultural institutions—and, indeed, the culture of class itself.[17]

Furthermore, no matter what the goals of women, an analysis that conflated femininity and morality contained within it both conservative and radical implications for the work of female activists themselves. As Nancy Cott, Barbara Berg, and others have shown, the insistence on women's shared characteristics and experience could constitute a conservative defense of existing sexual inequality but it could also provide the basis for women's organizing on their own behalf.[18] These radical and conservative possibilities were always in tension: the very assertion of an identity based on female morality carried within it both the conservative imperative to conform and a more radical call to define and act upon women's needs.[19] Within the same movement, organization, or, indeed, individual, the contradictory implications of female benevolence tangled its adherents (and later historians) in a web of ideology and

17. Peter Dobkin Hall, *The Organization of American Culture, 1700–1900: Private Institutions, Elites, and the Origins of American Nationality* (New York: New York University Press, 1982), p. 88; also pp. 109–10. On the use of the term "middle class" see Karen Halttunen, *Confidence Men and Painted Women: A Study of Middle-Class Culture in America, 1830–1870* (New Haven: Yale University Press, 1982), pp. 28–30, and Jeanne Boydston, *Home and Work: Housework, Wages, and the Ideology of Labor in the Early Republic* (New York: Oxford University Press, 1990), chap. 3. For a description of the different class and kin networks of different groups of activist women see especially Nancy A. Hewitt, *Women's Activism and Social Change: Rochester, New York, 1822–1872* (Ithaca: Cornell University Press, 1984), chap. 2.

18. Cott, *Bonds of Womanhood;* Barbara J. Berg, *The Remembered Gate: Origins of American Feminism: The Woman and the City, 1800–1860* (New York: Oxford University Press, 1978). This is not to suggest that women who organized for moral reform would later become advocates of woman's rights. As Anne Boylan has demonstrated convincingly, participation in conservative benevolent work did not lead women into more radical, or feminist, activity. The development of a feminist strain of reform was ideologically distinct and reflected a different social group's political interests rather than a linear transition. See her "Women in Groups: An Analysis of Women's Benevolent Organizations in New York and Boston, 1797–1840," *Journal of American History* 71 (December 1984): 497–523.

19. Mary P. Ryan points out that conservatism and "true femininity" were closely allied in performing "a subtle coercive function": "Femininity and Capitalism in Antebellum America," in *Capitalist Patriarchy and the Case for Socialist Feminism,* ed. Zillah R. Eisenstein (New York: Monthly Review Press, 1979), p. 155.

interest that included, in the context of the antebellum period, not only identities of gender but those of class and cause as well.

The female moral reform movement of the 1830s and 1840s illustrates explicitly how the ideology of benevolent femininity could convey the need and strategy for fundamental change in sexual behavior and standards in the antebellum United States even as it expressed an emerging class identity. In this case, a campaign against "vice" underpinned an attack on a wide range of social ills, including a transformation of male- and money-dominated society itself on the basis of traits that were supposedly characteristic of women. Founded in 1834, the New York Female Moral Reform Society and its hundreds of branches sought on one level simply to end prostitution, a campaign at which they were extraordinarily ineffective. More broadly, the movement advocated a single—"female"—standard of sexual behavior and urged its adherents to ostracize "licentious" men as they did "fallen" women.[20] Moral reformers' descriptions of their visits to women provide a glimpse of the radical potential of women's assertion of their own supposed difference from men, not so much because they identified with poor women and prostitutes as because of the way in which they understood worth by a different standard from that presumably adhered to by men. By describing women as victims in a lustful society—and men as the very personification of that lust—they sought to define respectability itself not by wealth, which they insisted was tenuous and under men's control, but by women's own virtues.

Female moral reformers blamed a bewildering array of societal circumstances for the seeming spread of licentiousness. Dancing, theater, long visits with men, foreigners, masturbation, and, especially, love for dress were constant temptations. Sarah R., for example, refused to abandon life as a prostitute: "The passion for dress was too strong to permit her to hesitate long about the means of gratifying it," explained the *Advocate of Moral Reform*. "Popery," idleness, and drink added fuel to an explosive moral situation.[21]

20. Carroll Smith-Rosenberg, "Beauty, the Beast, and the Militant Woman: A Case Study of Sex Roles and Social Stress in Jacksonian America," *American Quarterly* 23 (October 1971): 562–84; Barbara Meil Hobson, *Uneasy Virtue: The Politics of Prostitution and the American Reform Tradition* (New York: Basic Books, 1987), chap. 3; Larry Howard Whiteaker, "Moral Reform and Prostitution in New York City, 1830–1860" (Ph.D. diss., Princeton University, 1977). The society changed its name to the American Female Moral Reform Society in 1839 and to the American Female Guardian Society and Home for the Friendless in 1849.

21. On Sarah R., *Advocate* 3:17 (1 September 1837): 316. The following are a few of the

To female moral reformers, however, one evil dominated—indeed, created—all others: men. One cannot exaggerate the hostility toward men in their journals, auxiliary constitutions, and, most important, discussions of poverty and prostitution. Lust appeared as a disease that had infected the entire male population. "Men who seek to destroy [women's] virtue and happiness, are more dangerous than the wild animals that roam their native forests," asserted a writer to the *Advocate*. More alarming, while animals remained in their forests and criminals were in jail, society smiled upon sinful men: "the seducer, worse than *murderer*, stalks unmolested."[22] Moreover, licentious men enjoyed the evil they engendered. "There is not a licentious man on earth," claimed one male supporter, "who would not, if he could, circumvent and destroy the loveliest female in creation and . . . triumph in it, as the noblest act of his abandoned life." Although some men joined the moral reform movement, the *Advocate* maintained that, at least in theory, only women could perform the task of moral reform: "It could not be entrusted to man, as . . . he is often the worst enemy of the other sex, and generally has not virtue sufficient to qualify him for the trust."[23]

Opposition from men of all classes confirmed moral reformers' belief that men stood in the way of true virtue. Moral reformers more than hinted to wives that an evil motive lay behind their husbands' objections to the *Advocate*. Visiting "among the wealthy," Margaret Prior noted that many women would support the cause of moral reform were it not for their husbands' opposition. She suggested that men's dislike of the movement originated from their deviousness: "Many men who are husbands and fathers, nevertheless maintain the wretched victims they have ruined, and thus support licentiousness." Thus moral reformers placed themselves between women and men, constantly reminding women:

many examples about these themes: on novel reading, ibid. 2:12 (1 July 1836): 93; on "self-pollution," 2:14 (1 August 1836): 107; on theater, 3:3 (1 February 1837): 205, and Prior diary, 15 June 1837, in Sarah R. Ingraham, *Walks of Usefulness, or, Reminiscences of Mrs. Margaret Prior* (New York: American Female Moral Reform Society, 1844), p. 98; on foreigners, *Advocate* 3:12 (15 June 1837): 276, and 3:15 (1 August 1837): 299; on dress, ibid. 2:17 (15 September 1836), and *Christian Almanac for Connecticut* 2:9 (Hartford: American Tract Society, 1836), p. 36. For a listing of the evils that moral reformers thought young women should avoid see *Advocate* 3:4 (15 February 1837): 209–10. On "popery," see New York Magdalen Benevolent Society, *Missionary Labors through a Series of Years among Fallen Women* (New York, 1870), pp. 92–93; on punctuality and idleness, see *Christian Almanac* (1830) and N.Y.M.B.S., *Missionary Labors*, p. 20.

22. *Advocate* 3:1 (1 January 1837): 189; 3:3 (1 February 1837).

23. Reverend S. S. Smith, address to the Female Moral Reform Society of Lockport, excerpted in *Advocate* 3:4 (15 July 1837): 289; 3:24 (15 December 1837): 371.

"Opposition to Reform does *not* originate in modesty or purity—but springs from ignorance and lust." "Depend upon it," the *Advocate* assured women, "he who scoffs at what he calls your 'prudish severity,' is secretly trembling for fear of the consequences of your firmness."[24]

The Female Moral Reform Society and its auxiliaries demanded that respectable society treat rakes with the disrespect traditionally accorded prostitutes. Building on themes from early American and English seduction literature, the *Advocate* cheered women who valued virtue over male company. When one young woman refused to take the arm of her friend's (licentious) brother, the offended sister warned, "If you refuse the attentions of all licentious men, you will have *none*." Her virtuous companion retorted, "Then I can dispense with them altogether." This was just what the *Advocate* wanted to hear: "How long would it take to revolutionize society, were all young ladies to adopt this resolution?"[25] Moral reformers insisted that women define and implement universal standards of behavior based on their own virtues.

The Female Moral Reform Society position, by raising fallen women some distance on the moral scale, had the effect of reversing the traditional double standard of morality. Women were no longer considered perpetrators of lust and seduction; they were victims. Because of women's greater innocence, licentious men were more criminal than their female counterparts. Speaking to the moral reform auxiliary in Lockport, New York, the Reverend S. S. Smith asserted that, in God's eyes, men bore the greater burden of guilt, for it was men who "govern and control the destinies of society. . . . [If] they pursue, and entice others to the pursuit of practices which are utterly subversive. . . , are they not more criminal than the enticed and deceived females?" The *Advocate* urged that men whose behavior was merely suspect be treated as guilty, that mothers protect the virtue of their sons, and that women reject the argument that delicacy should prevent them from teaching their daughters about licentiousness.[26]

The ideology of female uniqueness and the benevolent work it sanctioned nurtured a sense of connection among these women within the framework of evangelical religion, a connection that, some hoped, could lead women to transcend their differences and act upon their shared sexual status. Female moral reformers aggressively embraced the

24. *Advocate* 3:20 (15 October 1837): 340; 3:24 (15 December 1837): 370; 2:12 (1 July 1836): 96.
25. Ibid. 3:6 (15 March 1837).
26. Reverend S. S. Smith in ibid. 3:4 (15 July 1837): 289.

notion that gender differences far outweighed other distinctions and urged women, in their own self interest, to behave accordingly. "The race of woman is *one,—*" the *Advocate* declared, "whether they be in the bonds of Slavery—the sinks of pollution—the dens of intoxication— the abodes of poverty—in festive halls, the palaces of the great."27 To moral reformers, if women were one race, men were the other; if women, by virtue of their sex, were moral, men, by virtue of theirs, were not.

Moral reformers fused their argument about the permanence of sex with one about the tenuousness of economic status, a point that merged criticism of men with the reality—and resulting insecurity—of class shifts in the antebellum period. Having argued that women had little control over their material wealth, moral reformers asserted that men did. Even the poorest man, reformers claimed, had more control than his wife over his family's material status. Women, in contrast, were seduced, abandoned, and ill-treated, made victims of vice, intemperance, and depravity. In compensation for women's dependence on men for their material comfort, moral reformers suggested that religion and domesticity were women's keys to asserting control over men and over their own social standing. "Respectability" would not only protect women; it would redefine social status according to female standards.28

Moral reformers' analysis of social standing as a moral quality was especially evident in their emphasis on the unlikelihood that economic status could provide true security. In a message directed more to the wealthy than to the poor, moral reformers emphasized the fluid and arbitrary nature of class status, which they equated with material wealth. Even middle-class girls became prostitutes; even wealthy wives found themselves impoverished. "No station is secure," warned the *Friend of Virtue,* the New England society's newspaper. "The wealthy, the educated, the accomplished, as well as the poor, the ignorant and the unprotected, will be among the fallen." The very nature of the fall took on two meanings—moral and economic—in moral reformers' discus-

27. *Advocate of Moral Reform and Family Guardian,* 1 November 1852.
28. As historians Mary Ryan, Barbara Epstein, and Paul Johnson have demonstrated, religion was indeed often a source of tension between women and men; men who did convert frequently did so on their wives' urging, after the latter had been visited by evangelical women: Mary P. Ryan, "A Women's Awakening: Evangelical Religion and the Families of Utica, N. Y., 1800–1840," in *Women in American Religion,* ed. Janet Wilson James (Philadelphia: University of Pennsylvania Press, 1980), pp. 89–110; Barbara Epstein, *The Politics of Domesticity: Women, Evangelism, and Temperance in Nineteenth-Century America* (Middletown, Conn.: Wesleyan University Press, 1981); Paul E. Johnson, *A Shopkeeper's Millennium: Society and Revivals in Rochester, New York, 1815–1837* (New York: Hill and Wang, 1978), pp. 98–99, 108.

sions. "*'Broadway'* and the *'points'* [a notorious New York slum]," announced the *Advocate,* "so far as externals are concerned, present a striking contrast. The one displays fashion, elegance, and splendor, the other misery, filth and pollution." Morally, the article continued, the two were much closer: a woman who led a stylishly dissipated life in 1835 was, in 1836, living in "pollution" at Five Points.[29]

"Sin is not confined to the lower classes," the *Advocate* constantly reminded women. Yet seduction—and the resulting sin—threatened both wealth and respectability; virtue was women's only protection of their status, especially during periods of economic hardship. Visitors to slums stressed the prevalence of fallen or poor women who had once enjoyed considerable material advantages. Sunday school teachers, merchants' daughters, and faithful wives could be trapped by the seducer or left in poverty by their husbands, for even ministers could become drunkards, descending easily "from the pulpit to the prison."[30] Such tales reminded women of the insecurity of material—or earthly—status. Yet although moral reformers held wealthy women accountable for defining social worth according to an economic scale, they absolved fallen and poverty-stricken women of responsibility for their own economic position. They argued that wages were too low to permit women to resist temptation; women, they insisted, were virtually starved into dependence on men. They were not entirely alone in advancing this view; ministers as well as factory women recognized that "dire necessity force[d] sad and fearful alternatives" upon poor women. "I could cite many instances of young, and even middle-aged women, who have been 'lost to virtue,' apparently by no other cause than the lowness of wages," asserted a physician.[31] The constant reiteration of the link between poverty and temptation reminded women of all classes how little stood between themselves and the fallen.

According to some reformers, then, the ideology of female characteristics and female unity made malleable the issues of class identity and

29. *Friend of Virtue* 5:5 (1 March 1842): 69; "The Contrast," *Advocate* 3:16 (15 August 1837).

30. *Advocate* 2:20 (1 November 1836) (New Haven Auxiliary): 155; Prior diary, 26 December 1839, in Ingraham, *Walks of Usefulness,* p. 216. Other Protestant activists agreed with this "evidence," although none formed as consistent an analysis of gender identity as did the moral reformers.

31. "Address of the Shirt Sewers' Cooperative Union," in Dolores Janiewski, ed., "Archives: Making Common Cause: The Needle-women of New York, 1831–1869," *Signs* 1 (Spring 1976): 782; Dr. Van Renssellaer quoted in Carey, *Appeal to the Wealthy,* p. 16. See also Carey, *Solemn Address,* p. 5.

class interest. In noting the tenuous nature of economic well-being and in attributing its fluctuations to men, some benevolent women sought to redefine social status as a measure of virtue—a female trait— rather than of class. Class, they claimed, was an artificial condition imposed upon women by men. If women only fulfilled their "female destiny," and behaved more morally than men, they could dissolve class boundaries, at least for women. If they identified with "virtue," all but the poorest could achieve what has come to be labeled "middle-class respectability." The ideology obscured real differences among women (not least the class interests of reformers themselves), but it also contributed to many women's sense of power and autonomy. The very concept of sisterhood, based on a belief in distinct female traits and experiences, encouraged in some women a concern for all women's economic and political status. For moral reformers, the concept of women's uniqueness underlay a broad critique of men's authority—over women as well as over society itself—at a time of considerable economic insecurity.

In spite of moral reformers' apparent unconcern for their own class standing, this ideology about gender contributed to a process of middle-class self-definition, to the notion that the United States itself was a middle-class society and that it was virtue, not wealth, that determined individuals'—and therefore the nation's—success. Moral reformers, anxious to define themselves as distinct from more established elites, were part of a class that, as Christine Stansell writes, "understood class in religious terms," terms that the benevolent invoked constantly.[32] Thus, the antislavery *Emancipator* listed as one of "Eleven Reasons for Not Accepting an Invitation to a Fashionable Party" that one would "find few, if any Christians there."[33] Abolitionist Juliana Tappan, a member of a family that was well-to-do by any standard, believed herself to be part of a virtuous class, one distinct from the elite; she complained that petitioning against slavery was made the more difficult in New York City because "there is so much aristocracy here, so much walking in Broadway to exhibit the butterfly fashions, that we can seldom gain access to the consciences of the women . . . . Ladies, sitting on splendid sofas, in the midst of elegance, looked at us, as if they had never before heard the word *Texas*."[34] In its attack on the elite and on wealth as the

32. Christine Stansell, *City of Women: Sex and Class in New York, 1789–1860* (New York: Alfred A. Knopf, 1986), p. 67.
33. *Emancipator* 1:36 (5 January 1837): 4.
34. Juliana Tappan to Anne Weston, 21 July 1837, vol. 9, no. 49, Antislavery Collection, Rare Books and Manuscripts Division, Boston Public Library.

measure of worth—an approach that embraced all the major revolution-
ary era themes about virtue, independence, and the corrupting influence
of luxury—this critique constituted a potentially radical analysis of the
emerging American social structure.

Apart from its role in developing a critique of male dominance and
of the dominance of materialistic values, however, the ideology of a
benevolent femininity served a powerful conservative function. First,
and most obviously, the ideology sought to mute real differences among
women, especially the class privileges of its middle-class proponents. As
Stansell has recently demonstrated—and as the working-class oppo-
nents of middle-class benevolence were quick to point out—benevolent
activists articulated a vision of an America that was "purged of the
supposed perfidies of working-class life," indeed, one that embraced
middle-class religious practices, leisure behavior, sexual and child-rear-
ing customs, and work patterns as the universal standard. In the face of
the growing distance between classes and the acceleration of urban
poverty—among the very things that provoked the demand for social
change in the first place—an ideology that sought to define class solely
as a moral condition seems at best naive, at worst, pernicious.[35]
In addition, benevolent women—and men—were quite prepared
to use the ideology of femininity as a weapon against female organizing
that served interests they thought too radical. The language of gender
spheres, with its charge of "straying," was often used less to describe the
boundaries of women's benevolent activity than to assert the unpopular-
ity of a cause, less to police oneself than to question other women's
"femininity." Again and again, both female and male reformers initiated
discussions of female propriety when more radical activists threatened
their own prerogatives, among which was their claim to setting the
standard for "female virtue." The conservative American Bible Society,
for instance, bridled at any suggestion that its female supporters might
be "acting out of their appropriate sphere." On the contrary: because of
"their rank and influence in the community," the women who operated
the branch societies "have an acknowledged right to dictate rules of
propriety." More conservative women assumed the right to define pro-
priety—and impropriety—for others without focusing as critical an eye
on their own efforts to do good.[36]

35. Stansell, *City of Women*, p. xii.
36. American Bible Society, *A Brief Analysis of the System of the American Bible Society*
(New York: Daniel Fanshaw, 1830), p. 130. Hewitt, *Women's Activism*, p. 55, agrees: "As they

The ideological conflation of femininity and morality thus freed observers from having to offer pertinent responses to their more radical opponents' demands; they could simply attack the femininity—and therefore the morality—of their critics. Speaking to Congress in 1840, Representative Garland of Virginia asked that his fellow representatives ignore antislavery petitions—especially from women. Rather than direct his opposition to the issue of abolishing slavery, he questioned the intelligence and marriageability of the women who signed such petitions: "These *women* undertake to petition Congress to redress grievances of which they know nothing . . . . Yes, sir, the grievances of the superstitious, ignorant, and oppressed people of this District are to be poured into our ears by a few school misses and factory maids in Massachusetts."[37] Similarly, secular social and political doctrines were said to create an atmosphere in which vice, especially sexual vice, flourished. Writers for the *Advocate of Moral Reform* blamed the radical Fanny Wright for "the *mobs* which have disgraced this nation," the "spirit of misrule," the deaths of once virtuous women, and prostitution itself. Catharine Beecher's diatribe against Wright's alleged immorality and unfemininity was graphic: "There she stands," Beecher raged, "with brazen front and brawny arms, attacking the safeguards of all that is venerable and sacred in religion, all that is safe and wise in law, all that is pure and lovely in domestic virtue." Thus Beecher warned against principles counter to her own, held by a woman who, "with her great masculine person, her loud voice, her untasteful attire, going about unprotected, and feeling no need of protection, mingling with men in stormy debate, and standing up with barefaced impudence, to lecture to a public assembly," dared advocate liberalized divorce laws and "free love."[38]

Attacks that made use of the conflation of morality and femininity functioned explicitly to dissuade individuals from allying with an unpopular cause. The well-to-do Sarah Blake Shaw, for example, struggled for several years over whether to include her name in the call for the Boston antislavery fair, apparently fearing adverse publicity associated

---

entered public paths on errands of mercy," she writes, "few fellow townsmen would accuse them of stepping outside their sphere, for Rochester's early ladies bountiful were precisely those women who were charged with defining the proper place of their sex in community life."

37. Speech of 21 January 1840, *Congressional Globe* (Washington, D.C., 1840), vol. 8, 26th Congress, 1st session, appendix, p. 749.

38. "What a Woman Has Done," *Advocate* 3:24 (15 December 1837); "Female Infidelity," *ibid.* 2:14 (1 August 1836); Prior diary, 11 August 1838, in Ingraham, *Walks of Usefulness,* pp. 130–31; Catharine Beecher, "Letters on the Difficulties of Religion" (1836), in Boydston et al., *Limits of Sisterhood,* p. 236.

with abolition itself.[39] Moral reform, too, carried the onus of immorality in some circles. The New York *Herald,* upon receiving the "Appeal" of the newly founded New York Female Moral Reform Society, promptly impugned the respectability of the society's founders, suggesting that they were *"roués,"* who had taken a "religious turn" and demanding to "know their names—to know the private history of their lives." The threat was explicit: "Let no woman who values her reputation for delicacy and taste—for virtue and morality, ever become a member of a moral reform society." Abolitionist Charles Follen recognized the nature—and success—of "the insolent remarks about women, in which those of the dominant sex . . . are particularly apt to indulge" and applauded those who suffered "the still stronger fear of being thought unfeminine. . . . It is, indeed, a proof of uncommon moral courage . . . ," he noted, "that a woman is induced to embrace the unpopular, unfashionable, obnoxious principles of the abolitionists."[40]

Men also suffered from derogatory slurs about their sexual identities, although these were less common. In 1835 a Boston mob failed to capture and lynch the English abolitionist George Thompson, who was on a speaking tour in the country. Frustrated, the *Boston Commercial Gazette* resorted to insulting Thompson's "masculinity" by noting nastily: "It does not astonish us that he should again call to his aid the petticoats of the ladies, for he has often been shielded by them from popular indignation. . . . [He] always throws himself under the protection of the female portion of his audience when in danger."[41] The Boston mob, composed in part of well-to-do Bostonians, moved from

39. In December 1841, Shaw informed Maria Weston Chapman that whereas her husband, Francis, would contribute to the cause, "I feel a stronger objection than ever, to making any public acknowledgment of my principles or feelings . . . . I hardly know myself why I should have this strong antipathy to putting my name to any advertisement . . . , excepting that it is against my taste, & my nature which is decidedly retiring." Defensively, Shaw assured Chapman that her hesitancy no longer had to do with what her father might think of the act: Sarah B. Shaw to Maria Weston Chapman, 3 December 1841, vol. 1, no. 13, Antislavery.

Shaw continued to defend her decision: Shaw to Eliza Lee Follen, 1842 [?], vol. 17, no. 1, Antislavery. By November 1842, however, all her "numerous slight reasons for refusing my name to the advertisement of the 'Fair' are vanished," and she asked that her name be included. She added, "I was strongly tempted to sign it when you sent it, but . . . if I had done [it] at that time, it would have been done with my HEAD & not my heart, & now I do it with real delight": Shaw to Maria Weston Chapman, 1 November 1842, vol. 1, no. 27, Antislavery.

40. "Female Moral Reform," *Herald* (New York), 29 October 1836, p. 2; Massachusetts Anti-Slavery Society, *Fourth Annual Report of the Board of Managers* (Boston, 1836), p. 52.

41. Quoted in Boston Female Anti-Slavery Society, *Report of the Boston Female Anti-Slavery Society; with a Concise Statement of Events, Previous and Subsequent to the Annual Meeting of 1835* (Boston, 1836), p. 12.

verbal to physical harassment of antislavery activists. The angry crowd had some difficulty, however, in locating the meeting of the Boston Female Anti-Slavery Society. Finally, it came upon a meeting of forty women that, with much bravado, the men scattered. One Boston newspaper congratulated the citizenry on this brave act and regretted only that George Thompson had again escaped their grasp. Maria Weston Chapman, leader of the Boston female abolitionists, viewed their failure with both amusement and alarm. So anxious had the men been to disperse women's meetings, she explained, that they had neglected to inquire about the meeting's intent. Instead of disbanding a wicked meeting of abolitionists, the crowd had sent forty women—surprised, no doubt, but unhurt—from their moral reform society meeting. Chapman viewed this as a warning to all women—and men—of the limits of society's tolerance for challenges to powerful institutions. Indeed, it was.[42]

Attacks on activist women's femininity and morality successfully inhibited women's activism on behalf of a radical cause. The 1830s witnessed the busy, if brief, antislavery career of a young woman named Juliana Tappan. As Lewis and Susan Aspinwall Tappan's daughter, Juliana was born into benevolent activity. Serving as her father's secretary acquainted her intimately with the business of benevolence, for Lewis was the benevolent administrator par excellence, a leading reformer, and financier of innumerable abolition and missionary projects.[43] Like her father, Juliana Tappan was drawn to the detail of administration, not the abstraction of abolitionist ideology. As the twenty-year-old secretary of the Ladies' New-York City Anti-Slavery Society, she served as a link between New York and the Boston and Philadelphia reformers in their shared efforts to collect items for the antislavery bazaars, organize women's antislavery conventions, and circulate petitions for the cause.[44] She was often worried, and probably intimidated, by the Boston reformers' grandiose statements, their intellectual radi-

42. The incident is related in B. F. A. S. S., *Report* (1836), especially pp. 9–18.

43. Biographical information on Juliana is sparse; what follows has been gathered from Lawrence J. Friedman, *Gregarious Saints: Self and Community in American Abolitionism, 1830–1870* (New York: Cambridge University Press, 1982), who also provides some information about Susan (pp. 147–49), and from Bertram Wyatt-Brown, *Lewis Tappan and the Evangelical War Against Slavery* (Cleveland: The Press of Case Western Reserve University, 1969). On the kinds of administrative tasks at which Lewis excelled see ibid., pp. 170–72.

44. Tappan's correspondence is scattered. Much of it, addressed to the Weston sisters, is in the Boston Public Library Antislavery Collection. There are a few letters from the late 1830s elsewhere, including to Mary Grew in the Philadelphia Female Anti-Slavery Papers at the Historical Society of Pennsylvania and to Susan Porter, Samuel Drummond Porter Family Papers, University of Rochester. I thank Nancy Hewitt for showing me this correspondence.

calism, and their Unitarian worldliness. Yet before 1837 Tappan did not express reservations about the propriety of her own or other abolition-ists' activities.

In May 1837, with her mother, Susan, Juliana Tappan attended the first antislavery convention of American women, which was held in New York; she was one of seventy-one delegates, among them Lydia Maria Child (who came to consider female conventions "like half a pair of scissors"), Margaret Prior, Anne Weston, Lucretia Mott, Grace and Sarah Douglass, and other abolition and moral reform luminaries. Sarah Ingraham and Abby Hopper Gibbons were corresponding members. The list of participants reads like a who's who of reform and Quaker women: the convention promised to be a stimulating event. Juliana was appointed to several rather mundane committees; the more exciting work took place in the general meetings, where numerous resolutions were proposed, debated, and adopted.[45]

The convention served to organize the enormous work of circulat-ing petitions, an activity in which Tappan was a fervent participant. The delegates adopted without difficulty a resolution put forth by Angelina Grimké claiming that "the right of petition is natural and inalienable," and calling on "every woman in the United States . . . annually to peti-tion Congress with the faith of an Esther." In contrast, an "animated and interesting debate respecting the rights and duties of women" took place when Grimké further proposed that "the time has come for wom-an to move in that sphere which Providence has assigned her, and no longer remain satisfied in the circumscribed limits with which corrupt custom and a perverted application of Scripture have encircled her." The resolution was finally adopted, although twelve women had their names recorded in the minutes as "disapproving of some parts of it." Juliana Tappan was not among them.[46]

Tappan promptly and faithfully implemented the decisions of the

45. Information on the convention is from the *Proceedings of the Anti-Slavery Convention of American Women, Held in the City of New-York, May 9th, 10th, 11th, and 12th, 1837* (New York: William S. Dorr, 1837). These proceedings have been reprinted by the Feminist Press (New York, 1987) under the title *Turning the World Upside Down*. Child's quotation is in a letter to Lucretia Mott, 5 March 1839, prior to the later convention, which she declined to attend: in Anna Davis Hallowell, ed., *James and Lucretia Mott: Life and Letters* (Boston: Houghton Mifflin, 1884), p. 136. See also Child to Henrietta Sargent, 17 April [1837?], in Milton Meltzer and Patricia G. Holland, eds., *Lydia Maria Child: Selected Letters, 1817–1880* (Amherst: University of Massachusetts Press, 1982), pp. 67–68. Tappan's own reports of the convention appeared in the *Evening Post* and the *Emancipator*. Copies are in her father's diary, dated 18 May 1838 and 23 May 1838, Lewis Tappan Papers, Manuscript Division, Library of Congress.

46. Anti-Slavery Convention, *Proceedings* (1837), pp. 8, 9.

convention. One week after the visiting delegates had left to organize in their own communities, she was again immersed in the task of gathering names on petitions and writing about the work to Anne Weston.[47] But that year Sarah and Angelina Grimké began to speak to "promiscuous," or mixed, audiences and were attacked as both unfeminine and ungodly by the Massachusetts Congregational ministers who wrote the soon famous "Pastoral Letter."[48] Before long, Tappan began to express some nervousness in the face of these clerical attacks, and she had no doubt heard or read the "Pastoral Letter" by the time she again addressed Weston. "I perceive by the papers," Tappan wrote warily, "that [the Grimkés] are addressing *gentlemen,* as well as *ladies. . . .* What do you think about it? Is it not very difficult to draw the boundary line? On the one hand, we are in danger of servile submission to the opinions of the other sex, & on the other hand, in perhaps equal danger of losing that modesty, & instinctive delicacy of feeling."[49]

Four months after the convention, deeply troubled by the furor raised against the Grimkés and against abolitionist women in general, Tappan confessed: "Since so much has been said about the 'rights of woman' I have *thought* much upon the subject, though I have not felt inclined to say much. I think there may be occasions when it will be perfectly proper for a woman to speak before a promiscuous assembly, and I am sure that the Lord will teach every serious inquirer after truth, what *her* duty is." Finally giving in to her growing confusion, she concluded, "Oh! if abolitionists will only keep near to God."[50]

By April 1838, already deep in planning for the second convention and obviously under a great deal of pressure from her co-workers (and probably from her father), Tappan sent Weston a kind of warning. She had been coordinating greater unity among the five women's antislavery societies in New York, she wrote, and was pleased to report that twenty-five women intended to go to the convention as delegates and still others as observers. Tappan did foresee trouble, however; as she noted, "There are a few, a very few, who prophesy that measures will be adopted, and views advanced in the Convention, which they cannot conscientiously

47. See, e.g., Juliana Tappan to Anne Weston, 18 May 1837, vol. 9, no. 35, Antislavery.
48. The "Pastoral Letter" of the "General Association of Massachusetts (Orthodox) to the Churches under Their Care" (1837) remains one of the most revealing pieces of prescriptive literature of its kind: in Alice Rossi, ed., *The Feminist Papers: From Adams to de Beauvoir* (New York: Bantam Books, 1974), pp. 305–06.
49. Tappan to Anne Weston, 21 July 1837. The "Pastoral Letter" was written in June and read from many pulpits in mid-July, according to Wyatt-Brown (*Lewis Tappan,* p. 189).
50. Tappan to Anne Weston, 18 September 1837, vol. 9, no. 70, Antislavery.

approve, and they therefore refuse to have anything to do with it." Still, the majority intended to participate, although, she warned the Bostonians, "They have expressed a hope that it may be *strictly* an *Anti-Slavery* Convention, and that no attempt will be made to introduce subjects not necessarily connected with our duties to the slave."[51]

Tappan was right to fear conflict at the 1838 Anti-Slavery Convention of American Women. Mary Grew, a Philadelphia Quaker, proposed a resolution demanding that abolitionists separate from churches that accepted slaveholders as congregants. Tappan joined moral reformers Margaret Dye, Margaret Prior, and four others in opposing the resolution, insisting that "there is still moral power sufficient in the Church . . . to purify it." This defense of religious institutions did not weaken Tappan's ardor for participating in political work, for at that same convention she urged women not to "cease our efforts [at petitioning] until the prayers of every woman within the sphere of our influence shall be heard in the halls of Congress on this subject."[52]

In 1840, Tappan sent James Birney, the Ladies' New-York City Anti-Slavery Society's representative to the London World's Anti-Slavery Convention, a copy of the resolutions adopted at its fifth annual meeting:

> Whereas, we are opposed to the public voting and speaking of women in [American Anti-Slavery Society business] meetings, to their acting on Committees, or, as officers of the Society, with men, therefore,
>
> *Resolved,* that it is no longer our desire to continue in the relations we have hitherto held to said Society.[53]

No more was heard from the society, or from Tappan.[54] Tappan's conflict with and sudden withdrawal from the antislavery movement was

51. Tappan to Anne Weston, 20 April 1838, vol. 10, no. 24, Antislavery.

52. *Proceedings of the Anti-Slavery Convention of American Women, Held in Philadelphia, May 15th, 16th, 17th and 18th, 1838* (Philadelphia: Merrihew and Gunn, 1838), pp. 5–6. Also discussed in Elizabeth Cady Stanton, Susan B. Anthony, and Matilda Joslyn Gage, *History of Woman Suffrage* (New York: Fowler and Wells, 1881), 1:338. On the relationship of these churches to abolition, see John R. McKivigan, *The War against Proslavery Religion: Abolitionism and the Northern Churches, 1830–1865* (Ithaca: Cornell University Press, 1984).

53. New-York Ladies' Anti-Slavery Society to Birney (1840), in Dwight L. Dumond, ed., *Letters of James Gillespie Birney, 1831–1857* (New York: D. Appleton-Century, 1938), 1:580.

54. Information on Tappan after she left the antislavery movement is scarce. Wyatt-Brown refers to her emotional condition following her mother's death and, later, father's remarriage: *Lewis Tappan,* pp. 302–04. Lewis Tappan, in his diary, refers several times to her

not simply a conservative reaction to women's public activity. She did, however, resist women's severing their ties with the evangelical churches, which had been for herself and others the source of their commitment to reform and remained their justification for assuming moral authority. Faced with pastoral charges of unfemininity, Tappan, like an unknown number of other women, left the antislavery movement. Others later appeared in the records of more respectable causes; Tappan, apparently, never surfaced in benevolent work again.

Actions taken at the 1840 World's Anti-Slavery Convention in London demonstrated again the effectiveness of this rhetoric. There, male delegates, some of whom had previously encouraged women to participate fully in the cause, agreed that propriety demanded the exclusion of the female delegates. Not coincidentally, the women in question, representatives from Boston and Philadelphia, sympathized with the more radical wing of the movement and their votes would have been essential to the numerical strength of the Garrisonians. Their ultraist stance, not only their femaleness, threatened more conservative abolitionists' control of the antislavery movement.

Throughout the convention's proceedings, influential abolitionists, including Lucretia Mott and Sarah Pugh—joined in admirable protest by Garrison himself—were relegated to seats behind a bar. Refusing to acquiesce silently in the decision to exclude female delegates, the women drew up and distributed protests and spoke out against their exclusion on every possible occasion; clearly they drew more public attention by their banishment than they would have by their participation in the convention itself. Yet conservatives' regulation of female behavior and authority both controlled radical influences and signaled the respectability of their own distressingly unpopular cause.[55]

Yet even ultraist women had done little to justify attacks based simply on their nonconformity to sex roles. To the extent that they were able, they had modeled their organizations along the lines of older benevolent societies. In addition, they shared with more conservative activists the rhetoric of female virtue. But the reforms that they advocated attacked deeply embedded and cherished institutions; the women

stay at a water cure establishment and eventual move to her sister and brother-in-law's house (spring and summer 1853, spring 1858). Most suggestive is a letter from Sarah Grimké inquiring about Juliana's health and clearly suggesting a long-term intimacy with her: Grimké to Lewis Tappan, 14 September 1858; all in Tappan.

55. On the London convention, see Stanton et al., *History of Woman Suffrage*, 1:53–62.

were in turn attacked for having "leaped from 'their spheres,'" as a satirical poem by Chapman put it.[56] The goals for which more radical reformers fought provided sufficient excuse for attacks by those who in other settings supported female organizing but who suddenly took a stand against women's public activity. For more conservative benevolent women these attacks had less to do with the constraints of a gender role than with the doubts the attacks raised about the morality of causes the women opposed and the need to defend their own prerogatives as benevolent activists.

Reformers sometimes recognized attacks on their femininity for what they were: screens used to impugn a "righteous cause." As always, Maria Weston Chapman was most blunt in her condemnation of hypocrisy, noting indignantly that although "*we* have been thought to act with undue publicity . . . no clergyman has been censured for reading the notification of the annual meeting of the Fatherless and Widows' Society, with the name of their lecturer. . . . *Those* ladies," Chapman fumed, "are designated as 'woman, stepping gracefully to the relief of infancy and suffering age,' and their treasury overflows with the donations of an approving public." In tones more wounded than angry, but with the same understanding, moral reformers recalled: "In the Temperance cause . . . its advocates looked to us for decided and efficient support. . . . Why then," they wondered, ". . . should we be stigmatized as amazons, who have committed an unprecedented breach of decorum, when we appear as advocates of the cause of moral reform?" "A Female Petitioner" to the *Hingham Gazette* mused after the publication of the "Pastoral Letter" that "whatever influence men fear, that influence they naturally endeavor to ridicule or contemn." Given the recent attacks on women speaking out against "the most dreadful scenes" in the nation, the writer continued, it seemed fair "to infer that woman's influence is much dreaded." After all, the writer noted pointedly, women's efforts on behalf of the Seaman's Aid Society, the Baptist Female Bible Association, and the fair for the benefit of the blind provoked no accusations of women "overstepping the bounds of propriety and delicacy."[57] In the context of nineteenth-century beliefs, the ideology of female virtue pro-

56. "The Times that Try Men's Souls," in Stanton et al., *History of Woman Suffrage,* 1:82.

57. Boston Female Anti-Slavery Society, *Report* (Boston, 1836), p. 6; *Advocate* 3:19 (1 October 1837); "Influence of Woman," *Emancipator* 2:23 (5 October 1837): 90, reprinted from the *Hingham Gazette.*

vided an accessible language for attacks against more radical reformers: simply by virtue of their demands, they were "unfeminine" and therefore immoral.

The language of opposition to reform, then, holds a key to understanding the relationship between ideology and women's actual benevolent activity. Women's *belief* in sexual differences and in a female sphere—their "still stronger fear of being thought unfeminine"— served well the opponents of a given cause. Even within a particular movement, charges of unfemininity regulated more radical influences. The point is not that women who supported causes as disparate as abolition and Bible distribution were equally conservative; rather, that within the contexts of their movements, certain actions took on conservative meanings in effectively restricting or labeling as unacceptable the actions or beliefs of others. In different historical settings, the precise labels have differed; in the early and mid-nineteenth century, the tightly joined terms of femininity and morality supplied the language of conformity with respect to gender roles, sexual behavior, and political beliefs.

This could have worked only in a context in which women, I would suggest the vast majority of women, believed at least some part of—and gained at least some benefits from—the ideology of morally expressed gender difference and of a uniquely female activism. Indeed, across much of the social and ideological spectrum, both between and within movements and between and within classes, people sought to set the boundaries of permissible female behavior and legitimate activity. Each group sought to claim and conflate the terms of morality and of femininity as its own. Their adherence to this ideology made even the most radical of reformers vulnerable to attack—and anxious about setting permissible limits of behavior and belief within their own movements. "Almost every reformer feels that the odium of his own ultraisms is as much as he is able to bear," commented Susan B. Anthony. "Every [one] says, 'I am *ultra enough*.'"[58] Thus even those who sought to transform the material conditions that made women and men socially unequal believed enough of the ideology of female propriety and female difference to serve the interests of the more conservative among them.

The ideology of benevolent femininity suggested, indeed demanded, that women act to heal or transform the world. Secure in their own virtue and armed with this mandate, thousands of women orga-

58. Diary, 8 April 1854, in Ellen Carol DuBois, ed., *Elizabeth Cady Stanton, Susan B. Anthony: Correspondence, Writings, Speeches* (New York: Schocken Books, 1981), pp. 75–76.

nized to combat vice and immorality. Along the way they used the ideology to limit the work of other women, to establish a class identity, and, as we shall see, to obscure their own often considerable authority. Although many benevolent organizations formally—and conspicuously—segregated the sexes, in general, within a social class, women and men shared activities, money, goals—and perhaps authority—in ways that belied the separateness of their work. For women involved in building charitable organizations, the rhetoric of female benevolence concealed authority that they wielded in the distribution of resources and services in their communities. Just as the rhetoric could obscure its adherents' own class identities and purposes, so it obscured some women's standing in their communities, their access to funds for charitable and benevolent work, and their dependence on political favors. The "dew of Heaven" concealed a great deal in its mist.

# *Two*

## The Business of Benevolence

In 1824, in Salem, Massachusetts, Reverend Elias Cornelius spoke on behalf of the Salem Society for the Moral and Religious Instruction of the Poor, which was composed of male members. Cornelius' sermon, later published in pamphlet form, described in some detail the society's work: the men hired agents to visit poor families, ran a male and female Sunday school, gave evening instruction to adults, and opened a church for sailors.

Eventually, Cornelius appealed for contributions; after all, Salem could not gain from the society's moral influence "without large and regularly accruing funds." A footnote immediately follows the fundraising appeal, which, Cornelius ruefully admitted, "should have been mentioned in the sermon. . . . The Society," he acknowledged, "have been greatly assisted by the exertions of benevolent females. Not only have they rendered very important personal services by visiting the poor, by instructing a large part of the Sabbath scholars, and taking the entire charge of the female adult school, but they have formed themselves into an Auxiliary Society, which affords annually a valuable addition to the funds."[1] Thus, in a seemingly insignificant footnote in a typical anniversary sermon, Reverend Cornelius inadvertently made visible what the ideology of gender spheres strove constantly to hide: that women and men did virtually identical benevolent work. Both women and men raised funds, taught, administered, and visited on behalf of benevolent organizations, and, sometimes, they did this work together.

1. Elias Cornelius, *Sermon before the Salem Society for the Moral and Religious Instruction of the Poor* (Salem, Mass.: Whipple and Lawrence, 1824), pp. 19, 20.

Was the Salem society anomalous or was women's benevolent activity less distinct from men's than the ideology of spheres maintained? Can the "dew of Heaven" itself be subjected to hard scrutiny? Reverend Cornelius, it turns out, only touched the surface. A close look at the business side of benevolent activism reveals that even within the most traditional and respectable organizations, women did everything most men did, worked alongside men, and maintained permanent organizations and institutions. The ideology of a peculiarly female form of benevolence obscured women's complex identities, for their work fit into a context as much concerned with the developing class and political structure of United States society as with women's sense of worth and solidarity as women. In order to understand this context and its meanings for the intersection of gender and class identity, we must explore the actual business of benevolence.

Female charitable societies, founded as early as the 1790s, were prompted by clergymen's sermons, published reports about poverty or "vice," and influential women in a town who were called upon to organize others. Frequently women founded auxiliaries to societies organized by their male relatives and acquaintances. By the 1830s, a bewildering array of organizations, with a great deal of overlap among their members, sought both to provide relief and to create a Christian nation.

Denominational organizing remained the most common form of grassroots activity among women throughout the century. The Newark Female Charitable Society first met in 1803 in response to a notice read from the Presbyterian pulpit, calling on women "to devise some means for caring for the poor and distressed persons in the village."[2] Across the Hudson River, Elizabeth Brasher Pintard and forty other women remained after services on Ash Wednesday in 1829 to form a Female Auxiliary Missionary Society, which apparently reluctantly followed the strict dictates of Episcopal Bishop Hobart and limited its activities to the diocese itself.[3] Some church groups faced outward, bringing charity, clothing, tracts, and prayers to the surrounding cities and towns. Still others included foreign missions in their range of activities.

2. [Mrs.] A. F. R. Martin, comp., *A Century of Benevolence: The History of the Newark Female Charitable Society from the Date of Organization, January 31st, 1803, to January 31st, 1903* (Newark, 1903), p. 5.

3. John Pintard to Eliza Pintard Davidson, 6 March 1829, in *Letters from John Pintard to His Daughter, Eliza Noel Pintard Davidson, 1816–1833* (New York: New-York Historical Society, 1940–41), 3:65. John feared that Hobart's rules too severely limited the society's usefulness and that "cold formality characterizes our denomination" (3:66).

37

Unlike their British counterparts, American Protestants encountered little High Church criticism in their efforts at organizing women; Elizabeth Pintard's bishop was exceptional in his restrictiveness. In New England, female "cent societies" sprang up before the turn of the century to raise money for foreign and domestic missions; as national, male-dominated benevolent societies arose, women formed auxiliaries. The steps from female prayer and sewing meetings to auxiliaries to independent female organizations and institutions went virtually unnoticed and unremarked.[4]

Increasingly, then, societies formed outside church congregations as well, building a network of nondenominational—not to say non-Protestant—organizations in cities and towns throughout the Northeast. As early as 1800, Hannah Stillman read a letter in the *Boston Gazette* from "A Mother," urging Boston women to join together to aid poor women. Undaunted when the correspondent turned out to be a man, and determined not to "excit[e] public attention [or] . . . unmerited censure," Stillman invited several friends to a meeting in her home. Thus the Boston Female Asylum was begun; it quickly became an established institution for poor women and children.[5]

Local societies with even the simplest of goals communicated with other organizations; a network of relatives and friends provided information on how to organize, elect officers, publish reports, and run meetings. In 1820 a young woman living in Philadelphia wrote her mother-in-law in Nantucket: "A few of the members of this district have in contemplation to form a society for the relief of the poor [and] . . . have asked me to write to thee on the subject. . . . Any information thou mayst judge useful to us will be acceptable," she assured the more experienced woman, "and if it is not asking too much, I should like to have a copy of your constitution. We expect to begin in a very small way; not because the objects of charity are few, . . . but our power of relief is so limited." This young Quaker later found the Fragment Society too

4. For a comparison of the British and American experiences, see Charles I. Foster, *An Errand of Mercy: The Evangelical United Front, 1790–1837* (Chapel Hill: University of North Carolina Press, 1960). Not all ministers were equally enthusiastic, of course. See, e.g., Mary Stone's letter on her somewhat thwarted plans for a female missionary society, quoted in Nancy A. Hewitt, *Women's Activism and Social Change: Rochester, New York, 1822–1872* (Ithaca: Cornell University Press, 1984), p. 45. See also Donald G. Mathews, "The Second Great Awakening as an Organizing Process, 1780–1830," *American Quarterly* 21 (Spring 1969): 23–43, and Nancy F. Cott, "Young Women in the Second Great Awakening in New England," *Feminist Studies* 3 (Fall 1975): 15–29.

5. Boston Female Asylum, *An Account of the Rise, Progress, and Present State, of the Boston Female Asylum* (Boston: Russell and Cutler, 1803), quotation from p. 4.

limited in its aims. Like other women of her day, she eventually broadened her organizational efforts into larger causes and wider networks. Her name was Lucretia Coffin Mott.[6]

On occasion, societies sprang from a need that was left unfulfilled by a mother organization. In 1797 a number of extremely prominent New York women, including Isabella Graham and Sarah Hoffman, formed the Society for the Relief of Poor Widows with Small Children; they were soon joined by other representatives of society, including Elizabeth Hamilton, Alexander's wife. Seven years later, twenty-nine young women, among them the daughters of the officers of the S.R.P.W.S.C., met to sew for and teach the children whose mothers were aided by the older organization. Worried over what would happen when the poor children's mothers died, the younger women called a meeting at the fashionable City Hotel in 1806 and founded the New York Orphan Asylum Society, which soon rivaled the mother organization in prestige and permanence.[7]

If we are to judge from the annual reports and fund-raising appeals of their organizations (and from historians' concern with the boundaries of woman's sphere), benevolent women and men conformed to a most precise propriety, for they organized separately and limited women's public speaking. Women and men generally formalized their societies under separate headings, with single-sex boards of directors and business meetings, although this had not always, or rigidly, been the case.[8] Reports insisted vigorously that women eschewed publicity or public recognition. Women commonly displayed this modesty by asking male acquaintances to chair and address their public gatherings.

The insistence that women's benevolent work conformed to a strict

6. Lucretia Mott to Anne Mott, 2 February 1820; James Mott to his parents, 14 March 1820, in Anna Davis Hallowell, ed., *James and Lucretia Mott: Life and Letters* (Boston: Houghton Mifflin, 1884), pp. 71–72, 73.

7. Joanna H. Mathews, comp., *A Short History of the Orphan Asylum Society in the City of New York* (New York: Anson D. F. Randolph, 1893), pp. 8–11. On kin networks within women's benevolent organizations see Hewitt, *Women's Activism,* and Anne M. Boylan, "Timid Girls, Venerable Widows, and Dignified Matrons: Life Cycle Patterns among Organized Women in New York and Boston, 1797–1840," *American Quarterly* 38 (Winter 1986): 789–91.

8. In 1752, e.g., the Society for Encouraging Industry and Employing the Poor made public a "promiscuous" listing of both female and male members: John Lytle Myers, "The Agency System of the Anti-Slavery Movement, 1832–1837, and Its Antecedents in Other Benevolent and Reform Societies" (Ph.D. diss., University of Michigan, 1961), p. 38. The British and Foreign Bible Society did not invite women to meetings until 1831; however, in setting up auxiliary Bible societies, which depended on the support of women, they advertised primly, "Seats will be provided for the Ladies": Foster, *Errand of Mercy,* p. 93.

propriety, however, concealed the fact that women wielded authority within their organizations even when men chaired their meetings and made their speeches. The terms of decorum themselves were adapted to an organization's needs. The issue of women's public speaking is but one example. It is clear that women made speeches. Hannah Kinney, president of the Newark Female Charitable Society, addressed the group's general meeting in 1805, following the address of Reverend Mr. Griffin.[9] In numerous cases, even women who vehemently opposed women's pronouncements opened meetings with public prayer. Maria Stewart, a black abolitionist, spoke to mixed audiences as early as 1832.[10] Finally, there is evidence that older and more established societies permitted themselves some flexibility in exercising the rules of propriety. Men conventionally "withdrew" from the public meetings of separately organized women's societies when the women made speeches. Yet public speaking on the part of women became the stuff of public controversy only in 1837, when Sarah and Angelina Grimké toured the North speaking out against slavery to mixed audiences; indeed, the boundaries of propriety were never so universally understood as when more radical women confronted them.

The dictates of propriety were constantly mocked in even more substantive ways. Women worked alongside men, either through their own organizations or as closely affiliated auxiliaries, in doing the daily work that sustained benevolent organizations. Reports, often as revealing for what they leave unsaid as for what they include, made it clear that few tasks were limited to one sex. Both women and men raised funds, visited homes and jails, and distributed tracts and material aid. By 1829, when the New York City Tract Society had divided the city's fourteen

9. Martin, *Century of Benevolence*, p. 9. In the New-York Female Auxiliary Bible Society, where public meetings drew a great deal of attention, men presided over annual meetings as late as 1864, where they read aloud the reports written by the female officers: New-York Female Auxiliary Bible Society, *Forty-eighth Annual Report* (New York: American Bible Society Press, 1864); also *Forty-second Annual Report* (New York: American Bible Society Press, 1858). Mixed meetings of moral reform societies were chaired by men, a fact that was pointed out with special care in newspaper and pamphlet reports. Yet separate "ladies' meetings" did the real business of moral reform activity, proposing and voting on resolutions, officers, and policies. In addition, these restraints were not universally self-imposed. Lucretia Mott recalled that a Female Moral Reform Society meeting in Philadelphia was permitted to use a particular church's basement "on condition that none of the women should speak at the meeting": quoted in Elizabeth Cady Stanton, Susan B. Anthony, and Matilda Joslyn Gage, *History of Woman Suffrage* (New York: Fowler and Wells, 1881), 1:76–77.

10. See, e.g., Boston Female Moral Reform Society, *Third Annual Report* (Boston: George P. Oakes, 1838). On Maria Stewart see Dorothy Sterling, ed., *We Are Your Sisters: Black Women in the Nineteenth Century* (New York: W. W. Norton, 1984), pp. 153–59.

wards into visiting districts, women were among the tract distributors assigned to each district. The Female Missionary Society for the Poor of the City of New-York reported that several "ladies," accompanied by "gentlemen," spent an afternoon each week "visiting from house to house, and distributing Tracts." Perhaps the men went along, as they claimed, to "protect" the women from the "public sphere." But the evidence can be viewed in precisely the opposite way: that there was no public sphere, that women and men worked side by side.[11] In addition, reform-minded writers tended to describe visiting as both characteristically female and characteristically male work—that is, both as personal contact of the most sentimental nature and as efficient, systematic work.

Early on, benevolent organizations stressed the importance of systematic visiting. In February 1803, the Newark Female Charitable Society divided the town into six districts and assigned a manager to supervise visitors in each one. The Boston Female Auxiliary Bible Society reported in 1823 that although the city had been divided into wards, the society's system of visiting "is not yet perfectly systematized." Within a year, "in order to avoid . . . disorder and confusion," it had corrected this inefficiency. Building on women's long-term religious roles, the North Church Sunday School of New Haven taught of "the *duty of visiting*" and stressed "*regular, systematic, visiting* [as] one which cannot . . . be neglected by the Sabbath School teacher with a clear conscience."[12] Female benevolence might originate in the heart; in organizational matters, however, only schedules and assignments could ensure success.

Indeed, especially among those organizations that distributed charitable resources or sought a place among a city or town's respected institutions, business concerns played a central role at all levels of benevolent work. In the practices of fund raising, incorporation, and wage-paying (as well as in decisions about a society's investments and fund-

11. Clifford S. Griffin, *Their Brothers' Keepers: Moral Stewardship in the United States, 1800–65* (New Brunswick: Rutgers University Press, 1960), p. 90; Female Missionary Society for the Poor of the City of New-York, *Fifth Annual Report* (New York: 1821), pp. 4–5. John M. Gibson almost always—and without further comment—refers to the "men and women" who distributed Bibles and raised funds: *Soldiers of the Word: The Story of the American Bible Society* (New York: Philosophical Library, 1958).

12. Martin, *Century of Benevolence*, p. 9; Boston Female Auxiliary Bible Society, *Ninth Annual Report* (Boston, 1823), p. 6; *Tenth Annual Report* (Boston, 1824), p. 5; [North Church] Sabbath School Association of the United Society, New Haven, *Annual Report* (New Haven: Whitmore and Buckingham, 1834), p. 10.

raising campaigns), benevolent women forged for themselves areas of significant authority. Women raised and distributed money. In addition, they sometimes paid and received wages for work that was nonetheless considered voluntary. More broadly, in their decisions to grant or withhold services and resources from particular groups, benevolent organizations articulated their own relationship to the deepening poverty of the nineteenth century. The emphasis on benevolence as a peculiarly female "impulse from the heart," removed from crass economic considerations, tended to conceal the fact that benevolence and money went hand in hand. Tracts encouraged the belief that it was the "widow's mite," not systematic fund-raising activities, that accounted for benevolent organizations' success. No doubt poor widows and orphans contributed to the American Bible and Tract societies and to other national organizations. Cent societies, as their name indicates, depended on small contributions, and they poured hundreds of dollars into state and national organizations. But large societies had more consuming financial needs. Vast sums of money had to be raised, and were—largely by women.[13] No ideology of gender characteristics could wholly gloss over what should have been evident from the start: economic relations were intrinsic to the work. The most socially prominent and respectable women, those who helped establish charities and asylums, if they ever felt troubled that the business nature of benevolence was not adequately feminine, seem not to have acted differently as a result.

Fund raising could serve as the sole rationale for a local society's existence. The New Hampshire Female Cent Institution and Home Missionary Union was but one example. Early in the century, a group of "gentlemen" initiated local societies of women, in which each woman set aside one cent per week for domestic missions. The constitution of the Cent Institution provided only for the position of "treasuress," who served as an intermediary between twenty-eight local and state societies. Eventually, women sent money directly to the New Hampshire Mis-

13. For a plea to women about the importance of their fund-raising efforts see New-York Religious Tract Society, *Eleventh Annual Report and First Annual Report of the Female Branch of the New-York Religious Tract Society* (New York: D. Fanshaw, 1823), p. 32. For an appeal to the poor see *Christian Almanac for Connecticut* 2:9 (Hartford: American Tract Society, 1836), p. 7. Michael Katz claims that about one-half of charitable funds came from private, as opposed to governmental, sources: *In the Shadow of the Poorhouse* (New York: Basic Books, 1986), p. 45. Hewitt describes in some detail the close connection between the economic success of officers' husbands (and, for that matter, of the business community in general) and the economic viability of traditional benevolent societies: *Women's Activism and Social Change*, e.g., pp. 47–56.

sionary Society, and the state no longer needed a female collector of women's pennies. For more than twenty years this society existed solely for the purpose of collecting money that supported a male-run organization in the state's capital. The men recognized, if they rarely applauded, the labor involved in such work. In 1839 the male managers of the Penitent Females' Refuge in Boston gave up fund raising completely because "it has been suggested to the Directors, that a more suitable and successful course would be to leave the collection of funds entirely to the Board of Directors of the Ladies' Auxiliary Society."[14] Benevolent men agreed that such experiments usually worked.

Women in auxiliary societies developed efficient ways to collect funds that they sent to parent organizations "after reserving sufficient to pay contingent expenses." Some organizations arranged to receive direct subsidies from individual Protestant congregations. The New-York Female Auxiliary Bible Society reported that its members "visit the pastors of the churches, and leave no means of influence untried to secure the co-operation of the churches with this Society." The Ladies Seamen's Friend Society of New Haven decided in 1859 that churches should give money directly to them rather than to the American Seamen's Friend Society, of which they were apparently not an auxiliary. The managers called on local pastors, who agreed to redirect their collections. Only after the society had purchased a Sailors' Home and established its independence as a viable financial entity in the city did the women decide to make voluntary contributions to the national society. A steady supply of money from church congregations ensured an organization's stability—and increased its influence in the distribution of charity and services within its city or town. By mid-century, this process had resulted in the institutionalization of regular church collections, which were sent directly to national societies. The more than seven hundred auxiliaries of the American Tract Society, which had been formed to raise money for the national organization, were by 1857 "extinct."[15]

14. [New Hampshire] Female Cent Institution, *Seventeenth Annual Report* (Concord: Asa McFarland, 1830); *Twenty-fourth Annual Report* (Concord: Asa McFarland, 1837); Penitent Females' Refuge, *Appeal to the Public* (Boston: Perkins and Marvin, 1839), p. 11.

15. New-York Female Auxiliary Bible Society, *Twelfth Annual Report* (New York: J. Seymour, 1828), bylaws, p. 4 (the society retained $2,700 that year); N.Y.F.A.B.S., *Forty-second Annual Report*, p. 11; Jack M. Seymour, *Ships, Sailors, and Samaritans: The Woman's Seamen's Friend Society of Connecticut, 1859–1976* (New Haven: W.S.F.S., 1976), p. 65; American Tract Society, *A Brief History of the American Tract Society* (Boston: T. R. Marvin, 1857), p. 17.

Of course, women raised money simply by asking acquaintances of both sexes for personal contributions. Never a pleasant task, fund raising was supposedly made more palatable by a system of goals and districts and a sense of pride in the endeavor. Most organizations published their donors' names at the end of their annual reports. Some organized the list under the name of each collector (often with her church affiliation), thereby giving public recognition and additional incentive for an otherwise thankless duty.[16] When Elizabeth Pintard achieved her goal of one hundred dollars for the Greeks, her husband John expressed relief that even though she was "over fatigued" from the effort, her name would not be "disgraced" when it appeared in the society's published report. John went on to observe that women with access to the very wealthy had a far easier time.[17]

Certainly it helped to have wealthy women in the ranks. This benefit accrued far more to large charitable and missionary organizations than to moral reform or abolitionist societies, which generally relied on one or two wealthy supporters. The wealthiest citizens of large cities were among the most visible of benevolent benefactors. Edward Pessen has calculated that, of life members of the New York Bible Society, 70 percent were in the uppermost 2 percent of New York City's taxpayers. Conversely, the wealthy spread their efforts and their money among a variety of charitable organizations. More than one hundred of the wealthiest men in New York in the second quarter of the nineteenth century (or more than 15 percent of the city's richest men), notes Pessen, "belonged to or were active in five or more cultural and benevolent associations, religious and secular." The same was true of their wives and daughters, who ran such organizations as the Association for the Benefit of Colored Orphans and the New-York Female Auxiliary Bible Society.[18] Women such as Frances Tappan, Arthur's wife (whose "hand was open to the needy"), Eliza Hamilton Schuyler, and an array of Woolseys, Jays, and Phelpses were a boon to any organization that successfully solicited their contributions and their contacts.[19]

16. See, e.g., New York Female Assistance Society for the Relief and Religious Instruction of the Sick Poor, *Annual Report Twenty-three* (New York, 1836).

17. John Pintard to Eliza Pintard Davidson, 4 March 1828, in *Letters from Pintard*, 3:14.

18. Edward Pessen, *Riches, Class, and Power before the Civil War* (Lexington, Mass.: D. C. Heath, 1973), pp. 263, 258, 267–68. In 1828 the N.Y.F.A.B.S. listed as honorary directresses the wives of the American Bible Society's wealthy leaders: Frances Tappan, (Mrs. William) Woolsey, and (Mrs. Levi) Coit to name a few. See N.Y.F.A.B.S., *Twelfth Annual Report*.

19. Lewis Tappan, *The Life of Arthur Tappan* (New York: Hurd and Houghton, 1870),

Male-run benevolent societies benefited from the commitment of the most socially prominent women in a given city or town. In turn, these women could count on the support of the men of their class, the merchants and politicians whose aid was essential in the institution building that women were increasingly to undertake. A network of both female and male activists within each social class assisted one another's organizations in numerous ways, sharing services, money, and skills. In 1850 the Boston Needlewoman's Friend Society received $300 from the Society for Employing the Female Poor. The New York Bible Society gave Bibles and testaments to the New York House and School of Industry and other organizations. A committee from the N.Y.H.S.I. in turn visited the largely male-run Five Points House of Industry and decided to adopt some of its methods for providing work for the "ignorant poor." Societies shared office space (Bible House in New York provided rooms for much of the benevolent empire over the years) and used one another's printing establishments, and members visited one another for advice.[20]

A hallmark of membership in antebellum benevolent and reform networks, pooling material resources was a policy decision that sometimes fanned dispute within poor or isolated groups. For example, those abolitionists who wished to maintain their ties to evangelical churches and institutions expected their societies to maintain cordial relations with other benevolent societies despite more conservative groups' hostility to abolition itself. On occasion, conflict arose in the Boston Female Anti-Slavery Society over sharing funds with benevolent societies. In 1837 Anne Weston reported to her sister Debora about a recent meeting of the Boston Female Anti-Slavery Society: "Mrs Shipley . . . introduced the motion that we give this year $5.00 to the Samaritan ["Colored"] Asylum. Ann Chapman made a very good speech opposing it, shewing that our enemies would maintain that, but that we must do for the [antislavery] Society. . . . We had the majority." Ann Chapman did not oppose the asylum per se. In her will, she left $100 each to the asylum and the local antislavery society. Indeed, in its support for black children this asylum was an endeavor undertaken largely by antislavery

p. 352. Women who contributed money to benevolent causes claimed an eclectic list of beneficiaries. In 1819, Susan Tappan, who was married to Lewis, gave money to the Female Asylum, the Fragment Society, a Society for Converting the Jews, a Cent Bible Society, and an organization for furnishing work to the poor: Myers, "Agency System," p. 34.

20. Boston Needlewoman's Friend Society, *Report for the Third Anniversary* (Boston, 1850), p. 7; New York House and School of Industry, *Fifth Annual Report* (New York, 1856); *Sixth Annual Report* (New York, 1857).

activists. Rather, the issue concerned sharing organizational funds with institutions that served more conventional goals.[21]

These businesslike features characterized the work of both the conservative benevolent empire and the abolitionists. But benevolent women involved in more traditional causes, who had far greater access to money, set up unambiguously corporate structures for their work. Emerging later, having less access to funds, and pursuing a more agitational cause, abolitionists modified the model they inherited. Always short on funds, they were more apt to share skills than money, and those largely with organizations that shared their goals. The success of the antislavery fairs and the ability of the relatively impoverished movement to sustain several newspapers and organizations testified to the success of the abolitionists' own financial efforts.[22]

In Philadelphia, New York, and Boston, antislavery fairs served not only as community gatherings and recruitment drives but as necessary fund raisers for the struggling movement.[23] Indeed, most abolitionists recognized that such fairs were essential to their movement's survival. Yet in contrast to more respectable social causes' efforts at raising money, only abolitionists were ever required to defend the righteousness of their methods. When Philadelphia Quakers criticized so "light-minded a proceeding" as fairs, Lucretia Mott simply called them "sales" and held them in her own home. Juliana Tappan, too, worried that abolitionists had become too involved in the material aspects of their cause. "It does not seem to me right to raise money for any benevolent society, or cause, by selling *useless* articles," she fretted. Tappan overcame her doubts by admitting that "silk bags *are* useful, and so are many things that might be, and often are sold at fairs." Still, she

21. Anne Weston to Debora Weston, 16 January 1837, vol. 9, no. 7, Antislavery Collection, Rare Books and Manuscripts Division, Boston Public Library. Chapman's will is quoted in B.F.A.S.S., *The Boston Mob of "Gentlemen of Property and Standing": Proceedings of the Antislavery Meeting . . . on the Twentieth Anniversary of the Mob of October 21, 1835* (Boston: R. F. Wallcut, 1855), p. 27.

22. In 1841, James and Abby Gibbons, pleading ignorance about fund raising, wrote to the Weston sisters for assistance with the New York fair: in Sarah Hopper Emerson, ed., *Life of Abby Hopper Gibbons Told Chiefly through Her Correspondence* (New York: G. P. Putnam's Sons, 1897), 1:99. Seventeen years later Abby Gibbons, no longer a novice, was still seeking aid from the highly successful Boston reformers: Abby Hopper Gibbons to Samuel May, Jr., 26 May 1858, vol. 6, p. 97, May Papers, Rare Books and Manuscripts Division, Boston Public Library.

23. On communal aspects, see Lawrence J. Friedman, *Gregarious Saints: Self and Community in American Abolitionism, 1830–1870* (New York: Cambridge University Press, 1982). On finances see, e.g., Philadelphia Female Anti-Slavery Society, *Annual Reports* (Philadelphia, 1839–70).

brooded, "there is so much time consumed, and so much consulting of fashion, and conformity to the world that I doubt much whether fairs, *as they are now conducted,* are pleasing to God. How little of *Christ* there is in our actions." But Tappan was exceptional in engaging in such thorough soul-searching about the contradiction between "pure" female benevolence and women's organizational work. More typical were those women who admitted to preferring the hard facts of fund raising. Asked by Maria Weston Chapman to write a report of the antislavery fair in 1839, Mary Robbins replied, "I . . . am not good at describing. $500 net proceeds. I can understand that. It is a blossom on the tree of liberty."[24] Benevolent women involved in traditional charitable endeavors, free from attacks by the more conservative and more powerful, troubled themselves little about the material aspects of their cause.

In fact, traditional benevolent organizations had more pressing worries than any possible inconsistency in their fund-raising activities; increasingly, these societies realized that they scrambled for access to the same sources of funds. When Elizabeth Brasher Pintard was selected to a prestigious fund-raising committee, her husband noted with both pride and concern: "She has accepted, but it will be a difficult task to get much, as a Committee of Females have just swept the streets in favour of the Orphan Assylum [*sic*], very destitute of Funds to support this important Institution." The Boston Fatherless and Widows' Society faced this prospect with more confidence: "We are not ignorant of the fact," wrote the officers, "that applications to the benevolent from various objects are frequent. But we feel assured, that our appeal for the widow and fatherless, is sanctioned by the word of God."[25] Others, no less certain of divine approval, turned to purely private solicitations and reliance on the interest from well-invested stocks.

In response to the strain on financial resources and the explosion of both charitable societies and poverty itself, charitable societies gradually but deliberately associated for more efficient action. By mid-century they operated as a coherent financial network within a given city or town. In Boston in 1834 twenty-six female and male societies agreed to

24. N. Orwin Rush, "Lucretia Mott and the Philadelphia Antislavery Fairs," *Friends Historical Association Bulletin* 35 (Autumn 1946): 70; Juliana A. Tappan to Anne Weston, 11 October 1837, vol. 9, no. 79, Antislavery; Mary Robbins to Maria Weston Chapman, 6 January 1839, vol. 11, no. 16, Antislavery.

25. John Pintard to Eliza Pintard Davidson, 26 [27] February 1828, *Letters from Pintard,* 3:11–12; Boston Fatherless and Widows' Society, *Twenty-sixth Annual Report* (Boston, 1843), p. 14. Lewis Tappan made a remark similar to Pintard's in 1816. See his diary, 2 November 1816, in Tappan.

send delegates to monthly meetings to decide upon better systems for distributing services and for raising funds. The Boston Female Fragment Society sent two delegates to these meetings. The Boston Fatherless and Widows' Society gladly joined the endeavor "to report some plan for a more systematic method of distributing charitable funds" and sent delegates monthly for many years.[26] Benevolent organizations, like for-profit business ventures, shared money, members, and systems and thus underscored the business nature of their work, even as their supporters insisted on the work's essentially moral nature.

Even more explicitly, when they incorporated their societies, prosperous benevolent women organized their independent relief and charitable societies along a business model. As the wives and daughters of merchants and lawyers, these women knew well the advantages of corporate status, and they went to great lengths to utilize it on behalf of their benevolent endeavors. So rarely did women discuss incorporating, however, that historians have by and large neglected the significant advantages it gave their organizations and its implications for a new understanding of some women's access to political and economic authority. For the legal mechanism of incorporation gives concrete meaning to the influence of some benevolent women; indeed, women's very interest in becoming incorporated challenges their insistence on a protected female sphere. No doubt women and men could create elaborate rationalizations for desiring incorporation. In fact, there is a far simpler explanation: for some organizations, incorporating was good business.

Today, incorporation involves filing papers with a state official and paying a fee. The resulting legal "individual" protects the incorporator's personal property from a business's debts. In the early nineteenth century, the process was more complicated, for corporations were themselves viewed with suspicion; corporate status was limited, by and large, to charities, churches, and cities, "harmless" and not profit-making,

26. Association of Delegates from the Benevolent Societies of Boston, *First Annual Report* (Boston: I. R. Butts, 1835), p. 3; Fragment Society, *Twenty-second Annual Report* (Boston, 1834); Boston Fatherless and Widows' Society, *Seventeenth Annual Report* (Boston, 1834), p. 8; *Twentieth Annual Report* (1837), p. 3; *Twenty-sixth Annual Report* (1843). Centralization has been discussed by Maria Kleinburd Baghdadi, "Protestants, Poverty and Urban Growth: A Study of the Organization of Charity in Boston and New York, 1820–1865" (Ph.D. diss., Brown University, 1975), and Carroll Smith-Rosenberg, *Religion and the Rise of the American City: The New York City Mission Movement, 1812–1870* (Ithaca: Cornell University Press, 1971).

entities.[27] Becoming incorporated required a special charter from the state legislature. Not until 1848 in New York, for example, did the legislature pass a law that provided a formula for "the incorporation of benevolent, charitable, scientific and missionary societies." No organization, whether officered by women or by men, became incorporated without the approval of a legislative majority. The standard articles of a corporate charter gave the officers the right to run the organization and specified that annual meetings, reports, and elections must take place. Incorporating also allowed a society's officers to raise money, enforce bylaws, and avoid taxes. In addition, and more important, the charter permitted a corporation to sue and defend itself against suit, make contracts, accept bequests in its own name, own, buy, and sell real estate.[28]

These corporate privileges could fulfill practical needs for female-run organizations that owned property or made sizable investments. In 1837 the Boston Fatherless and Widows' Society received a legacy of $1,000 "which could not be received before the Act [of Incorporation] was accepted." More than thirty years earlier, the Boston Female Asylum had sought corporate status in order to protect its bank stock and to transact business with minimal restrictions.[29] And legislators hesitated only briefly before granting to women with property and access to funds the legal mechanism that would enable them to assume corporate responsibilities. Approached in 1803 by members of the Boston Female Asylum, a committee from the legislature, aware of the novelty of incorporating a society of women, met with the "ladies" and suggested that they permit male trustees to control their funds. The

27. On incorporating see Lawrence M. Friedman, *A History of American Law* (New York: Simon and Schuster, 1973), chap. 8, and Oscar Handlin and Mary Flug Handlin, *Commonwealth: A Study of the Role of Government in the American Economy: Massachusetts, 1774–1861* (Cambridge: Harvard University Press, 1969). The first charity to incorporate in the state of New York was the Female Society for the Relief of Poor Widows with Small Children, which did so in 1802: Charles Z. Lincoln, *The Constitutional History of New York from the Beginning of the Colonial Period to the Year 1905* (Rochester: Lawyer's Co-operative, 1906), 2:61.

28. *Laws of the State of New-York, Passed at the Seventy-first Session of the Legislature* (Albany: Charles van Benthuysen, 1848), passed 12 April 1848, chap. 319, p. 447. Suzanne Lebsock's discussion of the incorporation of the orphan asylum in Petersburg, Va., is helpful here: *The Free Women of Petersburg: Status and Culture in a Southern Town, 1784–1860* (New York: W. W. Norton, 1984), pp. 200–01.

29. Boston Fatherless and Widows' Society, *Twentieth Annual Report* (Boston, 1837), p. 3.

female managers "firmly opposed" the idea, and the suggestion was withdrawn, apparently with little dispute.[30]

Thus state governments created accountable and legally autonomous entities composed of married and therefore legally dependent women. Corporate status circumvented married women's formal legal disabilities at the discretion of the state legislature by creating a legal "person" who was, for all practical purposes, not female; these charters contradict everything we thought we knew about the legal status of married women in the antebellum era.[31] The married women who became the officers of corporations received concrete, and often surprisingly broad, powers that were theoretically restricted to male or unmarried female citizens. For example, the unincorporated American Female Moral Reform Society's difficulties prior to 1849 had included "cases where they wished to obtain legal possession of a child." Corporate status could provide such authority. In 1813, the General Assembly of Connecticut granted ("with great unanimity") a charter to the Hartford Female Beneficent Society that permitted the board of managers, "at their discretion, to take such female children as they may judge suitable objects of charity, to enjoy the benefits of the Institution, and also to accept a surrender in writing, by the father, or where there is no father, by the guardian, or mother, of any female child or children, to the care and discretion of said Society." The act went on to delineate the duties of the society in "binding out" these children "in virtuous families." Thus the children, hoped the society's secretary, "may be rescued from impending ruin, and be so educated as to become useful and respectable in the world." As individuals, married women were denied for another half century the legal autonomy that as managers of a prosperous charitable or benevolent society they received.[32]

30. Boston Female Asylum, *Reminiscences* (Boston: Eastburn's Press, 1844), pp. 14–16. When Philadelphia women formed a Union Society of several Protestant denominations, they had first to convince the Superior Court of the state that they were citizens before they could receive a charter of incorporation: Foster, *Errand of Mercy,* p. 158. Anne M. Boylan, *Sunday School: The Formation of an American Institution, 1790–1880* (New Haven: Yale University Press, 1988), p. 12, notes that the society was formed in 1804.

31. Although unmarried women did have property rights, they did not have the right to marry *and* retain control over property; therefore, the corporate "person" had rights that were essentially withheld from all females.

32. Flora L. Northrup, *The Record of a Century, 1834–1934* (New York: American Female Guardian Society, 1934), p. 33; Hartford Female Beneficent Society, *Address of the Hartford Female Beneficent Society, the Act of Incorporation, and the By-laws of the Society* (Hartford: Hale and Hosmer, 1813), pp. 3, 7, 4. The New York legislature built a similar ruling into the incorporation of the American Female Guardian Society more than thirty-five years later. For two excellent treatments of the legal issues surrounding married women's

In granting women's organizations corporate status, legislators explicitly grappled with the contradiction of creating entities that were legally and financially autonomous to a degree that their founders were not. The corporate charter for the Boston Female Asylum, which served as a model for other female charities in the state, took care to protect the corporation from its members' legal dependence.[33] Since married women could not be sued, article two assured that "every married Woman, belonging to said Society, who shall, with consent of her Husband, receive any of the Money, or other Property of said Society, shall thereby render her said Husband accountable."[34] Husbands could not therefore induce their wives to abscond with corporate funds without being liable. To further protect corporate funds from married female officers, the charter required that the treasurer of the asylum be an unmarried woman over the age of twenty-one, and that she give bond for herself. (Often, an organization's bylaws neutralized this formality by restricting the treasurer's access to corporate funds.)[35] Legislators were not naive about the effect of married women's lack of control over property. They carefully protected societies from the legal implications of having married female officers.

Women who enjoyed access to legislators petitioned for and received quasi-male status when their organizations' goals accorded with

property rights see Norma Basch, *In the Eyes of the Law: Women, Marriage, and Property in Nineteenth-Century New York* (Ithaca: Cornell University Press, 1982), and Peggy A. Rabkin, *Fathers to Daughters: The Legal Foundations of Female Emancipation* (Westport, Conn.: Greenwood Press, 1980).

33. The Boston Fragment Society's incorporation in 1816, e.g., copies the B.F.A. verbatim—except for the seemingly redundant addition that "for the time being" only the managers could handle the society's funds: Fragment Society, *Act of Incorporation and Constitution* (Boston: Monroe and Francis, 1817) (quotation on p. 4). The Boston Female Asylum's Act of Incorporation is in B.F.A., *An Account of the Rise, Progress, and Present State, of the B.F.A.* (Boston: Russell and Cutler, 1803), and *An Account of the Boston Female Asylum, with the Act of Incorporation* (Boston: J. E. Hinckley, 1833). The Orphan Asylum Society in the City of New York's corporate charter appears in Mathews, comp., *Short History*, pp. 16–18.

34. The sixth article of the charter of the Association for the Relief of Respectable, Aged, Indigent Females to some degree separated wives' actions from their husbands': "The husband of any married woman, who is or may be a member or officer of said corporation, shall not be liable . . . for any loss occasioned by the neglect of misfeasance of his wife . . . but if he shall have received any money from his wife belonging to the said corporation . . . he shall be accountable therefor." The act went on to state that should a husband holding the corporation's funds declare insolvency, his debt to the corporation would take a first position in repayment: in A.R.R.A.I.F., *Constitution and First and Second Reports* (New York: J. Seymour, 1815), pp. 30–31.

35. See, e.g., Barbara J. Berg, *The Remembered Gate: Origins of American Feminism: The Woman and the City, 1800–1860* (New York: Oxford University Press, 1978), p. 161, and Fragment Society, *Act of Incorporation*, p. 4.

those of legislators. Clearly it was not just any organization that would seek or attain corporate status. The benevolent women who incorporated their societies were among the most influential in their communities, and their organizations were financially and culturally significant institutions. They invested their corporations' money in bank stock and insurance companies. The American Female Moral Reform Society, which had experienced difficulties that would have been aided by incorporation, was not incorporated until the society decided to build an asylum in 1849.[36] Legislators cared more about what societies did, what services they provided, than about the fact that acts of the legislature circumvented women's legal status as individuals. In a sense, the most important point about this granting of legal privilege to women is a negative one: few people openly objected.

In cases where legislatures refused to grant corporate charters, reports fail to mention whether the sex of petitioners played a role in politicians' decisions. The Women's Prison Association of New York confronted "much opposition [to its incorporation] on the ground that it would be likely to interfere with the authority of the State over prisons."[37] Eventually the legislature granted the act, although how the association's powers differed from those it exercised before incorporation, when it was a fully functioning auxiliary of the (men's) New York Prison Association, is unclear. Where benevolent organizations might impinge on government prerogatives, state legislatures hesitated to extend corporate autonomy. Where the organization supplemented or benefited the presumed responsibilities of the state, governments not only granted corporate status but granted it to women.

The novelty of women incorporating provoked no lasting debate among the benevolent about their "femininity." In 1815, the Association for the Relief of Respectable, Aged, Indigent Females of New York

36. Northrup, *Record of a Century*, p. 33. They had lost legacies because they were unable to fight wills' "indefinite wording" in the courts. The F.M.R.S. removed the words "moral reform" from its title at the legislators' suggestion.

37. Emerson, ed., *Abby Hopper Gibbons*, 1:253. The Pennsylvania legislature denied such an act to the (male run)American Sunday School Union in 1828. According to Charles Foster, "the American Sunday-School Union took so serious a view of its responsibilities in administering God's government that a frightened Pennsylvania legislature refused to grant the union a charter." Historian Joseph Blau agrees that the Reverend Ezra Stiles Ely's speech of the previous June, in which he called for a "Christian party in politics," caused some panic among the legislators, who feared that the A.S.S.U. would blur the distinction between church and state prerogatives: Foster, *Errand of Mercy*, p. 185; Joseph L. Blau "The 'Christian Party in Politics,'" *Review of Religion* 11 (November 1946): 25. For a more comprehensive history of this society see Boylan, *Sunday School*.

noted almost in passing: "A petition for an Act of Incorporation was presented last winter to the Legislature, which was granted by the Honourable Body."[38] One year later, Hannah Kinney, president of the Newark Female Charitable Society, hoped that the organization "may yet become an incorporate body, holding a very respectable fund. . . . For in this age of wonders, when the liberal dare to devise liberal things, applications to legislators by females to become incorporate bodies are not novelties. We have many male friends, who no doubt will aid us by their influence with the legislature, if it be needed."[39] Corporate charters were granted quite easily to benevolent societies run by prosperous women whose goals conformed to a traditional, charitable framework and whose organizational needs included protecting significant financial resources; antislavery societies, in contrast, did not seek incorporation. Well-connected women could count on the men of their class to assist them in their endeavors—even when that assistance clearly contradicted their assertions of a peculiarly feminine benevolence.

Although women raised money and acquired significant legal status, writers continued to insist that benevolence, like other aspects of woman's sphere, functioned at a distance from society's crass commercialism—an insistence challenged even in the antebellum period by the practice of paying benevolent workers. "A cherished belief" of benevolent workers, wrote professor of social work Dorothy Becker, "was that volunteer effort, by definition, was superior to paid work. Charity, like love, could not be purchased." These attributes—charity, love, virtue, the very stuff of woman's sphere—were to be protected from the encroachment of competing values. The belief that service to the unprivileged should be unwaged and thus invisible has persisted beyond a romantic definition of "women's nature." Yet as the discussion of incorporating showed, benevolent reformers were involved in a complex set of interests and privileges. In the disbursement as in the raising and investing of funds, benevolent women demonstrated a corporate as much as a philanthropic sensibility.[40]

---

38. A.R.R.A.I.F., *Constitution and First and Second Annual Reports,* p. 16.

39. Martin, *Century of Benevolence,* p. 13.

40. Dorothy G. Becker, "Exit Lady Bountiful: The Volunteer and the Professional Social Worker," *Social Service Review* 38 (March 1964): 63–64. Clearly both women and men perceived their benevolent work as markedly different from the work performed for profit— and in many respects it was. The point here is that in respecting contemporaries' beliefs about the ideology of woman's sphere, historians have largely ignored the fuzzy—and, importantly, largely *ideological*—distinctions between the different spheres of life.

Buried in the reports of even the earliest "voluntary" organizations is a startling fact: charitable love *could* be bought. In spite of loudly expressed contempt for "professional philanthropists," some men and women were paid to do the work of benevolence. Dorothy Becker notes that at no time in the New York Association for Improving the Condition of the Poor's annual reports, that is, in their most public documents, are references made to paying "friendly visitors" to the poor. The minutes of the board, however, indicate that some services were remunerated, either by gift or by a more regular allocation. The managers of the association apparently felt reluctant to let their donors know of this use of their funds; the rhetoric of benevolence maintained that all contributions went directly to relief. Indeed, the organization's official history states confidently that only in 1879 did the association first pay "social service workers" to replace "friendly visitors." Paying visitors, noted the association's historian, "marked the beginning of the transition from the giving of alms as a religious and moral duty to the study and solution of social problems on a scientific basis."[41] As we shall see, it was only during the Civil War that a debate emerged about the efficiency of waged versus voluntary benevolent labor. Yet despite later reformers' conviction that they had made charity a science by paying workers— and their forerunners' insistence that they had not—the records indicate that even early laborers for benevolence were sometimes paid for their work.

The practice of paying agents characterized organizations across the entire spectrum of benevolent reform. The national Bible and Tract societies always employed colporteurs, or agents, to serve in the work of moral regeneration.[42] These agents prayed with those whom they visited and urged them both to read God's word and to assist in supplying others with the gospel. They raised funds for the parent organization, gave lectures, and helped establish local societies. Many no doubt evinced a sincere spirit of bringing light to the poor or the isolated and believed that theirs was the charity of love. Some were passionate in their commitment to the cause. If so, their fervor only belied the assumption that true benevolence had no price, although the pay was not

41. Dorothy G. Becker, "The Visitor to the New York City Poor, 1843–1920," *Social Service Review* 35 (December 1961): 384–86; [Community Service Society], *Frontiers in Human Welfare: The Story of a Hundred Years of Service to the Community of New York 1848–1948* (New York: C.S.S. 1948), p. 30.

42. See American Tract Society, *Colporteur Reports to the A.T.S., 1841–46* (Newark: New Jersey Historical Records Survey, 1940), for an example of what their activities involved. As early as 1798, the Missionary Society of Connecticut paid agents to travel around Northern states: Myers, "Agency System," p. 22.

overgenerous: "To compensate for the low salary," historian Clifford Griffin notes, "and . . . convince other men that colportage was God's work, the national officers issued much propaganda."[43]

Women helped set the price for such labor, and not only because their "virtues" set a standard for "unselfishness": more directly, women were often the employers of ministers and agents who raised funds and distributed literature for their societies. The New York Female Benevolent Society advertised for "the entire labors of a well qualified clergyman" in its first annual report. Seventeen years earlier, the Boston Female Society for Missionary Purposes had agreed to "try the practicability of a new plan" to bring religion to the non-church-going poor. The latter society hired two (male) missionaries to "visit and labour" with those "whose poverty forbids their appearing decent at public worship." In 1838 the Boston (later New England) Female Moral Reform Society resolved to employ an agent "to visit houses of infamy and wretchedness" in Boston; within several years the society had hired an additional agent, who visited a number of states on the society's behalf.[44]

Information on payment to women is somewhat more ambiguous than that to men, in part because the rhetoric denied that women were paid at all. In 1833 John and Phebe McDowall agreed to serve the New York Female Benevolent Society by living in a temporary asylum for fallen women. He was to receive $600 for the year and, according to the society, she was paid $125 for five months, as well as several hundred

43. Griffin, *Their Brothers' Keepers*, p. 93. The American Board of Commissioners and American Education Society offered agents about $8 per week plus traveling expenses, a bit less than a minister's salary: Myers, "Agency System," pp. 44, 49. The American Colonization Society paid its New England agent, Ralph Randolph Gurley, $600 per year. In 1825, as secretary of the national organization, Gurley received more than twice that amount: Philip John Staudenraus, "The History of the American Colonization Society" (Ph.D. diss., University of Wisconsin, 1958), pp. 101, 127. When the American Bible Society employed a full-time treasurer in 1832, he was paid $1,000, a salary that John Pintard declared "inadequate": Pintard to Davidson, 4 February 1832, *Letters from Pintard*, 4:12.

44. Female Benevolent Society of the City of New York, *First Annual Report* (New York: West and Trow, 1834), p. 11; Boston Female Society for Missionary Purposes, *A Brief Account of the Origin and Progress of the Boston Female Society for Missionary Purposes, with Extracts from the Reports of the Society, in May, 1817 and 1818* (Boston: Lincoln and Edmands, 1818), p. 4; Boston F.M.R.S., *Third Annual Report* (Boston: George P. Oakes, 1838), p. 8; New England F.M.R.S., *Fourteenth Annual Report* (Boston: Bazin and Chandler, 1852), pp. 15–17; *Fifteenth Annual Report* (Boston: Bazin and Chandler, 1853), p. 9. See also Boston Female Auxiliary Bible Society, *Ninth Annual Report* (Boston, 1823), p. 9. Wages varied. The New England Female Moral Reform Society reported having paid $309 in 1853, up from $225 in 1837. See its *Annual Reports* for those years. In 1850, according to the treasurer's report, the Boston Needlewoman's Friend Society paid its agent $331 for the year: *Report for the Third Anniversary* (Boston, 1850).

dollars for the cost of operating a home for four young women. When John McDowall bitterly severed his connection with the society later that year, he waxed indignant at the very suggestion that his wife (although not himself) had accepted the money. "Mrs. McDowall [did not] intend that her family services rendered to the unfortunate under her care, should be regarded in any other light than as a free-will offering to the cause of benevolence," he wrote irritably.[45]

Whether or not Phebe McDowall actually accepted compensation for her "family services," other women certainly did. The McDowalls themselves were replaced by a Mrs. Dally, who received the meager salary of $150 per year. Matrons and teachers took jobs in the new asylums that women established. The growing focus on urban areas, rather than on the West, made it more practical to employ women for house-to-house visiting. In 1837, when the New York Female Moral Reform Society switched from male to female missionaries, it paid Margaret Prior for stepping "into [the] leprous haunts, . . . rescuing . . . one after another from the pit of corruption."[46] By the early 1860s even the New York Female Auxiliary Bible Society, one of the oldest and most conservative organizations, paid its "Bible women" $15 per week to distribute the gospel in city slums. Women were also employed as traveling agents. In 1852 the New York State Temperance Society employed women as agents at $25 per month plus expenses; like male colporteurs, they crisscrossed the state, holding meetings, raising the membership, and petitioning the legislature.[47]

Nor did abolitionists shrink from paying their agents to further the cause. When in 1836 the agency committee of the American Anti-Slavery Society decided to employ women as "speakers and propagandists," they offered Angelina and Sarah Grimké payment for their services as traveling agents; being independently well-off, the women refused the salary, but they did attend the agents' convention in New

45. *McDowall's Journal—Extra*, November 1833, p. 15.

46. N.Y.F.B.S., *First Annual Report*, p. 7; Helen E. Brown, *Our Golden Jubilee: A Retrospect of the American Female Guardian Society and Home for the Friendless from 1834–1884* (New York: A.F.G.S., 1884), pp. 14, 21.

47. In 1834 the New York Female Moral Reform Society hired a Mrs. Fenton to sell subscriptions to the *Advocate of Moral Reform*. In the summer of 1837 Sarah Ingraham and Miss M. I. Treadwell were sent (and probably paid) as lecturers for the society: Northrup, *Record of a Century*, pp. 19, 22. The Providence Female Tract Society hired both women and men to teach school, distribute tracts, and set up female auxiliaries elsewhere in Rhode Island: P.F.T.S., *Second Annual Report* (Providence, 1817); *Third Annual Report* (Providence, 1818). On temperance agents see D. C. Bloomer, *Life and Writings of Amelia Bloomer* (New York: Schocken Books, 1975; orig. 1895), p. 85.

York that year.[48] When the abolitionist movement split in 1839, Martha V. Ball became an agent for the Massachusetts Abolition Society, the "new organization" that opposed public speaking by women and their appointment to committees. Debora Weston, loyal to the "old organization," commented on Ball's rumored employment: "$252 a year for an agent, that would be a very pretty income for Miss Ball, & I dont doubt has been her object from the beginning." Ball apparently took the appointment with pleasure, as it allowed her to retire from teaching. Money by necessity played a role in the career decisions of the most committed reformers.[49]

The contrast between the rhetoric and the reality of the work of benevolence could be striking. In Louisa May Alcott's *Little Women,* the March girls, inspired and supervised by Mrs. March, perform an act of "pure" benevolence on Christmas Day. The girls have sacrificed presents that year, and have determined to give up their small vices and learn not to be selfish, when "Marmee" suggests that they give their breakfast to a poor, hungry family with seven children:

> They were all unusually hungry, having waited nearly an hour, and for a minute no one spoke; only a minute, for Jo exclaimed impetuously: "I'm so glad you came before we began!" . . . "*I* shall take the cream and the muffins," added Amy, heroically giving up the articles she most liked. . . . They were soon ready, and the procession set out. . . . A poor, bare, miserable room it was, with broken windows, no fire, ragged bedclothes, a sick mother, wailing baby, and a group of pale, hungry children cuddled under one old quilt, trying to keep warm. How the big eyes stared and the blue lips smiled as the girls went in! . . . That was a very happy breakfast, though they didn't get any of it; and when they went away, leaving comfort behind, I think there were not in all the city four merrier people than the hungry little girls who gave away their breakfasts and contented themselves with bread and milk on Christmas morning.

48. Keith E. Melder, *Beginnings of Sisterhood: The American Woman's Rights Movement, 1800–1850* (New York: Schocken Books, 1977, p. 76; Gerda Lerner, *The Grimké Sisters from South Carolina: Pioneers for Woman's Rights and Abolition* (New York: Schocken Books, 1971), pp. 37–45. The American Anti-Slavery Society also asked a Miss Wheelwright to visit various towns and communicate with the women about the cause, according to Myers, "Agency System," p. 411.

49. Debora Weston to Anne Weston, 25 November 1839, vol. 12, no. 94. See also Anne Weston to Debora Weston, 15 December 1839, vol. 12, no. 118, Antislavery.

Lest the reader miss the lesson of the anecdote, Alcott added: "'That's loving our neighbor better than ourselves, and I like it,' said Meg."[50]

The real Alcott family, although usually in financial difficulty itself, may well have performed similar acts of kindness—living examples of the "genteel poverty" among the antebellum middle class of which Alcott wrote. Yet benevolence provided them with financial support as well. In her biographical notes on Louisa May Alcott, Ednah Dow Cheney remarked, "The family removed to Boston in 1848, and Mrs. Alcott became a visitor to the poor in the employ of one or more benevolent societies, and finally kept an intelligence [employment] office." Alcott herself told the benevolent women, her employers, that "the only sad feature of my present position is the necessity I am under of accepting compensation." She soon discovered another sad feature, for she wrote the chair of the society that she could not support her family on $500 per year and ought to receive $600. For her salary she sent out leaflets soliciting clothing to aid a Boston mission, arranged for food for Irish immigrants, ran sewing classes, taught black children in the society's rooms, and wrote reports—work that historians and contemporaries alike have labeled voluntary and, therefore, not work.[51]

Paying agents was in most cases a financially successful venture for benevolent organizations, resulting in new auxiliaries, a greater influx of funds, subscriptions to societies' papers, and a vastly increased visibility for the organization's work. In 1836 one traveling agent for the New York Female Moral Reform Society wrote that she had visited five New England states in three months, met with women from fifteen associations, sold numerous subscriptions to the *Advocate,* helped form 8 new auxiliaries, and left a copy of the society's constitution for more than twice that number. In November 1837, Sarah Ingraham and M. I. Treadwell reported that in sixty-six days' traveling they had met with 36 auxiliaries and had helped form 8 new ones, mostly in western New York. No wonder that by the third year of its existence, the Female Moral Reform Society boasted 226 auxiliaries (108 founded within the last year) with a membership of more than 1,500. The following year

50. Louisa May Alcott, *Little Women* (New York: Airmont, 1966; orig. 1868), pp. 29–30.

51. Madelon Bedell, *The Alcotts: Biography of a Family* (New York: Clarkson N. Potter, 1980), pp. 164–65; Ednah Dow [Littlehale] Cheney, *Louisa May Alcott: Her Life, Letters, and Journals* (Boston: Roberts Brothers, 1889), p. 53; Elizabeth Bancroft Schlesinger, "The Philosopher's Wife and the Wolf at the Door," *American Heritage* 8 (August 1957): 99. Bedell says she was hired by the Friendly Society of South Congregational Unitarian Church in the fall of 1849 at $50 per month: *Alcotts,* p. 277.

126 more auxiliaries signed up and the society issued an average of
19,000 copies of the *Advocate* twice a month.[52] After five years' work,
the society had 445 auxiliaries and felt justified in changing its title from
"New York" to "American" F.M.R.S. Meanwhile, the New England
Female Moral Reform Society announced, by way of advertisement, that
they had employed Eliza Garnaut as their traveling agent "to organize
Societies, [and] obtain donations and subscribers for the *Friend of Vir-
tue*," the New England society's own newspaper.[53]

It is a testament to the power and pervasiveness of the ideology of
woman's sphere that, despite the affinity between benevolent activity
and business enterprises, contemporaries continued to insist on the
noneconomic nature of women's benevolent work. Like the work wom-
en performed in their homes, benevolence was "natural," an extension of
the nature of womanhood. When women provided services that re-
placed governmental expenditures or when they built large and perma-
nent institutions, contemporaries insisted that the work accorded with
women's natural functions. Also like housework, women's benevolent
work remained caught in a set of contradictions; it was ephemeral,
sentimental, and invisible but admittedly essential to the moral, if not
the economic, state of the world.[54]

Contemporaries drew explicit parallels between housework and
benevolence when they described women's asylum building, which his-
torian Kathleen McCarthy calls the "special terrain of the feminine
volunteer." Women did perform most of the daily and long-term ac-
tivities associated with private institution building from the 1830s. As

52. Sarah R. I. Bennett, *Woman's Work among the Lowly: Memorial Volume of the First
Forty Years of the American Female Guardian Society and Home for the Friendless* (New York:
A.F.G.S., 1877), pp. 45, 51; Northrup, *Record of a Century*, p. 22; A.F.M.R.S., "Fourth
Annual Report," in *Advocate* (1 June 1838).

53. *Friend of Virtue* 5:23 (1 December 1842): 368. Like their male counterparts, female
societies employed people to run their offices and maintain their books. In 1841 the American
Female Moral Reform Society fired its male bookkeeper and business agent upon discovering
discrepancies in the society's accounts. The board decided to hire a female bookkeeper and did
so immediately, although they themselves "cannot personally engage in making contracts,
purchasing paper, and performing all the labor of the publishing department." After "prayer-
fully considering the subject," the "ladies" decided to do without a male business agent
altogether. From then on, female employees printed the *Advocate* and ran the society's office in
New York. In spite of complaints from male printers, other women-run periodicals soon
followed suit: quotations in Northrup, *Record of a Century*, p. 25. On changing to female
printers, see, e.g., *Lily*, December 1853, January 1854, and February 1854.

54. On the ideology of housework see especially Jeanne Boydston, *Home and Work:
Housework, Wages, and the Ideology of Labor in the Early Republic* (New York: Oxford Univer-
sity Press, 1990).

with most "special terrains," however, the distinction between the work of women and that of men was blurred, and the ideology stretched to encompass activity that defied peculiarly female qualities.[55] Indeed, the language of "home" obscured just how great the differences between actual benevolent work and the rhetoric of domesticity were. In particular, it cloaked the considerable authority wielded by some benevolent women outside their institutions.

Besides the array of homes for wayward women, children, unemployed women, and destitute widows that sprouted up in antebellum cities, women increasingly founded industrial schools and houses of industry, establishments in which poor women earned wages in sewing and laundry rooms.[56] Shops for seamstresses, founded by women, represented a trend toward the "charity of wages." Increasingly, benevolent activists concluded that there was indeed a connection between money and virtue; poor women, they claimed, wanted work as well as advice to avoid temptation. The New York House and School of Industry employed women as seamstresses, both at their residences and at the institution itself; in 1855 alone the organization gave work to approximately five hundred women. One year later the managers reported that they had paid one-third more for work than in any other year. In 1857 this institution began to employ a number of poor women in a laundry, which the managers expected to be self-sustaining.[57] In Lancaster,

55. Kathleen D. McCarthy, *Noblesse Oblige: Charity and Cultural Philanthropy in Chicago, 1849–1929* (Chicago: University of Chicago Press, 1982), p. 6. See pp. 6–13 for a description of Chicago's women-run asylums. Men also built asylums, both state run and private. The (male run) New York Magdalen Society, e.g., briefly operated an asylum on Bowery Hill for prostitutes who wished to "return to a virtuous life": Northrup, *Record of a Century*, p. 13. In 1825 in New York, 1826 in Boston, and 1828 in Philadelphia, men sponsored the establishment of Houses of Refuge for juvenile delinquents, though in many cases the women provided the actual management: Charles C. Cole, Jr., *The Social Ideas of the Northern Evangelists, 1826–1860* (New York: Octagon Books, 1966), p. 111.

56. In the first decade of the century, Troy, N.Y., Salem, Mass., Newburyport, Mass., and Portsmouth, N.H., each had a woman-run orphanage: Berg, *Remembered Gate*, p. 159. The American Female Guardian Society (1848), Home for Discharged Female Convicts (1845, later the Isaac T. Hopper Home), the Five Points House of Industry (1850), the Chicago Orphan Asylum (1849), the Chicago Home for the Friendless (1858), and numerous other institutions sprang up later. There were twelve industrial schools in New York City by 1854. There was a "house of employment" with similar goals founded in Philadelphia in 1798; it was opened by the Female Society for Assisting the Distressed, itself established by Quaker women in 1795: John K. Alexander, *Render Them Submissive: Responses to Poverty in Philadelphia, 1760–1800* (Amherst: University of Massachusetts Press, 1980), pp. 133–35.

57. New York House and School of Industry, *Fourth Annual Report* (New York, 1855); *Fifth Annual Report* (New York, 1856); *Sixth Annual Report* (New York, 1857). In 1855 the institution bought its new premises for $8,100. The $300 that the Boston Needlewoman's Friend Society received from the Society for the Employment of the Female Poor was used to employ seamstresses: *Third Anniversary*, p. 7.

Pennsylvania, a group of "philanthropic persons" began in 1821 to provide work to spinners and weavers ("the worthy and industrious poor, who from lack of employment were unable to support their loved ones"). The managers of this society described its operations in careful detail: in 1827, for instance, the society purchased "332 ½ pounds of flax, 318 ½ pounds of tow, 21 pounds of hemp and 117 pounds of wool," producing "236 yards woven, 410 dozen spun, 428 ½ dozen dressed, 40 dozen bleached and 64 pounds of carpet chain manufactured." By the second year of the society's existence, the women decided to turn the management over to the men, while they themselves would supervise the manufacture of goods; for this supervision and for the use of her room as the manufactory, at least one woman, Julianna Jordan, received a commission.[58]

Careers in benevolence, paid or not, required hard and decidedly unsentimental work. Punctuality, order, and efficiency—habits that a later generation would label "corporate"—were explicitly stressed in advice to women on their benevolent roles. Women devoted long hours to writing and printing annual reports, publicizing events, and attending meetings, as well as performing the daily tasks of visiting the recipients of their benevolence. Managers of asylums worked in their institutions every day.[59] The managers of the Newark Female Charitable Society confessed that charity work made middle-class women, with all their privileges, tired. "We often hear people speak of the 'luxury of doing good,'" read one annual report: "But a score of years, which some of us have spent in the service of this Association, has been sufficient to disenchant our minds of this enthusiasm. According to our experience, it involves a sacrifice of time and ease and of comfort. Poverty knows no ceremony. It cannot wait on our convenience." In her study of Rochester women activists, Nancy Hewitt emphasizes that women's benevolent careers shared many of the characteristics of the careers of their husbands. "[These] women," she writes, "dedicated themselves to long

58. William Frederic Worner, "Society for the Promotion of Industry and Prevention of Pauperism," Lancaster County Historical Society, *Historical Papers and Addresses* 35 (1931): 121–35.

59. McCarthy, *Noblesse Oblige,* pp. 8–9; Hewitt, *Women's Activism,* describes long days and years of benevolent service on the part of many, e.g., pp. 221–22. An exhausted Catharine Sedgwick described her experience in one of these institutions: "I have just come from the House of Industry, from the infinite complicity of paying committees, purchasing committees, examining d[itt]o., reference do., receiving do., cutting do., etc. etc. I received about two hundred registered names, etc., poor women eagerly seeking the boon of fifty cents' worth of work. . . . It will be a noble institution; at present it is, of course, crude and defective": Sedgwick to Kate Minot, 3 June 1850, in Mary E. Dewey, ed., *Life and Letters of Catharine M. Sedgwick* (New York: Harper and Brothers, 1871), p. 322.

years of service, a regular and busy work schedule, and the formalities of vacations, leaves-of-absence, resignation, and retirement."[60]

Mary A. Man Hawkins exemplified this full-time career in benevolence.[61] Born in 1808 in Franklin County, New York, she shared with many women of her generation the common experiences of youthful marriage (1824) and migration to New York City (1828). After several years in fashionable circles, she became converted during a revival in the early 1830s. What followed was a fairly typical, if unusually active, career in benevolence. Hawkins became a Sunday school teacher, tract distributor, and slum visitor. In 1834 she helped found the New York Female Moral Reform Society, joined in editing the *Advocate of Moral Reform* in its early months, visited prisons and brothels, and stood up to the opposition that greeted the women's efforts at preventing sin. Hawkins served as president of the Female Moral Reform Society and, later, the American Female Guardian Society for some thirty-five years, helping to guide it though its stages of moral fervor and institutionalization. She also served on the board of the Mariner's Family Industrial Society (which employed "the female members of the families of Seamen" to sew and then sold the products to sailors in its own store) and the Female Department of the Prison Association of New York. In the New York City Directory of 1860, M. A. Hawkins' occupation is listed simply as "Pres[ident]."[62]

More was at stake in women's benevolent activity, however, than the organizational behavior urged upon and displayed by the women involved. Female societies were financially and culturally significant institutions in large cities. They invested their corporations' money in bank stock, insurance companies, and other relatively stable ventures. Early in the century, the Boston Female Asylum invested $45,500 in the Massachusetts Hospital Life Insurance Company, emphasizing security over their need for a large income. The transaction, the managers modestly noted, was "a complicated and anxious duty for a lady; and such as required the aid of [a man] acquainted with their fluctuating value and the general state of business." Nevertheless, these women controlled the

60. Quoted in Martin, *Century of Benevolence,* p. 22; Hewitt, *Women's Activism,* p. 229.

61. Information on Hawkins comes from Sarah R. I. Bennett, *Wrought Gold: A Model Life for Christian Workers* (New York: A.F.G.S., 1874).

62. Mariner's Family Industrial Society, handwritten history of the society, [n.d.], box 21, New York City Misc. Mss., New-York Historical Society; Caroline M. Kirkland, *The Helping Hand: Comprising an Account of the Home for Discharged Female Convicts, and an Appeal in Behalf of That Institution* (New York: Charles Scribner, 1853), p. 126; H. Wilson, comp., *Trow's New York City Directory* (New York: J. F. Trow, 1860), p. 376.

investment, a not insubstantial amount to the insurance company in which they placed it, and from which they earned a significant income.[63]

Those efforts for a moral cause such as abolition that did not—or could not—wholly adopt this corporate model nonetheless provided women with lifelong careers in administration. Extremely talented and ambitious women spent decades operating the machinery of a movement, sitting on committees, writing, printing, and mailing reports and leaflets, organizing speakers, carrying on huge correspondences, and otherwise performing tasks that were invisible only if one chose not to look.

In 1839 Anne Weston wrote her sister Debora about another of their sisters. "Maria," she announced, "says her whole life is one ____ [*sic*] grind." Maria Weston was born into a prosperous family in Weymouth, Massachusetts, in 1806. In 1830 she married Henry Chapman, a wealthy Boston merchant and fellow member of William E. Channing's Unitarian Church. Her career exemplified the hard work and virtually full-time nature of organizing. In 1832, Chapman and twelve other women, including her three sisters, Caroline, Anne, and Debora, established the Boston Female Anti-Slavery Society, and the Chapman home formed the emotional and financial center for the "Boston clique" of the antislavery movement.[64] Over the next decade, Chapman edited or coedited the *National Anti-Slavery Standard,* the

63. B.F.A., *Reminiscences,* pp. 30–31. The Massachusetts Hospital Life Insurance Company was an affiliate of the Boston Associates, the group of capitalists that developed New England textile mills: Robert H. Wiebe, *The Opening of American Society from the Adoption of the Constitution to the Eve of Disunion* (New York: Alfred A. Knopf, 1984), p. 263.

64. Anne Weston to Debora Weston, 15 December 1839. Information on Chapman's life is from Alma Lutz, "Maria Weston Chapman," in *Notable American Women, 1607–1950: A Biographical Dictionary,* ed. Edward T. James and Janet Wilson James (Cambridge: Harvard University Press, 1971), 1:324–25; Blanche Glassman Hersh, *The Slavery of Sex: Feminist-Abolitionists in America* (Urbana: University of Illinois Press, 1978); Friedman, *Gregarious Saints;* and Jane H. Pease and William H. Pease, *Bound with Them in Chains: A Biographical History of the Antislavery Movement* (Westport, Conn.: Greenwood Press, 1972), pp. 28–59. Chapman's letters are mostly in the Antislavery Collection at the Boston Public Library and the Gay collection at Columbia University, as well as in Clare Taylor, ed., *British and American Abolitionists: An Episode in Transatlantic Understanding* (Edinburgh: Edinburgh University Press, 1974). There are a few letters elsewhere, including the Philadelphia Female Anti-Slavery Society Papers at the Historical Society of Pennsylvania. The phrase "Boston clique" in association with Chapman's home is in Lawrence Friedman, *Gregarious Saints,* pp. 55–57. Franklin Sanborn no doubt had Chapman's community in mind when he recalled, "Active agitation against American slavery was confined to a few families, and in them chiefly to the women of the household": Franklin Benjamin Sanborn, *Recollections of Seventy Years* (Boston: Gorham Press, 1909), 2:446.

*Non-Resistant,* the *Liberator,* and the *Liberty Bell,* an annual gift book of abolitionist poetry and prose. With her sisters, she organized Boston's annual antislavery fairs and raised large sums of money for the cause. For eighteen years she served on the American Anti-Slavery Society executive committee and nine times sat on the New England Anti-Slavery Society business committee. In spite of Chapman's relative invisibility to history, other abolitionists suggested that William Lloyd Garrison was merely her "front man"; she, in turn, was generally considered Garrison's "principal lieutenant."[65]

Chapman's constant letter writing was a linchpin in abolitionist communications. Her correspondence kept neighboring communities up to date on the details of Boston antislavery activity; letters to and from reluctant reformers deliberated over their commitment, their signatures, and their money. She maintained a level of urgency that is difficult to imagine without poring over the intense scrawl of her notes: "Let me have some money as quick as you can, say $13.00 to pay the Lib[erator] Bill binders bill [*sic*]," she scribbled to her sister Debora.[66] Above all, Maria Weston Chapman was tenacious, a partisan who fought for the control of the organizational and ideological apparatus of a moral movement—as her grandson, John Jay Chapman put it, a "gladiator," whose "sword would leap from the scabbard at any allusion to past controversy in which she or Mr. Garrison had been concerned" and to whom "the *wrong kind* of anti-slavery was always considered as anti-Christ." Chapman's tenacity had consequences for the abolitionist movement during the organizational split of 1839–40; Lewis Tappan, who found himself locked in battle with Chapman for control over the movement, called her "a talented woman with the disposition of a fiend."[67] With immense administrative and political skill, she maneuvered a bitter division in the Boston Female Anti-Slavery Society into a crisis from which she emerged even more powerful. Chapman was a power broker of ultraist reform.

For all her undeniable importance to the movement, Maria Weston Chapman operated the silent activities that characterized abolition as they did traditional benevolent enterprises. She herself spoke to a con-

65. Friedman, *Gregarious Saints,* p. 48; Lutz, "Maria Weston Chapman," in *Notable American Women,* ed. James and James, 1:324. Nathaniel Colver thought that Chapman "entirely ruled" Garrison: Pease and Pease, *Bound with Them in Chains,* p. 56.

66. Maria Weston Chapman to Debora Weston, 6 December 1839, vol. 12, no. 108, Antislavery.

67. John Jay Chapman, *Memories and Milestones* (New York: Moffat, Yard, 1915), pp. 211, 214); Pease and Pease, *Bound with Them in Chains,* p. 29.

vention only once. Instead, she encouraged the Grimkés and other young women to make themselves heard. She built no lasting institutions; yet she was unsurpassed in raising funds for an unpopular cause, funds that paid agents to broadcast her ideals.[68] Chapman wrote the Boston Female Anti-Slavery Society's blistering annual reports, ran petition drives, engineered crises within local societies to the Garrisonians' advantage, housed visiting lecturers, and forged the ties with British abolitionists that helped to sustain United States activists in their most isolated periods. Chapman was a movement builder, an ultraist whose hold over the organizational aspects of abolition made her one of the most powerful activists in the cause and whose leadership role should place her at the center of a discussion of mid-nineteenth-century reform. Her career encompassed the variety of tasks involved in the business of benevolence and reform, and exemplified the authority exerted by those who handled what the New-York Female Auxiliary Bible Society called the *"minutiae of the interior."*[69]

Maria Weston Chapman knew well that benevolent women who worked in fashionable causes were among the most influential in their communities and movements—even as they insisted on their own invisibility. She also knew that their influence took concrete forms that were not available to ultraists such as herself. When those women wanted to establish institutions, they asked men in authority for support. They received legislative charters, appropriations for public monies, and laws that gave them greater authority than they had previously enjoyed. However "naturally virtuous" these women were, they defended more complex interests and more profound goals than the mere assertion of female morality.

For women involved in building charitable organizations, the rhetoric of female benevolence concealed authority that they wielded in the distribution of resources and services in their communities. These women's influence was more than the vague substance described in the previous chapter; the rhetoric concealed the business of female benevolence from careful scrutiny, obscuring some women's standing in their communities, their access to funds for charitable and benevolent work,

68. Her sole public speech was at the second Anti-Slavery Convention of American Women, held in Philadelphia in 1838. Chapman's fund-raising acumen was well known among abolitionists. When Samuel J. May entrusted her with a Hancock seal to sell at the 1842 fair, he expressed confidence that with her "inventive genius" it would bring $50 or $100 to the cause: Samuel J. May to Maria Weston Chapman, 13 December 1842, vol. 17, no. 144, Antislavery.

69. New-York Female Auxiliary Bible Society, *Twelfth Annual Report*, p. 9.

and their dependence on political favors. This explains in part why conservative and prosperous women, unchallenged in their efforts to organize benevolent institutions, clung so tenaciously to the rhetoric of silent, sentimental, female benevolence. As we shall see, only during the Civil War did the machinery of benevolence, established early in the century, become visible in such a way that debates over its structure and over the relationship between benevolence and the state became public. Even in the early part of the century, however, the discussion of women's influence takes us—as it took them—into the political realm, into activities that involved governmental assistance: appropriations, petitioning, legislative activities, and the demand for the vote.

# *Three*

## "Hot Conflict with the Political Demon"

In 1837, Catharine Beecher engaged in heated debate with Angelina Grimké over the propriety of women's antislavery petitions. "Petitions to congress," Beecher asserted, "in reference to the official duties of legislators, seem, IN ALL CASES, to fall entirely without the sphere of female duty. Men are the proper persons to make appeals to the rulers whom they appoint." This was a particularly revealing remark coming from Beecher; less than ten years earlier she had undertaken a campaign to oppose the Jacksonian policy of removing the Cherokees from Georgia, a campaign that included pamphlets and petitions by women to Congress.[1] Framed in the language of propriety, the Grimké-Beecher dispute clouded a more complex issue: embedded in the antebellum ideology of woman's sphere, and in the belief that politics occupied a wholly separate realm from morality, lay contradictory messages and practices by women bent upon implementing social change.

Catharine Beecher was not alone in her insistence that women's appropriate means for change lay in their peculiar influence—an influence that was moral, as opposed to political, in nature. Such a distinction was a hallmark of antebellum benevolent rhetoric and has been perpetuated by subsequent historical accounts of women's efforts to gain the vote—a campaign that presumably derived its historical importance precisely from the fact that it represented women's assault on the male

1. Catharine E. Beecher, "Essay on Slavery and Abolitionism" (1837), in Jeanne Boydston, Mary Kelley, and Anne Margolis, *The Limits of Sisterhood: The Beecher Sisters on Women's Rights and Woman's Sphere* (Chapel Hill: University of North Carolina Press, 1988), p. 128; Kathryn Kish Sklar, *Catharine Beecher: A Study in American Domesticity* (New York: W. W. Norton, 1976), p. 99; Beecher, *Educational Reminiscences and Suggestions* (New York: J. B. Ford, 1874), pp. 62–65.

sphere of politics. As women developed a strengthened perception of their own collective status—so the story goes—they presumably began to chafe under the restrictions of those roles, finally challenging them altogether in the revolutionary demand for suffrage. To be sure, some nineteenth-century observers recognized the ambiguous and shifting nature of politics. Abolitionist Joshua Leavitt, for example, warned in 1839: "It should be always borne in mind, that there are other modes of 'political' action, besides voting."[2] Still, since the 1840s, few have challenged the view of women's "sudden entrance" into politics or the implicit claim by suffragists themselves that only the vote guaranteed women real political access.[3]

It is clear that certain women exercised an influence that was far more substantial than the benign and familial authority so glorified by contemporaries. If Catharine Beecher shared with contemporaries the belief that a moral duty paralleled women's domestic responsibilities, neither was she unusual in interpreting that mandate in her own practice to include appeals to legislators on a variety of issues. Both before and after the advent of the woman suffrage movement, women strode in

2. Quoted in William Lloyd Garrison, "To the Abolitionists of Massachusetts," in Louis Ruchames, ed., *A House Dividing against Itself, 1836–1840,* vol. 2 of *The Letters of William Lloyd Garrison,* ed. Walter M. Merrill and Louis Ruchames, 6 vols. (Cambridge: Harvard University Press, 1971), p. 512. As in so many instances, it remained among historians for Mary Ritter Beard to heed that warning. Ever wary of simplistic analyses of women's "emancipation," Beard argued that some women exerted political influence without actually voting. "If it is true," she wrote, "that powerful economic interests . . . have often written their will into law, . . . what can we say of the weight of beneficent influences, and particularly the influence of voteless women?" As Beard suggests, the historical focus on suffrage has distorted the history of women's participation in the political process: Mary Ritter Beard, "The Legislative Influence of Unenfranchised Women," in *Mary Ritter Beard: A Sourcebook,* ed. Ann J. Lane (New York: Schocken Books, 1977), p. 90.

3. To a large extent, this view of the suffrage movement as a sharp departure from earlier nineteenth-century gender roles was the creature of the suffrage campaign itself. In her 1871 history of the woman's movement, Paulina Wright Davis boasted that the 1850 Memorial to the Ohio Constitutional Convention, which demanded political and legal rights for women, "was, we believe, the first ever presented by women to any Legislative body in this country": Paulina Wright Davis, *A History of the National Woman's Rights Movement for Twenty Years* (New York: Journeyman Printers' Co-operative Association, 1871), p. 9. See Elizabeth Cady Stanton, Susan B. Anthony, and Matilda Joslyn Gage, eds., *History of Woman Suffrage* (New York: Fowler and Wells, 1881), 1:105, for a copy of the memorial. As a former moral reformer, temperance activist, and abolitionist, Davis had to know that this was not the case. Davis herself had in 1837 circulated petitions in support of an act to protect the property of married women: Mary P. Ryan, *Cradle of the Middle Class: The Family in Oneida County, New York, 1790–1865* (New York: Cambridge University Press, 1981), pp. 124, 227. Davis had participated in organized petition campaigns for the abolition of slavery. Along with other advocates of woman's suffrage, who sought to unify women on the basis of their powerlessness, Davis limited the discussion of women's involvement in politics to the question of the vote.

and out of legislative halls—places where, in theory, females were not welcome. There they lobbied for new laws, sought appropriations for their organizations, and argued for changes in their own status—in short, they worked hard to influence the leadership of local, state, and national governments. The historical focus on the radical demand for the vote as women's only significant political act, however, has had the effect of both foreshortening and distorting the history of women's participation in the political process.

At least two additional dimensions must be woven into that narrative. First, in order to understand fully the nature of women's antebellum activism we need to recognize the inconsistencies between the ideological separation of politics and morality and their everyday interconnection. Untangling these threads of ideology and experience in women's activism requires a broadened definition of politics itself. With Weber, we must not confine our discussion of politics to one about voting but must "understand by politics . . . the leadership, or the influencing of the leadership, of a *political* association, hence today, of a *state*." Virtually all antebellum female activists, from ultraists to quite conservative women, recoiled from a public association with the potentially partisan nature of their efforts (after all, as historian Karen Halttunen has pointed out, the "party man" would "lie, slander, place wicked men in office, support the liquor traffic, and even deny his religion, in order to secure victory for his party"), but they lived with the contradictions of exerting their influence in decidedly political ways toward clearly political ends.[4]

Second, a conception of politics that better reflects political realities is essential in understanding the changes in women's benevolent activism over the course of the nineteenth century because during the late antebellum period the meaning of politics itself changed, coming to focus more exclusively on the vote and partisan loyalties. Throughout the antebellum decades, electoral means became both more broadly based and more essential to implementing social reform. This change posed a crisis for many women active in movements for moral change, for whom electoral politics, which for many of them meant partisanship, represented the elevation of party over principle, pragmatism over the rhetoric of morality that had inspired their involvement in benevolence

4. Max Weber, "Politics as a Vocation," in H. H. Gerth and C. Wright Mills, eds., *From Max Weber: Essays in Sociology* (New York: Oxford University Press, 1946), p. 77; Karen Halttunen, *Confidence Men and Painted Women: A Study of Middle-class Culture in America, 1830–1870* (New Haven: Yale University Press, 1982), p. 14.

in the first place. The decision to agitate for the vote—in itself a recognition of the new strategies necessary for reformers—thus often involved a profound and agonizing reappraisal of the nature of female benevolence itself. This recognition first emerged among more radical and middle-class activists; by the postbellum decades, more prosperous and conservative women—women who ordinarily might have taken for granted their relative access to local politicians—agitated for at least partial suffrage in order more efficiently to undertake the work of benevolence.

A growing dependence on electoral results and partisan advocacy characterized political life during the period. The greater prestige of the vote—and thus the narrowing of the definition of politics itself—is most simply described with numbers. Political parties organized unprecedented masses of voters after 1820. In addition, more people behaved as though voting mattered. Fewer than 30 percent of the adult white men, a particularly low turnout, voted in the presidential election of 1824; in 1828 more than 57 percent did. Turnout continued to rise dramatically throughout the decade. In 1840, more than 80 percent of the eligible voters, which by then included virtually all white men, went to the polls. Only once more in the nineteenth century, in 1860, did the proportion who voted in presidential elections top 80 percent (81.2 percent in 1860), but only once did it fall below 70 percent (69.6 percent in 1852). The change was even more extreme in some northeastern states.[5]

Women were increasingly visible among supporters in these electoral campaigns, reflecting both their growing concern with electoral power and the assumption that—even unenfranchised—women would participate in the political efforts of their class or cause. William Henry Harrison's presidential campaign of 1840 included crowds of enthusi-

5. The increase in the size of the eligible voting population does not alone account for this change; the growth of party organization played an enormous role. In Connecticut in 1824, 14.9% of the adult white men voted; in 1840, 75.7% did. In New York, where no figures are available for 1824 (but where, according to Paul S. Boyer, the electorate had already been increased by 30% in 1821 [*Urban Masses and Moral Order in America, 1820–1920* (Cambridge: Harvard University Press, 1978), p. 7]), 80.2% of adult white men voted in 1828; in 1860 that number hit 95.5%. In Pennsylvania, the proportion who voted was 18.8% in 1824, 77.5% in 1840, and more than 80% in 1856. Massachusetts showed the least range of these northeastern states, but even there the 1824 turnout of 29% was far below the 66.7% of 1840 and the 69.8% of 1856. All these numbers come from the United States Bureau of the Census, *Historical Statistics of the United States, Colonial Times to 1970*, 2 vols. (Washington, D.C., 1975), 2:1067–85. The makeup of city governments was also changing in this period, reflecting both the growing diversity of the urban electorate and the greater organization of ward politics. For an insightful account of these changes in one antebellum city see Amy Bridges, *A City in the Republic: Antebellum New York and the Origins of Machine Politics* (Cambridge: Cambridge University Press, 1984).

astic and active female supporters. "How we shouted and sang for the great Whig convention [of 1840]," recalled Ednah Dow Cheney of her enthusiasm at age sixteen, "and thought the country was safe and all right when Harrison was elected!" Amelia Bloomer's husband, Dexter, considered the 1840 presidential election a turning point in her political career, as she assisted him in editing the only Whig newspaper in their town. Party loyalties claimed women as well as men; Quaker abolitionist Sarah Pugh, for example, recalled with some embarrassment having been a "flaming Whig partisan" in the 1830s.[6]

Unenfranchised women across the spectrum of benevolent activism expressed political identities that accorded closely with their goals; it should not be surprising that Protestant benevolent women most often identified as Whigs. As we saw in the previous chapter, some women sought and obtained legislative privileges for their work in various benevolent endeavors. In addition, women, like men, appealed for financial appropriations, regulation of state-run asylums, and laws to aid them in the "business of benevolence." They wrote petitions, memorials, and acts that they brought to legislative chambers, where they actively worked to achieve passage by soliciting acquaintances and allies for support. They attended legislative debates on both the national and state levels and brought in thousands of names on petitions covering a broad range of issues.[7]

Virtually all women who employed the language of moral change—those active in charity work, moral reform, temperance, and abolition—moved casually into organizing for legislative action. In 1839, *Godey's Lady's Book* editor Sarah Josepha Hale, who so ardently exhorted women

6. Ednah Dow [Littlehale] Cheney, *Reminiscences of Ednah Dow Cheney* (Boston: Lee and Shepard, 1902), p. 25; D. C. Bloomer, *Life and Writings of Amelia Bloomer* (New York: Schocken Books, 1975; orig. 1895), pp. 17–18; Sarah Pugh to a friend, 26 May 1850, in *Memorial of Sarah Pugh: A Tribute of Respect from Her Cousins* (Philadelphia: J. B. Lippincott, 1888), p. 37. Catharine Sedgwick recalled that her party loyalties developed at quite an early age and were inextricably connected to her class identity: Mary E. Dewey, ed., *The Life and Letters of Catharine M. Sedgwick* (New York: Harper and Brothers, 1871), pp. 64–65.

7. Barbara J. Berg, *The Remembered Gate: Origins of American Feminism: Women and the City, 1800–1860* (New York: Oxford University Press, 1978), e.g., p. 211. Local efforts reflected national debates about the extent of the state's responsibility for various moral concerns. See Paul E. Johnson, *A Shopkeeper's Millennium: Society and Revivals in Rochester, New York, 1815–1837* (New York: Hill and Wang, 1978). On the state's involvement see David M. Schneider, *History of Public Welfare in New York State, 1609–1866* (Chicago: University of Chicago Press, 1938). On Americans' zeal for organizing and their use of political tools see too Arthur M. Schlesinger, Sr., *Paths to the Present* (New York: Macmillan, 1949), chap. 2, and Maria Baghdadi, "Protestants, Poverty and Urban Growth: A Study of the Organization of Charity in Boston and New York, 1820–1865" (Ph.D. diss., Brown University, 1975).

to "leave the work of the world and its reward, the government thereof, to men," introduced into the Massachusetts state legislature a measure for a maximum rent on housing of fewer than five rooms. The measure quickly died, apparently without Hale having to defend her entrance into politics on behalf of a benevolent cause.[8] Women often spoke of pleas to legislators in the familiar terms of religious supplication and divinely ordained rights. "Prayer is our weapon," argued Paulina Wright Davis as she urged women to flood state legislatures with petitions; "therefore, let us be importunate."[9]

Although many women insisted that these activities conformed to feminine constraints, a few recognized that the means that they employed to accomplish their goals were essentially political—and that women could be effective. For Maria Weston Chapman, being voteless did not preclude women's political activity. A careful observer of the privileges accorded more conservative women, she knew that benevolent work was not wholly confined to a moral, in contrast to a political, sphere. Proudly, however, she allied herself with those who denigrated the partisanship and the moral compromises that she believed inevitably followed participation in electoral politics, claiming that her choice constituted the assertion of true moral power. The Boston Female Anti-Slavery Society, she insisted, "is not a political party organization. Deprived though we are of the elective franchise, *we yet might spend our strength in partizanship,* did we believe it in the least calculated to promote our object; did we not feel that our aim ought to be higher and nobler." The Philadelphia Female Anti-Slavery Society agreed, stating in its 1845 annual report that "it would be worse than useless to expend

8. On the bill, see Ruth E. Finley, *The Lady of Godey's: Sarah Josepha Hale* (Philadelphia: J. B. Lippincott, 1931), pp. 78–79. The quotation is in Hale, *Woman's Record; or, Sketches of All Distinguished Women, from the Creation to A.D. 1854,* 2nd ed. (New York: Harper and Brothers, 1855; repr. New York: Source Book Press, 1970), p. xlv. In 1837 the Boston Seamen's Aid Society, led by Hale, had joined women from the Moral Reform Society to argue for new property laws for women; Hale herself called the current laws "a monstrous perversion of *justice* by *law*": Berg, *Remembered Gate,* p. 230; *Godey's Lady's Magazine* (May 1837), quoted in Finley, *Lady of Godey's,* p. 23.

9. *Una* 2:1 (January 1854): 196. "We have seen it [the Home] encouraged by the sacred right of petition in coming before Rulers, once and again until its prayer was heard," piously intoned one moral reformer, quoted in S. R. I. Bennett, *Woman's Work among the Lowly: Memorial Volume of the First Forty Years of the American Female Guardian Society and Home for the Friendless* (New York: A.F.G.S., 1877), p. 214. For a description of legislators in religious terms that nevertheless exposed an earthly distrust of them as men, see Boston Female Moral Reform Society, *Third Annual Report* (Boston: George P. Oakes, 1838), p. 7.

our time and energies in propelling the machinery of political parties," but never questioning that women could do so if they wished.[10]

Women's access to those in power correlated closely with their social status, which in turn, as other historians have pointed out, corresponded with the kind of organization in which they worked. Abolitionists' tone of self-righteousness in disdaining any association with politicians, however sincerely felt, was essentially a concession to the reality of their own relative lack of access to those politicians. Socially prominent and conservative women, in contrast, acted on their political identities through their close association with the men who ran governments. Those relationships translated directly into access to public funds for their organizations.[11]

The leaders of relatively conservative women's societies and charitable institutions early recognized the efficiency of seeking governmental financial aid rather than relying solely on individual appeals, especially when they planned a new building or some other large expenditure. The Orphan Asylum Society in New York, founded in 1806 by Isabella Graham's daughter, Joanna Graham Bethune, purchased lots for a larger asylum, furnished the building's interior, and expanded its grounds thanks to the "liberality of the Legislature." In 1814 thirty women signed Graham's petition to the mayor and common council for a steady supply of money for the Society for the Promotion of Industry Among the Poor, and the money for a building was appropriated; the corporation of the city granted a larger sum the following year. The Association for the Relief of Respectable, Aged, Indigent Females petitioned for and received funds from the Corporation of the City of New York as early as 1816, and for many years thereafter. Indeed, any organization in which Graham was visible was assured the active assistance of New York City politicians, usually in the form of corporate charters and "some pecuniary aid."[12]

10. Boston Female Anti-Slavery Society, *Ten Years of Experience: Ninth Annual Report* (Boston: Oliver Johnson, 1842), p. 16 (my italics); Philadelphia Female Anti-Slavery Society, *Eleventh Annual Report* (Philadelphia: Merrihew and Thompson, 1845), p. 6.

11. On elite benevolent women's status, see Nancy A. Hewitt, *Women's Activism and Social Change: Rochester, New York, 1822–1872* (Ithaca: Cornell University Press, 1984), pp. 50, 53–55. For comparison, on perfectionist women see pp. 56–59 and on ultraists see pp. 61–63; see also Ryan, *Cradle of the Middle Class,* pp. 84–85, 90–92.

12. Joanna Graham Bethune, ed., *The Power of Faith, Exemplified in the Life and Writings of the Late Mrs. Isabella Graham* (New York: Kirk and Mercein, 1817), p. 56 (and pp. 63–64 for text of the petition); Association for the Relief of Respectable, Aged, Indigent Females, *Third Annual Report* (New York, 1816), p. 3, and *Fourth Annual Report* through *Forty-ninth Annual Report* (New York, 1817–62).

No one involved in these early successes remarked on the inconsistency of the women's proximity to politics, including the men who sometimes spoke to city governments "to support [the women's] claims for patronage." Certainly these particular women saw no reason to seek so controversial a tool as the vote in order to accomplish their goals. Just as surely, gaining access to appropriations was a first, and highly significant, step toward ongoing—and mutually beneficial—relationships with government officials. According to historian Barbara Berg, these early successes merely expanded women's influence: "Emboldened by frequent favorable responses of public officials to their financial requests," she writes, "women began to bring their problems and plans to governmental authorities."[13]

And politicians, not blind to considerations of female propriety, listened. The sex of petitioners was simply one of a number of factors in legislators' decisions to accede to their demands. It was not simply because they were lobbied by women that politicians decided against temperance or antislavery petitions; nor would they grant their wishes merely because the petitioners were "ladies." Frequently, women's organizations received not only a hearing but a favorable vote. Not surprisingly, legislators and council members were most responsive to the pleas of relatively traditional organizations, those that sought to ameliorate specific social and economic conditions, to limit sin rather than to realize a grand moral transformation.

By granting assistance to women's benevolent organizations, local politicians implicitly acknowledged that the women's efforts directly relieved governments of much of the responsibility for poor or aged citizens. In Rochester, New York, officials distributed emergency relief to the poor during the financial crisis of the late 1830s only because the Female Charitable Society, the city's most elite institution, suffered a loss in donations. During more prosperous periods, women's benevolent organizations met these needs—and provided significant savings to taxpayers. In Utica, New York, "the combined services of sundry orphan asylums, hospitals, sewing circles, and relief associations surely surpassed the annual city appropriation for the poor, some $3,000. The proceeds of two female charities alone . . . exceeded this amount." The

13. John Pintard to Eliza Pintard Davidson, 13 January 1818, in *Letters from John Pintard to His Daughter, Eliza Noel Pintard Davidson, 1816–1833* (New York: New-York Historical Society, 1940–41), 1:104–05; Berg, *Remembered Gate*, p. 167. For the story of Pintard's assistance to the Ladies House of Industry see his letter of 29 December 1817, 1:100–01.

*Utica Daily Gazette* was duly impressed with the savings to the city generated by the Ladies' Relief Society. "With a few hundred dollars," the editor boasted, "they have bestowed a much larger measure of relief, and considering its moral influence, have done incalculably greater good than the thousands of dollars which in the years past were raised and distributed by the 'Fathers of the city' through the medium of ward committees."[14] In 1856 the American Female Guardian Society received $10,000 from the New York legislature—at least in part because, according to the legislature, the society kept people off the public relief rolls.[15] One year later, a New York senate committee reported: "Whether it be that the principal charge of [orphan asylums] is confided to females, or whatever be the cause," government subsidy of private benevolence ensured that "with less comparative expenditure of the public moneys an incomparably greater amount of comfort, cleanliness, kind treatment, health, and good education is secured to the inmates, than happens to be the lot of the paupers in our poorhouses." The report recommended continued state support of these institutions. Similarly, William Alcott, having proposed that women be trained as nurses who would perform work for free, went on to discuss the savings which would accrue to a community that made efficient use of women's altruism.[16]

How precisely did women's influence translate into political action? Some activist writers, implicitly acknowledging a growing focus on electoral means, suggested that women should (and did) directly sway individual men's votes. Urging women to "exert our powers of persuasion," the pro-temperance *Lily* wrote, "Let us give the men over whom we have an influence no peace, until they consent to make our votes their own, and deposit them for us." Temperance activist Mary

14. Hewitt, *Women's Activism,* p. 32; quotations are in Ryan, *Cradle of the Middle Class,* pp. 215, 214. See also Flora L. Northrup, *Record of a Century, 1834–1934* (New York: American Female Guardian Society, 1934), pp. 28–30.

15. Helen E. Brown, *Our Golden Jubilee: A Retrospect of the American Female Guardian Society and Home for the Friendless from 1834–1884* (New York: A.F.G.S., 1884), p. 33; Bennett, *Woman's Work among the Lowly,* pp. 249–50. This was in addition to its annual share from the common school fund of the city. The New England Female Moral Reform Society, which had just received $1,000 from the legislature, urged private support of its Temporary Home because this would save taxpayers from having to pay for asylums: N.E.F.M.R.S., *Twenty-first Annual Report* (Boston: W. & E. Howe, 1859), pp. 10–11.

16. "Report of the Senate Select Committee to Visit Charitable and Penal Institutions, 1857," in Sophonisba R. Breckinridge, ed., *Public Welfare Administration in the United States: Selected Documents* (Chicago: University of Chicago Press, 1927), p. 157; [William A. Alcott], "Female Attendance on the Sick," *American Ladies' Magazine* 7 (July 1834): 304.

Vaughan observed that "there is [not] a man in this state that woman cannot reach in some way or other."[17] Moral reformers, temperance workers, and abolitionists insisted that public opinion, over which women supposedly had a great impact, effected legislative change. These reformers, who had fewer contacts with governmental authorities than did more prosperous and conservative women, relied heavily on this mass appeal. In conformity with the language of benevolence, they contended that laws *"spring from a new state of feeling"*— among legislators as well as voters—rather than any partisan advocacy; nevertheless, they congratulated women for their passage.[18]

That women had personal influence with men cannot be denied. But, the rhetoric notwithstanding, in politics neither such influence nor its use was peculiarly female, nor did its success depend wholly on affecting individual men's votes. Politics also involves gaining access to those in power, exchanging favors, cajoling—or influencing—votes until one gains certain ends. "You cannot imagine the labor of converting and convincing," wrote Dorothea Dix as she lobbied for an insane asylum in New Jersey. "Some evenings I had at once twenty gentlemen for three hours' steady conversation." The higher up the social scale one looks, the less voting itself absorbed a man's political energies. This was especially true after 1820, when nearly universal white male suffrage and growing party organization weakened the elite's certainty of electoral success, especially in municipal elections, even as it highlighted the growing importance of elections to the middle and working classes. For men as well as for women, influence was an indispensable tool in the scramble for resources, privileges, and status.[19]

17. "Temperance and Politics," in *Lily* 1:8 (1 September 1849): 69; *Whole World's Temperance Convention Held at Metropolitan Hall in the City of New York* (New York: Fowler and Wells, 1853), p. 46.

18. As early as 1836, the *Advocate of Moral Reform* credited women with a law "to provide for the more effectual suppression of Houses of Ill-Fame" in Maine. "These laws were not made half a dozen years ago—and why? Because there was no call for them. . . . Why the victory is more than half achieved; the people are awake": *Advocate* 2:10 (1 June 1836).

19. Quoted in James Leiby, *Charity and Corrections in New Jersey: A History of State Welfare Institutions* (New Brunswick: Rutgers University Press, 1967), p. 51. To argue that the higher a woman's social status the more access she had to politicians is not to deny the insights of scholars such as Amy Bridges that, at least in large cities, the elite was losing its exclusive control over municipal politics. Although by the Jacksonian period wealthy merchants no longer dominated New York City politics, individual access to politicians—rather than participation in the growing ward political networks—characterized relatively prosperous women's participation in benevolent efforts. Bridges notes further that although New York's wealthy did not run for political office as often as they had previously, businessmen who no longer controlled municipal elections "had not abandoned politics," seeking instead to assert their control through state and national politics: *City in the Republic*, pp. 130, 133.

Although barred from voting, elite women could extend to elected officials many of the same benefits as the other forms of political support offered by their male counterparts. In exchange for material and legal benefits for their organizations, they could make financial contributions to political campaigns, put politicians in the good favor generally of a certain class of citizens, provide them with the contacts necessary for continued electoral success, and help them to maintain these contacts by inviting them to social events where they would meet like-minded constituents. Women participated in the complex informal process by which politicians maintained the patronage of their constituents.

Clearly some women were familiar with and adept at political maneuvering. Throughout the antebellum period, access to legislators and city council members was fairly available to women of high social status. Protected by the trappings and rhetoric of their class or cause, some women entered state legislative offices as if they assumed their welcome, spoke to individual legislators about their projects, and walked away with money, laws, and corporate status. Historians need not accept the caricatures of observers such as James Bryce, who, noting that women were "widely employed and efficient" in the solicitation of legislation, attributed their accomplishments to "the persuasive assiduity which had long been recognized by poets as characteristic of the female sex."[20] Political savvy and political connections—not femininity—explained women's successes.

Moral reformers and temperance activists, in the same breath that they urged the eradication of sin—and denied the possibility that governments could help in that endeavor—actively made use of legislative shortcuts. In 1833, moral reformer John McDowall endorsed the New York Female Benevolent Society's plan to lobby for a state-funded asylum for "wandering women." That same year he noted that although "PUBLIC OPINION MUST BE PURIFIED" it would also be useful if "American ladies petition each state legislature in the union at its next session."[21] Frustrated with their efforts at eradicating lust through education, the American Female Moral Reform Society initiated a massive

20. James Bryce, *The American Commonwealth,* 2nd ed. (New York: Macmillan, 1889), 2:603.

21. *McDowall's Journal* 1:3 (March 1833), and 1:4 (April 1833): 25. Both the Female Department of the Prison Association of New York and the A.F.M.R.S. investigated the House of Detention and petitioned for separate female departments in city prisons as well as for matrons; the Common Council granted their request after receiving a petition signed by several hundred women: "Report of the Female Department of the Prison Association of New York," in P.A.N.Y., *Second Report* (New York, 1846), p. 130; Bennett, *Woman's Work among the Lowly,* pp. 58–59; Northrup, *Record of a Century,* p. 24.

petition drive in June 1838 for laws making seduction and abduction criminal offenses. By 1841 the organization had forwarded forty thousand signatures to the New York legislature alone, as well as registering petitions in other states. Ten years later, the same session that passed the Married Women's Property Act and the act to simplify incorporation of benevolent societies adopted these laws. Rather than seek political gains, moral reformers downplayed the impact such victories might have, insisting that "laws . . . will never be strictly enforced, until the heart of [the] community is impressed with a just sense of [the crime's] great enormity."22

The more women worked successfully with politicians, however, and achieved respectability for their organizations, the more they declared their reluctance to assume the burden of political advocacy. The story of the American Female Guardian Society, the renamed and increasingly conservative American Female Moral Reform Society, is a case in point. Society members were adept at cloaking their own advocacy for laws in the language of female dependence, as they called on "Christian sisters and fellow-laborers" to do "a long-neglected work . . . that our own feeble arm is too short to compass except by faith and prayer. If done, it must be done by our rulers. The power, the resources are theirs, but the right of petition, this is ours. By this means we may come before them as their mothers, their companions, their sisters." Thus they recommended that legislators take children away from "dissipated and vicious parents" and place them in their own benevolent hands. Yet despite this rhetoric there is no evidence that members doubted the appropriateness of the society's massive petition campaign for laws against seduction and abduction.23 In 1848, the year the laws passed, the "lady managers" made "repeated visits to Albany" until they received a corporate charter for their organization that was "liberal in its provisions and well suited to its wants." By the 1850s, with tested experience and connections in the legislature, they boldly appealed for financial assistance, sending the society's president, Mary Hawkins, and Elizabeth Seldon Eaton to lobby the legislature. Their report emphasized that this activity had been

22. Larry Howard Whiteaker, "Moral Reform and Prostitution in New York City, 1830–1860" (Ph.D. diss., Princeton University, 1977), p. 258; Boston Female Moral Reform Society, *Third Annual Report*, p. 9. According to their own historical account, they got 30,000 signatures in one year alone: Northrup, *Record of a Century*, p. 26.

23. Bennett, *Woman's Work among the Lowly*, pp. 207–09; on the lobbying process and the society's success in gaining this law, see ibid., pp. 210–13, and Brown, *Our Golden Jubilee*, p. 38. The A.F.G.S. corporate charter allowed them to take children in some circumstances, although an 1853 law broadened their prerogatives.

pursued "discreetly" and that the women had been introduced to the politicians by their husbands. Apparently the ends justified the means, for the society proudly announced that the women had convinced two-thirds of the senate and three-fourths of the house to sign their petition for assistance. Of course, they added, they had achieved this result "with scrupulous regard to woman's sphere." The women modestly commended themselves on a good result "quietly obtained."[24]

More radical reformers shared with more traditional organizations the assumption that overt involvement in partisan politics would undermine femininity and would taint the universally pure position. "Far be it from me to encourage women to vote," declared the Quaker Lucretia Mott in an early speech that asserted women's right to do so, "or to take an active part in politics in the present state of our government. . . . Would that man, too, would have no participation in a government recognizing the life-taking principle."[25] A woman's petition to a legislature should merit respect, Angelina Grimké insisted, because "*they* will be the most likely to introduce it there . . . as a matter of *morals* and *religion*, not of expediency or politics."[26] These efforts to identify women's work for a moral cause as untouched by partisan goals led ultraist reformers onto twisted paths of logic, as they sought to disengage their own self-consciously political work from the increasingly partisan nature of politics itself.

Yet, however steadfast in their commitment to moral suasion, aboli-

24. Sarah R. I. Bennett, *Wrought Gold: A Model Life for Christian Workers* (New York: A.F.G.S., 1874), p. 31; Bennett, *Woman's Work among the Lowly*, p. 187. See also Northrup, *Record of a Century*, pp. 32–33. Senator "J.B." sent the women his personal congratulations: "Thus it frequently occurs that the faithful performance of those duties which at first seemed painful and even repulsive," he wrote sympathetically, "results in the greatest good to ourselves, and the cause for which we are called to labor": Bennett, *Woman's Work among the Lowly* (all quotations from pp. 260–62). A detailed description of the lobbying process is in *Reports and Realities from the Sketch-Book of a Manager of the Rosine Association [of Philadelphia]* (Philadelphia: J. Duross, 1855), pp. 297–304.

25. Lucretia Mott speech in Philadelphia [1849?], quoted in Stanton et al., *History of Woman Suffrage*, 1:372; see also Angelina Grimké to Theodore Weld, 21 January 1838, in Gilbert H. Barnes and Dwight L. Dumond, eds., *Letters of Theodore Dwight Weld, Angelina Grimké Weld, and Sarah Grimké, 1822–1844*, 2 vols. (Gloucester, Mass.: Peter Smith, 1965), 2:522–23. On anarchist thought in abolitionism see Lewis Perry, *Radical Abolitionism: Anarchy and the Government of God in Antislavery Thought* (Ithaca: Cornell University Press, 1973).

26. Angelina Grimké, "Appeal to the Christian Women of the South," in Alice S. Rossi, ed., *The Feminist Papers: From Adams to de Beauvoir* (New York: Bantam Books, 1974), p. 304. Without irony, one moral reformer defined petitions as "silent pleas for virtue" immediately before she called upon women to "let our legislators know that the female portion of their constituents have some claims upon them": *Advocate* 7:24 (15 December 1841): 189.

tionists made use of the political arena from the beginning. As early as 1836 they eagerly accepted invitations to speak to state legislative sessions, seeing them as opportunities to convert large numbers of people. Because they distinguished influencing politicians from asserting partisan goals, abolitionists, both women and men, were able to address legislators with few qualms. "My husband has been with me to the Legislatures of Delaware, New Jersey, and our own State [Pennsylvania]," wrote the "no-government" Lucretia Mott in 1841, "where a patient and respectful audience was granted while I plead the cause of the oppressed." Elizur Wright observed: "Though legislatures in this cause are no more than other men, yet the opportunity of sowing a little seed by their means in almost every part of a large state is something."[27] Abolitionists were determined not to seek electoral goals, but they happily turned legislators into "agents," the more easily to spread the word.

When they spoke to legislators, abolitionists did so on behalf of the thousands whose names appeared on the petitions that they presented. The practice of petitioning demonstrates the complexities of seeking to distinguish political from partisan activities on behalf of a moral cause. Those who organized mass petition campaigns claimed that their presence—both physical and written—in legislative halls represented a moral right to influence the public without risking a descent to what Chapman called "the dirty work of designing political partizans."[28] "What is implied in petitioning the United States government?" asked abolitionist and nonresistant Henry Wright. "*Not* that you are a part of that government. . . . To petition it, to remonstrate with it or memorialize it, does not imply that we are a part of it, in any such sense." Through petitioning, that "natural resource of the weak," women sought political access and obtained significant political favors in a manner that generally excited little public attention. Petitions from women flooded both Congress and state legislatures in the 1830s and 1840s, since, as Elizabeth Cady Stanton recalled, "it was only through petitions, a power seemingly so inefficient, that disfranchised classes could

27. Lucretia Mott to Elizabeth Pease, 18 February 1841, in Anna Davis Hallowell, ed., *James and Lucretia Mott: Life and Letters* (Boston: Houghton, Mifflin, 1884), pp. 194–95; Wright to Weld, 19 May 1836, in Barnes and Dumond, *Weld-Grimké Letters,* 1:305.

28. The Chapman quotation is from B.F.A.S.S., *Ten Years of Experience,* p. 17. See Ronald G. Walters, *The Antislavery Appeal: American Abolitionism after 1830* (Baltimore: Johns Hopkins University Press, 1976), p. 24, on the appeal of abolition to what he terms the "moral part of the nation."

be heard in the national councils, hence their importance."[29] Large numbers of women and men petitioned against laws that distinguished between the races, against liquor sales, for making seduction a criminal offense, for regulations of prisons, asylums, and "homes," for changes in property laws, and, of course, for restrictions on slavery.[30] Whereas more conservative benevolent women directed their pleas for funds and status mainly to municipal and state governments, ultraist women, who petitioned on behalf of controversial principles, brought their demands to the state and federal legislatures, reflecting both the mass nature of the cause and their own relative lack of access to local politicians, who, they noted self-righteously, chose to win elections rather than support moral causes. Their petitions represented organizational drives in which the people who signed their names were often unacquainted with one another—and nearly always unfamiliar with the politicians themselves. Increasingly, middle-class women sought to influence strangers. Like the men of their class or cause, they hoped to achieve by their numbers a political impact that they lacked through connections with the men in authority.

For both moral reformers and abolitionists, acquiring this impact in the form of signatures on petitions, such as raising funds for an organization's coffers, was frustrating, the "most odious of all tasks" according to Lydia Maria Child. "I never undertook anything that was so entirely distasteful to me," grumbled Sarah Pugh. The *Advocate of Moral Reform,* urging women to further exertions, sympathized with the "sacrifice of feeling . . . demanded in obtaining signatures"—especially if the petition sought an unpopular goal. Maria Weston Chapman, too, re-

29. *Non-Resistant* 2:5 (11 March 1840): 18–19; *Advocate* 4:22 (15 November 1838): 173; Stanton et al., *History of Woman Suffrage,* 1:461. On petitioning generally as well as on women's early involvement see Raymond C. Bailey, *Popular Influence upon Public Policy: Petitioning in Eighteenth-Century Virginia* (Westport, Conn.: Greenwood Press, 1979).

30. The journals of the various state legislatures list all the petitions brought before their houses, as well as what actions were taken. For example, on New Yorkers' petitions against laws that distinguished between the races (all of which were tabled), see *Journal of the Assembly of the State of New-York* (Albany, 1838), 61st session, 18 April 1838, p. 1101. The following January session read and referred to committees the "petition of sundry inhabitants, male and female. . . , praying for legislative action in suppressing the crying evils of intemperance," as well as one from "ninety two legal voters and seventy six ladies of the County of Clinton": New York, *Journal of the Assembly* (Albany, 1839), 62nd session, 2 January 1839, p. 39; 8 January 1839; 16 February 1839, p. 143. Numerous petitions were brought to state legislatures against the gag rule. See e.g., New York, *Journal of the Assembly,* 61st session, 19 March 1838, p. 638.

called with a pang the early days of antislavery organizing, when women "overcame the reluctant pain of accosting the hostile circles in our neighbors' drawing rooms with anti-slavery petitions."[31]

The size, scope, and organizational impact of the massive abolition petition campaigns from 1835 through the 1840s made them the single most effective tool in grassroots organizing among women, and attacks against them were significant in building further antislavery sentiment. In 1838 alone the American Anti-Slavery Society sent four hundred thousand names on petitions to Congress. Within two years, according to James Freeman Clarke, more than two million signatures were sent. In addition, historian Gerda Lerner has estimated that 70 percent of the petitions' signers in 1838 were women.[32]

Even as they insisted on the essential purity of their own political activities, however, ultraists struggled with their relationship to politics in a far more self-conscious way than more conservative women would have considered. For traditional charity workers, the rhetoric of female benevolence served both to gain and to obscure access to politicians and seemed to generate little, if any, self-examination. In contrast, for a brief but intense period, while political life and loyalties were in tremendous flux, the most radical groups of middle-class women in the antebellum period articulated a radical nonvoting position that grappled both with the meaning of politics and with the conflation of morality and femininity. By definition, being voteless and, in theory, nonpartisan was part of their vision for the moral transformation of American society. Although female abolitionists recognized that some women were indeed effective in making themselves heard by politicians, they believed that changes brought about by electoral means were shortsighted and ultimately counterproductive: only moral change was absolute. For them, the

31. Lydia Maria Child to Henrietta Sargent, 18 November 1838, in Milton Meltzer and Patricia G. Holland, eds., *Lydia Maria Child: Selected Letters, 1817–1880* (Amherst: University of Massachusetts Press, 1982), p. 93; diary, 31 December 1839, *Memorial of Sarah Pugh,* p. 22; *Advocate* 4:22 (15 November 1838): 173; B.F.A.S.S., "Right and Wrong in the Anti-Slavery Societies: Seventh Annual Report of the B.F.A.S.S.," in the *National Anti-Slavery Standard,* (29 October 1840): 81.

32. James Freeman Clarke, *Anti-Slavery Days* (New York: J. W. Lovell, 1883), p. 37 (these figures involve a good deal of guesswork, since many of the petitions were never unsealed by Congress); Gerda Lerner, "The Political Activities of Antislavery Women," in *The Majority Finds Its Past: Placing Women in History* (New York: Oxford University Press, 1979), pp. 112–28 (her statistics of the percentage of signatures that were women's appear on p. 126). See also Walters, *Antislavery Appeal,* p. 4, and Gerda Lerner, *The Grimké Sisters of South Carolina: Pioneers for Women's Rights and Abolition* (New York: Schocken Books, 1971), p. 275.

adoption of practical means for change represented a retreat from principle itself. Making a virtue out of necessity, ultraist women embraced a principled "no-government" position—one that permitted, they believed, activism on behalf of the highest moral standard in American life.[33]

Understanding ultraist women's struggle to define their relationship to the state also helps explain the appeal to many of them of the ideology of nonresistance, the radical Garrisonian analysis of non-collaboration with a government based on force. The attractiveness of the belief in nonresistance went beyond women's alleged affinity for pacifism. For nonresistants did not simply reject violent means; they opposed any allegiance to earthly governments, which, they claimed, "are sustained by violence." Central to their pledge of noncollaboration with the state, nonresistants were not to vote. Whoever exercises the right of voting, declared the newspaper, the *Non-Resistant,* "actually consents to be vested with all the powers which the constitution bestows on Congress. He declares . . . that he possesses power of life and death over man, and has the right of an armed and bloody resistance to evil." Engagement in electoral politics signaled collaboration in bloodshed. "All preparations for war, in this nation, are begun at the ballot-box," explained Henry Wright. "Voting is the first step; . . . a bullet is in every ballot."[34]

This nonvoting position held potentially radical implications for the structuring of political power in the United States. Although the elevation of the female ideal did not give more authority to women, it did put abstract power into the hands of the relatively powerless and thus might have redefined the focus of social change. Moreover, by adopting this view, ultraist women reacted against the traditional informal political privileges of more elite and conservative women.[35]

33. On Garrisonian analysis of politics compared to that of other activists see Bertram Wyatt-Brown, *Lewis Tappan and the Evangelical War against Slavery* (Cleveland: Press of Case Western Reserve University, 1969), pp. 269–76; Aileen S. Kraditor, *Means and Ends in American Abolition: Garrison and His Critics on Strategy and Tactics, 1834–50* (New York: Vintage Books, 1967); and James Brewer Stewart, *Holy Warriors: The Abolitionists and American Slavery* (New York: Hill and Wang, 1976).

34. Declaration of Sentiments Adopted by the Oberlin Non-Resistance Society, *Non-Resistant* 2:17 (9 September 1840): 65; "Can a Non-Resistant Consistently Vote for a Member of Congress . . . ?" ibid. 2:4 (26 February 1840): 15; Henry C. Wright, quoted in Peter Brock, *Pacifism in the United States from the Colonial Era to the First World War* (Princeton: Princeton University Press, 1968), p. 600.

35. Immediatist abolitionism had emerged in part from a sense of frustration with political means for eradicating slavery, abolitionists arguing that "it is now an opinion, supported by

Yet the radical implications of abolitionists' nonvoting position—and of female means for social change—were steadily eroded by the very historical context which had allowed them to develop that analysis. For as the significance of voting grew, so did the significance of votelessness—especially for those who lacked access through class and economic privilege and whose goals seemed to preclude legislative victory. Female abolitionists in particular recognized that the debate over moral versus political means had serious consequences for their own work.

Even as they articulated a no-government position, female ultraists, having little to lose in terms of social prestige and the privileges of "benevolent femininity," were more willing to label their own and other women's influence political. Angelina Grimké questioned neither women's right to petition nor that it was a political tool. "As to [women's] ever becoming partisans, i.e. sacrificing principles to power or interest," she wrote Catharine Beecher, "I reprobate this under all circumstances, and in *both* sexes." But, she continued, not all political activity involved such a sacrifice, and she hoped "my sisters may always be permitted to *petition* for a redress of grievances. . . . The right of petition," Grimké insisted, "is the only political right that women have: why not let them exercise it whenever they are aggrieved?"³⁶ Soon after, Grimké became the first woman to address an open hearing of a state legislature, in a speech that Lydia Child called "a spectacle of the greatest moral sublimity I ever witnessed." There Grimké made clear that the ideological distinction between morality and politics obscured women's interest in the antislavery cause:

> I stand before you as a citizen [Grimké proclaimed boldly], on behalf of the 20,000 women of Massachusetts, whose names are enrolled on petitions [against slavery]. . . . American women have to do with this subject, not only because it is moral and religious, but because it is *political,* inasmuch as we are citizens of this republic, and as such, *our* honor, happiness,

the Bible, that slavery is a sin, a *moral* evil": New Hampshire Anti-Slavery Convention, *Proceedings of the New Hampshire Anti-Slavery Convention, Held in Concord, on the 11th & 12th of November, 1834* (Concord, N.H.: Eastman, Webster, 1834), p. 13. Gerrit Smith, who later entered Congress, insisted in 1836 that "the fact, that the Constitution does not clothe us with *political* power to abolish slavery is no . . . reason why we may not exert a *moral* power to this end": American Anti-Slavery Society, *Third Annual Report* (New York: William S. Dorr, 1836), p. 13.

36. Angelina Grimké, *Letters to Catharine E. Beecher, in Reply to an Essay on Slavery and Abolitionism, Addressed to A. E. Grimké* (Boston: Isaac Knapp, 1838), pp. 111–12.

and well being, are bound up in its politics, government and
laws.[37]

Grimké sought to maintain an inclusive definition of politics that would
recognize women's participation and interest in social change but pre-
vent their—and men's—"descent" to electoral goals. Thus ultraists
were the group both most willing to label women's political work as
such and least willing to accept a definition of politics that would se-
riously restrict their participation.

Within a short time, however, the conflict between a moral stance
and the increasingly electoral—and partisan—nature of reform forced
ultraist women to choose between loyalty to the ideology of female
benevolence and an approach to social change more in keeping with the
times. Different conceptions among benevolent women in the 1830s of
the relative importance of maintaining a moral voice and acquiring new
forms of political influence foreshadowed larger rifts between more
radical activists and evangelically minded women both in the abolition-
ist movement and throughout the century.[38]

In 1839 the Massachusetts Anti-Slavery Society and a year later
the American Anti-Slavery Society split apart over two related issues:
whether to encourage (male) members to vote in local and federal elec-
tions and whether to accept women as members of mixed antislavery
committees. Not coincidentally, those male abolitionists who agitated
for moral actions and disdained electoral results appealed most actively
to women. Influenced by female-style activism, these men also advo-
cated a more visible role for women within mixed organizations.[39]
However, those men who turned increasingly to electoral work in the
1840s forced their female co-workers to examine more closely their own
access to those in authority and the continuing viability of a nonvoting

37. Lydia Maria Child to Esther Carpenter, 20 March 1838, in Meltzer and Holland,
*Child: Selected Letters,* p. 72. Text of speech in Maria Weston Chapman's report to the *Liberator,*
2 March 2838, p. 35. On the event see Grimké to Theodore Dwight Weld, 11 February 1838,
in Barnes and Dumond, *Weld-Grimké Letters,* 2:538–39; David Lee Child to Grimké, 12
February 1838, in ibid. 2:544; and Lerner, *Grimké Sisters,* pp. 1–12. See also the following,
both of which are in Barnes and Dumond, *Weld-Grimké Letters*: Sarah Grimké to Theodore
Dwight Weld, 16 February 1838, 2:552, and Angelina Grimké to Sarah M. Douglass, 25
February 1838, 2:572–75.

38. For one interpretation of this split see Amy Swerdlow, "Abolition's Conservative
Sisters: The Ladies' New York City Anti-Slavery Societies, 1834–40," paper presented at the
3rd Berkshire Conference on the History of Women, Bryn Mawr College, 9–11 June 1976.

39. For an intriguing interpretation of the relationship between abolitionism and mas-
culinity, see Friedman, *Gregarious Saints,* chap. 5.

stance. Purity, which had once seemed so clearly identified with female power, might in fact lead to powerlessness.

The full story of the manipulations and alliances resulting from the schism in the American Anti-Slavery Society can be found elsewhere, but it is worth recounting here the steps that led many ultraist women to a reassessment of nonvoting.[40] The Garrison faction, which dominated the Massachusetts Anti-Slavery Society, contained a large proportion of women and consistently resisted any effort to consider voting a duty or to form an antislavery party; its 1839 annual report pointed out that if the organization became electoral, "[nonvoting] men, . . . (and all the women, likewise, who are prohibited from voting,) would probably be excluded," thus weakening the movement's "moral force."[41] These ultraists also fought efforts on the part of some male abolitionists, including Lewis Tappan, to exclude women, most of whom opposed both electoral participation and clerical decrees, from voting on organizational issues. At the 1839 Massachusetts Anti-Slavery Society annual meeting, the Garrisonians narrowly won a vote that formally endorsed the practice of women's admission, a practice that had been long-standing in the parent society; no woman voted against her own participation.[42] The *Massachusetts Abolitionist,* an anti-Garrison paper edited by Elizur Wright, claimed indifference to the issue of woman's rights but could not resist predicting that the women who had voted, "if left to their own reflections, *will be ashamed of what they have done.*"[43]

40. See Kraditor, *Means and Ends,* especially on politics, pp. 119–36; Friedman, *Gregarious Saints,* contains a fascinating analysis of the different antislavery cliques; see also Walters, *Antislavery Appeal,* pp. 3–18. For partisan summaries of the dispute see Lydia Maria Child to William Lloyd Garrison, 2 September 1839, in Meltzer and Holland, *Child: Selected Letters,* pp. 119–24, and Samuel May to Mary Carpenter, 28 October 1844, in Clare Taylor, ed., *British and American Abolitionists: An Episode in Transatlantic Understanding* (Edinburgh: Edinburgh University Press, 1974), pp. 227–30. See also the debate between Birney and Garrison that took place in *Emancipator* and *Liberator* during the dispute.

41. Massachusetts Anti-Slavery Society, *Seventh Annual Report of the Board of Managers* (Boston, 1839), p. 25. See Garrison to *Emancipator,* 31 May 1839, in Ruchames, *A House Dividing against Itself,* 2:467–69.

42. M.A.S.S., *Seventh Annual Report,* pp. 31–38, and the "Proceedings" at the back of the *Report.* See Wyatt-Brown, *Lewis Tappan,* pp. 192–94, on Tappan's role.

43. Quoted in M.A.S.S., *Eighth Annual Report of the Board of Managers* (Boston, 1840), pp. 13–14. Wright himself, interestingly, seemed to hold more complicated views. In a letter marked "confidential," he wrote in 1837: "The day this American A.S. Society refuses to employ well qualified agents to address all who will hear, *because they are women,* I for one shall leave it. If the sects can't bear women's preaching, let them stay away" (to "Brother" [Amos] Phelps, 5 September 1837). Less than a year later, he was convinced that the whole "Woman question" was "*ridiculous*" but added that he was "disposed to give the *women People* all the rope they have a mind to take" (to "Brother" [Amos] Phelps, 11 July 1838). Phelps did not

By the annual meeting of 1840, the American Anti-Slavery Society was divided over the issues that had split the Massachusetts branch. The appointment of Garrisonian Abby Kelley to the business committee served as the excuse for triggering a crisis. The approximately 450 delegates from Massachusetts included about 100 women, who accounted for the margin in the vote to accept Kelley on the committee. Of the 1,000 abolitionists who attended the meeting, 300—led primarily by a "few clerical gentlemen"—withdrew and formed the American and Foreign Anti-Slavery Society; most of these men eventually participated in the Liberty party, the antislavery party founded in 1840.[44] Although several of the seceders had earlier supported women's prominent activity, propriety now served as their excuse for opposing Garrison. "Few were stodgier than Lewis Tappan," writes Ronald Walters, "who stalked out of the American Anti-Slavery Society upon Abby Kelley's election, declaring it immoral for women to be in closed meetings with men."[45] But Tappan himself had urged Lydia Maria Child to speak before a "promiscuous audience" in the fall of 1836. Indeed, he opened a speech against women's full membership in the society by stating that he had "long been in favor of Woman's Rights." His colleague in secession, Alanson St. Clair, had, at a different meeting, solicited Child's vote on a particular issue. Both men had participated in benevolent activities in which women played leadership roles. "Never did more barefaced, shameless *Hypocrisy* exist!" fumed Samuel May several years after the schism. "Those very men . . . had drawn up and signed papers commissioning Sarah and Angelina Grimké as public agents and lecturers."[46]

---

think Wright was considering the issue with appropriate seriousness (Phelps to Wright, 2 August 1838); several weeks later Wright wrote that he considered it "contrary to nature, propriety and the gospel for women . . . to assume equality with men." However, he added, with a modesty not characteristic of abolitionists, "Still I do not feel called upon to set up for executioner of the laws of nature" (17 August 1838). All letters are in Wright.

44. Dwight L. Dumond, *Antislavery: The Crusade for Freedom in America* (Ann Arbor: University of Michigan Press, 1966), p. 285, says there were 464 Massachusetts delegates; Keith E. Melder, *Beginnings of Sisterhood: The American Woman's Movement, 1800–1850* (New York: Schocken Books, 1977), p. 110, says 449. There is a reference to "a few clerical gentlemen" in Garrison, "To the Abolitionists of Massachusetts," 17 July 1839, in Ruchames, *A House Dividing against Itself,* 2:503.

45. Walters, *Antislavery Appeal,* p. 11. Garrison remarked somewhat slyly that the seceders, as members of the American Anti-Slavery Society, had participated in an organization that had women on committees, although the Massachusetts Society had not: "To the Abolitionists of Massachusetts," in Ruchames, *A House Dividing against Itself,* 2:505.

46. Lydia Maria Child to *Liberator* [before 6 March 1840], in Meltzer and Holland, *Child: Selected Letters,* p. 128; Lewis Tappan diary, 8 May 1839, Tappan; Samuel May to Mary Carpenter, 28 October 1844, in Taylor, *British and American Abolitionists,* p. 229. These men continued to be involved in benevolent endeavors led by women, especially the moral reform

The timing of the debate about woman's rights reflected a broad power struggle within the organization. "New organizationists," who advocated electoral action and eventually the formation of a third party, knew full well that the woman question "affected distribution of power within the antislavery movement," since a majority of female activists supported Garrison's no-government policies. For a brief moment, the outcome of that struggle was held in suspension. When in 1840 Mott, Child, and Chapman were elected to the newly constituted executive committee of the American Anti-Slavery Society, their selection signified both a woman's rights and a radical nonvoting stance in the organization. Political abolitionists who supported voting and church-oriented abolitionists who used the issue of women's visibility to limit the movement's radicalism thus allied, using the language of morality and femininity in their own behalf. Women such as Juliana Tappan, appealed to on the basis of femininity and moral suasion, joined these abolitionists briefly in their efforts. They soon moved on to other benevolent causes (or, in Tappan's case, disappeared entirely), as the concerns of electoral antislavery excluded them from the movement's central endeavors.[47]

Elizabeth Cady Stanton began her abolitionist career at the time of the antislavery schism, when she married Henry Brewster Stanton, one of the American Anti-Slavery Society's most promising agents.[48] In 1837, Henry Stanton had urged a convention of abolitionists to petition, hoping to "shake every Legislature to its centre, with discussion." Within two years, frustrated with the limits of petitions' influence, he had joined those who favored a third party; nevertheless, at the 1840 London convention he made "a very eloquent speech in favor of admitting the women delegates."[49] Elizabeth Cady Stanton sailed to that conven-

---

movement. See, e.g., New England Female Moral Reform Society, "Eighth Annual Report," in *Friend of Virtue,* 1 July 1846. Lewis Tappan lay the cornerstone for the society's new building in May 1848; his second wife, Sarah Jackson Tappan, became a member of the board of directors in 1854. See Northrup, *Record of a Century,* pp. 31–32, and Brown, *Our Golden Jubilee,* p. 77.

47. Walters, *Antislavery Appeal,* p. 12. According to Hewitt, some "perfectionist" women virtually disappeared after the controversy over their public speaking: *Women's Activism,* pp. 120–27. The distinction between political and church-oriented abolitionists was far from absolute. See John R. McKivigan, *The War against Proslavery Religion: Abolitionism and the Northern Churches, 1830–1865* (Ithaca: Cornell University Press, 1984).

48. On Stanton see her *Eighty Years and More: Reminiscences, 1815–1897* (New York: Schocken Books, 1971; orig. 1898).

49. New England Fourth Anti-Slavery Convention, *Proceedings* (Boston: Isaac Knapp, 1837), p. 42; Stanton, *Eighty Years,* p. 79. Clearly disappointed, Lucretia Mott remarked that Henry, despite his support of the female delegates, was "not so strong in confidence in moral

tion with Henry and his co-workers. She recalled that she soon found herself in the anomalous position of being "the only lady present who represented the 'Birney faction,' though I really knew nothing of the merits of the division. . . . I soon found that the pending battle was on woman's rights, and that, unwittingly, I was by marriage on the wrong side." In spite of Henry's "eloquent speech" on behalf of the women delegates, the apparent choice for abolitionists in 1840 was simple: one sided either with electoral action or with woman's rights. It was immediately clear to Stanton why no other women were associated with the "new organization" of her husband. "I found myself in full accord with the other ladies," she recalled.[50]

Stanton was not, however, really on the wrong side of the antislavery controversy, nor did she wholly sympathize with the other "ladies." Throughout the antislavery campaign she, in rare accord with Henry, refused to forswear the use of more "efficient" political tools than moral suasion. In some ways she was as confused as Juliana Tappan in her allegiances. No organization represented her emerging commitments to both woman's rights and political action; not until 1848 did she locate herself at the head of those who advocated full political rights for women.

In the meantime, Elizabeth and Henry began to move in opposing directions within the antislavery movement, in accordance less perhaps with their beliefs than with their interests. "[Lizzy Stanton] attended & *joined* the Mass. soc. while Henry was not visible at all! . . . " gloated abolitionist Elizabeth Neall in 1843. "How she & Henry must differ in their notions of things."[51] Yet unlike the ultraists with whom she worked, Elizabeth Stanton was not fully convinced that "moral sua-

power as desirable": diary, 20 June 1840, in Hallowell, *Mott Letters,* p. 158. She continued to believe, however, that Henry was never quite a "new organizationist" and "ought to . . . return to [his] first love": Mott to Richard D. Webb, 2 April 1841, Hallowell, *Mott Letters,* p. 211. See also Mott to Richard and Hannah Webb, 25 February 1842, in ibid., p. 228. Following the "Pastoral Letter" he warned Elizur Wright not to publish anything in his newspaper disapproving of the Grimkés' work: Angelina Grimké to Jane Smith, quoted in Catherine H. Birney, *Sarah and Angelina Grimké: The First Women Advocates of Abolition and Woman's Rights* (Boston: Lee and Shepard, 1885; repr. St. Clair Shores, Mich.: Scholarly Press, 1970), p. 187.

50. Stanton quoted in Hallowell, *Mott Letters,* pp. 185–86. James G. Birney was the Liberty party candidate for president of the United States in 1840.

51. Neall went on to note that the Chapmans and Westons had avoided meeting Elizabeth "because of their aversion to coming in contact with Henry": Elizabeth Neall [Gay] to Abby Kimber, 27 March 1843. On 11 December 1841 Neall marveled that the Stantons did not "pick each other's eyes out" and called Henry's behavior toward Elizabeth "abominable." Both are in box 1, Sydney Howard Gay Papers, Rare Book and Manuscript Library, Columbia University.

sion" would end slavery or any other injustice; in seeking an alliance with a pro-woman's rights position, she had for the time being to choose moral suasion as the means for change.

That her allegiance to moral suasion would be temporary was indicated in a remarkable letter to British abolitionist Elizabeth Pease written one year before Stanton joined the "old organization." "Well, then . . . I am not yet fully converted to the doctrine of no human government," Stanton asserted boldly. "I am in favour of political action, & the organization of a third party as the most efficient way of calling forth & directing action. . . . By organization we show our force," she insisted, noting that a third party would organize masses of people to hear antislavery views.[52]

Stanton, in essence, challenged the ultraist conviction that only by maintaining the moral nature of the movement could women exert an influence equal to that of men. Certainly many other reform women were beginning to recognize the growing efficacy of electoral politics as well as the increasing inadequacy of older forms of influence. Unlike most of her co-workers, however, Stanton, who was not burdened by a commitment to evangelical religion, also affirmed that the supposed separation of morality from politics was as tenuous as that of a female from a male sphere and thus dissociated womanhood from the rhetoric of purely moral concerns. Never one to shy away from the implications of her own conclusions and unwilling to choose woman's rights at the expense of political power, Stanton boldly sought to forge a new position about women's relationship to the state, ultimately adding to the demands of the 1848 Seneca Falls Convention that of woman's suffrage.

Most abolitionist women hesitated to accept, as Stanton did, that the increasing centrality of electoral action carried important implications for all moral efforts, especially those of women. Adhering to the terms of antebellum benevolence, many women believed that they could maintain and invoke political identities and interests only if they held fast to the language of their own purely moral influence. They feared that ultraists who dismissed church decrees about women would limit the moral force that as women they were to exert, and would threaten the privileges which accrued from traditional loyalties. Both new and old organizationists, however, recognized that an organization based on strictly partisan goals seriously undermined women's participation and the centrality of so-called female values in the movement itself.

52. Elizabeth Cady Stanton to Elizabeth Pease, 12 February 1842, vol. 12.2, p. 26, Antislavery.

•  *"Hot Conflict with the Political Demon"*  •

For these reasons, the schism within the Boston Female Anti-Slavery Society was particularly bitter: Lydia Maria Child thought its meetings "painful and disgusting." Certainly Maria Weston Chapman's ardent defense of the organization's purity did not encourage compromise. "Let us prepare ourselves . . . to maintain our lofty and influential position to the last . . . ," she wrote dramatically. "Utter abnegation of self,—this is the armor in which we may pass unheeding through the shafts of malignant misrepresentation and opposition and treachery." In turn, Martha V. Ball, soon to become a new organization agent, complained that the "no-government friends'" consciences had gotten out of hand, encouraging them to carry "their *peculiar* views along with them IN THE ANTI-SLAVERY CAR"; she found them simply too "annoying" to work with any longer.[53] There was probably more than a grain of truth in this remark, although Ball seems to have been an unpleasant and difficult character in her own right who finally faded into more cautious activity in the New England Female Moral Reform Society.[54]

The bitterness of this schism reflected interests held by antislavery women. By emphasizing the vote, new organizationists both excluded women from their main constituency and denigrated the very means of change that women were supposed to represent. However much Chapman believed that women could "spend our strength in partizanship," the fact remained—and grew increasingly burdensome—that women played a more central role under the terms of moral change than they could in partisan politics. Confronted with a political system in which electoral organization was gaining in importance, ultraist women were caught in an increasingly anachronistic defense of moral change; not yet fully prepared to transcend their allegiance to a female activism based on moral suasion, they focused instead on the numerous inconsistencies of others. "Men so suddenly and so preposterously deferential to usages will soon be silent on this head," Chapman warned those who opposed women's full participation. "They have submitted in silence to see

53. Lydia Maria Child to Lydia B. Child, 12 December 1839, in Meltzer and Holland, *Child: Selected Letters,* p. 125; B.F.A.S.S., "Seventh Annual Report"; Ball to Elizabeth Pease, 6 May 1840, quoted in ibid.

54. Lydia Maria Child could not believe the reports about Martha and Lucy Ball that Chapman was circulating. "It was easier for me to think [Chapman] somewhat blinded by her zeal," she wrote, "than it was to believe they were deliberately carrying two faces." Attendance at a B.F.A.S.S. meeting convinced her that Chapman, although zealous, was not exaggerating: Child to Lydia B. Child, 12 December 1839, in Meltzer and Holland, *Child: Selected Letters,* pp. 125–26. See, e.g., [M——C——] to Debora Weston, 26 July 1840, vol. 13, no. 109, and Anne Weston to Debora Weston, 15 December 1839, vol. 12, no. 118, Antislavery.

'women on committees' in other enterprises, and . . . feel no call to proscribe the 'mixed commissions' " involved in more conventional activity. Attacks against women's activity as political were, in Chapman's phrase, "a mere fallacy," obscuring what she saw as her opponents' partisan ambitions.[55] "We are in hot conflict with the political demon," she exclaimed to Elizabeth Pease, charging that those who favored third-party antislavery nominations for political office were outsiders who wanted to undermine the movement. The new organization people, reported Lydia Maria Child, "are resorting to all manner of management and trickery, taking ground on false issues, shifting ground, when that on which they stand is too obviously hollow, &c."[56] Female ultraists tried to assert their own claim to the terms of "benevolent womanhood" when they avoided associating with people they saw as partisan—or unprincipled—advocates of the moral cause.[57]

While abolitionists argued over the benefits of electoral action to their cause, their demands triggered angry debates over the propriety of petitions from women that had rarely been raised when more conservative women sought funds, status, and legal rulings—debates that revealed the full conservative implications of the ideology of female benevolence. Although moral reformers were occasionally subjected to "those licentious insinuations with which . . . legislative bodies never fail to greet petitions from women, upon the subject of marriage, or of crimes against their sex," legislators were somewhat more willing to view women's concerns about male sexual behavior through the prism of "domestic," rather than political, interest. In 1842, when 1,044 women petitioned the Ohio state legislature for laws punishing adultery, a legislative committee warned fellow legislators that "no question about

55. B.F.A.S.S., "Seventh Annual Report"; B.F.A.S.S., *Report* (Boston, 1836), p. 47. The cry of women's partisanship was "only an evasion," insisted Chapman in the same report, "raised by those who know the power of the weapons we wield" (p. 78).

56. Maria Weston Chapman to Elizabeth Pease, 16 March 1840, in Taylor, *British and American Abolitionists,* p. 89; Lydia Maria Child to Abby Hopper Gibbons, n.d., in Sarah Hopper Emerson, ed., *Life of Abby Hopper Gibbons Told Chiefly through Her Correspondence* (New York: G. P. Putnam's Sons, 1897), 1:94.

57. Samuel May agreed that some of the new organization abolitionists were politically ambitious; he also suspected them of being unwilling to carry their true beliefs into the churches. "The 'Liberty Party,' " he wrote several years later, "is employed mostly as a cover for those who dare not, or will not, carry their Anti-slavery into their Churches and *religious* bodies. . . . They rely too [much] on political power, and comparatively neglect *moral*": May to Mary Carpenter, 28 October 1844, in Taylor, *British and American Abolitionists,* p. 230. For a pained response to the hostility of the split, see Theodore D. Weld to Gerrit Smith, 23 October 1839, in Barnes and Dumond, *Weld-Grimké Letters,* 2:810.

the propriety of the interference of women in these affairs will justify the slightest levity toward the petitioners."[58]

Faced with abolitionist petitions, however, congressional representatives were less circumspect; unwilling to debate slavery itself, they resorted to the time-honored practice of hurling contempt at the advocates of a radical cause. "Nature seems to have given to the male sex the exclusive powers of Government, by giving to that sex the physical strength and energy which the exercise of those powers calls into constant and active exertion," asserted Senator Benjamin Tappan of Ohio, omitting to list the physical powers that he had most recently been called upon to exert. Because of women's "more delicate physical organization," Tappan refused to "recognize the right of my fair countrywomen to interfere with public affairs." He therefore "decline[d] presenting [their] petitions to the Senate."[59] Attacks that made use of sexual stereotyping distracted from the business at hand, but they were effective, forcing activists to defend the propriety of female involvement in their cause—and, thus, the morality of the cause itself.

Senators knew no better than their constituents what precisely constituted the issues from which women should be excluded. Representative Howard, for example, asserted that women shamed themselves and their nation by petitioning Congress on political matters, implying that they retained the right to petition on matters that were not political. "Why, sir," exclaimed John Quincy Adams, "what does the gentleman understand by 'political subjects?' Every thing in which this House has an agency—every thing which relates to peace and relates to war, or to any other of the great interests of society, is a political subject. Are women to have no opinions or actions on subjects relating to the general welfare?"[60]

58. *Advocate of Moral Reform* 6:5 (1 March 1840): 34; *Oberlin Evangelist,* quoted in *Friend of Virtue* 5:21 (1 November 1842): 323–24.

59. [Benjamin Tappan], *Remarks of Mr. [Benjamin] Tappan, of Ohio, on Abolition Petitions, Delivered in Senate, February 4, 1840* ([Washington, D.C.?], 1840), p. 4. He was Lewis and Arthur's brother, a Democrat and nonabolitionist: Wyatt-Brown, *Lewis Tappan,* pp. 277–78. Passed in 1836, the so-called gag rule tabled all petitions having to do with slavery. Those who fought the rule year after year, most notably John Quincy Adams, brought thousands of signatures to the House, introduced them formally, and lay them on the table, where many of them literally remain unopened to this day. In February 1836, the House tried to expel and then censure Adams himself. For a summary of the events surrounding the gag rule, see Clarke, *Anti-Slavery Days,* pp. 41–60. See also John Quincy Adams, *Letters from John Quincy Adams to His Constituents* (Boston: Isaac Knapp, 1837).

60. John Quincy Adams, *Speech of John Quincy Adams of Massachusetts, upon the Right of the People, Men and Women, to Petition* (Washington, D.C.: Gales and Seaton, 1838), pp. 65–66.

Not surprisingly, those who concerned themselves with electoral results rarely spoke of women as full citizens. In defending the propriety of petitions from women, John Quincy Adams stopped short of asserting any direct responsibility on his part to accede to their demands. Rather, he established his link to them through voters: "Every one of [these petitions'] signers is, I presume, a mother, a wife, a daughter, or a sister of some constituents of mine." The Boston Female Anti-Slavery Society, in contrast, defined women's relationship to the state in more precise and direct terms. In an 1838 "Address to the Women of New England," these abolitionists insisted that the United States Congress would limit slavery if Northern representatives knew the wishes of their constituents. "Who are their constituents?" the circular demanded. "YOU: women of the North! Remember that the representation of our country is based on the numbers of the population, irrespective of sex. . . . In vain it is said, this is nothing to us. Have we not a COUNTRY?" The circular insisted that women held the key to Congress' acting on the issue: "We are upholding slavery in the most effectual manner, if we keep silence." Ultimately these activists were not concerned with theorizing about citizenship, and the leaflet ended on a characteristic note of realism: "Let every woman in whose hands this page falls, INSTANTLY, (for the work must be done before the extra September session,) prepare four rolls of paper, and attach one to each of the annexed form of petition; and with pen and ink-horn in hand, and armed with affectionate, but unconquerable determination, go from door to door 'among her own people.'" "Although we are *women, we* still are citizens," proclaimed the Philadelphia Female Anti-Slavery Society in 1836.[61]

The growing association of politics with voting suggested the dangers for women's political identities and actions of a strict, if theoretical, separation of politics from morality. During the controversy in Congress over antislavery petitions, Whig writer Calvin Colton wrote a pamphlet entitled *The Right of Petition*. The pamphlet inadvertently set forth both a defense of women's petitions and an argument about their ultimate inadequacy. Colton denied the right of "religionists" "to employ political agencies for a moral reformation," namely, abolishing slavery.[62] He left no doubt that petitions were political, not moral, means.

61. Adams, *Right of Petition,* p. 65; B.F.A.S.S., *Address of the Boston Female Anti-Slavery Society to the Women of New England* (Boston, 1837); Philadelphia Female Anti-Slavery Society, *Address . . . to the Women of Pennsylvania* (Philadelphia: Merrihew and Gunn, 1836), p. 5. In her speech to the Massachusetts legislature, of course, Grimké too had referred to women as citizens.

62. Calvin Colton, *The Right of Petition* (n.p. [1840?]), p. 12.

Colton explained that petitions originated under monarchies, when people "had no voice in the making and administration of law." The right to petition was therefore "unalienable," "not bestowed by man, but derived from the author of our being." Petitioning had once been the only access to those in power; the act was "simply one of supplication." Now that "the people" have recourse to the polls, he continued, they should not lower themselves to "the condition of dependence on [their] own public servants," should not "stoop to petition for that which they have a right to demand." To Colton, efforts at influencing legislators represented either the action of a subject people or the efforts of a small "cabal" to impose its will by bypassing legislative decisions. The time had passed for either of these means: it was the day of majority rule. Petitioning was but "a feather in the scale" compared to the vote itself, the latter the true tool of self-respecting citizens. Petitioning, Colton asserted, signaled "a retreat from the rights of the franchise towards the submissions of a slave."[63]

With never a mention of women, Colton dismissed their principal political tool as evincing a lack of self-respect and as unworthy of a proud people. First, he reminded his readers, petitioning was merely prayer, petitions themselves subject to the whim of legislators. Second, petitioning symbolized dependence, even "the submissions of a slave." Third, Colton assumed that petitioners by definition represented a minority interest, praying for that which they did not have the numerical strength to enforce. Colton's message to women—and to those men who continued to insist on moral action—was clear; they were humiliated, groveling, and ultimately powerless. He held up the reflection of female influence in an age of electoral rule.

During the decades when voting came to predominate among political activities, activist women disagreed about their own influence, implicitly acknowledging that there were other forms of political access that were either inefficient or from which they were excluded by virtue of their class or the cause that they espoused. The debate was not merely tactical but involved efforts at understanding and resolving political changes then under way. When in 1850 fifteen hundred women petitioned the Common Council of Buffalo against the sale of liquor, the pro-suffrage *Lily* insisted: "If they had 1500 votes to give, the Common Council would no doubt open their ears, and eyes too." The Temperance Convention of women of Chester County, Pennsylvania, in

63. Ibid., pp. 1, 7, 8. Boyer, *Urban Masses,* describes Colton's fear of a "small cabal" (p. 57). Colton appears in Allen Johnson and Dumas Malone, eds., *Dictionary of American Biography* (New York: Charles Scribner's Sons, 1937), 4:320–21.

contrast, took credit for the passage of antiliquor legislation; further, the convention admonished the men of their community for saying that "we gain nothing by petitioning. Was it not through this means, we obtained the law under which a vote of a majority excluded the sale of i[n]toxicating liquors amongst us?"[64]

Whereas virtually all who invoked the language of benevolence insisted that they worked in the name of a higher morality, activists differed in their relationship to the ideological division between politics and morality as they did to that between the sexes. More conservative women claimed that the terms of moral virtue were natural to women and that only women need maintain their distance from the squabbles of political life. Yet just as the ideology of virtuous femininity did not seriously limit these women's organizational activities, so their insistence on a purely moral stance concealed the nature of their political influence. In reality, conservative women, among them the most prosperous in a community, had more access to politicians, fewer qualms about using that access, and availed themselves of governmental apparatus long before—and after—more radical women demanded the vote. It was not until after the Civil War that significant numbers of women involved in local causes would feel compelled to organize for partial suffrage. Conservative women concealed their own access to and dependence upon government with a rhetoric of female identity that maintained that women were not touched by political interest; yet for them, as for their male counterparts, politics and morality had always been closely intertwined.

Ultraist women, having fewer material and political resources than the leaders of traditional benevolent organizations, reacted in complex and contradictory ways to the political access enjoyed by conservative women, as well as to the growing use of electoral tools by men. On the one hand, new voters, new powers of the state, and the rise of machine politics increased activists' sense of the importance of electoral politics, with obvious implications for voteless women. At the same time, ultraists realized that traditional forms of access to the men in power, which continued to be available to some women, were denied the advocates of an unpopular cause. For a time, seeking to maintain the language of benevolence, ultraists insisted that men uphold a standard hitherto expected only of women; while moral reformers called for a single—female—standard of sexual behavior and temperance activists insisted

64. *Lily* 2:5 (May 1850); Stanton et al., *History of Woman Suffrage*, 1:347.

that men exert the self-control considered natural to women, abolitionists demanded that men abstain from voting.

Yet during the antebellum decades even the most passionate believers in moral suasion directed their attention to the state. Even as they advocated female models for change, some women began to recognize that their commitment to the terms of benevolent womanhood severely limited their work. Denied the access enjoyed by other women as well as the tools increasingly employed by their male co-workers, women who clung to the language of female values faced being excluded from a central position in the changing work of benevolence. If female benevolence had ever offered radical reformers a sure road to female power, that time was clearly past.

As a new generation came of age in the practical 1840s and 1850s, a different atmosphere pervaded reform movements and a new focus began to assert itself, one that was clearly established after the country had experienced a war. Benevolent women began to speak less of moral regeneration and increasingly of shortcuts to reform. Like men, they focused more and more on electoral and institutional strategies with which to accomplish the work of benevolence. For many, the results of moral suasion simply could not justify the fervor and commitment it required. Others recognized that their hopes for fundamental moral and social change were becoming less compelling, and that the apparatus of government was becoming frustratingly inaccessible to nonvoters in an age of electoral rule. For a variety of reasons, most came to agree with temperance activist Mary Vaughan, who warned in 1851 that "the effect of moral suasion upon men's habits and prejudices is daily lessening."[65]

65. *Lily* 3 (October 1851): 79.

# "Moral Suasion is Moral Balderdash"

"This is a utilitarian age," asserted a writer in the *American Temperance Magazine* in 1852. "The speculative has in all things yielded to the practical. . . . In this sense, moral suasion is moral balderdash." Writing to Paulina Wright Davis' newspaper, the *Una,* "Isola" agreed: "Fanatical philanthropy is growing cooler, and the hairbrained are becoming more practical and matter of fact." In 1848, former moral reformer Sarah Smith Martyn, who still insisted that "virtue alone is indestructible and eternal," admitted, "The day of romantic dreams and visionary philanthropy has gone by. Every thing is now in motion, and he who would stamp his impress . . . on society, must be at least a practical utilitarian."[1] By the late 1840s, all but the most ultra of reformers agreed that moral suasion had failed to transform society. Increasingly, reformers turned to electoral means and to institutional settings through which to consolidate the work of the previous decades. Abolitionism, like other benevolent movements, focused more and more narrowly on electoral activity. In 1840 the Liberty party was founded, and although it drew relatively few votes, it established an antislavery voice, or at least a whisper, within electoral politics. The Free Soil party entered the political scene in 1848 with greater strength but also with a platform

---

This chapter contains a version of Ginzberg, Lori D., "'Moral Suasion is Moral Balderdash': Women, Politics, and Social Activism in the 1850s," *Journal of American History,* 73 (December 1986): 601–22.

1. "The Maine Law vs. Moral Suasion," *American Temperance Magazine* (1852), quoted in David Brion Davis, *Antebellum American Culture: An Interpretive Anthology* (Lexington, Mass.: D. C. Heath, 1979), p. 408; *Una,* November 1854, p. 358; "The Spirit and Wants of the Age," *Ladies Wreath: An Illustrated Annual for MDCCCXLVIII-IX* (New York, 1848–49), pp. 82, 81.

that exhibited a far smaller emphasis on the moral transformation of American society.[2] The transformation of benevolent activism during the 1850s signaled both new settings for reform activity and a changed context for the moral radicalism in which women had played a central role.

The social and intellectual history of women in the 1850s contrasts sharply with that of the earlier decades: around 1850, both historical and contemporary discussion of women and of the grassroots work of abolition, charity, and other forms of benevolence ends. Biographies and autobiographies are either strangely silent about the decade or else focus almost entirely on Congress or the fluctuations in antislavery and nativist political parties. Numerous accounts of the abolitionist movement devote the entire section on the 1850s to congressional issues. The 1850s are treated as the decade one must "get through" to arrive at the Civil War.

The benevolent, of course, did not simply hold their breath in expectation of apocalypse. Like other human beings, they worked for whatever goals they espoused, held conventions, built institutions, raised children, and welcomed new faces into their movements. Yet the sense that a group of female benevolent workers "disappeared" with their reform fervor in the 1850s haunts antebellum women's history. Women were in fact less prominent in a number of activities in which they had participated fully in the earlier decades. The proportion of New York's antislavery petition signers who were women, for example, dropped from 70 percent in 1838 to 2.3 percent in 1850. Whether signaling or instigating the change, new organizationists Arthur Tappan and Joshua Leavitt proposed in 1841 that *"for the present purpose,*

2. Historians who have bothered to notice life outside the halls of Congress in the 1850s have commented on this decline in religious fervor and the turning to electoral politics. Ellen DuBois points out that the revival that the temperance movement experienced in the 1850s resulted in a "turn toward politics": DuBois, ed., *Elizabeth Cady Stanton, Susan B. Anthony: Correspondence, Writing, Speeches* (New York: Schocken Books, 1981), p. 16. Mary P. Ryan, after noting the collapse of a number of women's organizations in the mid-1840s, adds simply that "male reformers were turning away from moral persuasion into more political channels": Ryan, *Cradle of the Middle Class: The Family in Oneida County, New York, 1790–1865* (New York: Cambridge University Press, 1981), p. 142. According to Ruth Bordin, the use of legislative solutions by temperance activists in the 1850s displaced women from playing a significant role in the movement until the 1873 Woman's Crusade: *Woman and Temperance: The Quest for Power and Liberty, 1873–1900* (Philadelphia: Temple University Press, 1981), p. xvi. Jed Dannenbaum also suggests that women were indeed "left without a meaningful function to perform in the [temperance] movement" of the 1850s, as men turned to electoral means: *Drink and Disorder: Temperance Reform in Cincinnati from the Washingtonian Revival to the W.C.T.U.* (Urbana: University of Illinois Press, 1984), p. 182 and chap. 6.

... petitions should be signed by lawful voters only"; an American and Foreign Anti-Slavery Society circular called on abolitionists to "adopt prompt and systematic measures to have each legal voter called upon for his signature."[3] In many respects, the focus on electoral issues by contemporaries ensured women's invisibility; women vanish from the very categories used to discuss the final antebellum decade.

Parallel to the growing invisibility of women in movements that focused on electoral action is the dearth of detailed information about women's benevolent organizations in the 1850s. Some organizational histories simply bypass the decade entirely, occasionally remarking on the spurt of charitable activity following the depression of 1857. Many societies' published records nearly vanish, leaving the historian with an eerie sense of work halted—or postponed—in anticipation of a larger work to come.[4]

In fact, women's reform work was neither halted nor postponed during the decade of the 1850s. Rather, it was engaged in one of the most profound and wrenching shifts of its history, as middle- and upper-middle-class female reformers were at last forced to confront the changing social and political context of benevolence. In a decade of apparent silence and immobility, female activists gradually redefined not only the strategies but the most basic assumptions of their lives' work. Two trends of the 1850s both forced and shaped this transformation. First, women reformers faced a narrowing definition of political action that emphasized electoral activity instead of the traditional forms of lobbying in which women had participated. As moral suasion became a less effective call to action, ultraist women's influence declined. At the same time, more conservative benevolent activists sought to alleviate social and moral conditions by focusing more and more on benevolent institutions, often founded in close alliance with men. Both trends affected

3. Gerda Lerner, "Political Activities of Antislavery Women," in *The Majority Finds Its Past: Placing Women in History* (New York: Oxford University Press, 1979), p. 126. (Antislavery petitions doubled in number in this period.) See also "Appeal to Abolitionists and the Friends of the Constitutional Right of Petition throughout the United States," *Emancipator* 6:20 (16 September 1841): 79, and "Circular, 1850, American and Foreign Anti-Slavery Society," Misc. Mss., Manuscript Division, Library of Congress. Thomas Dublin has calculated that women comprised two-thirds of signers of petitions for the ten-hour day in Lowell in 1845; only six years later they constituted fewer than 40 percent: *Women at Work: The Transformation of Work and Community in Lowell, Massachusetts, 1826–1860* (New York: Columbia University Press, 1979), p. 201.

4. See, e.g., [Mrs.] A. F. R. Martin, comp., *A Century of Benevolence: The History of the Newark Female Charitable Society from the Date of Organization, January 31st, 1803, to January 31st, 1903* (Newark, 1903), pp. 20–22.

reformers' commitment to broad social change, for the narrower focus on elections and on institutions corresponded to a declining faith in the moral transformation of American society, a more limited, if perhaps more realistic, vision of the possibilities of benevolence. Increasingly, the benevolent sought to restrain the sins they had been unable to eradicate.

These trends clarified further the growing divergence between a commitment to charity and one to social reform. Some groups that had once sought the redemption of society through benevolent means and goals—moral reformers, for example—moved into institutional settings as the most effective route to a more limited social transformation. Other groups that had also employed the language of female benevolence, such as abolitionists and temperance activists, turned to the state for a new self-definition. As these groups looked to ever higher and more distant levels of government for aid, they distinguished and distanced themselves from the charity organizations and benevolent institutions that continued to maintain a predominantly local outlook. Ironically, both transitions, that toward the state and that toward institutions, thrived in and contributed to an atmosphere that was both more secular and more conservative and that would later seem to have been warranted by the demands of war.

Thus for women and girls just coming of age, the 1850s posed new challenges and attitudes toward societal change. In order to understand what it was like to become a benevolent activist in the 1850s (as compared, say, to the 1830s), it is necessary to untangle the many threads that connect individuals both to their generation and to their times. The intersection of two levels of change during the 1850s is especially important for an analysis of female benevolence. On the one hand, change occurred in the linear sense with which historians generally concern themselves: events took place, organizations prospered, ideas were transformed, depressions and religious revivals left their mark. On another level, people experienced these events as members of a generation, at a particular stage of life, and with a particular set of expectations about their importance.

Changes over time—foreseen or ignored, feared or celebrated—could not and did not hold the same meaning for all women. A child of twelve who attended the 1848 Seneca Falls Convention responded differently to the idea of women voting than had the hesitant ultraists who, as adults, first made the demand. If the great lecturers in an age of lyceums—Lucy Stone, Henry Ward Beecher, and Abby Kelley Foster, to name a few—affected the spirit of their age, how much more directly

did they influence the young people who heard them speak? The events that formed the context of a given period of life provided options for the individuals who became the historical figures of a later era. Bounded by the historical framework of their time, these individuals in turn created historical change.

Our concern here is not with the inner workings of the psyche. The primary issue is not why one person rather than another processed her experiences so as to arrive at one or another analysis of social ills or political change. Instead, the focus is on how a younger generation's experience of certain events molded their own organizational and intellectual history. How did the atmosphere of a time frame people's understanding of the options for the future? Did young women who witnessed the growing concern with the brick and stone of institutionalized benevolence sympathize with broader possibilities for social change? What did it mean to unenfranchised women reformers to grow up in a decade of unprecedented interest in and emphasis upon the electoral scene? What, in other words, did it mean for women that "more than in any subsequent era, political life formed the very essence of the pre-Civil War generation's experience"?[5]

The year 1848 provides as good a benchmark as any in the chronology of these changes. That year, Europe was occupied with revolutions by those who sought greater access to political systems. A little-known German writer named Karl Marx published his *Communist Manifesto*. In the United States, some antislavery Whigs discarded their old loyalties and joined the new Free Soil party. Zachary Taylor became president; Salmon Chase and Horace Mann entered the Senate. John Quincy Adams died and the Mexican War ended. In New York State, both the Married Women's Property Act and the anti-seduction bill became law, culminating years of lobbying by women who had supported the legislation. The American Female Moral Reform Society renamed itself the American Female Guardian Society, and, reversing fifteen years of nonasylum activity, founded its Home for the Friendless. In a church in Seneca Falls, a group of women and men, mainly abolitionists, launched a new movement for, among other things, woman's suffrage.

For some, these events culminated years of work and personal change. For others they were awakenings. Still other, younger women

5. William E. Gienapp, "'Politics Seem to Enter into Everything': Political Culture in the North, 1840–1860," in *Essays on American Antebellum Politics, 1840–1860,* ed. Stephen E. Maizlish and John J. Kushma (College Station: Texas A&M University Press, 1982), p. 66.

would later mark 1848 as the beginning of events that they took for granted. In 1848, Lucretia Mott was fifty-five, Elizabeth Cady Stanton thirty-three, and Louisa Lee Schuyler eleven. Abby Hopper Gibbons (born 1801), Elizabeth Buffum Chace (born 1806), and Lydia Maria Child (born 1802) observed that year and its changes from a different standpoint than did Amelia Bloomer and Sallie Holley, both born in 1818 and both far more comfortable with language that evoked explicitly electoral goals.6 Emily Howland, Abby Woolsey, and Louisa May Alcott each considered herself an abolitionist; yet they were between the ages of seven and twelve when the antislavery movement's schism occurred, signaling the decline of the movement's ultraist fervor. They were barely adults when some of the movement's leaders acknowledged the changing nature of politics by calling for suffrage for women. These young women and many others of their generation would not look upon decades of agitation for moral change as having successfully chipped away at sin; from the perspective of the 1850s, movements that called upon slaveowners to free the slaves, drunkards to reject liquor, and seducers to protect the innocent had, quite simply, failed.

Many women who later established reform careers had their training in the movements of the 1830s and 1840s, especially abolition. For young women who grew up during the height of antislavery fervor, there was much work to be done and, from a child's perspective, sacrifices to be made for the cause. Abby Morton (later Diaz), child of a family of prominent abolitionists and a future organizer of the Woman's Educational and Industrial Union of Boston, was secretary of the Juvenile Anti-Slavery Society. She went without butter and knit garters to raise her twenty-five cents weekly contribution. Anna Dickinson wrote articles against slavery for the *Liberator* at the age of fourteen. Mattie Freeman, born in 1839, heard Abby Kelley Foster speak when she was fifteen and soon after gave her own speech against slavery, one that enraged her father. Some young women undertook a range of causes. Catharine A. Fish (later Stebbins) began circulating antislavery petitions at twelve and added the total abstinence pledge at fifteen, the year she attended the Seneca Falls Convention.7

6. Blanche Glassman Hersh describes Bloomer, for example, as representative of "a transitional stage between the millennialist zeal of early antislavery days and the pragmatism of postwar reform." She adds that Bloomer's emphasis on political means accounted for part of this transition and places her in the mainstream of her era: *The Slavery of Sex: Feminist-Abolitionists in America* (Urbana: University of Illinois Press, 1978), pp. 49–50.

7. These examples are from Frances E. Willard and Mary A. Livermore, *American Women: Fifteen Hundred Biographies,* rev. ed. (New York: Mast, Crowell and Kirkpatrick, 1897; repr. Detroit: Gale Research, 1973), 1:240, 241, 302; 2:681.

Still younger women only began to develop a consciousness of social and political issues during the 1850s. For Josephine Shaw, anti-slavery activism extended into the far distant past; her support of abolition was a given, not the radical step that had been painful for her mother, Sarah Shaw, to take. On the first anniversary of the firing on Fort Sumter, eighteen-year-old Shaw became effusive about the abolition of slavery in the District of Columbia, an act, she believed, "which only the war had power to accomplish." Awed by the event, she stressed how very long abolitionists had fought in vain for the act: it was, she wrote in her diary, "a thing which has been petitioned for since Mother was 23 years old." Hers was a new breed of children, a generation with different assumptions, choices, and idols.[8]

Reformers who came of age in the 1850s were old enough—or young enough—to savor rose-colored images of the old guard of abolition and woman's rights and to appreciate the relative ease of their own careers. Olympia Brown, who later became a Universalist minister, worshiped reformers from a distance: "They all seemed so far away, so grand, so noble." At fifteen she read the account of the woman's rights convention in Worcester: "The idea seized upon me," Brown recalled, but she went on to speak at greater length of how "the names of the participants loomed up before me as the names of great heroes often inspire young boys. . . . All the great reformers of that day had a fascination for me." Ednah Dow Cheney reminisced fondly about a sixteen-year-old self strongly influenced by the reformers around her and "in the full glow of anti-slavery and radical feeling." Charlotte Forten, member of a prominent family of black abolitionists, moral reformers, and temperance activists in Philadelphia, filled her teenage diary during a stay in Salem with stories of abolitionists. She glorified the New England leaders, wrote eagerly in her journal about letters written to and received from them, and admonished herself for being unable to speak in the presence of some.[9]

8. Diary, 12 April 1862, in William Rhinelander Stewart, *The Philanthropic Work of Josephine Shaw Lowell* (New York: Macmillan, 1911), p. 24.

9. Olympia Brown [Willis], *Acquaintances, Old and New, among Reformers* (Milwaukee: S. E. Tate, 1911), pp. 9, 10; Ednah Dow [Littlehale] Cheney, *Reminiscences of Ednah Dow Cheney* (Boston: Lee and Shepard, 1902), p. 25. On Forten see Ray Allen Billington, ed., *The Journal of Charlotte L. Forten: A Free Negro in the Slave Era* (New York: Collier Books, 1961), e.g., diary entries for 8 October 1854 (p. 60), 30 and 31 January 1855 (p. 69), 31 May 1855 (pp. 72–73), 3 February 1855 (p. 78), 2 January 1857 (p. 88), 11 January 1857 (p. 89), 22 January 1857 (p. 90), and 31 January 1857 (p. 90). On the moral reform activities of the Fortens see Howard H. Bell, "The American Moral Reform Society, 1836–1841," *Journal of Negro Education* 27 (Winter 1958): 34–40. A more recent discussion of Charlotte Forten can

When her mother helped organize the Seneca Falls Convention, Ellen Wright was a child of eight, one of Martha Coffin Wright's many offspring who caused their mother to be, in her own words, "very stupid & dispirited at Seneca Falls the prospect of having more *Wrights* than I wanted tending materially to subdue [my] ardor & energy."10 Ellen's teenage letters from Theodore and Angelina Grimké Weld's school at Eagleswood are a delightful blend of awe and familiarity with famous reformers, all infused with a wit and irreverence much like her mother's. Best of all, they provide a wholly un-self-conscious, if breathless, portrait of growing up in a community where the ultraism of her parents' generation remained vital.

Ellen wrote her mother and friends about ordinary adolescent events: the gossip circulating among her friends, for example, and her indignation at being considered too young to be informed of someone's pregnancy. Yet her views on clothing were confined to descriptions of bloomers, her school debates were on woman's rights and tobacco, her vacations were often spent at conventions, and her career plans included being a public speaker. "*See if Im not a speaker some day,*" fifteen-year-old Ellen wrote passionately to a friend. "*See if I dont rouse the people.* O! if I but *knew what to say* the will is in me *so* strong. . . . Yes, John I'm a real thorough *Reformer.* And so glad of it. Opposition is nothing."11

Of course, for children like Ellen Wright, who lived in a narrow community of ultraist reformers, opposition in the 1850s was also minimal, as the abolitionist cause was becoming almost respectable. In a sense, Ellen realized this. "I think it is fun to go opposition, dont you?" she cheerfully wrote her friend Anna Davis in the mid-1850s. Ellen's idols had paved for her a far smoother path than they themselves had

---

be found in Emma Jones Lapsansky, "Feminism, Freedom, and Community: Charlotte Forten and Women Activists in Nineteenth-Century Philadelphia," *Pennsylvania Magazine of History and Biography* 63 (January 1989): 3–19. Lillie Buffum Chace Wyman, born in 1847, recalled thinking William Lloyd Garrison "a perfect being," in Wyman and Arthur Crawford Wyman, *Elizabeth Buffum Chace, 1806–1899: Her Life and Its Environment* (Boston: W. B. Clarke, 1914), 1:136.

10. Martha Coffin Wright to Lucretia Mott, 1 October 1848, box 33, folder 900, Garrison Family Papers, Sophia Smith Collection, Smith College.

11. Ellen Wright to John Plumly, 11 October 1855, box 14, folder 365a, Garrison. All the following letters are in Garrison. On bloomers, see Wright to Martha Coffin Wright, 19 April 1854, 21 May 1854, box 14, folder 361. On the childbirth, see Wright to Anna Davis [Hallowell], 27 March 1856, box 14, folder 359. "I did knock him down once in awhile," Ellen boasted about one debate on woman suffrage with a man she had just met: to Martha Coffin Wright, 4 August 1855, box 14, folder 364. In the same letter, Ellen almost wished to "die before I grow up!" rather than disappoint those who thought she should become a public speaker.

enjoyed. Asked to hold a lyceum at school about "woman's proper sphere," Ellen drew upon images of these models to aid her in her inexperience. "As 'twas all new to me, . . . I had to guess at what was right," she explained to her mother. "I thought of [the convention at] Saratoga, and wished I was Lucy Stone!" By age twenty Ellen Wright was a secretary at the National Woman's Rights Convention.[12] She stepped into an already established movement, taking for granted the advantages to women of being able to assert themselves directly in the electoral process. Ellen, who knew that it was difficult continually to reignite radical fervor, was aware that she had been raised in, not converted to, her commitment to social reform. "This is a good atmosphere for us perhaps," she wrote Lucy McKim from Elizabeth Sedgwick's school in Lenox in early 1861, where she found only "milk & water reformer[s]. . . . I feel more radical than ever—more than ever thankful to have been bred among 'Reformers.'"[13]

Not all children of ultraist reformers were as thankful for their parents' legacy, opinions, or (sometimes embarrassing) fervor, however much they recognized these qualities as the central experience of their young lives. Lillie Buffum Chace Wyman, Elizabeth Buffum Chace's daughter, wrote that her mother "accepted too completely a limited social sphere," one occupied almost exclusively by like-minded reformers. She recalled having felt "shame-stricken over the family peculiarities of political opinion . . . on that December day when John Brown was hanged. Some of my village comrades asked me who was dead, that we had crape on our door. . . . I became suddenly abashed with a vague sense that it was a little absurd to be so different from our

12. Ellen Wright to Anna Davis [Hallowell], n.d. [1855?], box 14, folder 359, Garrison; Ellen Wright to Martha Coffin Wright, 10 December 1855, box 14, folder 364, Garrison. On Wright's role in the woman's rights convention see Lucy McKim to Ellen Wright, June 1860, box 29, folder 798, Garrison; and Elizabeth Cady Stanton, Susan B. Anthony, and Matilda Joslyn Gage, *History of Woman Suffrage* (New York: Fowler and Wells, 1881), 1:688. Wright's mother was president.

13. Ellen Wright to Lucy McKim, 1 January 1861, box 14, folder 378, Garrison. "My parents, relatives, and best friends were all abolitionists," recalled Sarah Southwick. "I was born into the cause, and it would have involved much moral heroism to have differed from them to such a degree as to have apologized for slavery": Southwick, *Reminiscences of Early Anti-Slavery Days* (Cambridge, Mass.: Riverside Press, 1893), pp. 38–39. Men also experienced being part of a movement at a particular stage in their own and the cause's development. Aaron M. Powell, one of the youngest of the ultraist abolitionists, began his antislavery work in 1850 after having been "converted" as a boy, and his reminiscences reflect a kind of hero worship. See his *Personal Reminiscences of the Anti-Slavery and Other Reforms and Reformers* (New York: Caulon Press, 1899).

neighbors." As one "too young to share" in the movement's fervor, Wyman recalled reading old newspapers that her mother had saved and thus participating vicariously. "There were others beside myself," she recalled, "among the children of that period, who in some similar way experienced a sort of participation in a struggle which closed just as they were ready to enter into it actively." She attributed a "mental age" to that experience: "Nothing makes the mind feel old like the sense of having been intimately connected with a phase of life that is wholly dead, and these youths had entered into the spirit of the anti-slavery epoch as fully as their elders." Members of her generation, she claimed, "were trained for a conflict in which they were not permitted to fight."[14]

Elizabeth Cady Stanton thought it unlikely that the children of reformers would "take up the work that falls from [our] hands. . . . To a certain extent they have shared the odium and persecution we have provoked," Stanton remarked. "They have been ostracised and ignored for heresies they have never accepted. The humiliation of our children has been the bitterest drop in the cup of reformers." Upon meeting Maria Weston Chapman's daughter in 1859, abolitionist Henrietta Sargent observed to Chapman that "Anna resembles you very much. I asked her if she intended to emulate your career? She shook her head, but I think you could bring her forward in the race, by giving short courses to begin with, as the warfare will be long, our *human* reliance must be in the generation now coming into the arena—your children should be in the van." If reformers often found it impossible to pass on their own fervor, which had been fed on opposition, to children raised in a less fervent age, many of the younger generation also doubted their ability to carry the mantle. "I am so proud of you and father, that you are both so devoted . . . to all the reforms," wrote Vassar College student Alla Foster to her mother, Abby Kelley Foster. "I am sure that I shall never do anything half so useful. But the children of good and great people are apt to [be] ugly or forceless, and I think you and I should be thankful that I am not any worse."[15]

On the other hand, the extent to which activist fervor continued in

14. Wyman and Wyman, *Elizabeth Buffum Chace,* 1:124; Wyman, "From Generation to Generation," *Atlantic Monthly* 64 (August 1889): 176–77.

15. Elizabeth Cady Stanton, "Reminiscence of Lucretia Mott," in Stanton et al., *History of Woman Suffrage,* 1:431; Henrietta Sargent to Maria Weston Chapman, 24 December 1859, vol. 29, no. 84, Antislavery Collection, Rare Books and Manuscripts Division, Boston Public Library; Foster [1870s?] quoted in Nancy H. Burkett, *Abby Kelley Foster and Stephen S. Foster* (Worcester: Worcester Bicentennial Commission, 1976), p. 38.

families varied so greatly that generalizations are impossible.[16] For the daughters of those active in conservative benevolent causes, about whom far less personal information is available, the choice to follow their parents involved no social stigma and was probably quite easily made. They experienced the changes brought about by the 1850s in less dramatic ways. Generally, these young women assumed roles in benevolent institutions, often institutions that their mothers had founded, with little public comment. Indeed, for these daughters, following in their mothers' footsteps—far from exciting criticism—would be the hallmark of a successful upbringing. Some young women directly filled positions that were subordinate to their mothers, much as sons followed their fathers into corporations or trades. Young Abby May succeeded her mother on the board of the Aunty Gwynn Temporary Home. Lucy Gibbons (later Morse) joined the executive committee of the Women's Prison Association in 1862, while her mother nursed wounded soldiers at the front. Similarly, Louisa Lee Schuyler taught sewing to immigrant children in an industrial school in the 1850s, under the auspices of the Children's Aid Society, an organization that her parents supported; twenty-four when the war started, Schuyler became involved in the Woman's Central Association of Relief because her mother was one of the founders.[17]

Yet for those daughters who found it easiest to adopt their parents' causes, the world of their parents, a world of benevolent language, of

16. The daughters of a number of reformers wrote biographies and published their mothers' letters. See, e.g., Wyman and Wyman, *Elizabeth Buffum Chace;* Sarah Hopper Emerson, ed., *Life of Abby Hopper Gibbons Told Chiefly through Her Correspondence,* 2 vols. (New York: G. P. Putnam's Sons, 1896–97); Laura E. Richards and Maud Howe Elliott, *Julia Ward Howe: 1819–1910,* 2 vols. (Boston: Houghton Mifflin, 1916); Theodore Stanton and Harriot Stanton Blatch, eds., *Elizabeth Cady Stanton as Revealed in Her Letters, Diary and Reminiscences,* 2 vols. (New York: Harper and Brothers, 1922); Alice Stone Blackwell, *Lucy Stone: Pioneer of Woman's Rights* (Boston: Little, Brown, 1930); and Katherine D. Blake and Margaret L. Wallace, *Champion of Women: The Life of Lillie Devereaux Blake* (New York: Fleming H. Revell, 1943). Sons of abolitionists also wrote biographies of their fathers, frequently continuing the long past battles in which their fathers found themselves in the 1840s. See William Birney, *James G. Birney and His Times* (New York: D. Appleton, 1890), and Wendell Phillips Garrison and Francis Jackson Garrison, *William Lloyd Garrison, 1805–1879: The Story of His Life Told by His Children,* 4 vols. (New York: Century, 1885).

17. On Abby May see Ednah Dow Cheney, *Memoirs of Lucretia Crocker and Abby W. May* (Boston, 1893), and Shirley Phillips Ingebritsen, "Abigail Williams May," in *Notable American Women, 1607–1950: A Biographical Dictionary,* ed. Edward T. James and Janet Wilson James (Cambridge: Harvard University Press, 1971), 2:513. Lucy Gibbons first appears in the Women's Prison Association, *Seventeenth and Eighteenth Annual Reports* (New York: Wynkoop, Hallenbeck and Thomas, 1863). On Schuyler see Robert D. Cross, "Louisa Lee Schuyler," *Notable American Women,* ed. James and James, 3:244–46.

calls upon women to exert their peculiarly female powers of influence, was incongruous with the society in which they themselves would work. Concrete changes in the work of benevolence—whether charitable work or more radical—informed the context from which this new generation's approach to social change evolved. As their mothers moved into either electoral or institutional settings, younger activists took for granted a more utilitarian approach to moral or social change.

The editors of the *History of Woman Suffrage* recognized that a significant change in the popular perception of elections occurred in 1840, when women began to attend "political meetings, as with the introduction of moral questions into legislation, they had manifested an increasing interest in government." Within a decade, that growing concern for electoral politics had led activist movements increasingly to frame their conception of social change in terms of electoral means and goals. Thus, the 1850s witnessed a burst of legislative activity on the part of women; hundreds and thousands demanded their civil and political rights and joined men in appealing for laws against alcohol, for removal of politicians and judges, and for corporate charters and funds for their organizations. Women's interest in legislation introduced them to a growing range of political issues. As one writer for the *Lily* commented ironically, "The women of Seneca Falls have so far dared to outstep their sphere as to go by scores and hundreds to the political meetings recently held to discuss the constitutionality of the Canal Bill, and to pass upon the conduct of the resigning Senators! And what is more strange still, the men consented to it. . . . Yes, our ladies have mingled at political meetings with the 'low rabble' who go to the polls." Meanwhile, the *Una* published regular and varied reports from a correspondent in the visitors' gallery of the United States Senate. In 1854, for the benefit of its largely female readership, the paper added a column entitled "Acts of Legislatures."[18]

Gradually, in the decade or so before the Civil War, ultraists of both sexes, including the most unyielding of nonvoters, shifted their enthusiasm to elections. "I am rejoiced to say that Henry is heart and soul in the Republican movement," wrote Stanton to Susan B. Anthony, adding that she herself had "attended all the Republican meetings." Such intense interest in electoral politics characterized the decade that Martha

18. Stanton et al., *History of Woman Suffrage*, 1:474; *Lily* 3:6 (June 1851): 45; *Una*, June 1854. Throughout the 1850s every issue of the *Lily* or *Una* demonstrates the broad range of political issues in which the women readers took an interest.

Coffin Wright feared for the attendance at the 1856 woman's rights convention: "[The] engrossing subject of the coming elections," she wrote worriedly to Anthony, "will distract somewhat from the interest of anything not strictly political." Lucretia Mott agreed, and hoped that "in view of the absorbing interest in the Presidential question," the convention would be postponed.[19] Ultraist abolitionist reports were filled with news about the federal government, if only to "prove" the moral logic of their calls for the dissolution of the Republic. "The opening session of the Thirty-Second Congress could not be expected to vie with the robust villany [*sic*] of its infamous predecessor," began the 1853 report of the Massachusetts Anti-Slavery Society.[20]

The temperance movement provides perhaps the best example of the decidedly "partisan political turn" taken by reformers in the late 1840s and the 1850s.[21] Interestingly, the shift toward electoral politics coincided with the entrance of significant numbers of women into temperance work and with the beginning of a long history of viewing temperance as a woman's issue.[22] Its timing suggests that temperance women might have early become convinced of their own growing need for the ballot. Indeed, those women most identified with temperance— Mary Vaughan, Amelia Bloomer, and, of course, Susan B. Anthony— turned quickly to the demand for suffrage for a new source of authority. As reformers' goals increasingly focused on legislation, activist women came to feel more acutely the limitations of disfranchisement.

19. Elizabeth Cady Stanton to Anthony, 4 November 1855, in DuBois, *Stanton, Anthony,* p. 59; Martha Coffin Wright to Susan B. Anthony, 30 August 1856, box 35, folder 921, Garrison; Mott to Lucy Stone, 31 October 1856, Lucy Stone Correspondence, Blackwell Family Papers, Manuscript Division, Library of Congress.

20. Massachusetts Anti-Slavery Society, *Twenty-first Annual Report* (Boston, 1853), p. 3. *The National Era,* a Liberty party paper founded in 1847, logically focused almost entirely on electoral events. But so did old organization newspapers such as Frederick Douglass' *North Star.* Not surprisingly, interest in the federal government increased with the passage of the Fugitive Slave Act (1850) and the Supreme Court's Dred Scott decision (1857).

21. The so-called Maine Law, passed in 1851, restricted liquor sales in the state and was followed by similar laws in other states despite court rulings against its constitutionality: Ernest H. Cherrington, *The Evolution of Prohibition in the United States of America* (Westerville, Ohio: American Issue Press, 1920), pp. 136–39. Cherrington, pp. 139–40, blames growing partisanship for the failure of state prohibition.

22. See Bordin, *Woman and Temperance,* p. 5: she claims that the Daughters of Temperance experienced a peak membership of 30,000 members in 1840. Bloomer, in contrast, claimed that women did not enter the movement in large numbers until 1848 or 1849: Dexter C. Bloomer, *Life and Writings of Amelia Bloomer* (New York: Schocken Books, 1975; orig. 1895), pp. 39–40.

The *Lily,* Amelia Bloomer's paper, most self-consciously articu-
lated the connection between the temperance movement of the 1850s
and women's emerging recognition of the value of suffrage. "We have
not much faith in moral suasion for the rumseller," the paper admitted in
its third issue, as it advocated legislative solutions to problems associ-
ated with drunkenness. Over time, contributors—including the vo-
ciferous, although not typical, Elizabeth Cady Stanton—demanded
that women have a share in the making of laws to restrict the sale of
liquor and to permit wives to divorce intemperate men. The paper's tone
broke sharply from that of the previous decade, when reformers had
encouraged petitioning as a moral tool. "Why shall [women] be left only
the poor resource of petition?" wondered one article. "For even peti-
tions, when they are from women, without the elective franchise to give
them backbone, are of but little consequence."[23]

Because of the temperance movement's outspokenness about the
importance of electoral politics, temperance women were relatively will-
ing to express what Amelia Bloomer called "a strong woman's-rights
sentiment." In Buffalo, New York, she wrote, "All feel that the only way
in which women can do anything effectually in this cause is through the
ballot-box, and they feel themselves fettered by being denied the right to
thus speak their sentiments in a manner that could not be misun-
derstood." As early as 1846, "fourteen hundred women from Monroe
County [New York] 'bemoan[ed] their lack of the ballot' and 'petitioned
voters to safeguard their welfare at the polls' by voting for candidates
opposed to the liquor traffic." Indeed, it was through frustration with
temperance men and the "senseless, hopeless work that man points out
for woman to do" that Susan B. Anthony became a supporter of wom-
an's suffrage.[24]

Still convinced that the broadest possible social change would be
achieved by female means, many women were dismayed by the trend
toward electoral goals and eschewed the demand for woman's suffrage.
Only a few, such as Elizabeth Cady Stanton, had always been aware of
the dual nature of moral suasion, its power and its weakness, and had
labeled nonpolitical means a screen set up by conservative men who

23. *Lily* 1:3 (1 March 1849): 21; 8:4 (15 February 1856): 28.
24. Bloomer, *Amelia Bloomer,* p. 112; Nancy A. Hewitt, *Women's Activism and Social
Change: Rochester, New York, 1822–1872* (Ithaca: Cornell University Press, 1984), p. 113
(also p. 161); Anthony to Amelia Bloomer, 26 August 1852, in DuBois, *Stanton, Anthony,*
p. 38.

smugly advised more radical women to "pray over it." More had doubted whether the vote was a tool that could advance a moral cause: "It is with reluctance that I make the demand for the political rights of women," admitted Lucretia Mott.[25] Even as they moved into suffrage activity, some women continued to insist that only in moral suasion lay the possibilities for a major social transformation and for an enlarged female influence. By the 1850s, however, the radical possibilities of that analysis, like the evangelical fervor that had nurtured it, had been exhausted and some advocates of social change looked more to the ballot for assistance.

Those who turned to electoral means and goals continued to express ambivalence about partisanship, that buzzword of moral compromise. When New York abolitionist Gerrit Smith was elected to Congress in 1852, the Philadelphia Female Anti-Slavery Society could barely bring itself to applaud the victory. "We rejoice in the event," read the annual report, "as we do in any reformatory step taken by any political party, while to none of those parties do we look for our country's salvation. Too clearly have they all demonstrated their incompetency to achieve a great moral reform. The experience of every year confirms our faith in the divine efficacy of moral weapons." Less than two years later, when Smith resigned his seat, Philadelphia abolitionist Esther Moore expressed a view of electoral politics as ambiguous as the society's. She congratulated Smith on his reprieve from Congress and then argued that the salvation of the Republic depended on "clearing out those Pestiferous monsters who are sent there . . . and paid for making laws destructive to the Liberty Peace and comfort of all. Surely they must be routed out and their places filled with better men or a dreadful catastrophe awaits us." Even abolitionists who embraced the idea of a third party worried over what partisanship would do to their souls. "Political aspirants will . . . promise anything, on the eve of an election, when on the rack of hopes and fears," warned the *Emancipator*. "*Avoid the screws of party discipline.*" Women, who did not benefit directly from political victory, sought to take the moral high ground in the electoral contest. Antoinette Brown, who "like her father was a 'voting abolitionist'" and who had campaigned actively for Gerrit Smith's election, told Lucy Stone that she "should hate to sink so low as to become a common vulgar politician. Let me first be a [nonvoting] Garrisonian ten times over. I say, Lucy, I pray you won't get converted to such politics as the

25. Stanton et al., *History of Woman Suffrage,* 1:498; Lucretia Mott speech in ibid. 1:371.

world at large advocates." Brown had reason to worry; conversions to "such politics as the world at large advocates" were becoming more frequent every day.[26]

The earlier generation of reform women often came through a more gradual process to the electoral strategies that their daughters would take for granted. The changing focus of benevolent reform in the late 1840s and the 1850s transformed individuals such as Sarah Towne Smith Martyn, whose contempt for "visionary philanthropy" belied an earlier, more enthusiastic career in evangelical benevolence. Born in New Hampshire in 1805, by the mid-1830s Sarah Smith resided in New York City, where she joined the newly founded New York Female Moral Reform Society, became a manager of the society in 1837, and edited the *Advocate of Moral Reform*. Like many other moral reformers, Smith equated the subordination of women to "lustful" men with that of slaves to their masters and became an abolitionist. She served as a vice president at the second Anti-Slavery Convention of American Women, held in Philadelphia in 1838. In opposition to her sister, Grace Martyn (who had been among the twelve women to oppose Angelina Grimké's resolution about "woman's sphere" the previous year), Sarah Smith allied herself with more ultraist activists and supported Mary Grew's resolution that women remove themselves from churches whose members owned slaves.[27]

Smith filled numerous roles offered by benevolent activity, traveling with Sarah Ingraham to several western states in 1840, where she lectured to, among others, the young women at Oberlin. She was apparently on her way to a lifetime career in the moral reform and prison reform movements, one which could have resembled that of the society's president, Mary Hawkins. But in 1845 the Female Moral Reform Soci-

26. P.F.A.S.S., *Nineteenth Annual Report* (Philadelphia: Merrihew and Thompson, 1853), p. 13; Moore quoted in Ralph Volney Harlow, *Gerrit Smith: Philanthropist and Reformer* (New York: Henry Holt, 1939), p. 332; "Political Action," *Emancipator* 3:19 (6 September 1838): 77; Elizabeth Cazden, *Antoinette Brown Blackwell: A Biography* (Old Westbury, N.Y.: Feminist Press, 1983), pp. 31, 68.

27. Information on Martyn is scattered, although she does appear in Allen Johnson and Dumas Malone, eds., *Dictionary of American Biography* (New York: Charles Scribner's Sons, 1937), 12:352–53. Robert S. Fletcher, *The History of Oberlin College* (Oberlin: Oberlin College, 1943), mentions her on 1:299, 304, 313–14. See Anti-Slavery Conventions of American Women, *Proceedings* (New York: William S. Dorr, 1837; Philadelphia: Merrihew and Gunn, 1838). Smith probably attended the 1837 convention in New York as well. A Sarah F. Smith appears on that list and then not again; it was most likely the same woman. Smith read an address at the 1838 convention in which she noted that women had a right to a political interest.

ety discovered that the treasurer had failed to report a payment. After a nasty dispute, Sarah Smith Martyn (she married her late sister's husband, the Reverend Job H. Martyn, in 1841) and a few other sympathizers withdrew from the society with the expelled treasurer and published their own short-lived moral reform papers. By 1846 Martyn was busy editing her own journal, the *Ladies Wreath,* as well as writing numerous tracts for the conservative American Tract Society.[28]

During the 1850s, still seeking the root causes of social ills, Martyn turned to legislative change for answers. By 1854 she was ready to declare, "The disfranchisement of women is a wrong, which we find *underlying the whole enormous structure of evil* which it is the object of good men and true to overthrow, and it must be removed, before the regeneration of the world can take place."[29] Unlike Mary Hawkins, who was still president of the American Female Guardian Society in the 1850s, Martyn moved toward a new base for exerting social and political authority. Still concerned with the moral transformation of society, she came to believe that one "must be at least a practical utilitarian" and changed her language accordingly. Only reformers' use of the ballot, she insisted, would guarantee the "regeneration" of the world of the 1850s.

Longtime temperance activist Mary C. Vaughan was abruptly changed by the demands of the 1850s.[30] In an 1850 issue of the *Lily,* Vaughan addressed herself to a matter increasingly on the minds of benevolent women. Women would "unsex" themselves if they went to the polls, she asserted: "I trust she will never become man's competitor

28. On the conflict within the society, see Flora L. Northrup, *The Record of a Century, 1834–1934* (New York: American Female Guardian Society, 1934), p. 27. She appears as an officer of the Female Department of the Prison Association of New York in 1844: Caroline M. Kirkland, *The Helping Hand: Comprising an Account of the Home, for Discharged Female Convicts, and an Appeal in Behalf of That Institution* (New York: Charles Scribner, 1853), p. 125.

29. "The Right of Woman to the Elective Franchise," *Una* 2:2 (February 1854): 216 (my italics). Martyn also spoke on women's legal disabilities at the Whole World's Temperance Convention (*Una* 1:9 [September 1853]: 131).

30. Information about Vaughan is sparser than that about Martyn. Sandra Koppelman, in an introduction to Vaughan's short story "Fruits of Sorrow, or an Old Maid's Story," *Old Maids: Short Stories by Nineteenth-Century U.S. Women Writers* (London: Pandora Press, 1984), p. 86, refers to Vaughan as "an almost completely elusive figure." I cannot locate Vaughan's unmarried name, nor can I find extant copies of her *Woman's Temperance Paper* or records of the New York State Temperance Society, of which Vaughan was president, besides the scattered information in Stanton et al., *History of Woman Suffrage.* With Linus Brockett, Vaughan edited *Woman's Work in the Civil War: A Record of Heroism, Patriotism, and Patience* (Philadelphia: Zeigler, McCurdy, 1867), but it contains no further information.

in the prizes of political warfare, or occupy promiscuously with him the learned professions." However, she supported women's rights to property, education, intellectual achievement, and, most radically, divorce on the grounds of a husband's drunkenness. Less than a year later, Vaughan had been converted and publicly regretted her errors; from then on she insisted in the *Lily*'s pages that women had to legislate for their own needs. Her personal transformation had not been effected by a sudden realization of women's natural right to the vote. Instead, she argued, activists such as herself were finding that moral suasion was becoming less and less effective in their work. At the Whole World's Temperance Convention in 1853 (so named because the World's Temperance Convention held at the same time had prevented women delegates from speaking, in a meeting reminiscent of the London antislavery convention thirteen years before), this "Daughter of Temperance" acknowledged the centrality (and shortcomings) of electoral goals in women's work: "We have been laboring for the Maine law in this, [she informed the audience]: we have held conventions, we have presented petitions, and we have applied to politicians, and we have thought that we were right in so doing. . . . The right to vote is withheld from us women, and therefore we must appeal to the voters to do what they in their conscience think is right."[31] Increasingly disgusted with their votelessness, numerous reformers, including Martyn and Vaughan, whose work focused on building a moral society, came to demand the vote for themselves.

In less dramatic ways as well, the careers of individual women who had long been active in reform work reflected the growing significance of electoral politics, especially as moral suasion failed to eradicate sin. Lydia Maria Child surprised even herself with her emerging interest and faith in the electoral scene. In 1846 Child had informed her brother, "I know much better who leads the orchestras than who governs the State." Ten years later, during a presidential campaign that, according to one congressman, inspired the "devotion and dedicated zeal of a religious conversion," she admitted to Sarah Shaw that the times had changed her. "Our hopes, like yours, rest on Frémont," she wrote. "I

31. *Lily* 2:12 (December 1850): 94; on her "conversion" see *Lily* 3:10 (October 1851): 79, and *The Whole World's Temperance Convention Held at Metropolitan Hall in the City of New York* (New York: Fowler and Wells, 1853), p. 45. Later issues of *Lily* included more of Vaughan's letters. See, e.g., *Lily* 3:11 (November 1851): 82; 3:12 (December 1851): 94; and 4:10 (October 1852): 85. In addition, *Lily*'s editor often commented on Vaughan's letters in the issue in which the letter appeared. For more on the convention, see Stanton et al., *History of Woman Suffrage,* 1:499–513.

would almost lay down my life to have him elected. . . . I never was bitten by politics before; but such mighty issues are depending on *this* election, that I cannot be indifferent."[32] Julia Lovejoy, a Kansas minister's wife, condemned women who advocated woman's rights, but in 1856 she too sought an "appropriate" way to express support for the Republican party: "Let little Misses and young ladies in their ornamental work for the parlor," she wrote, "have the names of 'Frémont and Jessie' wrought in choicest colors; let the matrons in the dairy-room, make a mammoth 'Frémont cheese.'"[33]

A growing disillusionment with moral suasion corresponded with an increased faith in the promise of legislative change. Throughout the 1840s, for example, opponents of the moral reform campaign to make seduction a crime had argued that "people cannot be made moral by legislation." By 1853, however, when William Lloyd Garrison expressed similar reservations about the electoral process, he was strikingly at odds with the times. At the Whole World's Temperance Convention, when Garrison warned temperance advocates not to place "too much confidence . . . in law" or to "shift off their moral responsibility, and rely upon Legislation," his was a rare voice in defense of moral suasion. More in tune with his audience was the Reverend Pierpont: "We ask a law to protect the wife and family of the intemperate man. We ask it from kind feelings to our fellow-creatures. . . . We cannot get that, in the present form of society, except through political organization. . . . Moral sentiment carried out by political organization is my argument." Emily Clark, an agent and lobbyist for the New York State Woman's Temperance Society, saw tremendous promise in electoral change: "Neither the fearful wreck of manhood, nor the destruction of all that is noble, generous, and manly in youth, nor all the suffering of womanhood, nor all the miseries of childhood are so great but they can be

32. Quotation from Rep. George Julian, in Pamela Herr, *Jessie Benton Frémont: A Biography* (New York: Franklin Watt, 1987), p. 259; Lydia Maria Child to Convers Francis, 6 December 1846, in *Letters of Lydia Maria Child* (Boston: Houghton, Mifflin, 1883), p. 59; Child to Sarah B. Shaw, 3 August 1856, in Milton Meltzer and Patricia G. Holland, eds., *Lydia Maria Child: Selected Letters, 1818–1870* (Amherst: University of Massachusetts Press, 1982), pp. 290–91. Child had recently written to Lucy and Mary Osgood, 20 July 1856, p. 289: "For the first time in my life, I am a *little* infected with *political* excitement." "As the 1850s advanced," writes one biographer in a common refrain, ". . . Graceanna [Lewis, a Philadelphia Quaker and abolitionist,] . . . became increasingly political": Deborah Jean Warner, *Graceanna Lewis: Scientist and Humanitarian* (Washington, D.C.: Smithsonian Institution Press, 1979), p. 44.
33. Quoted in Herr, *Jessie Benton Frémont*, p. 262.

remedied by a temperance ballot-box."[34] "Thus the *ballot-box leaven* is beginning to work all over the land," exclaimed the *Lily,* quoting from a Worcester, Massachusetts, newspaper, "and when 'the whole lump' of the teetotal mass of the people is thus leavened into action at the polls, then will law, temperance, and humanity triumph."[35]

By the early 1850s, as they came more and more to associate social change with the ballot, activists of both sexes expressed a growing faith in the power of the vote. As early as 1851 a resolution of the woman's rights convention (the report of which had so impressed Olympia Brown) claimed far more for the ballot than would have been possible ten years earlier: "*Resolved,* That it will be woman's fault, if, the ballot once in her hand, all the barbarous, demoralizing, and unequal laws, relating to marriage and property, do not speedily vanish from the statute-book." An 1857 Wisconsin legislative committee report in support of woman's suffrage bluntly summed up the prevailing tone: "No man or woman can be regarded as an entity, as a power in society, who has not a direct agency in governing its results. Without a direct voice in molding the spirit of the age, the age will disown us." To committee members, the "spirit of the age" was clear enough: "There is *no reality in any power that can not be coined into votes,*" they asserted.[36]

That faith in legislation extended even to that most sentimental of benevolent tools: the temperance tale. One such book, published in 1853, related the usual saga of a once comfortable family who, because of the father's inability to fight temptation, sank into the degradation of poverty and intemperance. But *The Sedley Family; or, the Effect of the Maine Liquor Law,* a product of its decade, had a new twist. Mr. Sedley, the intemperate father and husband, reluctantly agreed to sign a temperance pledge proferred by his wife. The pledge, however, was not strong enough to reform him. Mrs. Sedley sought a more effective protector that, like the Bible, would deter her husband from drinking. She moved her family to Maine. In case the reader might miss the

34. Northrup, *Record of a Century,* p. 26; *Whole World's Temperance Convention,* pp. 62, 56, 51. Clark, Bloomer, and H. Atillia Albro presented the New York legislature with almost 30,000 names on a petition for prohibition in 1852–53. On temperance work and politics see Bloomer, *Amelia Bloomer,* pp. 93–96, and Hewitt, *Women's Activism,* pp. 160–64.

35. *Lily* 1:[10] (1 October 1849): 78.

36. *The Proceedings of the Woman's Rights Convention, Held at Worcester [Massachusetts], October 15th and 16th, 1851* (New York: Fowler and Wells, 1852), p. 11; "Wisconsin Report of the Suffrage Question, 1857," in Stanton et al., *History of Woman Suffrage,* 1:868 (my italics).

significance of her choice (and it was unlikely that any reader in 1853 would), the author observed that Mrs. Sedley went where *the law might save her husband.*" Needless to say, the Maine law fulfilled its mission, and the Sedleys anxiously fought efforts for its repeal, knowing that only its existence on the statute books would protect Mr. Sedley from temptation. Parallels between secular and religious legislation pervade the book; the law itself had become essential to the millennium. As *The Sedley Family* taught, legislation not only worked: It *saved.*[37]

In this context, it is hardly surprising that the daughters of antebellum reformers were often largely unaware that their mothers had ever doubted the efficacy of the vote or that electoral politics had not always been activists' central concern. Indeed, for them electoral politics was no "demon" at all but rather the best ally of social reform. In 1855 twelve-year-old Caroline C. Richards attended, with several school friends, a lecture given by Susan B. Anthony. "She talked very plainly about our rights and how we ought to stand up for them," the girl recorded in her diary, "and said the world would never go right until the women had just as much right to vote and rule as the men." When Anthony "asked us all to come up and sign our names who would promise to do all in our power to bring about that glad day when equal rights should be the law of the land . . . ," Richards reported, "a whole lot of us went up and signed the paper." Sarah Shaw's daughters, Josephine and Ellen, who were adolescents during the presidential campaign of 1856, did not share Lydia Maria Child's surprise that virtually all anyone talked about was electoral politics; appropriately, the girls reserved their "enthusiasm about their 'first hero'" for Frémont himself.[38]

Like abolitionists, temperance workers, and woman's rights activists, more conservative benevolent workers also were losing faith in the earlier vision for the grand moral transformation of American society. The trend toward practical routes to societal improvement; the growing physical, financial, and psychological distance between rich and poor; and greater economic hardship contributed both to an increase in the

37. *The Sedley Family; or, the Effect of the Maine Liquor Law* (Boston: T. O. Walker, 1853), quotation on p. 100 (my italics).

38. Diary, 20 December 1855, in Caroline Cowles Richards [Clarke], *Village Life in America, 1852–1872, including the Period of the American Civil War as Told in the Diary of a School-Girl,* rev. ed. (New York: Henry Holt, 1913), pp. 49–50; Lydia Maria Child to Sarah B. Shaw, 14 September 1856, in Meltzer and Holland, *Child: Selected Letters,* p. 293. Ednah Dow Littlehale Cheney also heard a woman's rights lecture while at school and recalled that she had immediately advocated it in debate: Cheney, *Reminiscences,* p. 20.

number of asylums and homes and to a changing emphasis on the part of the benevolent. The 1850s witnessed what historian John Higham considers an institutionalization of religious benevolence.[39] As reformers faced their inability to achieve the widespread salvation of urban America, women who had made a profession of benevolence increasingly concentrated their efforts on more circumscribed populations who (they thought) might be isolated from the vices of the city.

The result during the 1850s was a dramatically greater emphasis on asylum building. Permanent, stable institutions that engaged in ameliorating conditions for urban women and children, once merely a part of the women's benevolent strategies, became the focus of attention. As with earlier efforts at fund raising and benevolent visiting, the leaders of the new institutions were children of the benevolent empire and were drawn from the ranks of families such as the Phelpses, Dodges, Woolseys, and Schuylers of New York, and the Shaws and Tappans of Boston. They were joined by some of the leaders of the moral reform movement, who were newly convinced of the efficacy of asylums.[40] The late 1840s and 1850s marked the benevolent elite's conversion to more purely institutional solutions.

This transition was reflected in the work of individual women who consolidated decades-old benevolent organizations in new settings that signified both stability and more limited goals. For Catharine Beecher, the period marked "a brief hiatus" in a long career. "In the late 1840s the evangelical emphasis fell away from Catharine's work," writes Beecher's biographer Kathryn Kish Sklar, "and she was left with a single focus upon women—a more secular, distinctively urban perspective. . . . Professional competence replaced evangelical fervor in Catharine's framework for women in the 1850s."[41] Sklar's description of one woman could serve as well for the experience of a decade and of a generation. For whereas this new emphasis on professional competence would mark a profound transition in the lives and work of older benevolent women, their daughters would take it for granted as the very emblem of benevolent activity.

Abby Hopper Gibbons, abolitionist, prison reformer, and a fre-

39. John Higham, *From Boundlessness to Consolidation: The Transformation of American Culture, 1848–1860* (Ann Arbor, Mich.: Clements Library, 1969), p. 21; see also p. 12.

40. Hewitt notes that perfectionist women and the more conservative and elite benevolent women increasingly formed alliances in this period: *Women's Activism*, e.g., pp. 147–49, 171–72.

41. Kathryn Kish Sklar, *Catharine Beecher: A Study in American Domesticity* (New York: W. W. Norton, 1976), p. 203.

quent and effective lobbyist who increasingly turned to institutional contexts in which to achieve her benevolent ends, illustrates the experience of the older generation. In 1854, following a dispute with male colleagues over conflicting prerogatives, the female department of the Prison Association of New York, with Gibbons as president, formed an independent Women's Prison Association and Home. At the same time, Gibbons became president of the Industrial School for German Girls, under the auspices of the Children's Aid Society of New York. Most of her work in the 1850s was geared toward building and promoting those institutions.[42] Gibbons was unusual in that she maintained contact with abolitionist and woman's rights circles. Her almost exclusive focus on institutional and legislative means, however, was characteristic of the time.

Even activists who united for the purpose of lobbying for legislation occasionally ended up building institutions. In January 1847 a group of women organized in Philadelphia to petition the state legislature for the abolition of capital punishment. After sending off almost twelve thousand signatures a mere six weeks later, the women eagerly applauded the suggestion made by one of their number that they "open a house for the reformation, employment, and instruction of females, who had led immoral lives." By October they had formulated a plan for the new undertaking, purchased a building, recruited 346 women as members, and opened a house of industry. By the following April they had acquired an act of incorporation and a $1,300 mortgage and were on their way to becoming a respected, established institution in the city. In 1854, as evidence of that status, the legislature granted the Rosine Association an annual appropriation of $3,000.[43]

42. On the dispute with the (men's) Prison Association of New York see Estelle B. Freedman, *Their Sisters' Keepers: Women's Prison Reform in America, 1830–1930* (Ann Arbor: University of Michigan Press, 1981), pp. 33–34. The home had been founded nine years before. Catharine Sedgwick, Sarah Doremus, and Caroline Kirkland, as well as moral reformers Sarah Ingraham, Sarah Smith Martyn, and Mary Hawkins, joined Gibbons in this work: Kirkland, *Helping Hand*, p. 125. Sarah Doremus was also active in the New York House and School of Industry, the Nursery and Child's Hospital, the Presbyterian Home for Aged Women, and numerous mission, tract, and Bible societies: Mary S. Benson, "Sarah Platt Haines Doremus," in *Notable American Women*, ed. James and James, 1:500–01. For a "history" of Gibbons' week, see Abby Hopper Gibbons to Sarah Gibbons [Emerson], 3 May 1856, in Emerson, *Abby Hopper Gibbons*, 1:229–30.

43. Rosine Association, *Reports and Realities from the Sketchbook of a Manager* (Philadelphia: J. Duross, 1855), pp. 7, 12 (500 women attended); Rosine Association, "Annual Report of the Managers, April 1848," in ibid., pp. 29–41; Rosine Association, "Annual Report of the Managers, April, 1854," in ibid., pp. 303–04. The association's members included abolitionists Lucretia Mott, Gertrude Kimber Burleigh, Mary Grew, and Sarah

More conservative women avoided the questionable connotations of aiming their efforts at prostitutes and pursued the tradition of aiding the "worthy poor." Still they, like members of the Rosine Association, focused on establishing institutions. In 1848 the Ladies Home Missionary Society of New York's Methodist Episcopal church announced its intention of establishing a permanent House of Industry in Five Points, New York's most impoverished—and, to the benevolent, both repellent and challenging—slum area.[44] With some difficulty the women hired a missionary and began their labors; by 1853 they had succeeded in demolishing the Old Brewery and in building a new asylum at a cost of $36,000. In 1850 a group of women "of wealth and position" met at the New York Hotel to found the New York House and School of Industry. Incorporated the following year, the organization quickly became a model for this new kind of institution, providing employment, housing, and training to a few of the urban poor. The names of New York's benevolent elite graced the pages of its reports.[45]

By mid-decade, industrial schools and houses of industry had sprouted throughout urban areas. The American Female Guardian Society sponsored a number of industrial schools in New York City and elsewhere in addition to its Home for the Friendless and House of Industry.[46] Numerous older institutions celebrated their growth and stability by moving into larger buildings in the 1850s. The New Haven

Pugh. Elizabeth Neall Gay wrote her husband that she had attended the founding meeting of the association while visiting friends and family in Philadelphia; she had gone from there to tea at Mott's, where she had been delighted to see everyone from the "Old Female Society," the P.F.A.S.S.: 8 April 1847, box 1, Gay. The treasurer of the Rosine Association, Mira Townsend, was a vice president of the A.F.G.S.

44. On the Old Brewery Mission and the Five Points Mission (the two eventually split), see *The Old Brewery, and the New Mission House at The Five Points* (New York: Stringer and Townsend, 1854); William F. Barnard, *Forty Years at the Five Points* (New York, 1893); and Carroll Smith-Rosenberg, *Religion and the Rise of the American City: The New York City Mission Movement, 1812–1870* (Ithaca: Cornell University Press, 1971), pp. 225–44.

45. On the cost of the building, see *Old Brewery,* p. 80, and History of the New York House and School of Industry, copied from a 1905 pamphlet, misc. papers, N.Y.H.S.I. papers, Manuscript Division, New-York Historical Society. The Association for the Relief of Respectable, Aged, Indigent Females had founded an asylum in 1838. Only in 1847 did the society begin to highlight that work on the cover of its annual reports. By the 1850s, its annual reports concentrated almost exclusively on that institutional work.

46. Northrup, *Record of a Century,* pp. 37–41. In contrast, the 1850s were a difficult time for the established national benevolent societies, which "fell prey to doubt and discouragement": Paul S. Boyer, *Urban Masses and Moral Order in America, 1820–1920* (Cambridge: Harvard University Press, 1978), p. 65. Increasingly, organizations focused on areas within their reach; indeed, Boyer entitles a chapter on the 1850s, "Narrowing the Problem." See also Smith-Rosenberg, *Religion and the Rise of the American City.*

Orphan Asylum did so in 1853, adding a new wing soon after the war. The American Female Guardian Society dedicated its first building in 1848 and opened a larger one in 1857. Sketches of those imposing structures constitute the frontispiece of many an annual report, capturing in a picture a changing intellectual and physical environment that the women saw little need to explain.[47]

After the founding of its Home for the Friendless in 1848, the American Female Guardian Society revealed in its reports the new emphasis on institutional settings for aiding the poor and fallen. Its annual reports and its newspaper, which earlier had attacked "the seducer, worse than *murderer,* [who] stalks unmolested," now consisted of little more than statistical summaries and anecdotes about the inmates of the home. Some advocates of moral change were apparently dismayed by this trend. So much of the organization's energies were focused on the institution and its accompanying industrial schools that the managers of the society felt called upon to issue a clarification of their goals. "The question is often asked . . . by persons interested in the *Home,* 'Has the Society any other object than this?'" Defensively, the *Advocate of Moral Reform and Family Guardian* responded, "1st, The Society *has* other objects. Objects that are no more lost sight of than the temporary Home and its varied agencies. 2d, It is doing the same work mainly, that it had been doing for twelve or fourteen years previous to the erection of the Home." The paper went on to reiterate that the goal of the society was to prevent licentiousness. It insisted that nothing in the operation of the home contradicted that primary objective, even though "a large portion of this work is more or less concentrated in the Institution." In accordance with its new emphasis, the once fervent moral reform movement no longer portrayed male lust as the primary cause of female dependence and as the basis for female unity. Rather, it encouraged the founding of institutions to protect the innocent from the terrible influences of urban life.[48]

47. "New Haven Orphan Asylum: History of the Institution," *[New Haven] Morning Journal and Courier,* 26 April 1873; on the 1857 dedication see Sarah R. I. Bennett, *Woman's Work among the Lowly: Memorial volume of the First Forty Years of the American Female Guardian Society and Home for the Friendless* (New York: A.F.G.S., 1877), pp. 251–56. See, e.g., the frontispieces of the A.F.G.S. *Annual Reports* (New York). The Lancaster (Massachusetts) State Reform School for Girls, the first in the country, was founded in the 1850s. See Barbara M. Brenzel, *Daughters of the State: A Social Portrait of the First Reform School for Girls in North America, 1856–1905* (Cambridge: MIT Press, 1983).

48. *Advocate of Moral Reform* 3:3 (1 February 1837): 204; *Advocate of Moral Reform and Family Guardian* 18:1 (1 January 1852). As historians Smith-Rosenberg, *Religion and the Rise of the American City,* and Boyer, *Urban Masses,* have pointed out, these new charitable

Socially prominent women who worked in stable institutions required closer relationships with local governments, although as yet they felt no need for the ballot. Indeed, the fact that their needs could be largely satisfied on a local level—where family and class contacts were likely to be most efficacious—may well have encouraged this position. Men who assisted the women-run institutions continued to praise the women for doing "what no legal enactment could accomplish—what no machinery of municipal government could effect." But the words carried a certain defensiveness because governments played an increasing role in the women's work. The glorification of female benevolence sounded increasingly strained in the face of that growing financial dependence.⁴⁹ At the dedication of the American Female Guardian Society's new building, for example, the Reverend T. L. Cuyler honored the women with an example of noteworthy benevolence. He told how "Dorothy [*sic*] Dix had conquered a half dozen legislatures. What woman had done, and might still do for suffering humanity, was beautifully portrayed."⁵⁰

As part of their emerging focus on a more secular route to a Christian society, the institution builders of the 1850s turned to government not only for material assistance but, at times, for self-justification. The Society for the Prevention of Pauperism in Boston, which had evolved from the 1834 meetings of the Association of the Delegates of Benevolent Societies, accorded the state an ever larger responsibility for the creation and cure of pauperism. "Government ought undoubtedly to *help* to support the poor," noted a speaker for the society in 1851, "because it has a stake in their contentment. Besides, it provides some of the immediate *occasions* of poverty." Several months later the society warned that the burden for the support of the poor should rest "where it belongs; that is, upon the State."⁵¹ The Children's Aid Society of New

---

organizations concentrated increasingly on the environmental factors thought to cause poverty.

49. R. A. West, quoted in *Old Brewery*, p. 64. The very structure that the speaker honored had been built with $1,000 from the Common Council in addition to the $5,000 from individual sources. States began increasingly to form committees to investigate the efficiency of state funding of asylums and poorhouses. See "Report of the Joint Standing Committee on Public Charitable Institutions as to Whether any Reduction can be Made in Expenditures for Support of State Paupers" (Massachusetts, 1858), and "Report of Select Senate Committee to Visit Charitable and Penal Institutions, 1857," both in Sophonisba R. Breckinridge, ed., *Public Welfare Administration in the United States: Selected Documents* (Chicago: University of Chicago Press, 1927), pp. 134–69.

50. Bennett, *Woman's Work among the Lowly*, p. 256.

51. Reverend F. D. Huntington, quoted in the *Journal of the Society for the Prevention of Pauperism*, February 1851, p. 6; *Journal of the S.P.P.*, October 1851, p. 29.

York frequently chided the state government for not giving pecuniary aid to the society's industrial schools. At an 1858 meeting of the women who managed the schools, the society's secretary, Charles Loring Brace, informed his audience, "You are doing, in fact, the work of Government. You are taking the poor who would be soon a burden on society . . . and you are fitting them to be useful members of our body politic." The benevolent did not yet believe that governments should administer charitable efforts, but they did seek to maintain close relations with elected officials.[52]

Both the trend toward electoral means and that toward institutional structures tended in the context of the 1850s to narrow the goals of social activism. At least in the short run, these forces also worked to weaken women's overall position in benevolent movements. The rhetorical evidence of women's displacement is clear: Rarely does a student of the 1850s come across calls to men to adopt the standard set by female virtues and female votelessness. Even for women working in all or predominantly female institutions, this change in rhetoric indicated an altered context—a waning of authority based on the special morality of female values. Indeed, female virtue was coming to be seen as just that: an exclusively female quality to be applied within those settings that continued to be dominated by women rather than to be inculcated in the world at large. Increasingly those who had once called for the regeneration of the world through female virtues relied on asylums and on laws as pragmatic steps to a more limited transformation.[53]

As the goals that activist women sought became more frequently centered on legislation and the issues that absorbed the nation increasingly focused on elections and on the federal government, some women came to feel acutely the limitations of their disfranchisement. The fact that activists recognized voting as an essential tool suggests a new interpretation of the call for woman suffrage made by a small group of women in 1848. The changing political context of the era, rather than simply a sudden awareness of the injustices of women's status, was central to women's demand for the ballot.

The emerging woman's rights movement constituted a wholly new route for women, one that advanced explicitly electoral instead of moral means for effecting social change. Women active in the movement understood the limitations placed on their work by the ideology of benev-

52. Children's Aid Society, *Fifth Annual Report* (New York: Wynkoop, Hallenbeck, and Thomas, 1858), p. 18.

53. See Smith-Rosenberg, *Religion and the Rise of the American City,* pp. 203–24.

olent womanhood and by the strategy of moral suasion. At the same time that they articulated a profound critique of American democracy, woman's rights activists engaged in a rhetorical displacement of female virtues: They demanded, in essence, that women's status be "raised" to a level of equality with men rather than that men should aspire to the standard supposedly set by women. Determined to use the essential tools of electoral change, they adopted a political rather than a moral definition of social change. For them, the growing centrality of electoral politics underscored the irony of extolling the virtue of a nonvoting stance. Female influence seemed to have lost its power of persuasion.

Woman's rights activists recognized implicitly that as the struggle for reform centered more on electoral politics, women became both less visible and less effective. In the antislavery movement women's participation in grassroots work had dwindled drastically despite the growing number of female lecturers and converts. Women learned from their own association with "voting abolitionists" the truth of Frederick Douglass' remark to his third-party allies that while "woman is deprived of the right to vote it is impossible that she shall feel the same interest in political anti-slavery meetings as she would do in meetings of an anti-slavery Society."[54] According to Thomas Dublin, the decline in female visibility was as true of the working-class ten-hour movement as it was of the benevolent middle class. During the 1850s, he writes, "As local petition campaigns gave way to ward political work, women's participation in reform declined drastically. Traditional electoral activity displaced the public agitation and lobbying of the earlier decade. . . . The integration of the labor reform movement into the electoral process *tended to displace women activists* and gave workingmen a new prominence in the movement." Similarly, in the nativist movement, although women had established auxiliaries to men's "patriotic" associations as early as 1844, the Know-Nothing party of the 1850s did not include women's organizations in its partisan program.[55]

Contemporaries' turn to electoral politics thus excluded women in practical as well as rhetorical ways. As men focused their attention on electoral organizations, politicians focused theirs on voters. In 1850 Antoinette Brown attended a meeting of voting abolitionists, with

54. Quoted in Philip S. Foner, ed., *Life and Writings of Frederick Douglass* (New York: International Publishers, 1971), 5:230. Foner cites *Frederick Douglass' Paper,* 25 May 1852; it should read March. I am grateful to Jack McKivigan for help in locating the correct citation.

55. Dublin, *Women at Work,* p. 200 (my italics); Jean Gould Hales, "'Co-Laborers in the Cause': Women in the Ante-Bellum Nativist Movement," *Civil War History* 25 (June 1979): 120–21.

whom she allied herself. When no one at the meeting asked her to address the audience, she expressed a keen sense of disappointment, resentful that "I should not be welcome on the antislavery platform with which my father had always been allied and in whose methods I believed." Five years later, Elizabeth Cady Stanton experienced even more acutely the implications of being voteless in a day of electoral rule. A Republican editor whom she met in the street informed her that she ought not to attend Senator John P. Hale's lecture that night. " '*We*,' " the man informed an indignant Stanton, " 'we do not wish to spare any room for ladies; we mean to cram the hall with voters.' 'I have done my best to be a voter,' " was Stanton's response, " 'and it is no fault of mine if unavailable people occupy your seats.' " In such instances, the limitations of nonvoters' moral influence became painfully apparent, especially to the advocates of a radical cause. For those more conservative women who sought—and, traditionally, gained—direct access to politicians, the 1850s presented new challenges, but not for several decades would they experience their exclusion from politics in so acute a way that they would demand a vote.[56]

In contrast to ultraists' growing stress on the federal government, women who worked in charitable causes continued to work on a local level—establishing intercity links, developing new views of societal ills, and, especially, building institutions.[57] The limitations of votelessness continued to hinder conservative or socially prominent women less than they hindered more middle-class women or those involved in radical causes. Abby Hopper Gibbons knew from long experience that she could obtain her ends without voting; she had moved from abolitionist activity into institutional settings without requiring the ballot. Nevertheless, as an activist who worked successfully with a broad spectrum of reformers, she was sympathetic to efforts at obtaining suffrage, and she served as a vice president of the Tenth Woman's Rights Convention in New York in 1860. Gibbons recognized that the vote had become an essential tool for noninstitutional efforts for social change, and she admitted freely in 1892 that "if men can give the vote to women while I

56. Cazden, *Blackwell*, pp. 56–57; Elizabeth Cady Stanton to Susan B. Anthony, 4 November 1855, in DuBois, *Stanton, Anthony*, p. 59.

57. Dorothea Dix and Sarah Josepha Hale appealed to the federal government for land for various projects; they were exceptions. Dix, for instance, appealed to Congress for acreage for insane asylums in 1848–54. Her bill passed both houses in 1854 and was vetoed by Franklin Pierce. See Dorothy Clarke Wilson, *Stranger and Traveler: The Story of Dorothea Dix, American Reformer* (Boston: Little, Brown, 1975), pp. 165–67, 177–212, and Francis Tiffany, *Life of Dorothea Lynde Dix* (Boston: Houghton, Mifflin, 1891), pp. 166–200.

live, I shall *cast mine."* Gibbons, however, was unusual for acknowledg-
ing that access to political privileges made voting largely irrelevant to
the institutional work in which she was engaged. She had not become
an active suffragist, she observed bluntly, because "I have not needed
[the vote] up to this time, as I always *take* what I want."[58]

Those women who worked to build local institutions, howev-
er, may have sacrificed autonomy within their organizations for organ-
izational stability and growth. By the 1850s the trend toward mixed
boards and male advisory committees probably limited women's
decision-making powers over the long-term goals of their organizations
even as it provided them with greater access to men in positions of local
authority. It was in 1849 that the American Female Guardian Society
first engaged an advisory board composed of men. In her study of
Petersburg, Virginia, Suzanne Lebsock asserts, "In the 1850s, women
lost their monopoly on organized charity, as men reclaimed voluntary
poor relief as a legitimate male concern." She suggests that the "to-
getherness" resulting from a "general move away from autonomous
women's organizations" and involving "the women playing well-
defined auxiliary roles" constituted an overall loss of authority for the
women.[59] With the increase in paid male workers in organizations
established and operated largely by men, women and women's auxili-
aries lost their central role. Frequently the hiring of male employees
meant a loss in work and status for volunteers, many of whom were
women. The New York Association for Improving the Condition of the
Poor and the Children's Aid Society, run by Robert Hartley and Charles
Loring Brace, respectively, depended almost entirely on male staff

58. Abby Hopper Gibbons to D. N. Carvalho, 5 August 1892, in Emerson, *Abby Hopper Gibbons*, 2:309. Gibbons' name appears as a vice president in Stanton et al., *History of Woman Suffrage*, 1:688.

59. Northrup, *Record of a Century*, p. 28; Suzanne Lebsock, *The Free Women of Petersburg: Status and Culture in a Southern Town, 1784–1860* (New York: W. W. Norton, 1984), pp. 226, 229. Lebsock also considers benevolent women's increasing use of the title "Mrs." with their husbands' first names in public reports one of the "new forms of ritual submission": ibid., p. 198. The Board of Directors of the Boston Children's Aid Society, e.g., listed an equal number of women and men: *First Annual Report* (Boston, 1863–65). So did the list of managers (although not officers) for the Association for the Relief of Aged and Destitute Women in Salem, founded in 1860: Robert S. Rantoul, DeWitt S. Clark, and George M. Whipple, *A Record of the First Fifty Years of the Old Ladies' Home at Salem* (Salem, Mass.: Observer Press, 1910), p. 7. In her book on Sunday schools, Anne M. Boylan also argues that when women worked alongside men, "women were relegated to secondary status": *Sunday School: The Formation of an American Institution, 1790–1880* (New Haven: Yale University Press, 1988), pp. 119–22 (quotation on p. 120).

members and volunteers, with women working primarily in industrial schools and under the direction of male superintendents.[60]

Within women's organizations, authority rested on an increasingly narrow and formalized base. The American Female Guardian Society, which, as Carroll Smith-Rosenberg writes, demonstrated "an increasing and ultimately absorbing concern for the day-to-day problems of the urban poor," narrowed not only its goals but also its active constituency. There was less for its rural auxiliaries to do as the organization shifted its attention to major northeastern cities. That may account for the decision of the managers of the Home for the Friendless in Rochester, New York, not to become an auxiliary of the American society, "seeking instead to integrate themselves more fully into the local benevolent network." Local organizations depended for their viability on the financial and political support provided by local elites. Becoming an auxiliary to a large urban institution decreased local effectiveness. Over time the rural groups that were auxiliary to the American Female Guardian Society were called on only to find homes for poor women and children and to ship boxes of clothing and food to urban asylums rather than to engage in the more inspiring work of advocating fundamental change.[61]

As urban institutions had aged in the 1850s, so had their boards, another indication of organizations' entrenchment and of the limited options offered younger benevolent women. Some long-standing societies were run by the same women who had founded them decades before. The board members of the New York Female Moral Reform Society had been young women in the 1830s; twenty years later, many of the same individuals still ran the organization, now the American Female Guardian Society, and its home and industrial schools. In 1854 the board members of the Women's Prison Association were also middle-aged: Sarah Doremus, Caroline Kirkland, and Abby Hopper Gibbons were in their early fifties, and Catharine Sedgwick was already sixty-five. When she helped found the New York House and School of Industry in 1850, Doremus was forty-eight. Mary Ryan notes that the 1850s were marked by the funerals of the founders of Utica's Female

60. *Journal of the S.P.P.,* February 1851, p. 13. On these changes in the New York City Tract Society see Smith-Rosenberg, *Religion and the Rise of the American City,* pp. 192–93; on the A.I.C.P.'s male visitors, see Boyer, *Urban Masses,* p. 89. In addition, as noted in chap. 2, many of women's fund-raising efforts were appropriated by church congregations.

61. Smith-Rosenberg, *Religion and the Rise,* p. 203; Hewitt, *Women's Activism,* p. 148; Rosine Association, "Semi-Annual Report of the Managers, October 1848," *Reports,* pp. 66–67, mentions the quantities of goods sent by rural auxiliaries to the A.F.G.S. in New York. On rural auxiliaries, see Smith-Rosenberg, pp. 210–11.

Missionary Society and Maternal Organization. The maturing of the leaders of institutional benevolence indicates the continuities of the work as well as the models with which younger women were familiar. Young women either filled subordinate roles in established societies or moved into other forms of benevolent work. Just as a new generation of ultraist reformers sometimes fretted that "there is nothing more to be dared and done," so the daughters of more conservative benevolent women found that institutional benevolence had become formalized.[62] It would take a war to provide them with new outlets for their own innovations.

John Higham has described the 1850s in terms of "the sobriety and restraint that descended like a pall on many of the enthusiasms of the forties." Indeed, a new tone pervaded benevolence prior to the Civil War. The growing stability of benevolent organizations attendant upon "a utilitarian age" took a variety of forms. Abolitionists, for example, found that their meetings were filled with spectators, most of whom were quiet and respectful. The celebration of the end of the American Anti-Slavery Society's second decade, held in Philadelphia in 1853, became a "Mass Meeting" of enormous proportions rather than the "Family Gathering" that abolitionists had come to expect. Sarah Pugh's cynical summary of the 1859 Philadelphia Female Anti-Slavery Society fair accurately reflected a perception that the 1850s had seen a maturing, even a mellowing, of a middle-aged cause. Pugh described the condescending attitude that older female abolitionists experienced during "business meetings of the Fair Committee, all ladies, surrounded by gentlemen, who looked with wonder on the 'irrepressible women,' amazed to see them so 'plucky,' and declaring they would vote for them for the Legislature." One can well imagine the feelings of those women who, after more than two decades of running antislavery fairs, were subject to the goodwill of the new breed of antislavery sympathizers.[63]

The restrained and sober tone of the 1850s influenced a new generation's experience with and vision of social change, as the context for their work was increasingly characterized by elections or institutions. During the 1830s Lucy Stone's family's reading material had included

62. Ryan, *Cradle of the Middle Class,* p. 186; Higginson, in B.F.A.S.S., *The Boston Mob of "Gentlemen of Property and Standing": Proceedings of the Antislavery Meeting . . . on the Twentieth Anniversary of the Mob of October 21, 1835* (Boston: R. F. Wallcut, 1855), p. 58.

63. Higham, *Boundlessness to Consolidation,* p. 20; American Anti-Slavery Society, *Annual Report* (Boston, 1855), p. 109; Sarah Pugh to (Miss) Estlin, 28 February 1860, in *Memorial of Sarah Pugh,* pp. 95–96.

the *Advocate of Moral Reform* and the *Liberator,* magazines that focused on sin, redemption, and the decline of a virtuous republic.[64] In contrast, the generation of the 1850s read journals that reported on events in Congress and on the building of large, stable institutions. They read Harriet Beecher Stowe's *Uncle Tom's Cabin,* first published in the Liberty party paper, the *National Era,* and the best-selling novel of all time— and a symbol of the growing popularity of the antislavery cause.[65] Their families attended political conventions in which candidates became local heroes, their platforms as engrossing as those of the most ultraist reformers of twenty years before. Lillie B. C. Wyman recalled hearing Joshua R. Giddings, congressional representative from Ohio, when she was a small child in the 1850s.[66] Young women like Ellen Wright, Olympia Brown, and Charlotte Forten grew up with idols who were remarkable for any age—Lucy Stone, Lucretia Mott, and Abby Kelley Foster, to name a few. Even if wary of the woman's movement, well-informed young women felt less constrained by the rhetoric of propriety than had their mothers. They took for granted the benefits to women of dealing openly with government officials, and they were accordingly skeptical of romantic calls for the conversion of society or for the raising of men to a level of Christian womanhood.

In 1843 the once hesitant Sarah Shaw began to write the reports of the Massachusetts Anti-Slavery Society, a project that would occupy her for the next ten years.[67] That same year she gave birth to her daughter Josephine. Josephine was raised well after the flames of evangelical and ultraist reform had subsided; to her, the furious fervor of the early radicals and the expectation that exhortation could free the slaves had proved to be romantic and unsuccessful. During her youth, antislavery activists had come to seize upon electoral goals, even if her mother affiliated with those who shunned partisanship. The rhetoric of social

64. Stone Blackwell, *Lucy Stone,* pp. 16–17. Emily Howland's family subscribed to the *Liberator,* the *North Star,* the *Philanthropist,* and the *National Anti-Slavery Standard*: Willard and Livermore, *American Women,* 1:397–98.

65. The Philadelphia Female Anti-Slavery Society made a tribute to the book in its *Nineteenth Annual Report* (1853), pp. 10–11, but regretted that any part of it countenanced colonization. Lillie B. C. Wyman was said by abolitionist Henry C. Wright to know the story of *Uncle Tom's Cabin* before she was six years old: Wyman and Wyman, *Elizabeth Buffum Chace,* 1:130. Franklin Sanborn's "two or three strong influences" included the *National Era.* See his *Recollections of Seventy Years* (Boston: Gorham Press, 1909), 1:31.

66. Wyman and Wyman, *Elizabeth Buffum Chace,* 1:118.

67. Sarah B. Shaw to John Elliot Cairnes, 28 November 1862, in Adelaide Weinberg, ed., *John Elliot Cairnes and the American Civil War: A Study in Anglo-American Relations* (London: Kingswood Press, 1969), p. 155.

redemption through female virtue was for her an anachronism, and she would never adopt it.

Yet Josephine too experienced an awakening, that burst of emotion that characterized religious conversion. When she was not yet eighteen years old, the Civil War began. In contrast to some older abolitionists, whose calls for disunion and nonresistance sounded discordant in the face of battle, Josephine Shaw welcomed the conflict enthusiastically. "These are extraordinary times and splendid to live in," she wrote fervently in her diary. "This war will purify the country of some of its extravagance and selfishness. . . . It can't help doing us good; it has begun to do us good already." In language reminiscent of a previous generation's, she continued, "I suppose we need something every few years to teach us that riches, luxury and comfort are not the great end of life." Like countless other young women and men in wartime, Josephine wished she could fight. And like many of her background, she expressed that desire in quasi-religious terms. "I'm not an atom afraid of death," she wrote proudly, "and the enthusiasm of the moment would be sublime." Josephine's "awakening," so unlike, even counter to, that of her parents' generation, would lead her onto a path equally unfamiliar to older reformers.[68]

Josephine Shaw would have more than the usual chance to prove her enthusiasm for war. Almost exactly one year after her marriage to Charles Russell Lowell in 1863, he was killed in battle. While leading one of the earliest troops of black soldiers to serve the Northern army, her brother, Robert Gould Shaw, was also killed. Hers was not a naive view of the losses of war. Yet from her perspective, the war efficiently accomplished goals to which her mother and others had given decades of their lives with few visible results. George Fredrickson counts Josephine Shaw Lowell among a generation whom "the war . . . weaned . . . from an inheritance of utopian idealism and pointed . . . in the direction of a more conservative, 'realistic,' or practical approach to reform."[69]

Clearly the war played a major role in hardening a generation of activists and in redefining the terms of benevolence itself. But Lowell's

68. Josephine Shaw diary, 15 August 1861, 6 June 1862, in Stewart, *Philanthropic Work of Josephine Shaw Lowell,* pp. 16, 28. Significantly, Shaw went on to write that "Mother says she hates to hear me talk so."

69. George M. Fredrickson, *The Inner Civil War: Northern Intellectuals and the Crisis of the Union* (New York: Harper and Row, 1965), p. 215. For a sentimental version of Lowell operating a world of philanthropy from a desk behind which hung her husband's sword, see Ferris Greenslet, *The Lowells and Their Seven Worlds* (Boston: Houghton Mifflin, 1946), p. 334.

inheritance was already being modified by the 1850s, the decade in which she matured. Along with others of her generation, she entered the war from a world of electoral struggle and institutional goals, not one of grand moral impulses and radical enthusiasms. If the war was the final nail in the coffin of ultraist reform, the 1850s had readied the benevolent for its burial. The younger among them were fully prepared to identify with a war that, in Fredrickson's words, "weakened the feminine or humanitarian sentiments which the antislavery movement had tried to drum up . . . [and] turned the genuine radicalism of the prewar period into an obvious anachronism." This new generation replaced a fervor for evangelical reform with a passion bred by war.[70]

70. Fredrickson, *Inner Civil War*, p. 188.

# *Five*

## A Passion for Efficiency

This war "is exactly like a revival," cried eighteen-year-old Josephine Shaw, "—a direct work of God, so wonderful are some of the conversions."[1] For Shaw, the war promised all the passion and purpose that had been lacking in the previous decade. Indeed, many of Shaw's contemporaries, especially among the children of abolitionists, referred blissfully to the struggle for the "redemption of the nation" and to the "jubilee" that would follow the North's victory and the freeing of the slaves.[2] Yet these and other young women's actions undermined the enthusiasm of their words; wartime benevolent work celebrated explicitly business, not evangelical, principles, and the "conversions" that Shaw suggested signaled not a millennial vision of society but a glorification of the new virtues of efficiency and order. The themes that pervaded efforts at sustaining the soldiers (and, to a lesser extent, the freed slaves) contrasted sharply with those of an earlier age: nationalism, discipline, centralization, and, above all, efficiency became the watchwords of a new benevolence. In spite of Shaw's initial enthusiasm, the war deadened rather than awakened the flickering utopian impulse of her parents' generation.

1. Diary, 12 April 1862, in William Rhinelander Stewart, *The Philanthropic Work of Josephine Shaw Lowell* (New York: Macmillan, 1911), p. 24. "Glory to God!" cried a voice from the visitors' gallery of the Ohio State Senate when, on 12 April 1861, Southern troops fired on Fort Sumter, S.C. The voice was that of Abby Kelley Foster, who "after a lifetime of public agitation, [now] believed that only through blood could freedom be won," and thus "shouted a fierce cry of joy that oppression had submitted its cause to the decision of the sword": Jacob Dolson Cox, *Military Reminiscences of the Civil War* (New York: Charles Scribner's Sons, 1900), 1:2.

2. See, for an example of this enthusiasm, Lucy McKim to Ellen Wright, 12 August 1862, box 29, folder 800, Garrison Family Papers, Sophia Smith Collection, Smith College.

The conflation of femininity with benevolence had constituted an ideological given among antebellum Protestants. By the 1850s the radical possibilities of that ideology had already been weakened as women and men sought, in electoral and institutional strategies, the moral transformation of society. The generation that undertook the enormous task of providing Civil War relief went even further, replacing the language of gender identity—and of female moral superiority—with that of war. Civil War philanthropy aspired to a more "masculine" ideal, as the new generation of benevolent women and men proposed that scientific rather than moral principles characterize social welfare.

Civil War benevolent workers established the first centralized, quasi-public organization for the relief of Northern soldiers: the Sanitary Commission, backed by its women's branches, furnished food, clothing, and nurses for the nation's first "modern" war. In *The Inner Civil War,* George Fredrickson has argued that the leaders of these organizations, who were primarily members of the urban elite, sought by guiding the nation through its period of greatest stress to assert their own class, ideological, and regional prerogatives in the postwar society. The "Sanitary Elite," men and women such as Henry Bellows, Louisa Lee Schuyler, Frederick Law Olmsted, and Josephine Shaw Lowell, reacted against the utopian hopefulness of an earlier generation by appealing to national loyalty, not individual moral perfection, by urging manly exertion rather than feminine feeling, and by scorning humanitarianism and exulting in the reality of war. The Sanitary Commission's "belief in the need for an expert to act as intermediary between irrational popular benevolence and the suffering to be relieved," Fredrickson writes, "was the great contribution of the Sanitary Commission to American philanthropic ideas. . . . They were contributing to a general assault on the long-standing American belief in volunteerism."[3]

The women who built the Woman's Central Association of Relief in New York, the Sanitary Commission's main branch, had received their training at the knee of an older generation of benevolent women—a generation who (even as they had embraced the belief that it was the essentially female and unbusinesslike quality of feeling and morality that would transform the world) had gone carefully and methodically about putting benevolent work on a corporate footing. But their daughters would take this legacy to new heights of organizational fervor in the

---

3. George M. Fredrickson, *The Inner Civil War: Northern Intellectuals and the Crisis of the Union* (New York: Harper and Row, 1965), p. 108, and chap. 7, "The Sanitary Elite."

work of supplying the army, training and sending nurses and agents to the front, and establishing local and regional centers for the systematization of their work. "Now is the judgment of this generation," warned abolitionist and war nurse Hannah Ropes.[4] Raised in the utilitarian 1850s—and thus considerably less susceptible to the rhetoric of sentiment than their mothers had been—a new generation of benevolent women combined the lessons of corporate benevolence with those of warfare. Whereas religious awakenings, the emergence of distinctly urban poverty, and a yearning toward moral reform had molded an older generation's approach to social change, a war provided the younger generation with its most significant experience, its period of passionate commitment to the nation's moral struggle. In contrast to the workers in previous benevolent organizations, the new generation displayed an elaborate concern for the details of organizational structure. Also unlike their antebellum counterparts, the leaders of the Sanitary Commission extolled a language of wartime discipline that for them defined the essential nature of the war experience. It was a change that wrought a profound intellectual transformation in women's reform, and one that eventually challenged the most fundamental tenets of benevolent femininity.

The war forced the business of benevolence into the open by stripping away—albeit temporarily—the rhetoric which concealed the essential nature of that work. This wartime visibility provoked the first public debates about paying benevolent agents and centralizing relief, issues that previous generations had taken for granted. Mistaking this greater attention to benevolent work for the dawn of women's public activity, observers have made extravagant claims for the Civil War's impact on Northern women. The authors of the *History of Woman Suffrage,* insisting that the "social and political condition of women was largely changed by our civil war," believed that the war "created a revolution in woman herself."[5] The war, insisted a wide range of writers and lecturers, weakened the barriers between women's and men's ap-

---

4. Diary, 26 December 1862, in John R. Brumgardt, ed., *Civil War Nurse: The Diary and Letters of Hannah Ropes* (Knoxville: University of Tennessee Press, 1980), pp. 117.

5. Elizabeth Cady Stanton, Susan B. Anthony, and Matilda Joslyn Gage, *History of Woman Suffrage* (New York: Fowler and Wells, 1882), 2:23. For traditional interpretations of the war's expansion of women's horizons, see, e.g., Agatha Young, *The Women and the Crisis: Women of the North in the Civil War* (New York: McDowell, Obolensky, 1959) Marjorie Barstow Greenbie, *Lincoln's Daughters of Mercy* (New York: G. P. Putnam's Sons, 1944); and Mary Elizabeth Massey, *Bonnet Brigades* (New York: Alfred A. Knopf, 1966).

propriate activities. "Women pay not the least regard to the sententious definitions about themselves . . . ," asserted a wartime writer in *Frank Leslie's Illustrated Newspaper.* "The one sensible suggestion . . . is, that women should test what they can do by the same standard and the same tests that are applied to men."[6] According to these writers, the Civil War forced women to adapt their meager organizational and nursing skills to meet unforeseen demands.

The significance of the Civil War for Northern women lay more in heightening trends that had been apparent in the 1850s than in opening wholly new horizons. The work of abolitionists provides one example. The war reinforced abolitionists' transition to a political—and national—rather than a religious basis of authority. Whether as agitators for wartime policies or as teachers of ex-slaves, they experienced the war as the climax of decades of work to eradicate the sin of slavery—work finally to be undertaken by political and military means. By the postwar period, having largely discarded the language of moral change, they would no longer identify themselves as workers for a benevolent cause.

These reformers, the most radical of antebellum middle-class Protestants, were in some sense peripheral to the transformation of wartime benevolence. Some recognized that the Civil War culminated their greatest work, and several of them spent the war years compiling papers and memoirs of the antislavery movement; others engaged in bickering within their organizations over when their work could be declared ended.[7] Older women abolitionists continued the agitational and lobbying work of the previous decades, often in overt opposition to the war effort, which they considered insufficiently antislavery. Through the old abolitionist organizations as well as through the National Women's Loyal League, abolitionists and woman's rights activists ran massive petition drives, held conventions, and called on Lincoln to fight openly for

6. *Frank Leslie's Illustrated Newspaper* 15 (27 September 1862): 2. Wartime writers disputed at length the issue of Northern women's readiness for wartime sacrifices. See Gail Hamilton [Mary Abigail Dodge], "A Call to My Country-women," *Atlantic Monthly* 11 (March 1863): 345–49; *A Few Words in Behalf of the Loyal Women of the United States, by One of Themselves* [response to Hamilton] (New York: Loyal Publication Society, tract number 10, 1863); and Ann S. Stephens, *Address to the Women of the United States* (Washington, D.C.: Gibson Brothers, 1864).

7. See Lawrence J. Friedman, *Gregarious Saints: Self and Community in American Abolitionism, 1830–1870* (New York: Cambridge University Press, 1982), chap. 9. On abolitionists' ambivalence about the war, see, e.g., Lillie Buffum Chace Wyman and Arthur Crawford Wyman, *Elizabeth Buffum Chace, 1806–1899: Her Life and Its Environment* (Boston: W. B. Clarke, 1914), 1:215–20.

antislavery principles.[8] After the Emancipation Proclamation took effect in January 1863, they began in earnest to battle for blacks' and women's political rights and for blacks' material welfare; Maria Weston Chapman, for example, early in the war devoted herself (and her finances) to freedpeople's aid associations. Although they found it "difficult to rouse [most women's] enthusiasm for an idea" and complained that "the mass of women never philosophize on the principles that underlie national existence," these activists boasted self-righteously that "there were those in our late war who understood . . . that to provide lint, bandages, and supplies for the army, while the war was not conducted on a wise policy, was labor in vain."[9] Yet as their movement drew to a close in the crisis of wartime, abolitionists sensed as well that an ultraist style of reform and its moral rhetoric had given way to a new era, one more conducive to war.

Building on abolitionists' traditional role as agitators and secondarily as self-proclaimed "uplifters" of free blacks, some women, both black and white, joined the experiment to introduce the former slaves to literacy and self-sufficiency, thus working to make concrete the hope that the war would end slavery. "A new field of labor has opened to us," announced the Rochester Ladies' Anti-Slavery Society in 1863: ". . . comforting, cheering, advising, educating the *freed* men, women, and children of the race upon whom . . . the chains seemed so securely fastened." Significantly, it was younger abolitionists—women who at the beginning of the antislavery movement were "too young . . . to have any political views whatever"—who most often went south to work with freed and escaped slaves, while veterans such as Sarah Pugh felt "happy to look on & see younger hands at the work."[10] Many rather

8. On the National Women's Loyal League, see N.W.L.L., *Proceedings of the Meeting of the Loyal Women of the Republic, Held in New York, 14 May 1863* (New York: Phair, 1863); Nancy A. Hewitt, *Women's Activism and Social Change: Rochester, New York, 1822–1872* (Ithaca: Cornell University Press, 1984), p. 196; and Stanton et al., *History of Woman Suffrage,* 2:50–89. On the work of the antislavery societies during the war see, e.g., Philadelphia Female Anti-Slavery Society, *Annual Reports* 27–31 (1861–65).

9. Friedman, *Gregarious Saints,* pp. 260–61; Stanton et al., *History of Woman Suffrage,* 2:2, 3. See also Massey, *Bonnet Brigades,* pp. 163–67, and Elizabeth Cady Stanton, *Eighty Years and More: Reminiscences, 1815–1897* (New York: Schocken Books, 1975; orig. 1898), pp. 234–44.

10. Rochester Ladies' Anti-Slavery Society, *Twelfth Annual Report* (Rochester: A. Strong, 1863), p. 3; Willie Lee Rose, *Rehearsal for Reconstruction: The Port Royal Experiment* (New York: Vintage Books, 1964), p. 37; Pugh to Elizabeth Neall Gay, 6 April 1862, in Gay. See Hewitt, *Women's Activism and Social Change,* pp. 192–94, on ultraists' work during the

easily put aside pacifist and antigovernment convictions to declare their intention to go to war. Quaker Cornelia Hancock recalled, "After my only brother and every male relative and friend that we possessed had gone to the War, I deliberately came to the conclusion that I, too, would go and serve my country."[11]

For Hancock as for many others, careers in nursing and teaching merged. She served at the hospital in Gettysburg, worked with freed blacks in Washington, D.C., and finally moved to South Carolina to teach. Lucy and Sarah Chase and Laura Towne were actually planning to become nurses when the opportunity arose to teach.[12] Laura Haviland ran a manual labor school for both black and white children, worked for the Sanitary Commission, did hospital work, and then became an agent of the Freedmen's Aid Commission. Charlotte Forten seems to have had no specific plans until John Whittier suggested that she go to Port Royal: "He is very desirous that I sh'ld go," she noted in her diary. "I shall certainly take his advice." Others, both black and white, worked under the auspices of the American Missionary Association (a society led by, among others, Lewis Tappan), which abandoned domestic missions in favor of establishing schools among the freed blacks; by 1867 the society had established hundreds of schools, located in virtually every Southern state.[13]

---

war. According to Emerson David Fite, in the final year of the war, at least one thousand Northern women and men went to the South to teach and otherwise assist ex-slaves: *Social and Industrial Conditions in the North during the Civil War* (New York: Macmillan, 1910), p. 295.

11. Henrietta Stratton Jaquette, ed., *South after Gettysburg: Letters of Cornelia Hancock, 1863–1868* (New York: Thomas Y. Crowell, 1956; orig. 1937), p. 4. On the society that paid her ($28 per month) as its agent, see Henrietta Stratton Jaquette, "Friends' Association of Philadelphia for the Aid and Elevation of the Freedmen," *Bulletin of Friends' Historical Association* 46 (Autumn 1957): 67–83.

12. Jaquette, *South after Gettysburg,* pp. 30–50; Hannah E. Stevenson to [Sarah?] Chase, 9 November 1862, in Henry L. Swint, ed., *Dear Ones at Home: Letters from Contraband Camps* (Nashville: Vanderbilt University Press, 1966), pp. 17–18.

13. Diary, 9 August 1862, *The Journal of Charlotte L. Forten: A Free Negro in the Slave Era,* ed. Ray Allen Billington (New York: Dryden Press, 1953), p. 136. It took a great deal of bureaucratic maneuvering before Forten got her commission. Other letters from black teachers are in Dorothy Sterling, ed., *We Are Your Sisters: Black Women in the Nineteenth Century* (New York: W. W. Norton, 1984), pp. 261–305. Published letters by white women are plentiful. Among the most useful is Rupert Sargent Holland, ed., *Letters and Diary of Laura M. Towne Written from the Sea Islands of South Carolina, 1862–1884* (New York: Negro Universities Press, 1969; orig. Cambridge, Mass.: Riverside Press, 1912); on the Port Royal experiment, which included Laura Towne and others, see Rose, *Rehearsal for Reconstruction;* on the American Missionary Association see Joe M. Richardson, *Christian Reconstruction: The American Missionary Association and Southern Blacks, 1861–1890* (Athens: University of Georgia Press, 1986), esp. chap. 10, "Yankee Schoolteachers."

What most distinguished these teachers from other wartime relief workers was their explicit commitment to antislavery and their sense of their war work as a continuation of abolitionists' efforts. For them, living among the former slaves, teaching schools of as many as four hundred students, and struggling to provide food, clothing, and health care in areas isolated and threatened by warring armies comprised the obvious next step in the moral battle to end slavery after the military one was well under way. Seeing in the work among the freedpeople the best assurance that the war was, after all, an antislavery war (the teachers played a significant role in making it so), Northern antislavery societies raised money and collected supplies for agents and read anxiously the reports of those in the field that "Government means to do right by these refugees from slavery."[14] That the workers among the freedpeople would find themselves increasingly isolated from—indeed, largely abandoned by—Northern societies signaled the continued marginality of abolitionists, the utter lack of concern by most Northerners for the freed blacks, and the transformed focus of benevolence itself.

Whether as teachers in the South or not, younger activists were more likely than were their mothers to become caught up in enthusiasm for the conflict. Sarah Pugh, who was over sixty when the war began, followed events closely but concluded that her "faith in the peace principles only waxes stronger." Twenty-one-year-old Ellen Wright, in contrast, approved of the war effort: "I wouldn't *look* at a nonresistant," she insisted. Younger abolitionists' very language evoked evangelical memories even as they rejected the ultraist nonviolence of their elders. "O! this war is a great grand thing!" exulted Lucy McKim. "A sharp resistless cure for a huge disease. . . . Can anyone help being 'restless for action?'" Both Ellen Wright and Lucy McKim hungered for a larger, even a military, role in the moral conflict. "The whole cry of my soul is that all the battles may not be fought without my having fired one shot," wailed McKim.[15]

14. Rochester Ladies' Anti-Slavery Society, *Twelfth Annual Report,* p. 19. Supplies are listed on p. 16. Accounts of the struggles of these teachers are in all their letters and diaries. Lucy Chase's school of four hundred students was exceptional, but many teachers found themselves with more than one hundred pupils at a time. See Chase letter, 24 December 1863, in *Extracts from Letters of Teachers and Superintendents of the New-England Educational Commission for Freedmen* (4th ser., 1864), p. 12.

15. Diary, 14 July 1861, *Memorial of Sarah Pugh: A Tribute of Respect from Her Cousins* (Philadelphia: J. B. Lippincott, 1888), p. 98; Ellen Wright to Lucy McKim, 16 November 1861, box 14, folder 378, Garrison; final two quotations are in Lucy McKim to Ellen Wright, 1 February 1863, box 29, folder 801, Garrison. McKim joined her father, Laura Towne, and Charlotte Forten at Port Royal, where she worked with freed slaves and collected information

Not surprisingly, younger abolitionists were also more likely to express their enthusiasm in terms of loyalty to the government. Although the teachers might share abolitionists' characteristic distrust of politicians, in their determination to remain in the South they found themselves far more dependent on the government and its agencies than their elders would ever have dreamed. Those women who were active on behalf of the former slaves continued the work of abolition in the context of a partnership between government and benevolent societies; physically removed from the centers of Northern benevolence, they also experienced a sense of intellectual distance from their elders' antiquated insistence on remaining above the fray of partisan political life. Personal loyalties reflected this change: It was during the war that Garrisonian abolitionist Sallie Holley, now working among the freedpeople, first identified herself as a Republican and became fervent in her support of the governing party. Similarly, younger reformers were more excited than were their elders over the promise of the Emancipation Proclamation. Ellen Wright admitted to Susan B. Anthony that "Mother thinks the President's Proc. of Emancipation no such great things, after all." But her friend Lucy McKim disagreed: "O! that proclamation! Is it not worth living for, selfish & imperfect as it may seem to Abolitionists?" A bit prematurely, but with characteristic enthusiasm for what the government would do for the freed slaves, McKim exclaimed, "Goodbye! . . . The Rebellion is over, & I think the Millenium is some where 'round."[16]

The war may have represented a millennium for young abolitionists. For the leaders of Civil War relief organizations it offered instead an opportunity to establish careers that would help redefine the ideology of benevolence. On 25 April 1861, fifty or sixty women met at the New York Infirmary for Women and Children, founded by Doctors Elizabeth and Emily Blackwell, to plan an organization that would coordinate the disparate efforts by women in New York. "The importance of system-

---

for her later work on slave songs. Wright, who wanted badly to be a nurse, remained restlessly at home, active in the Loyal League.

16. John White Chadwick, ed., *A Life for Liberty: Anti-Slavery and Other Letters of Sallie Holley* (New York: G. P. Putnam's Sons, 1899), p. 191; Ellen Wright to Susan B. Anthony, 25 September 1862 (continues from letter of 18 September 1862), box 14, folder 370, Garrison; Lucy McKim to Ellen Wright, 1 October 1862, box 14, folder 370; Lucy McKim to Ellen Wright, 27 May 1864, box 29, folder 802, Garrison. Wright and McKim's Civil War letters blend wartime enthusiasm with both details of friends' deaths in the war and plans for both their approaching marriages to the Garrison brothers. Wright's wartime letters to William Lloyd Garrison, Jr., are also included in the Garrison collection.

atizing and concentrating the spontaneous and earnest efforts now making [*sic*] by the women of New York . . . must be obvious to all reflecting persons," began the appeal "to the Women of New York," heralding a transformation in benevolence. "Numerous societies, working without concert, organization, or head . . . are liable to waste their enthusiasm in disproportionate efforts." The society would coordinate the collection and distribution of supplies and would screen and train women nurses for the military hospitals. Even in this earliest document, the proposed organization was clear about its relationship to antebellum ideals: it sought to bring order from the supposed chaos of benevolent enthusiasm. "It will at once appear that without a central organization, with proper authority, there can be no efficiency, system, or discipline in this important matter of nurses," stated the appeal. Signed by ninety-one "Most Respected Gentlewomen," the appeal asked women, doctors, and ministers to meet at the Cooper Institute the following Monday.[17]

Some two to three thousand women and many of New York's most prominent benevolent men attended the founding of the Woman's Central Association of Relief. Demonstrating the federal government's approbation of the women's work and the status of the organizers, Vice President Hannibal Hamlin addressed the audience. A committee of twelve men and twelve women was appointed to govern the organization.[18] The W.C.A.R. (and the other organizations that would eventually become regional branches of the Sanitary Commission) differed dramatically from older benevolent societies in the vastness of its scale, the scope of its distribution of war resources, and its leaders' almost obsessive concern with organizational matters. In other respects as well, the organi-

17. "To the Women of New York," in U.S.S.C. (doc. no. 32), *Report concerning the W.C.A.R.* (New York: William C. Bryant, 1861), pp. 6, 9; Greenbie, *Lincoln's Daughters of Mercy,* p. 65. See also Young, *Women and the Crisis,* pp. 72–77. (All U.S.S.C. numbered documents appear in *Documents of the United States Sanitary Commission, 1861–66,* 3 vols. [New York, 1866–71].)

18. Greenbie, *Lincoln's Daughters of Mercy,* p. 65, claims that 4,000 women attended; Massey, *Bonnet Brigades,* p. 33, says 3,000 "New Yorkers" attended; *New York Times,* 30 April 1861, p. 8, says 2,000; *New York Herald,* 30 April 1861, says 3,000. Historical accounts of relief organizing as well as those about nurses have suffered from jingoism. For quite different accounts of the founding of the Sanitary Commission see Charles J. Stillé, *The History of the United States Sanitary Commission* (New York: Hurd and Houghton, 1868), esp. pp. 40–43, 178–83; Greenbie, *Lincoln's Daughters of Mercy,* esp. pp. 41–42, 54–60, 70–73; William Quentin Maxwell, *Lincoln's Fifth Wheel: The Political History of the United States Sanitary Commission* (New York: Longmans, Green, 1956), pp. 1–3; and Robert H. Bremner, *The Public Good: Philanthropy and Welfare in the Civil War Era* (New York: Alfred A. Knopf, 1980), pp. 37–46.

zation of the W.C.A.R. signaled a departure for benevolent organizing. In September 1861 the association became an auxiliary to the Sanitary Commission "at its own generous instance, . . . retaining full power to conduct its own affairs in all respects independently of the Commission." The *New York Times* underscored the ambiguity of the association's position when it informed the public that the Woman's Central Association of Relief "was . . . incorporated with (or rather as an auxiliary branch of) the U.S. Sanitary Commission." Although its female and male leaders were technically organized separately, the Sanitary Commission made no secret of the fact that they worked closely together, showing, according to Bellows, "no disposition to discourage, underrate, or dissociate from each other."[19] The relations between the women and men who led the Civil War relief organizations indicated new assumptions about the professionalism of benevolence.

The women who became the officers of the Woman's Central Association of Relief were born between 1828 (Abby Woolsey, Ellen Collins) and 1843 (Josephine Shaw Lowell). All were from quite well-to-do families established in professional and mercantile life as well as in urban benevolence. They were too young to have filled leadership roles prior to the war, although some had worked in already established benevolent organizations.[20] Louisa Lee Schuyler, the undisputed leader in the work, was only twenty-four when the war began; Josephine Shaw joined the executive committee in 1863, when she was only twenty. Caroline Lane was twenty-two in 1863, Georgeanna Woolsey was twenty-nine, and Angelina Post was probably in her twenties. Of the eight women on the executive committee that year (there were also six men), only two were married.[21] The builders of the machinery of war

19. Frederick Law Olmsted, "Communication to the Woman's Central Assoc'n, N.Y., expressive of the mutual advantages resulting from the connexion with the San. Com., Sept. 10, 1861," box 735, United States Sanitary Commission Records, Rare Books and Manuscripts Division, New York Public Library; *New York Times,* 10 November 1861, p. 8; Bellows, in Linus Brockett and Mary C. Vaughan, *Woman's Work in the Civil War: A Record of Heroism, Patriotism, and Patience* (Philadelphia: Zeigler, McCurdy, 1867), p. 42.

20. Abby Woolsey, e.g., served as an assistant manager of the House of Industry on 16th Street in New York: Anne L. Austin, *The Woolsey Sisters of New York: A Family's Involvement in the Civil War and a New Profession, 1860–1900* (Philadelphia: American Philosophical Association, 1971), p. 14. See also Austin, "Abby Howland, Jane Stuart and Georgeanna Muirson Woolsey," in *Notable American Women, 1607–1950: A Biographical Dictionary,* ed. Edward T. James and Janet Wilson James (Cambridge: Harvard University Press, 1971), 3:665–68; Shirley Phillips Ingebritsen, "Abby Williams May," in ibid. 2:513; and Ednah Dow Cheney, *Memoirs of Lucretia Crocker and Abby W. May* (Boston, 1893).

21. Lane, Post, Georgeanna Woolsey, and Gertrude Stevens all married after the war. Post's age is guessed because after the war (1869) she married Caspar Wistar Hodge, who was

relief had barely begun their adult lives when they ventured to systematize on a national scale the feeding, clothing, and healing of the soldiers.

None of these young women signed the appeal "to the Women of New York," which launched the association. Those whose names appear were older, established figures in benevolence; of the ninety-one women who signed, only two were unmarried. The women who actually ran the day-to-day operations of the Woman's Central Association of Relief had neither the status nor the influence to be considered essential to a public appeal. Nevertheless, it was these younger women, rather than the thousands of middle-aged women who organized local aid societies, who best characterized the changing style of that work. "I shall have some trouble to subdue the zeal of Miss Mary Hamilton and Miss Schuyler," wrote forty-year-old Maria Lydig Daly of the Women's Patriotic League. "I plainly see they have made me president but wish to rule themselves."[22] These young women approached their careers with a vision nurtured in the decade of the 1850s and a fervor inspired by war.

It was in wartime nursing that the women and men who ran the United States Sanitary Commission and its branches found the opportunity to repudiate older notions of female benevolence most explicitly. The approximately thirty-two hundred women nurses received the most public attention during and after the war, both praise for their "pure" benevolence and contempt for their "sentimental" care.[23] Although the Civil War truly elevated nurses' status in the form of pay and government authorization, nurses came to epitomize the tension between the traditional emphasis on sentiment and womanly feeling on the one hand and the new values of scientific care on the other. The actual experiences of Civil War nurses resembled those of the women who worked among the freedpeople; both confronted military intransigence to their work, miserable living conditions, and, if not appointed as government agents, disputes over their prerogatives as representa-

born in 1830; she was his third wife and had two children with him. See Woman's Central Association of Relief, *Second Annual Report* (New York: William S. Dorr, 1864), for the list of officers.

22. Maria Lydig Daly, diary, 8 June 1864, in Harold Earl Hammond, ed., *Diary of a Union Lady, 1861–1865* (New York: Funk and Wagnalls, 1962), p. 299. In Rochester, older, more experienced leaders led local soldiers' aid societies: Hewitt, *Women's Activism and Social Change,* p. 197.

23. The estimate of the number of nurses is in Maxwell, *Lincoln's Fifth Wheel,* p. 69, and in George Worthington Adams, *Doctors in Blue: The Medical History of the Union Army in the Civil War* (New York: Harry Schuman, 1952), p. 178. Adams attributes the estimate to Samuel Ramsay, a former chief clerk at the Medical Bureau.

tives of private benevolence. Yet nurses also encountered the leaders of Civil War relief work, women and men who claimed for themselves the mandate to discipline wartime benevolence and who subjected nurses to the tangled skeins of the ideology of benevolent femininity.

Whether women became nurses under the auspices of the Sanitary Commission, were directly commissioned by the government, or had no official status, according to popular rhetoric they sought to create a semblance of home amid the horrors of war. Mary Ann Bickerdyke, for example, achieved her fame for nursing "with a mother's self-sacrificing devotion." Nurses emphasized that the mere presence of women was "joyfully welcomed," that it "brought to [the boys'] minds mother and home."[24] If their labor consisted of wrenching, debilitating, dangerous work, writers continued to stress that nurses' duties included "various works of love, to be truly devoted to the soldier's temporal and eternal welfare."[25]

In their attitudes toward this humanitarian sentiment—and toward the women who were its representatives—the young leaders of Civil War relief expressed a new elitism, one that rejected the tenets of "virtuous femininity" that had characterized the antebellum era—and to which most women still adhered. "If I owned a hospital no philanthropist should ever enter," vowed young Caroline Woolsey from the

24. "Diary of Mrs. E. C. Porter," *Sanitary Commission Bulletin* 1:21 (1 September 1864): 660. Also in Mary H. Porter, *Eliza Chappell Porter: A Memoir* (Chicago: Fleming H. Revell, 1892), p. 198. For more on "Mother" Bickerdyke see George W. Adams, "Mary Ann Ball Bickerdyke," in *Notable American Women,* ed. James and James, 1:144–46, and Brockett and Vaughan, *Woman's Work in the Civil War,* pp. 172–86. Examples of the use of the rhetoric of "hominess" pervade the literature. See, e.g., Jane C. [Blaikie] Hoge, *The Boys in Blue; or Heroes of the "Rank and File"* (New York: E. B. Treat, 1867), p. 111.

25. "The Soldier's Friend!" *S.C. Bulletin* 3:30 (15 January 1865): 938–39. Women nurses were both more and less central to the legacy of the war than the myths about them convey. Clara Barton, e.g., idealized for generations as the "angel of the battlefield," was indeed a courageous figure. Yet even Marjorie Greenbie, who considers Barton "a kind of natural multiplier of the loaves and fishes," admits: "The legend that surrounded her, and the memory she left behind her were much greater than anything she seems to have actually done . . . during the Civil War": Greenbie, *Lincoln's Daughters of Mercy,* p. 161. On Barton see also Merle Curti, "Clara Barton," in *Notable American Women,* ed. James and James, 1:103–08; Bremner, *Public Good,* pp. 65–69; and Brockett and Vaughan, *Woman's Work in the Civil War,* pp. 111–32 and frontispiece; Young, *Women and the Crisis,* has many references. Even the authors of *History of Woman Suffrage,* 2:23–26, glorified Barton's impartial benevolence. On other Northern nurses, see Brockett and Vaughan, *Woman's Work in the Civil War;* Frank Moore, *Women of the War: Their Heroism, and Self-Sacrifice* (Hartford: S. S. Scranton, 1866); Mary A. Gardner Holland, *Our Army Nurses: Interesting Sketches, Addresses, and Photographs* (Boston: B. Wilkins, 1895); Anna Morris Holstein, *Three Years in Field Hospitals of the Army of the Potomac* (Philadelphia: J. B. Lippincott, 1867); and Charlotte E. McKay, *Stories of Hospital and Camp* (Philadelphia: Claxton, Remsen and Haffelfinger, 1876).

Beverly Hospital near Philadelphia. "I could have pounded two benevolent old ladies yesterday on a tour of 'inspection' through my ward." These young women's contempt for the traditional virtues of female benevolence merged with that of their male contemporaries and later historians for the "hoards of eager women" who filled hospital wards and whose greatest fault was "self-righteousness." Surgeon Francis Bacon, who would later marry Georgeanna Woolsey, wrote half-seriously of being "subjugated and crushed by a woman who sings the Star Spangled Banner copiously through all the wards of my hospital." Bacon's main complaint concerned the woman's disrespect for his professional position, for she remained "unabashed by the fact that I am the Surgeon-in-Charge, and that an orderly in white gloves stands at the door."[26]

This scorn for "pure benevolence"—and the assumption that that phrase precisely defined their contribution to the war—shaped both the wartime experience and the postwar image of competent female nurses. Indeed, for nurses the main struggle of the war may have been the constant battle between old and new values. Reformer Dorothea Dix, who did not want to be judged by her role as superintendent of the women nurses, epitomized this tension.[27] Dix's service pleased no one, as she struggled against a morass of organizational and bureaucratic obstacles to adhere to her "old style" humanitarianism. Accounts of her work range from backhanded praise (she "was an old hand at pushing the officials in Washington around") to simple contempt (she was "a muddled executive, . . . a mother hen"). Commission treasurer George Templeton Strong called Dix a "philanthropic lunatic" and blamed her for the various schisms within the Sanitary Commission. George Fredrickson summarizes the Sanitary Commissioners' attitude toward Dix in a most telling phrase: she was, they believed, an "irresponsible do-gooder."[28]

The younger generation of benevolent women expressed consider-

26. Woolsey quoted in Sylvia G. L. Dannett, ed., *Noble Women of the North* (New York: Thomas Yoseloff, 1959), p. 306; Adams, *Doctors in Blue*, pp. 176, 182; Bacon quoted in Austin, *Woolsey Sisters*, p. 81.

27. Fredrickson, *Inner Civil War*, p. 110. See also Dorothy Clarke Wilson, *Stranger and Traveler: The Story of Dorothea Dix, American Reformer* (Boston: Little, Brown, 1975), pp. 264–307, and Francis Tiffany, *Life of Dorothea Lynde Dix* (Boston: Houghton, Mifflin, 1891), pp. 331–43.

28. Greenbie, *Lincoln's Daughters of Mercy*, p. 63; Adams, *Doctors in Blue*, p. 179; Young, *Women and the Crisis*, p. 103; Maxwell, *Lincoln's Fifth Wheel*, p. 101; Fredrickson, *Inner Civil War*, p. 110. See too Laura Ward Roper, *FLO: A Biography of Frederick Law Olmsted* (Baltimore: Johns Hopkins University Press, 1973), p. 177.

able—if sometimes exaggerated—impatience with Dix's old-fashioned priorities. Some objected to Dix's insistence that nurses be over thirty and "plain"; according to Jane Stuart Woolsey, these regulations resulted in "the unprecedented spectacle of many women trying to make it believed that they are over thirty!"[29] Louisa May Alcott, who spent a month in late 1862 nursing at the Union Hospital in Georgetown, thought Dix "very queer and arbitrary." In her derision of Dix, Jane Woolsey embraced military imagery as she urged her nursing sisters to assert their own prerogatives: "Whatever you do, go in and win. Outflank the Dix by any and every means in your power, remembering that prison visitors and hospital visitors and people who really desire to do good have taken no notice of obstacles." "We had a good-natured laugh over a visit from Miss Dix," wrote Georgeanna Woolsey, "who, poor old lady, kept up the fiction of appointing all the army nurses." Dix failed, observes George Fredrickson, "because of the very qualities which had produced her prewar triumphs."[30]

Nurses were further resented for having been commissioned by the government over the objections of the military; in this regard the leaders of relief organizations, committed to distinguishing between competent nurses and unregulated visitors and to allying with governmental authorities, defended them. If the public's view of nurses ranged from sentimental adoration to cynical tolerance, many army doctors (who, according to Georgeanna Woolsey, cared only about "that sublime, unfathomed mystery—'Professional Etiquette,'" which, within the medical department, "was an absolute Bogie") regarded them with simple contempt.[31] Woolsey recalled bitterly:

29. Dannett, *Noble Women,* p. 47. Dix described the ideal candidate, in ibid., pp. 62–63. In spite of Dix's efforts, women continued to come to hospitals without commissions to nurse family members or simply to care for "the boys"; upon being rejected by Dix on the grounds of age and appearance, twenty-three-year-old Cornelia Hancock simply sneaked onto a train where she remained until her arrival in Gettysburg: Jaquette, *South after Gettysburg,* p. 6. See also Young, *Women and the Crisis,* pp. 90–104. On rivalries between Protestant and Catholic nurses see Adams, *Doctors in Blue,* pp. 183–84; Maxwell, *Lincoln's Fifth Wheel,* p. 68; and Mary Ashton [Rice] Livermore, *My Story of the War* (Hartford: A. D. Worthington, 1889), pp. 224–25. A letter by "Truth" (a Miss Powell) in the *New York Times* of 4 December 1861, p. 3, complained that Dix never touched a soldier but only administered. Hancock noted that Dix "stuck her head in the tents" but did not work; she was pleased that "her nurses are being superseded very fast": Hancock to Sallie (her niece), 8 August 1863, in Jaquette, *South after Gettysburg,* p. 21.

30. Louisa May Alcott, *Hospital Sketches* (Boston: J. Redpath, 1863), p. 146; Dannett, *Noble Women,* pp. 91, 305; Fredrickson, *Inner Civil War,* p. 110.

31. Woolsey quoted in Dannett, *Noble Women,* p. 89. See also U.S.S.C., *Report concerning the W.C.A.R.,* pp. 28–29. Hannah Ropes voiced a common complaint in referring to one

No one knows, who did not watch the thing from the beginning, how much opposition, how much ill-will, how much unfeeling want of thought, these women nurses endured. . . . Government had decided that women should be employed, and the army surgeons . . . determined to make their lives so unbearable that they should be forced in self-defence to leave. It seemed a matter of cool calculation, just how much ill-mannered opposition would be requisite to break up the system.[32]

The image of sentimental nursing clung to women in spite of evidence that many nurses were efficient, official, and hard working. Mary J. Safford, for instance, "brought order out of chaos [and] systematized the first rude hospitals" but was remembered as a "little angel." Determined to inject nursing with the same tone of efficiency that, in theory, characterized relief work on the home front, several young women who had been active in the Woman's Central Association of Relief entered nursing in the spring and summer of 1862. They joined Sanitary Commissioners Frederick Law Olmsted and Frederick Knapp on the hospital transports, ships granted by the government to move wounded soldiers from the Virginia peninsula to army hospitals.[33] Four women served on the *Daniel Webster* until late August, when the campaign ended: Katherine Wormeley from Newport, Christine Griffin, Eliza Woolsey Howland, and Georgeanna Woolsey from New York, all of whom were "from the higher walks of society, women of the greatest culture and refinement." A great deal was made of the young women's social standing: "The women [on the hospital transports]," stated an article in the *Sanitary Commission Bulletin,* "belong nearly all to the most wealthy or most respectable families. . . . This is the more surprising, because it could not be supposed that their former habits of comfort

doctor who "delight[ed] so in the exercise of brief power over others": diary, 8 November 1862, in Brumgardt, *Civil War Nurse,* p. 93. See also Ann Douglas Wood, "The War within a War: Women Nurses in the Union Army," *Civil War History* 18 (September 1972): 197–211.

32. Quoted in Dannett, *Noble Women,* p. 88.

33. Quoted in Greenbie, *Lincoln's Daughters of Mercy,* p. 83. On Safford see Brockett and Vaughan, *Woman's Work in the Civil War,* pp. 357–61. On the hospital transports see Greenbie, *Lincoln's Daughters of Mercy,* pp. 124–31, and United States Sanitary Commission, *Hospital Transports: A Memoir of the Embarkation of the Sick and Wounded from the Peninsula of Virginia in the Summer of 1862* (Boston: Ticknor and Fields, 1863). A number of women, including Abby May, Harriet Whetten, and women married to the Sanitary Commissioners, served on the transports for varying periods of time. See Ingebritsen, "Abby Williams May," *Notable American Women,* ed. James and James, 2:514; on Olmsted's experience, see Roper, *FLO,* pp. 190–206.

and luxury could prepare them for encountering the perils and priva-tions which they must necessarily meet with in this field of labor." The work of these women was as arduous as any in the war. They loaded, unloaded, inventoried, and distributed the supplies that arrived on the ships; washed, fed, and nursed patients under dreadful conditions; and put the vessels into condition for use as hospital transports.[34]

Because of their insistence on a new style adapted to war, the young women' on the transports considered themselves unburdened by the rhetoric of benevolent femininity; they were, they boasted, well received by the men. Everyone, "official, military, naval, and medical . . . re-spect[s] our work, and rightly appreciate[s] it," wrote one. "They strengthen our hands when they can, they make no foolish speeches, but are direct and sensible in their acts and words." One male co-worker exclaimed: "God knows what we should have done without [the ladies]!" The four women were celebrated for their youth and refinement but, above all, for their efficiency; they came to represent—in no small part as a result of their own memoirs—a new style of benevolence.[35]

The war experience confirmed to many younger women that "calls of humanity," as Abby Hopper Gibbons termed her own wartime du-ties, were less pertinent to the war effort than were calls to order.[36] Over four years of war, unaffiliated women such as Clara Barton and Mary Bickerdyke found themselves with a shrinking role in the work at the front, as the Sanitary Commission solidified its hold on the collection and distribution of supplies, the assignment of nurses in the field, and the development of a new rhetoric of order. Although there were still women who trespassed boldly over official restrictions in the name of humanity, a new spirit pervaded the war. Far from glorifying pure benevolence, the Sanitary Commission sought to control it, to discipline the ardor of women who, notwithstanding regulations, sought to bring "womanly influence" to the war.

34. Brockett and Vaughan, *Woman's Work in the Civil War,* p. 321; "Hospital Transports," *S.C. Bulletin* 3:39 (1 July 1865): 1229. See also Brockett and Vaughan, *Woman's Work in the Civil War,* pp. 299–315, and Greenbie, *Lincoln's Daughters of Mercy,* p. 130.

35. U.S.S.C., *Hospital Transports,* pp. 123, 36.

36. Gibbons to Dr. Heger, 11 May 1863, in Sarah Hopper Emerson, ed., *Life of Abby Hopper Gibbons Told Chiefly through Her Correspondence* (New York: G. P. Putnam's Sons, 1897), 2:27. Sarah Hopper Emerson, Abby Hopper Gibbons, and James Sloan Gibbons' Civil War correspondence is a fascinating and rather untraditional one. James wrote about the home front while Abby's letters resemble those of a soldier: Gibbons family Civil War correspon-dence, Manuscripts Division, New-York Historical Society.

In his introductory essay to Brockett and Vaughan's *Woman's Work in the Civil War,* Sanitary Commission president Henry Bellows attempted vainly to ensure that people's postwar memories would be free of any sentimental exaggeration of nurses' importance to the war effort. Bellows praised at length the women at home who provided food and clothing for the army; he only reluctantly discussed the women who "actually went to the war," insisting that although their work "naturally occupies a larger space in this work . . . [it was] much smaller . . . in reality." Bellows noted that those who worked in camps and hospitals were "persons of exceptional energy . . . [which] hardly submitted itself to any rules except the impulse of devoted love for the work." They were, he readily admitted, "as rare as heroines always are." Yet nursing was not, he insisted, women's important contribution to the war effort; the ongoing, steady, businesslike work—the submission to rules, in fact—was what maintained the North through its long struggle.[37]

The business of benevolence on the home front, not the activism of abolitionists, the determination of teachers among the freedpeople, or the self-sacrifice of female nurses, most precisely characterized the changes that the Civil War experience catalyzed. Three days after the war began, a group of women in Bridgeport, Connecticut, organized the first soldiers' aid society in the North. Within the week societies had been established in dozens of cities and towns. Eager for work to do in the first flush of wartime enthusiasm, church congregations and established benevolent organizations began sewing for the soldiers, packing boxes of food, and picking lint for bandages. By war's end thousands of societies had been organized to supply the army with badly needed food and clothing.[38] Women's Civil War relief work—in sewing societies as

37. Bellows, "Introduction," in Brockett and Vaughan, *Woman's Work in the Civil War,* p. 44.

38. For a description of various societies that were quickly formed see John Bach McMaster, *A History of the People of the United States during Lincoln's Administration* (New York: D. Appleton, 1927), p. 40. Robert H. Bremner, *American Philanthropy* (Chicago: University of Chicago Press, 1960), p. 77, says there were approximately fifteen thousand soldiers' aid societies of women; Greenbie, *Lincoln's Daughters of Mercy,* p. 206, says there were "about 32,000 groups of women, large and small, organized as co-operating Ladies'Aid Societies." The number is impossible to estimate with any accuracy, especially since societies often ceased work and then began again with a new name. On the numbers of aid societies associated with each of the main branches, see Brockett and Vaughan, *Woman's Work in the Civil War,* pp. 531, 541, 553. According to Mary Livermore, the Boston branch had 475 societies and corresponded with 275 more during its first year: Livermore, "Massachusetts Women in the Civil War," in *Massachusetts in the Army and Navy during the War of 1861–65,* ed. Thomas Wentworth Higginson (Boston: Wright and Potter, 1895), 2:588.

well as under government contracts—introduced a new scale and a new rhetoric to women's benevolent efforts.[39]

These changes were most evident in Northern women's contacts with the Woman's Central Association of Relief and the Sanitary Commission. By 1862, according to William Maxwell, "most women of the North had been brought into direct relation with the commission."[40] The network of civilian aid was, in theory, rigidly structured. Hundreds of local aid societies performed the mundane work of gathering supplies for the soldiers; thousands of women knit and sewed, canned and dried foods, and packed cartons that they sent to a regional office.[41] These offices in turn sent supplies to one of twelve railroad centers; some sent directly to the national office.[42] The central offices mailed the boxes to hospitals and agents at the front. In addition, women organized "refreshment saloons" for passing soldiers along key railroad routes. By distributing supplies solely through the Sanitary Commission and its agents, the local societies and branches acknowledged, if they did not always share, the principles of nationalism and efficiency propounded by

39. See, e.g., Ladies' Industrial Aid Association, *Report . . . from July, 1861, to January, 1862* (Boston: J. H. Eastburn's Press, 1862), p. 11 (employed 700 women). More traditional institutions were also active. See New York Ladies' Educational Union for the Protection and Education of the Homeless or Destitute Children of Diseased or Disabled Soldiers, *Patriot Orphan Home* (Flushing, N.Y., 1864). The *New York Times* in April 1861 provided frequent, if brief, notices of various church and independent relief efforts by women. It is interesting to note that male-led organizations such as the Association for the Improvement of the Poor and the Young Men's Christian Association, founded in the decade before the war, shared many of the traits that came to characterize women's wartime relief work, notably a greater emphasis on efficiency and business skills. See Paul S. Boyer, *Urban Masses and Moral Order in America, 1820–1920* (Cambridge: Harvard University Press, 1978), esp. pp. 85–120.

40. Maxwell, *Lincoln's Fifth Wheel*, p. 299.

41. County and town histories often include information about soldiers' aid societies. See, e.g., Emily C. Blackman, "Woman's Work for the United States Sanitary Commission," in *History of Susquehanna County, Pennsylvania* (Philadelphia: Claxton, Remsen and Haffelfinger, 1873; repr. Baltimore: Regional Publishing, 1970), pp. 584–620; and *The History of the Hartsville [Pennsylvania] Ladies' Aid Society* (Hartsville: W. W. H. Davis, 1867). In addition, some large societies sponsored histories of their Civil War work. See, e.g., Sarah Edwards Henshaw, ed., *Our Branch and Its Tributaries; Being a History of the Work of the Northwestern Sanitary Commission and Its Auxiliaries* (Chicago: Alfred L. Sewell, 1868), and *Our Acre and Its Harvest: Historical Sketch of the Soldiers' Aid Society of Northern Ohio* (Cleveland: Fairbanks, Benedict, 1869).

42. See Greenbie, *Lincoln's Daughters of Mercy*, pp. 147–48, and Blackman, *History of Susquehanna*, p. 586. In April 1862 Louisa Lee Schuyler listed as "centres of collection" Albany, Troy, Rochester, Syracuse, Hartford, and New Haven: Schuyler to A. W. Chace, 23 April 1862, box 671, USSC. See also Mary Morris Husband to Schuyler, 13 January 1863, box 668, USSC.

the organization. In 1864 the Buffalo depot announced with no little pride that "thus far we have never lost a package."[43]

The central offices in New York, Boston, and Chicago, besides shipping out huge accumulations of boxes, administered an enormous relief organization. Managers maintained a copious correspondence with hundreds of local societies, sent out a steady stream of lecturers, and ran an occasional Women's Council in Washington to reignite the fervor of those who had enlisted, in the common phrase, "for the war." The *New York Times* reported that the Woman's Central Association of Relief's "rooms present[ed] the aspect of a busy warehouse." Louisa Lee Schuyler, Mary Livermore, Angelina Post, Ellen Collins, and Abby May spent long days and weeks in the offices, each fulfilling specific although broadly defined responsibilities. Schuyler, for example, supervised publications, appointed regional managers, and scheduled lecturers. In addition, she sternly delegated duties to her co-workers: "I know how you dislike all this responsibility—which is so very little in itself," she wrote her friend Angelina Post, "but I don't think it will do you any harm."[44] Both she and Ellen Collins, who chaired the committee on supplies, worked beyond the generally accepted office hours of nine to six; Collins frequently took work home in order to complete the meticulous charts of the association's supplies and distribution.[45]

In 1863 the Woman's Central Association of Relief announced its adoption of the Boston Plan for Sectional Divisions, a system developed by Abby May for appointing associate managers to bring the message of systematic relief to local communities. The associate managers, women chosen for their administrative skill and local influence, supervised communication between sewing circles and the central organization. They distributed Sanitary Commission literature and reports from the front and kept the central office in touch with the needs and activities of

43. General Aid Society for the Army, Buffalo, N.Y., *Second Annual Report* (Buffalo: Franklin Steam Printing House, 1864), p. 3. On the internal and overall organization see "The Women's Council," *S.C. Bulletin* 1:7 (1 February 1864): 193–99.

44. "Progressive Success of the Sanitary Commission," *New York Times,* 20 October 1861. See *S.C. Bulletin* 1:9 (1 March 1864): 273–75, for an excerpt from Mary Livermore's "A Day at the Rooms of the Sanitary Commission"; also her *My Story of the War* (Hartford: A. D. Worthington, 1890), pp. 155–70. For Schuyler quotation see Louisa Lee Schuyler to [Angelina Post], 19 February 1865, L. L. Schuyler Correspondence, Misc. Mss., Manuscripts Division, New-York Historical Society.

45. Brockett and Vaughan, *Woman's Work in the Civil War,* p. 533. See also Ellen Collins, "W.C.A.R. Supplies.—No. IV," *S.C. Bulletin* 3:30 (15 January 1865): 947–48.

women throughout their region. Often they organized new societies as they toured an area.[46] They bridged—and were torn by—the local concerns and nationalizing tendencies of wartime benevolence.

Few could meet the qualifications for an associate manager. "It is very desireable that they should be ladies against whom no local prejudices exist," instructed Schuyler, "& who are able to *work along* with the country people of the little villages—which I know is no easy task, requiring both tact & sympathy. Of course earnestness, zealousness & energy are indispensible." "You will see from the enclosed circular that the duties may be summed up in the word *influence,*" Schuyler wrote Lydia Wallace, the new associate manager for Syracuse, signaling a use of the word that measured not sentimental affect but the skill and status associated with community leadership: "We want some one who will help us to investigate the floating reports against the Commission . . .—who will keep the interests of the Commission before the people of her section & help to give them that confidence in it which we feel so deeply ourselves—& finally who will keep us informed of the spirit of the people about her."[47] The New-England Women's Auxiliary Association, in correspondence with 750 societies early in the war, relied on each associate manager to report on "the state of affairs in her neighborhood." In return, the association passed on information from Washington about which supplies were most needed. Thus sewing circles in cities as well as isolated rural areas could work on the appropriate projects in order, according to this auxiliary, that "not one unneeded stitch may be set."[48]

The women who accepted the appointment of associate manager identified with and worked ardently to achieve the central office's standard of efficiency. They filled with some pride their recognized role in a national organization. Invited to serve, M. M. Miller noted that "except

46. Abby May had proposed the plan at the Woman's Council the previous November. See Hoge, *Boys in Blue,* p. 81; W.C.A.R., *Second Annual Report* (New York: William S. Dorr, 1863), pp. 4–5; and Brockett and Vaughan, *Woman's Work in the Civil War,* p. 532. By war's end approximately forty-five such regions worked directly under the W.C.A.R.'s supervision: Schuyler, "W.C.A.R.-Associate Managers.—No. VIII," *S.C. Bulletin* 3:34 (15 March 1865): 1075–77. On the appointment of one associate manager, see Blackman, *History of Susquehanna,* pp. 587–88.

47. Louisa Lee Schuyler to Benjamin H. Hall, 21 January 1863, box 667, USSC; Louisa Lee Schuyler to Lydia Wallace, 3 February 1863, box 667, USSC. See also Schuyler to Emily Barnes, 20 January 1863, box 667, USSC; on decision about an associate manager see Schuyler to Angelina Post, 17 December 1864, Schuyler; on the politics of the appointment see Mary Morris Husband to Schuyler, 14 January 1863, box 668, USSC. Box 667 also contains the published requirements for an associate manager.

48. N.E.W.A.A., *[First] Annual Report* (Boston: Prentiss and Deland, 1863), p. 11.

[for] being *under orders* & working . . . beyond my present sphere, I shall not have much more to do, than I am now doing *without* the name [of associate manager]." Nevertheless she accepted the position, proud that it would be thought helpful. Elisa B. Culver felt "much flattered" by the appointment; her "only hesitation at accepting the position at once is on account of incompetency." Yet she too agreed to take the job and was soon writing bitterly to Schuyler that "patriotism is about *dead* in [this] Co[unty]."⁴⁹

The offices in New York and Boston were flooded with descriptions of local populations by their associate managers. Women described problems ranging from their household cares to the ambiguous loyalties of local aid societies.⁵⁰ "I am the Mother of a family of six children," wrote Harriet Wing in response to an invitation to become an associate manager, "—*two sons* absent in the Army. . . . with my present domestic arrangements I have nearly the whole of my time to devote to the Soldiers—and *I do it*. . . . It is a necessity of my being—while my Country is bleeding—to do all that my puny arm can do." Many women actively engaged in wartime benevolence wrote angrily of the ambivalent sympathies toward the war or the commission manifested by the local populace, and of the weak commitment to steady work exhibited by the other women. From Sharon, Connecticut, Helen Smith reported an "aversion to systematized action on the part of working members"; her tone indicated both exasperation with the local society and her own identification with the rhetoric and organizational style of the national organization.⁵¹

The phrases used to describe the work of the war—efficiency, machinery, harnessing enthusiasm, order—captured both the tone and the actual experience that a new generation brought to benevolence.

49. The following letters are in box 676, USSC: M. M. Miller [Rhinebeck, N.Y.] to Louisa Lee Schuyler, 23 April 1864; Elisa B. Culver [Newark, N.Y.] to Schuyler, 11 March 1864; and Culver to Schuyler, 22 April 1864.

50. The abundance of material is extraordinary. In January 1863 Louisa Lee Schuyler requested local leaders to send her information about their regions' feelings toward the commission, the war, and other matters. During the first three months of 1863 letters flooded the W.C.A.R. offices in New York detailing information on a wide range of issues of concern to the associate managers; these letters are bound in volumes in box 669, USSC. See, e.g., the letters of Mrs. A. McDougal [Dryden, N.Y.], 29 January 1863; Mary Lee [Batavia], 2 February 1863; L. L. McFadden [?] February 1863; and Melissa Collins [Chestertown], 24 January 1863.

51. Harriet Wing [Glens Falls, N.Y.] to Louisa Lee Schuyler, 27 January 1863, box 674, USSC; Helen E. Smith [Sharon, Conn.] to Louisa Lee Schuyler, 29 January 1863, box 674, USSC.

Asking, "How can we best help our camps and hospitals?" the Woman's Central Association of Relief estimated that "fully one-half of the People's voluntary contributions in aid of the Army . . . has been wasted, because not systematically distributed by a central organization." Amateurs, continued the argument, injured the army's morale: "It must be remembered that private charity, patriotism, and humanity . . . do far less for our soldiers than Government is doing every day." Indeed, private charity endangered the war effort. "The Commission recognized the depth of the National impulses that were at work," asserted another Sanitary Commission document, "the immense mischief they might do if allowed to run wild, and the good they might do if organized and regulated. . . . Its endeavor has been and is to direct this stream into measured channels." "The women—God bless them!—think that it requires nothing but a good and loving heart to aid the poor soldier," observed Bellows in a rare overt criticism of women's local efforts. "But I can assure you, that however ardent and warm the heart, its pulsations . . . must be regulated by order and method."[52]

In spite of the notorious inefficiency of the Northern army during the Civil War, Sanitary Commissioners evoked a military model to describe their own concerns: the commission, Bellows boasted, "has followed the regulations of army life." The commission warned in its first *Bulletin*: "Only the most persistent and strenuous resistance to an impulsive benevolence, the most earnest and obstinate defence of a guarded and methodized system of relief, can save the public from imposition, and the Army from demoralization."[53] This refrain, consciously opposed to the prewar rhetoric, was heard by women throughout the war.

Where antebellum benevolent women had moved quietly to model their organizations on the lines of business, those women and men who administered war relief were unabashed in their commitment to "business relations" that, the Woman's Central Association of Relief insisted, "have been found indispensible." Women's work in the war, recalled

52. W.C.A.R., *How Can We Best Help Our Camps and Hospitals? Statement and Correspondence, Published by Order of the Woman's Central Association of Relief* (New York: William C. Bryant, 1863), pp. 6–7, 13; U.S.S.C. (doc. no. 69), *Statement of the Objects and Methods of the Sanitary Commission* (New York: William C. Bryant, 1863), p. 49; Henry Bellows, *Speech . . . Made at the Academy of Music, Philadelphia, Tuesday Evening, Feb. 24, 1863* (Philadelphia: C. Sherman, 1863), pp. 15–16.

53. Bellows, *Speech,* p. 16; *S.C. Bulletin* 1:1 (1 November 1863): 1. See also U.S.S.C., *Hospital Transports,* p. 84, and Schuyler, "W.C.A.R. Organization.—No. VI," *S.C. Bulletin* 3:32 (15 February 1865): 1009–11.

Mary Livermore, like that of "the best business houses," was charac-
terized by "money-making enterprises, whose vastness of conception,
and good business management, yielded millions of dollars."⁵⁴ This
rhetoric was contagious, affecting many local societies. "At first, simply
a Charity, [the Ladies' Industrial Aid Association] soon became also an
Industrial School," stated its report proudly, "and we hope to make it a
*self-supporting business,* in which Ladies step in between the Govern-
ment and the seamstress." The Civil War, according to Henry Bellows,
"brought [women's] business habits and methods to an almost perfect
finish. . . . They showed . . . a perfect aptitude for business, and
proved . . . that men can devise nothing too precise, too systematic or
too complicated for women." The Sanitary Commission's insistence on
business principles aimed to erase any lingering attachment to senti-
mental benevolence. The "ultimate end" of the Sanitary Commission,
admitted its leaders, "is neither humanity nor charity. It is to economise
for the National service the life and strength of the National soldier."⁵⁵

Ideas of female propriety and descriptions of home—both tradi-
tionally arenas for paeans to benevolent femininity—were quickly
merged with the new language of efficiency and professionalism. Louisa
Lee Schuyler advised women who planned to form soldiers' aid societies
to invite a man to preside at their founding meeting. "This formality,
which may appear unnecessary to some, is, in reality, important to any
efficient action on the part of a Society." Similarly, Mary Livermore
described her return home after a long day at the Sanitary Commission
rooms in terms that were assumed to be relevant only for men: "Wearied
in body, exhausted mentally, I . . . hail the street-car, which takes me to

54. Livermore, *My Story of the War,* pp. 133, 109–10. Until 1 May 1866, Northerners
donated almost $5 million to the Sanitary Commission, and the branches had raised $2 million
more. With contributions from railroad and telegraph companies among others, the sum of
public services was estimated at $25 million: Maxwell, *Lincoln's Fifth Wheel,* p. 310. Fite,
*Social and Industrial Conditions,* says $7 million was donated by individuals and societies, with
all goods and services estimated at $25 million, p. 277; goods are itemized on pp. 277–78.
There are financial accounts in every annual report of the branches. For detailed accounts, see,
e.g., W.C.A.R., *Fourth Annual and Final Report* (New York: Sanford, Harroun, 1865), and
Philadelphia Branch of the Sanitary Commission (Women's Branch), *Report* (Philadelphia,
1866), pp. 12–13. Harriet Foote Hawley described the work of supplying the soldiers in
Dannett, *Noble Women,* p. 318. See also Young, *Women and the Crisis,* p. 69.
55. Ladies' Industrial Aid Association, *Report,* p. 12; Bellows, in Brockett and Vaughan,
*Woman's Work in the Civil War,* pp. 41–42; U.S.S.C., *Objects and Methods,* p. 5. The women
were often praised for their "executive ability": E. W. Locke, *Three Years in Camp and Hospital*
(Boston: Russell, 1870), p. 187.

my home. Its pleasant order and quiet, its welcome rest, its cheerful companionship, its gayety . . . all seem strange and unnatural after the experiences of the day. It is as if I had left the world for a time, to refresh myself in a suburb of heaven."[56]

It was no coincidence that reform women turned to this imagery in describing their wartime experiences; the Sanitary Commission waged a continuing struggle to convince women in local communities that their benevolent work must parallel the ongoing contribution of men. In its first *Bulletin*—whose very existence indicated that the work was to continue indefinitely—the commission reiterated, "We have warned [the women] from the first that they were enlisted for the war. . . . There is no longer novelty or artificial excitement to sustain their activity. Only a steady principle of patriotic humanity can be depended on for continued labors in this holy cause." The article went on to urge women to make war work their daily business. "*I* must, *we all must* buckle on the armor & work with all our might," agreed one associate manager.[57]

An earlier generation had believed that a benevolent impulse would ensure the world's salvation; the women and men of the Sanitary Commission sought to channel this moral force, to control erratic bursts of wartime enthusiasm through persevering labor. Louisa Lee Schuyler's correspondence emphasized this point again and again; she worked long hard hours administering war relief and expected no less from her co-workers. "There seems to be a growing feeling among the people," she wrote, "that Government is doing so much now that the work of the Commission is nearly at an end. They should be *entirely dispossessed of any such idea*. Our work is to last as long as the war does & probably longer." Exclaiming over having written "OUR THIRD ANNUAL REPORT!" Schuyler combined description and moral when she observed: "At the Council of Women held in Washington last January, nothing impressed the minds of those present so much as the manifest *stability* of this work." Sanitary Commissioners contended that the discipline of war work was changing the Northern people for the better; according to Joseph Parrish, "the people want cold, hard figures and

56. W.C.A.R., *Third Semi-Annual Report* (New York: Baker and Godwin, 1863), p. 18; "Plan for the Formation of Soldiers' Aid Societies," *S.C. Bulletin* 1:12 (15 April 1864): 370–71, and Livermore, *My Story of the War,* p. 170.

57. *S.C. Bulletin* 1:1 (1 November 1863): 1; Mrs. A. McDougall to Louisa Lee Schuyler, 29 January 1863, box 669, USSC. See also Alfred Bloor to Schuyler, 29 May 1863, box 668, USSC.

realities, not so much stories and sentimentalities as they did in the commencement of the war."[58]

From small towns and rural areas around the North, women active in their local auxiliaries wrote about their efforts to conform to the central office's standards of efficiency and hard work. "We meet every Tuesday," wrote L. R. James from Ogdensburg, New York, a town on the Canadian border, "and give ourselves credit for perseverence . . . as we have never adjourned our meetings in summer or winter since we were first organized for more than one or two weeks." From Montreal L. M. Brown promised on behalf of her society "to try to work with more system and regularity, than heretofore." The *Soldier's Aid,* a publication of the Rochester society, reminded women "that the service required . . . is something more than the result of occasional spasms of patriotism; that it is *work,* undisguised, continuous work, that we must render."[59]

The qualities attributed to local aid societies were admired as well in individual women. The women who organized the New York Metropolitan fair, which raised great sums of money from fashionable society for the Sanitary Commission, were the crème de la crème of New York society; the commission, true to form, praised them primarily for their "administrative ability." A report on the Northwestern Sanitary fair was effusive in this respect: "Enough is said of the marvelous energy and wise business talent displayed by the ladies who had the Fair in hand, when it is stated that from beginning to end . . . there was perfect system, and no break, no jars in the machinery." But it was the new generation of elite women who received the most ardent commendations for these virtues. "Kate [Wormeley] is a most thoroughly satisfactory woman," wrote Georgeanna Woolsey in her journal, in part because she had "not a single grain of mock-sentiment about her." Wormeley, according to Brockett and Vaughan, was indeed "endowed with extraordinary executive ability."[60] Admiration for the nurses on the hospi-

58. Louisa Lee Schuyler to A. W. Chace, 16 June 1863, box 667, USSC; W.C.A.R., *Third Annual Report* (New York: Sanford, Harroun, 1864), p. 5; Joseph Parrish to Schuyler, 6 January 1865, box 669, USSC.

59. L. R. James to Louisa Lee Schuyler, 26 April 1865, box 673, USSC; L. M. Brown [Montreal] to Schuyler, 8 August 1864, box 676, USSC; *Soldiers' Aid,* dated 19 June 1863, quoted in Hewitt, *Women's Activism and Social Change,* p. 197.

60. "Metropolitan Fair at New York," *S.C. Bulletin* 1:4 (15 December 1863): 98; "The Great Northwestern Sanitary Fair," ibid. 1:3 (1 December 1863): 71; G. Woolsey diary, 26 May 1863, quoted in Austin, *Woolsey Sisters,* p. 62; Brockett and Vaughan, *Woman's Work in the Civil War,* p. 321.

tal transports was expressed in telling terms: "As for the ladies, they are just what they should be, efficient, wise, active as cats, merry, light-hearted, thoroughbred, and without the fearful tone of self-devotedness about them that sad experience makes one expect in benevolent women." Wormeley described the requisite characteristics of a hospital transport nurse unequivocally: "No one must come here who cannot put away all feeling," she wrote her mother. "Do all you can, and be a machine."[61]

Above all, these young leaders of corporate benevolence admired business aptitude. Louisa Lee Schuyler granted Ellen Collins the highest compliment she knew when she said she was "systematic and methodical, and enjoy[ed] the business side of the work." Similarly, co-worker Julia B. Curtis praised Collins' meticulous charts ("a marvel of method and clearness"), which described in efficient detail the Woman's Central Association of Relief supplies. Schuyler attributed Abby May's "superior ability" to her admirable "system and efficiency." The Sanitary Commission's final thanks to women after the war's end praised them, significantly, for two characteristically male activities: wage-earning and warring. "Your volunteer work has had all the regularity of paid labor," noted this document admiringly. "In a sense of responsibility, in system . . . you have rivalled the discipline, the patience, and the courage, of soldiers in the field."[62]

Henry Bellows overflowed with such praise. "The distinctive features in woman's work in this war," he wrote in his introduction to Brockett and Vaughan's postwar tribute, "were magnitude, system, thorough co-operativeness with the other sex, distinctness of purpose, business-like thoroughness in details, sturdy persistency to the close." The women who ran the branch offices of the Sanitary Commission in particular, agreed Brockett and Vaughan, "exhibited business abilities, order, foresight, judgment, and tact, such as are possessed by very few of the most eminent men of business in the country."[63]

Louisa Lee Schuyler, a close co-worker of Bellows', embodied and

61. U.S.S.C., *Hospital Transports,* pp. 66–67 (Young, *Women and the Crisis,* p. 178, identifies Wormeley as the author of this letter); Katherine Prescott Wormeley, *The Other Side of War with the Army of the Potomac* (Boston: Ticknor, 1889), p. 102.

62. Louisa Lee Schuyler, "Ellen Collins," *Survey* 29 (4 January 1913): 436; Curtis in Brockett and Vaughan, *Woman's Work in the Civil War,* p. 533 (she wrote the chapter on the W.C.A.R.); Louisa Lee Schuyler to Samuel J. May, 23 January 1863, box 667, USSC; U.S.S.C. (doc. no. 93), *Circular Addressed to the Branches and Aid Societies* (New York, 4 July 1865), p. 5.

63. Brockett and Vaughan, *Woman's Work in the Civil War,* pp. 40, 63.

celebrated traits that undermined previous ideals of female benevolence. Hers was a veritable passion for efficiency, businesslike discipline, and unsentimental hard work, epitomizing in her own career the transformations in benevolence that the Civil War period strengthened. Schuyler was only twenty-four years old when she and her mother, Eliza Hamilton Schuyler, attended the founding meeting of the Woman's Central Association of Relief in 1861. Yet from the start, with the confidence in her own leadership that she seemed to have inherited from her distinguished ancestors, she assumed her mother's place on the executive committee and soon chaired the committee of correspondence, on whose behalf she wrote and received thousands of letters over the next four years. In fact, Schuyler operated the association, made contact with its numerous branches, and prepared its reports and publications.[64] Schuyler prided herself on her ability to systematize the work of the Woman's Central Association of Relief and its auxiliaries. Taking on the obstacles of "religious feeling, localism, and sentimentalism" to rationalize "the 'production' of supplies," she adopted the language of war—and disdained that of femininity—to express a wholly new conception of benevolence. She frequently referred to her co-workers as having military status; Angelina Post was her "chief-of-staff," who knew well "the likes & dislikes of her Commanding General," and Joseph Parrish was the "Colonel" to his "L$^t$ Co$^l$." It was Schuyler who continually impressed on the women with whom she corresponded that they had all "enlisted for the war."[65]

Schuyler's counterparts in Chicago, who operated the Northwestern Sanitary Commission, displayed a commitment to efficiency more by their actions than their words. Mary Ashton Rice Livermore and Jane Currie Blaikie Hoge—two "fearful and wonderful women," reported George Templeton Strong—were older than the New York leaders, veterans of several benevolent institutions of the 1850s.[66] In 1848 Jane and Abraham Hoge had moved to Chicago from Pittsburgh, and Jane, who had been secretary of the Pittsburgh Orphan Asylum, plunged immediately into benevolent endeavors. In 1858 she helped

64. See Robert D. Cross, "The Philanthropic Contribution of Louisa Lee Schuyler," *Social Service Review* 35 (September 1961): 290–301, and Cross, "Louisa Lee Schuyler," in *Notable American Women,* ed. James and James, 3:244–46.

65. Cross, "Philanthropic Contribution," p. 292; Louisa Lee Schuyler to Angelina Post, 6 December 1864, Schuyler; Joseph Parrish to Schuyler, 26 November 1864, box 668, USSC.

66. Diary, 9 March 1865, George Templeton Strong, *Diary of the Civil War, 1860–1865,* ed. Allan Nevins (New York: Macmillan, 1962), p. 562.

found the Chicago Home for the Friendless; it was there that she met Mary Livermore, recently moved from Boston to Chicago, who was also interested in the institution. Like many middle-class women of their generation, the two women became co-workers in a variety of institutionally based benevolent works: besides the Home for the Friendless, they were prominent in work for the Home for Aged Women and the Hospital for Women and Children. When the war began, they moved easily into relief work, unaware of the dramatic shift toward a national base that their work would take.[67]

Within one month of the war's beginning, Chicago boasted twelve or more aid societies.[68] Soon, Dorothea Dix appointed Hoge and Livermore as general agents to recruit female nurses. Eventually the two women would have four thousand aid societies and a number of soldiers' homes under their direction. In addition to their administrative duties, both Hoge and Livermore traveled to army camps, attended Women's Councils in Washington, and originated and executed the massive city-wide fund-raising fair, which became a model for other large fairs.[69]

Henry Bellows recognized that women's prewar benevolent work had provided them with many of the skills necessary for Civil War relief work, for he acknowledged:

> Everywhere, well educated women were found fully able to understand and explain . . . the public questions involved in the war. . . . Everywhere started up women acquainted with the order of public business; able to call, and preside over public meetings of their own sex; act as secretaries and committees, draft constitutions and bye-laws, open books, and keep accounts with adequate precision, appreciate system, and postpone private inclinations or preferences to general principles; enter into extensive correspondence with their

67. On Livermore see her *The Story of My Life, or the Sunshine and Shadow of Seventy Years* (Hartford: A. D. Worthington, 1899) and her *My Story of the War;* Robert E. Riegel, "Mary Ashton Rice Livermore," in *Notable American Women,* ed. James and James, 2:410–13; and Brockett and Vaughan, *Woman's Work in the Civil War,* pp. 577–89. Information on Hoge comes from Wayne C. Temple, "Jane Currie Blaikie Hoge," in *Notable American Women,* 2:199–201; Hoge, *Boys in Blue;* and *Woman's Work in the Civil War,* pp. 562–76.

68. Much of the information on what would become the Northwestern Sanitary Commission is from Livermore, *My Story of the War,* and Hoge, *Boys in Blue.* The figure of twelve aid societies is from Livermore, p. 135.

69. Greenbie, *Lincoln's Daughters of Mercy,* p. 156. Interestingly, Bremner claims that Livermore and Hoge were on the S.C.'s payroll as "canvassers," yet they never discuss having been compensated for their Civil War work: *Public Good,* p. 62. On the council see Livermore, *My Story of the War,* pp. 232–33, 248.

own sex; co-operate in the largest and most rational plans proposed by men.[70]

But the war explicitly celebrated the virtues which best accorded with that work: efficiency and the subordination of enthusiasm to routine. In addition, the war, in part because of the great demand for the products of benevolent labor, placed benevolence in the center of the public eye. For the first time, debates took place over organizational issues that the rhetoric of benevolent femininity had previously hidden from public scrutiny.

Throughout the war, Northerners battled one another over the values that the Sanitary Commission and the Woman's Central Association of Relief represented. Women and men, nurses and doctors, "amateurs" and "professionals," religious and scientific benevolence—all sought to define the relationship between older notions of benevolence and the evolving demand for public service in wartime society. In particular, tensions about paying wages, centralizing corporate functions, relating benevolence to government, and using funds solely for administrative purposes all came into the open. These disputes flooded the pages of Sanitary Commission and Woman's Central Association of Relief reports, forced lecturers into the field to defend a particular organizing style, and instigated vociferous local disputes over where funds and energy would be best spent.

These differences emerged publicly in a conflict between the Sanitary Commission and a rival organization, the Christian Commission, founded in November 1861. The Christian Commission, which sent ministers and tract distributors to relieve the "temporal and spiritual" wants of the soldiers, was organized by the leaders of the prewar benevolent empire.[71] Its strength derived from evangelical ministers, the American Tract Society, and "disaffected areas," where grassroots sup-

70. Bellows, in Brockett and Vaughan, *Woman's Work in the Civil War,* p. 41.

71. Clifford S. Griffin, *Their Brothers' Keepers: Moral Stewardship in the United States, 1800–1865* (New Brunswick: Rutgers University Press, 1960), p. 249. "Its management," notes historian Robert Bremner, "resembled an interlocking directorate of the national benevolent societies": *Public Good,* p. 57. The C.C.'s leaders included William E. Dodge, Jr., Stephen Tyng, and Jay Cooke, the financier of the American Sunday School Union. On the meetings of the Y.M.C.A. that led to the forming of the C.C. and on the C.C.'s goals, see the *New York Times,* 7 June 1861, p. 8, and 1 September 1861, p. 5; and United States Christian Commission, *First Annual Report* (Philadelphia, February 1863). On the Christian Commission generally see Lemuel Moss, *Annals of the United States Christian Commission* (Philadelphia: J. B. Lippincott, 1868), and Andrew B. Cross, *The War and the Christian Commission* ([Baltimore?], 1865).

port emerged from loosely affiliated church congregations. According to Frederick Law Olmsted's biographer, its evangelical focus "gave it a clear advantage in communities where the Unitarianism of the Sanitary Commission's president [Bellows] was suspect; and the fact that it placed its offerings directly in the hands of soldiers, instead of distributing them through authorized army personnel . . . , gave it a touch appealingly personal."72

The debate between the two commissions involved a conflict between an evangelical and an emerging liberal style of benevolence. In practice, it centered on the benefits of paying or not paying benevolent workers, or agents. The Christian Commission claimed that unpaid agents were the more pure of heart, the Sanitary Commission that they were inefficient. Volunteers, explained a Woman's Central Association of Relief pamphlet, were "unreliable for permanent, systematic, and subordinate labor." In response to charges that its agents were un-businesslike, the Christian Commission retorted that the Sanitary Commission was not a "Christian" organization, that it represented "*partisan, political views*." "It is attacked for its *sectarianism*," cried Louisa Lee Schuyler indignantly. ". . . It is accused of squandering the people's money regardless of the oft-repeated statement of its officers that *experience* has taught the true economy to be the employment of salaried agents."73 The charge of partisanship and unchristian behavior has a familiar ring—but the Christian Commission's benevolent rhetoric sounded, in the face of the Sanitary Commission's government-oriented liberalism, increasingly anachronistic.

Several months before the end of the war, an article in the *Sanitary Commission Bulletin* defended the organization's position on paid agencies. In response to the charge that "because Sanitary agents receive a scanty compensation they cannot be expected to labor with such a purity of benevolence . . . as do agents who receive no compensation," J. A. Anderson retorted that, if true, that position would impugn the motives of the "noble bands of Christian ministers" who, although "as a class worse paid than men of the same abilities in the other professions,"

72. Roper, *FLO*, p. 214.

73. W.C.A.R., *How Can We Best Help?* pp. 7–8; Schuyler to the Standing Committee of the S.C., 9 December 1864, box 667, USSC. Robert Bremner suggests that "the Christian Commission attracted the pious elite and the Sanitary Commission appealed to the professional and intellectual elite"; "The Prelude: Philanthropic Rivalries in the Civil War," *Social Casework* 49 (February 1968): 79. The S.C. paid each of fifteen inspectors $1,200 per year, according to Maxwell, *Lincoln's Fifth Wheel*, p. 90.

nevertheless were salaried. "No excellence," Anderson boldly stated, "accrues to the motives of unpaid agents because of their being unpaid, which does not equally accrue to paid agents in spite of their being paid." Commenting on the article, the *Bulletin* clinched the Sanitary Commission's position in simple business terms: "The system of a voluntary agency is more expensive than that of a compensated agency."[74]

The conflict between the two commissions did not confine itself to official reports. In fact, local disputes were the more vigorous, involving competition among old acquaintances and past co-workers for limited funds and support. According to a report of the New-England Women's Auxiliary Association, the conflict between the two commissions was "paralyzing activity everywhere in New England."[75] In letter after letter women from around the North wrote Schuyler and other defenders of the Sanitary Commission about their troubles with Christian Commission lecturers, agents, and supporters, especially in the face of "the preference of a certain class of people [who] incline very strongly to that organization." One representative complained: "Paid agencies . . . are constantly held up to us, as an argument against the Sanitary & in favor of the Christian Commission." According to a report of the General Soldiers' Aid Society of New Haven, "The efforts made for the creation of the Christian Commission in this city took from us many valuable supporters, who believed that they were sustaining a more economical and evangelical association." From Hartford, Mary Olmsted complained passionately that she had "to contend with this obstacle constantly—they are *indefatigable* in their efforts and I am sorry to say *unscrupulous* also. . . . I think that it is absolutely necessary that there should be some more pains

74. J. A. Anderson, "Paid and Unpaid Agents," *S.C. Bulletin* 3:30 (15 January 1865): 941–43; "The Two Commissions—Comparative Economy," ibid., p. 943.

75. New-England Women's Auxiliary Association, *Third Annual Report* (Boston: Prentiss and Deland, 1865), p. 8. The leaders of both commissions expressed concern lest their differences absorb too much public attention and were therefore relatively circumspect in public: Schuyler to the Standing Committee, 9 December 1864, box 667, USSC; "The Sanitary Commission and the Christian Commission," *S.C. Bulletin* 1:3 (1 December 1863): 87–90. The leaders of the two commissions did work together on a local level; see, e.g., Hoge, *Boys in Blue,* pp. 74–75. Members of both commissions worked together in the Union League Club: "Address to the 20th Regiment . . . by the Ladies, March 5th, 1864," in Henry W. Bellows, *Historical Sketch of the Union League Club of New York* (New York: Club House, 1879), pp. 187–89.

On local disputes see Catherine C. van Cortlandt [Sing Sing] to Louisa Lee Schuyler, 18 May 1864, box 676, USSC; Mary Olmsted to Louisa Lee Schuyler, 29 May 1864, box 676, USSC; and Lydia Stranahan to Schuyler, 27 February 1864, box 673, USSC. On one local group's decision to send supplies only to the S.C. see U.S.S.C., *The Best Way to Aid the Sick and Wounded* (Pittsburgh, 1863).

taken here, and indeed *all about the country,* to keep the Sanitary before the people, or the C.C. *will gain possession of the whole land.*"76

Although they cited evidence that they worked harmoniously together—indeed, in hospitals and on battlefields they were forced to —both the Sanitary and the Christian commissions sent lecturers throughout the states to assert their own claims to the funds and loyalty of the benevolent. "The *Christian* Commission . . . is doing the Sanitary Commission much harm throughout the State," Emily Barnes wrote Schuyler. "Its members may be well-meaning & conscientious but their attempt to distract the public sympathies and contributions, seems to me not only very unwise but highly mischievous." The main office of the Woman's Central Association of Relief had little of comfort to offer, urging continued efforts, explaining the benefits of the Sanitary Commission's system, and recommending compromise. "It is not necessary that the little villages should *pledge* themselves to send *entirely* to the [Sanitary] Commission," conceded Schuyler, who realized with some disappointment that "they will not do this."77

In fact, no rigid dichotomy in organizational matters characterized the two commissions; as was the case with antebellum benevolence, the rhetoric of "true" benevolence obscured similarities between apparently different styles of activism. The Christian Commission did send almost five thousand unpaid delegates to the army, proclaiming that its "RELIANCE UPON UNPAID DELEGATES" was a new principle for a national organization. The C.C. also, however, often paid the agents who supervised delegates a higher wage than that received by Sanitary workers.78 In any case, many of the "unpaid" agents were ministers, who received support from their congregations at home. Similarly, the Sanitary Com-

76. [Name illegible] [Rome, N.Y.] to Louisa Lee Schuyler, 8 December 1864, box 673, USSC; General Soldiers' Aid Society [New Haven], *Second Annual Report* (New Haven: E. Hayes, 1864), p. 7; Mary Olmsted to Schuyler, 10 December 1864, box 677, USSC. See also Elizabeth W. Saunders to Schuyler, 13 July 1864, box 676, USSC, and Mary Olmsted to Schuyler, 29 May 1864, box 676, USSC. Clara J. Moore [Philadelphia] warned Schuyler that "we must . . . educate the people as [to] *the Christian work* which *our* Commission is doing": 10 April 1863, Schuyler.

77. Emily [Weed] Barnes [Albany] to Schuyler, 16 February 1863, box 674, USSC; Schuyler to Barnes, 4 June 1863, box 667, USSC.

78. James H. Moorhead, *American Apocalypse: Yankee Protestants and the Civil War, 1860–1869* (New Haven: Yale University Press, 1978), pp. 65–66; U.S.C.C., *Second Annual Report* (Philadelphia, 1863), p. 17. Maxwell claims that in December 1864 the C.C. paid delegates higher wages than did the S.C.: *Lincoln's Fifth Wheel,* p. 266. Indeed, Moss, who wrote as a C.C. partisan, claimed that no C.C. delegate was paid more than $2,000 per year, but that is more than the S.C.'s $1,200: Moss, *Annals of the U.S.C.C.,* p. 100; see also p. 147, and Griffin, *Their Brothers' Keepers,* p. 250.

mission, for all its emphasis on the "scientific" benefits of paying agents, often paid individuals who immediately returned the money "to the soldiers." In addition, bowing to the time-honored doctrine that the lower the pay, the more disinterested the motive, the *S.C. Bulletin* reminded its readers that the $2 per day that it paid its two hundred agents was "less than an ordinary mechanic's wages."[79]

Aware of local populations' ambivalence toward its rhetoric, the Sanitary Commission indulged in some inconsistency in occasionally granting nurses the mantle of "disinterested" benevolence and itself the shelter of religious rhetoric. One S.C. report noted that the Auxiliary Relief Corps "is more acceptable from the fact that it is *voluntary;* for although the soldier nurse may be kind and attentive, the patient knows that he is assigned to that duty, that it is compulsory." Women who endured great hardships to nurse the wounded continued to serve a useful image as the purest—because unwaged, poorly paid, or simply female—form of benevolence. In any case, the Sanitary Commission insisted that its own work was "eminently and *essentially* a Christian work." Consider yourselves "'Soldiers of Christ,'" Schuyler urged Northern women, "[and] fight the good fight of humanity, of patriotism, of Christianity."[80]

The rivalry between the two commissions was waged less over actual practices than over two conflicting styles and rhetoric of benevolence. The Christian Commission embodied a more traditional form of benevolence; its strength derived from the continued grassroots respect accorded church-related organizations and the continuing power of the older ideology of benevolence. Eliza Powers of Boston recognized this and wrote worriedly that the Christian Commission's appeals "to the different denominations of *Christians* is gaining ground." Ophelia Wait, another of the Woman's Central Association of Relief's associate managers, advised Schuyler to "call upon the clergymen to explain the whole matter [of the Sanitary Commission]" to local populations. "Ladies who would not work with us, entered into [another benevolent effort] with zeal," she insisted, *"because it was done in the church."*[81] Sanitary Com-

79. "The Sanitary Commission," *S.C. Bulletin* 3:26 (15 November 1864): 807, exaggerates the pay of an "ordinary mechanic."

80. *S.C. Bulletin* 3:32 (15 February 1865): 998; "The People and the Commission," ibid. 3:32 (15 February 1865): 1001; W.C.A.R., *Third Semi-annual Report* (New York: Baker and Godwin, 1863), p. 12. For a defense of the S.C. as a Christian organization see N.E.W.A.A., *Third Annual Report,* pp. 9–10.

81. Eliza Powers to Schuyler, 15 August 1864, box 676, USSC; Ophelia Wait [Belleville, N.Y.] to Schuyler, 30 January 1863, box 669, USSC.

missioners, in contrast, advocated a new style of state-linked benevolence on a large corporate scale, a passion for efficiency, a commitment to discipline, and a sense of themselves and the class they represented as a centralizing force for the nation.

Conflict also arose over the centralized, government-oriented structure and rhetoric that the Sanitary Commission and its branches so forcefully advocated. Publications of the S.C. constantly reiterated that the war was being fought for a national, not a local, idea; that supplies had therefore to be sent where they were needed, regardless of people's loyalties to their own state's troops; and that women had to abandon localist notions of benevolence (or "statishness") to unite in support of centralized relief. With a characteristic sense of its own importance, the commission likened itself to the federal government. "Because it is an 'arm of Government,'" declared a report of the New England branch, the Sanitary Commission functioned better than could any local or state agency.[82]

Sanitary Commission leaders stressed the importance of its "practical lesson on the blessings of National Unity" so frequently as to make clear that people resisted their rejection of localism.[83] Indeed, despite this constant barrage of rhetoric, the women's branches "had steadily to contend with the natural desire of the Aid Societies for local independence, and to reconcile neighborhoods to the idea of being merged and lost in large generalizations." Julia N. Crosby of Poughkeepsie explained to the aid society of which she was a member the "great necessity" of aiding the Sanitary Commission. "But I found the old American spirit of independence too strong for my argument," she wrote, caught between annoyance and pride, "and the plan was decidedly opposed. This was . . . from a natural unwillingness to become, after three & a half years of independent existence, in any sense a branch Society. . . . Do not denounce us as a very unmanageable, obstinate set of women," Crosby pleaded to Schuyler, "but give us still your sympathy." In its third annual report the Hartford Soldiers' Aid Association, eager to protect its "position as an independent organization," claimed that it

82. N.E.W.A.A., *[First] Annual Report*, p. 9. See also U.S.S.C., *Objects and Methods*, p. 53. Caroline Briggs recalled that when she moved to Springfield, Mass., before the war, she "soon identified . . . with church and charitable work of various kinds, working, however, in a narrow and unsatisfactory fashion till the war broke out, and from that time on we learned wisdom in such matters": George S. Merriam, ed., *Reminiscences and Letters of Caroline C. Briggs* (New York: Houghton, Mifflin, 1897), p. 115.

83. U.S.S.C., *Objects and Methods*, p. 6. See U.S.C.C., *Second Annual Report* (Philadelphia, 1864), pp. 15–16, on its own adherence to nationalism.

was able and "ready to distribute of our supplies wherever the need is most urgent, [because] we are permitted to know of wants supplied and benefits conferred which it is impossible to communicate through the general channels of relief." Such reports were anathema to the officers and loyal workers of the Sanitary Commission.[84]

Some communities reacted to the Sanitary Commission's appeals to nationalism by questioning the integrity of the commission itself. Loyal representatives of the Sanitary Commission wrote frantically of the negative rumors that circulated throughout their towns. People were suspicious of an organization that seemed to absorb enormous amounts of money and still cried out for more, that urged local effort but refused to allow aid societies to provide for local soldiers, and that so self-consciously aspired to a status akin to that of the federal government— not to mention one that expected people to trust the leadership of an urban elite whose values sometimes seemed so at odds with their own. Ophelia Wait assured Schuyler anxiously that she for one did not believe that well-known philanthropists were "engaged in the nefarious business of plundering the public." "Unsupported slanders"—that the S.C.'s officers were pocketing its funds and that its agents were selling food to the soldiers—plagued local societies' fund-raising efforts.[85] Especially after the large urban fairs, many thought the commission rich and resisted sending it money or supplies.

The Sanitary Commission joined observers in warm praise for the efficiency and abilities of the women, many of them members of an older generation of benevolent workers, who had organized the fairs.[86] After all, the fairs raised huge sums of money, which the women donated to the commission. The first large fair, in Chicago, organized by Mary Livermore and Jane Hoge, netted between $86,000 and $100,000.[87] The Boston fair, held in December 1863, earned a profit of nearly

84. Bellows, in Brockett and Vaughan, *Woman's Work in the Civil War,* p. 42; Julia N. Crosby [Poughkeepsie] to Louisa Lee Schuyler, 1 December 1864, box 673, USSC; Hartford Soldiers' Aid Association, *Third Annual Report* (Hartford, 1865), p. 5.

85. Ophelia Wait to Louisa Lee Schuyler, 30 January 1863, box 669, USSC; Benjamin Hall to Schuyler, 9 December 1864, box 673, USSC. See also Susan Rogers [Sandy Hill, N.Y.] to Schuyler, 25 November 1863, box 671, USSC, and Laura Savage [Utica] to Schuyler, 9 February 1863, Schuyler.

86. According to the *History of the Brooklyn and Long Island Fair, February 22, 1864* (Brooklyn: "Union" Steam Presses, 1864), p. 83 fn., "Mrs. Caroline M. Kirkland . . . and Mrs. David Dudley Field, both lost their lives through excessive and exhausting labors for the New York fair."

87. These estimates on the fair are in Livermore, *My Story of the War,* pp. 409–62, and Hoge, *Boys in Blue,* pp. 332–68.

$146,000, and that of Brooklyn and Long Island earned $400,000; Philadelphia cleared more than $1 million.[88] But no fair compared to New York's, which imitated Chicago's innovations on a New York scale. The very wealthy bought and sold elegant goods from Paris and Rome; antiques, silver, handmade quilts, and tapestries were exhibited and purchased. The city, complained Harriet Woolsey, was in a "disgusting state of fashionable excitement." Held in a large building in Union Square, the extravaganza netted $2 million for the Sanitary Commission's coffers.[89]

In spite of its gratitude for the money, however, the Sanitary Commission viewed the "popular benevolence" that exerted itself for the large fund-raising fairs as an obstacle in its campaign to encourage system and regularity among contributors. First, the fairs celebrated local pride and wealth rather than national unity: the official account of the Brooklyn and Long Island fair called the event "the first great act of self-assertion ever made by the City of Brooklyn."[90] Second, tension arose over such formidable sums of money raised in so short a time. "The Fairs held in our large cities," explained the General Soldiers' Aid Society of New Haven, "had netted such large amounts that many persons . . . regarded the sums inexhaustible, and seemed to consider their duty ended in that channel."[91] As people throughout the North learned of the fairs' profits, they ceased to send as steady a supply of aid; many of them began to focus their energies on the Christian Commission at that time. The Sanitary Commission and its branches spent a great deal of energy convincing people of their unending duty—not only to the war effort but, as importantly it seemed, to the commission itself.

88. Livermore, "Massachusetts Women in the Civil War," in *Massachusetts in the Army and Navy*, ed. Higginson, 2:590; *Brooklyn and Long Island Fair*, p. 43; Fite, *Social and Industrial Conditions*, p. 282.

89. Harriet Woolsey in Dannett, *Noble Women*, p. 279; see also Jane Woolsey's description in ibid., pp. 277–79. Mary Lydig Daly, diary, 3 March 1864, complained that the fair was "the apotheosis of fashionable and cheap patriotism:" Hammond, ed., *Diary of a Union Lady*, p. 286. Mary Olmsted reported that the "higher, and more influential class" was not enthusiastic about a fair in Hartford, being "completely sickened of such efforts, by their experience in the N. York fair": Olmsted to Caroline Nash, 5 January 1865, box 678, USSC.

90. *History of the Brooklyn and Long Island Fair*, p. 5.

91. G.S.A.S. [New Haven], *Second Annual Report*, p. 7. Mrs. Douglas of Middletown, Conn., agreed. See her letter to Julia Curtis, 1 April 1864, box 676, USSC. See also Mary Butler to Julia Curtis, 9 July 1864, and Mary Olmsted to Louisa Lee Schuyler, 18 May 1864, both in box 676, USSC; as well as "The Effects of the Fairs on our Funds," *S.C. Bulletin* 1:14 (15 May 1864): 417–19.

When the need for war work did end in April 1865, the leaders of the Civil War relief organizations expressed a profound ambivalence, perhaps more dismayed than relieved by the cessation of war. An article in the *Bulletin* about the Northern victory was entitled, amazingly, "The Crisis." "What will the Commission do now?" it asked. "Will it wind up its affairs, make a final report of its proceedings and disband, or continue its work?" In its own final report the Woman's Central Association of Relief admitted to its "mingled feelings of joy and sorrow" at the onset of peace.[92]

Schuyler, Post, Collins, and the other administrators of the Woman's Central Association of Relief postponed the inevitable closing of the rooms where they had spent four long years. "We had a little informal chat to-day among the boxes . . . ," one W.C.A.R. worker wrote to Angelina Post. "Our Ch^m bless her, agrees with me, that it would be in very bad taste for *us* to be the first to show signs of wishing to relax our efforts: that the gentlemen of the Commission will not be slow to inform us, so soon as it is necessary to narrow our sphere of operations." Louisa Lee Schuyler had trouble believing that the July 1865 board meeting was the W.C.A.R.'s last: "I haven't got used to the passive tense yet," she confessed to Post. Before adjourning the meeting Schuyler proposed a social gathering at her home in Dobbs Ferry in October. "I couldn't bear to have the dear, old people, disperse & go away, without fixing some time for meeting again somewhere. . . ," she acknowledged in a rare admission of sentiment. "I have so much to tell you about the dying hours of our dear W.C.A.R. that I don't know where to begin," Schuyler wrote Post in October, when the organization could not extend its rationale for existing any longer: "Aug^t 12th, Saturday, was our last day at dear, old Cooper. Miss Collins & I were the only members left, & we, fortunately, were too busy to indulge in much sentiment. . . . Our little chairman kissed me for goodbye, & walked away. . . . By a sort of tacit consent we never mentioned the words 'last day,'. . . but I know some *thinking* was done, which will be remembered. They had been marked years."[93]

To compound their own ambivalences about the end of the work,

92. "The Crisis," *S.C. Bulletin* 3:37 (1 May 1865): 1171; W.C.A.R., *Fourth Annual and Final Report,* p. 14. Individuals also expressed what Abby Woolsey experienced as "a dash of sadness in the thought of peace": quoted in Austin, *Woolsey Sisters,* p. 117.

93. Catherine Nash to Angelina Post, 12 April 1865, Post Correspondence, Misc. Mss., New-York Historical Society; Louisa Lee Schuyler to Angelina Post, 11 July 1865, and 1 October 1865, Schuyler.

the managers of the W.C.A.R. were overwhelmed by letters from women around the North expressing dismay at the completion of their shared labors. "Sometimes we wonder what we shall do, and how we shall feel when the sad necessity for such work no longer exists," wrote L. R. James. Minnie Brooks expressed great happiness upon receiving a photograph of the New York managers. "I think much of [the association] and shall continue to more and more," she informed Angelina Post, "as time hallows those days, and we are permitted to realize more and understand better, the times in which we were permitted to live and work." "Those last letters!" Schuyler scrawled, "Hundreds & hundreds of them—so full of feeling, so sad at the breaking up of their intercourse with us. . . . They send their love, they want our photographs, they want us to advise them what to do next. . . . It is almost impossible to read over those letters without crying, or choking rather for me. We are all feeling the break-up very deeply. . . . It is worth a dozen years of hard work—this ending." The association's final report resolved: "Henceforth the women of America are banded in town and country, as the men are from city and field. We have wrought, and thought, and prayed together . . . and from this hour the Womanhood of our country is knit in a common bond, which the softening influences of Peace must not, and shall not weaken or dissolve."[94]

Never given to idle rhetoric, Sanitary Commission leaders were making plans for their continued work almost before the war ended. "The machinery of the Commission is still in good working order, and only needs to be contracted in some directions and extended in others," promised an *S.C. Bulletin*. The commission proposed that women's aid societies help the returning soldiers adjust to civilian life and, in some cases, build institutions to assist the disabled. Only the women who were linked to the Sanitary Commission, the article claimed, could help the returning soldier "collect his claims upon the Government he has sustained." A member of the commission's supply department instructed workers: "We recommend you to impress on every aid society on your books, the importance of its making itself the local centre of all that concerns the welfare of returning soldiers, in its own neighborhood." He advocated centrally located asylums for invalid veterans, maintaining to the end the lessons of the war: "State and sectional feeling should be steadily withstood in favor of a larger and more pa-

94. L. R. James to Schuyler, 26 April 1865, box 673, USSC; Minnie Brooks to Angelina Post, 25 September 1865, Post; Schuyler to Angelina Post, 11 July 1865, Schuyler; W.C.A.R., *Fourth Annual and Final Report*, p. 6.

triotic sentiment." The commission had no intention of slackening its wartime campaign on behalf of systematic benevolence. "That we should profit by the instructive experience of the past four years is plainly a duty now," claimed its leaders.[95]

At the final board meeting of the Woman's Central Association of Relief, Henry Bellows proposed having the organization's history written. Several members suggested, logically, that Louisa Lee Schuyler write it. Unwilling to undertake such a project ("I am not capable of doing anything of the kind—& don't mean to") and in any case nearing a breakdown from overwork, she sat "upon pins & needles" throughout the discussion.[96] The work was never written in any official sense.

But Louisa Lee Schuyler, Henry Bellows, and the other leaders of the Sanitary elite were not without a sense of their own importance and of the significant changes in benevolence that they had helped bring about. With characteristic self-consciousness they sought to determine the historical image they would leave behind. Despite her exhaustion, Schuyler made sure to have photographs of W.C.A.R. members made and sent to representatives in local communities. In addition, she sought carefully to preserve the image of the W.C.A.R. that best represented her ideal. As she left her own "private S.C. Diary" with Angelina Post when Schuyler went to Europe after the war ("Don't show this to anyone," she warned), Schuyler also instructed Post about how to preserve W.C.A.R. documents:

> I don't think there is anything in the gentlemen's letters which requires erasing, but those letters from Aunt Mary! . . . Take a pen, & scribble over all the personal parts you think *may give offence*. I remember parts which the New Haven people might not like. And, where you think best, tear out whole pages or the entire letter—& destroy them. . . . I think Mrs. Olmsted's letters may need to have the pen & scissors freely used.

With whatever editing Post did do, there are nevertheless mountains of documentation about the Sanitary Commission and its auxiliaries, much of it the elaborate trivia of a corporation's accounts. "There are twenty-five large, thick books, still standing upon our shelves," read the W.C.A.R.'s final report, "in which every one of your invoiced letters . . . have been carefully preserved. . . . Let those who want to un-

95. "What Remains," *S.C. Bulletin* 3:38 (1 June 1865): 1202; N.E.W.A.A., *Monthly Report* (19 June 1865); "Sanataria," *S.C. Bulletin* 3:34 (15 March 1865): 1073.
96. Louisa Lee Schuyler to Angelina Post, 11 July 1865, Schuyler.

derstand our work in its truest sense, read over these hundreds, or rather thousands of letters."[97] The S.C.'s leaders had no intention of limiting the lessons of wartime benevolence to the war itself.

The legacy of the Sanitary Commission was an elitist repudiation of an older style of female benevolence. Sanitary leaders such as Henry Bellows and Louisa Lee Schuyler "regarded the spontaneous benevolence of the American people . . . as a great danger to the discipline of the army which it was their business to limit and control."[98] Sanitary Commission publications as well as individuals' correspondence over and over linked a concern for efficiency and professionalism with a denigration of the rhetoric of female benevolence. "Spontaneous" benevolence, particularly on the part of women, had to be efficiently disciplined into appropriate channels.

The language of femininity and masculinity pervaded this rhetoric as it had an earlier, evangelical vision of social change. Patriotism, insisted the Sanitary Commission, the clergy, and numerous other writers, was a manly virtue, the counterbalance, perhaps, to humanitarianism, which had been recognized as feminine. Even ministers, suspicious of "charity and compassion," fervently celebrated the manly emotions requisite for battle. The Sanitary Commission, proclaimed one of its leaders in a remarkable statement, was the child of two parents:

> . . . on the one side, the motherly love which kept swelling up night and day . . . in such a stream as threatened to overrun all bounds. On the other side, the manly demand for law and system to guide and control this great moving tide. . . . Except for that union—the masculine with this feminine element—that tremendous tide of love, and impulse, and anxious tenderness, would ere long have been met by pointed bayonets and turned back, and forbidden entrance to the camp and hospital.[99]

The metaphor could not have been clearer—or more violent to antebellum sensibilities. Without the controlling influence of paternal discipline, female benevolence and its representatives would be thwarted by the sword.

Many women in local aid societies resisted this transformation,

97. Schuyler to Post, 8 November 1865, Schuyler; W.C.A.R., *Fourth Annual and Final Report,* p. 14.

98. Fredrickson, *Inner Civil War,* p. 105.

99. Moorhead, *American Apocalypse,* p. 157; Frederick Knapp, "Plain Answers to Plain Questions," *S.C. Bulletin* 1:10 (15 March 1864): 289.

recognizing that the denigration of benevolent femininity signaled the adoption of the professional, not of women themselves, as the new symbol of social service. There was no universal rush to embrace the new emphasis on efficiency and nationalism, the forthright glorification of the Sanitary elite, and the attendant plaudits accorded organizational skills over humanitarian impulse. Many women were still reluctant to replace the rhetoric of female identity with one of professional interest or to accept the "masculinization" of the ideology of benevolence. Nonetheless, a critical divide had been crossed during the weeks, months, and years devoted to war work.

If benevolent women (and a few men) sought in the 1830s and early 1840s to control male passions by infusing the male realm with female virtues, the Civil War gave a new generation an opportunity to reverse completely that rhetoric. Increasingly, male values were viewed as necessary to control and limit a female effusion of emotion, sensibility, or passion; either those sensibilities would submit to law and system or they would become entirely ineffective, even dangerous. The wartime masculinizing of the ideology of benevolence consolidated trends that had been apparent in the 1850s. It pushed women—many of whom continued to accept an ideology of benevolence based on female values—further from the symbolic and real centers of power for social change.

# "The Moral Eye of the State"

Ties of business and battle linked benevolent women at war's end as they prepared for peacetime careers. Some Northern women followed the Sanitary Commission's suggestion and turned immediately to the problems resulting from the war itself, building soldiers' and orphans' homes and providing jobs and relief for widows. Others worked to assist newly freed blacks, either going south as agents or raising money at home. Still others turned to the state either to achieve suffrage for women or to abolish intemperance and prostitution. In whatever setting, however, the leaders and many of the participants in Civil War organizations sought their postwar constituency from among their wartime co-workers and articulated a rhetoric based on the lessons learned from war. In particular, they helped introduce a new class-based ideology of gender sameness that would exist alongside the older one of gender difference that had sustained antebellum movements.[1]

Those women who had administered wartime benevolence most clearly viewed the local relief organizations as a kind of standing army, available at any time for action. Thus several months after the war, Ellen Collins appealed to Mary K. Wead, associate manager for Franklin County, New York, on behalf of the National Freedmen's Relief Association.

1. See, e.g., Abby Hopper Gibbons to James and Sophy Mayer, 25 February 1866, in Sarah Hopper Emerson, ed., *The Life of Abby Hopper Gibbons Told Chiefly through Her Correspondence* (New York: G. P. Putnam's Sons, 1897), 2:141, where she describes the Labor and Aid Association of New York. The *New York Times,* 8 May 1884, p. 4, announced that the Union Home and School for the Education of Children of Volunteers, organized in 1862 and operated by a Mrs. Farragut and Mary Lydig Daly, was winding up its affairs and would turn over its unused funds to St. Mary's Free Hospital for Little Children.

The great strength of the Sanitary Commission lay in the earnest women scattered throughout the land who gave their money & their labor to comfort and bless the poor soldier. . . . We feel that this new object has not the same hold upon the popular sympathies, and we are doubly anxious to secure your cooperation, that the subject may be earnestly and fully presented to the Aid Societies, and the necessity for prompt & liberal action, pressed upon their notice.

"Some of our old circle will re-unite for this work," Collins concluded, "and will be rejoiced to have your assistance."[2]

Abby May also assumed that the bonds between women war workers would operate in peacetime when, in 1867, she published an appeal on behalf of the "more than 34,000 women and children of Crete . . . [who] are suffering excessively for want of food and clothes. . . . When we took leave of you as fellow-workers for the soldiers in our late war," May reminded her readers, "we told you that we should not entirely dissolve our organization; intending to hold ourselves in readiness to aid in any good work that might occur. The time seems now to have come."[3] The end of the war did not for these women signal a reprieve from wartime rhetoric, fervor, or responsibility. They carried the war and its lessons with them in embarking on new benevolent endeavors.

The war had consolidated a generation's conception of benevolence and social change; for many, it persisted as the central experience of their lives. Josephine Shaw Lowell had changed from an eighteen-year-old enthusiast for war to a widow, mother, and hardened administrator ready for new benevolent endeavors. In effect, the war never ended for Lowell; always dressed in black, she silently reminded people of its place in her life. "Those who knew Mrs. Lowell well knew that the experiences of those years of the war were the abiding influences in her life . . . ," recalled Louisa Lee Schuyler on Lowell's death. "One could not be with her—I never could—without feeling . . . the ever-present background of the war; . . . without seeing the halo upon her brow."[4]

Others experienced the war as a turning point in their intellectual development. Mary Livermore credited the war with awakening her to

2. Ellen Collins to Mary K. Wead, 18 September 1865, Wead Papers, Sophia Smith Collection, Smith College.

3. Abby May, "Appeal to the Women of New England," 27 February 1867, broadside in box 992, United States Sanitary Commission Records, Rare Books and Manuscripts Division, New York Public Library.

4. Louisa Lee Schuyler, quoted in William Rhinelander Stewart, *The Philanthropic Work of Josephine Shaw Lowell* (New York: Macmillan, 1911), p. 544.

women's political and social inequalities and with expanding her scope of action. "During the war . . . ," she later wrote, "I became aware that a large portion of the nation's work was badly done, or not done at all, because woman was not recognized as a factor in the political world." For Livermore, the war's national orientation and the scope of her relief work opened up new areas for political activity: she became a woman's rights activist as well as a leader in the women's clubs and prohibition movement. In some respects, as Mari Jo Buhle points out, Livermore was a member of an older generation, one that "chose their political weapons from the traditions of a gender-conscious culture harkening back to their youth." Yet Livermore was also a product of the war years, becoming, for example, an advocate of professionalized, collective housekeeping: "Efficiency and industrial training were her bywords," writes historian Dolores Hayden.[5]

Battle weary, Louisa Lee Schuyler left the country in 1865 for an extended trip to Europe; she was too exhausted, mentally and physically, to continue her work. To Angelina Post, Schuyler admitted that she was sorry to leave New York just then for there were plans afoot for new church organizations and for a society to help soldiers' families, "making the nucleous of it from as many of our old members, as could be got together."[6] When she returned she picked up benevolent activity where she had left it.

Government provided the context for much of benevolent workers' postwar activism. Increasingly, women sought formal access to government, whether in demanding suffrage, access to state-funded institutions, or a role in determining the relationship between benevolence and the state. According to her daughter, Elizabeth Buffum Chace "more and more steadily and intelligently directed the energy of her life into governmental channels of effort."[7] Rather than simply expanding their personal horizons, as we shall see, the postwar decades introduced new ways for women such as Chace to participate in politics.

5. Mary Ashton [Rice] Livermore, *The Story of My Life, or, the Sunshine and Shadow of Seventy Years* (Hartford: A. D. Worthington, 1899), p. 479; Mari Jo Buhle, *Women and American Socialism, 1870–1920* (Urbana: University of Illinois Press, 1981), p. 51; Dolores Hayden, *The Grand Domestic Revolution: A History of Feminist Designs for American Homes, Neighborhoods and Cities* (Cambridge: MIT Press, 1981), p. 115. On Livermore's commitment to cooperative housekeeping see pp. 115–31.

6. Louisa Lee Schuyler to Angelina Post, 2 August 1865, L. L. Schuyler Correspondence, Misc. Mss., Manuscripts Division, New-York Historical Society.

7. Lillie Buffum Chace Wyman and Arthur Wyman, *Elizabeth Buffum Chace, 1806–1899: Her Life and Its Environment* (Boston: W. B. Clarke, 1914), 1:269.

The old style of benevolent activism, with its emphasis on the moral transformation of society, did not immediately or fully vanish in the postwar era, but it took place more than ever in settings that were defined by government action; indeed, arguably the greatest accomplishments of the immediate postwar era, the three Reconstruction amendments, seemed to vindicate reformers' faith in the radical potential of electoral action. Reconstruction furnished new opportunities for some women—most of them former abolitionists, Quakers, or war nurses, women who believed that the Civil War had been a fundamentally moral struggle with a goal beyond the constitutional eradication of slavery—to provide relief and education for the freed slaves. Emily Howland, Sallie Holley, and Caroline Putnam remained in the South after the war for varying periods of time as teachers and charity workers.[8] So did Laura Towne, joined in 1866 by Civil War nurse Cornelia Hancock. These two women worked closely with federal officials in assisting freed blacks to establish economic independence and gain literacy on the Sea Islands off South Carolina. In 1866 they traveled to Washington, D.C., to lobby President Andrew Johnson on behalf of the bill to extend and expand the Freedmen's Bureau. Hancock eventually returned to Philadelphia, where she joined the emerging movement for centralizing charitable organizations, but Towne lived for the rest of her life on a renovated plantation with her friend and co-worker Ellen Murray.[9] Other young women visited the South for short periods of time. In 1866 Josephine Shaw Lowell and Ellen Collins traveled to Virginia on behalf of the National Freedmen's Relief Association to

8. Biographies and published letters of Reconstruction workers abound. See John White Chadwick, ed., *A Life for Liberty: Anti-Slavery and Other Letters of Sallie Holley* (New York: G. P. Putnam's Sons, 1899), and Judith Colucci Breault, *The World of Emily Howland: Odyssey of a Humanitarian* (Millbrae, Calif.: Les Femmes, 1974). Jane Woolsey taught from 1868 to 1872 at the newly founded Hampton Normal and Agricultural Institute in Virginia: Anne L. Austin, *The Woolsey Sisters of New York: A Family's Involvement in the Civil War and a New Profession, 1860–1900* (Philadelphia: American Philosophical Society, 1971), pp. 121–23.

9. Willie Lee Rose, *Rehearsal for Reconstruction: The Port Royal Experiment* (New York: Vintage Books, 1964), describes the Sea Island experience in fascinating detail, including the numerous controversies between the female teachers and the federal government. See also Rose, "Laura Matilda Towne," in *Notable American Women, 1607–1950: A Biographical Dictionary*, ed. Edward T. James and Janet Wilson James (Cambridge: Harvard University Press, 1971), 3:472–74; Henrietta S. Jaquette, "Cornelia Hancock," in *Notable American Women*, James and James, 2:127–29; Henrietta Stratton Jaquette, ed., *South after Gettysburg: Letters of Cornelia Hancock, 1863–1868* (New York: Thomas Y. Crowell, 1956); and Rupert Sargent Holland, ed., *Letters and Diary of Laura M. Towne, Written from the Sea Islands of South Carolina, 1862–1884* (Cambridge, Mass.: Riverside Press, 1912).

report on black schools; Ednah Dow Cheney did so several times, once taking her thirteen-year-old daughter along with her.[10]

As the only viable authority in the South immediately following the war, the federal government undertook to provide, however ambivalently and inadequately, relief and education for the ex-slaves.[11] But although the Freedmen's Bureau built school buildings, for example, it was private benevolence that was needed to pay teachers' salaries. That aid was not boundless. Although on war's end a great deal of money was raised in aid of Southern blacks, Northerners, including former abolitionists, soon made clear that their long-term commitment to helping the former slaves was minimal and that their attention and sympathies lay elsewhere. Whatever popular agreement had emerged about ending slavery did not extend to assisting the newly freed slaves, for, reported one society, "slavery . . . still exhales a poison over our land." As Ellen Collins noted, freedpeople's relief had far less of a "hold upon the popular sympathies" than had aiding the soldiers. Josephine Griffing, untiring in lobbying for the establishment of the federal Freedmen's Bureau, may have believed that those who supported the ex-slaves "are the same who made garments for the brave soldiers who fell on the battlefield for the nation's life." In fact, freedpeople's associations found it extremely difficult to raise money.[12] As early as 1866 Cornelia Hancock was writ-

10. Stewart, *Philanthropic Work of Josephine Shaw Lowell,* pp. 48–49; Ednah Dow [Littlehale] Cheney, *Reminiscences of Ednah Dow Cheney* (Boston: Lee and Shepard, 1902), pp. 85–98. Cornelia Hancock recorded visits by a number of abolitionists, including Abby Kimber and Sarah Pugh: Hancock to Rachel Hancock, April 1866, 27 May 1866, in Jaquette, *South after Gettysburg,* pp. 231, 241.

11. The literature on Reconstruction is vast, although that on its impact on benevolence is fairly small. See Robert H. Bremner, *The Public Good: Philanthropy and Welfare in the Civil War Era* (New York: Alfred A. Knopf, 1980), pp. 113–43; George M. Fredrickson, *The Inner Civil War: Northern Intellectuals and the Crisis of the Union* (New York: Harper and Row, 1965), pp. 189–98; and Eric Foner, *Reconstruction: America's Unfinished Revolution, 1863–1877* (New York: Harper and Row, 1988). A most insightful work on those Northerners who went south to teach during Reconstruction is Jacqueline Jones, *Soldiers of Light and Love: Northern Teachers and Georgia Blacks, 1865–1873* (Chapel Hill: University of North Carolina Press, 1980).

12. Rochester Ladies' Anti-Slavery Society and Freedmen's Aid, *Sixteenth Annual Report* (Rochester: William S. Falls, 1867), p. 4; *Work of the National Freedmen's Relief Association for the Year: Report of Mrs. J. S. Griffing* [1869?], Historical Society of Pennsylvania. See also Rochester Ladies' Anti-Slavery Society and Freedmen's Aid, *Fifteenth Annual Report* (Rochester: William S. Falls, 1866), which hoped in vain that now that work for the soldiers had ended, the "great tide of sympathy and benevolence" would assist the freedpeople (p. 4). On Josephine Griffing see Keith E. Melder, "Josephine Sophia White Griffing," in *Notable American Women,* ed. James and James, 2:92–94, and "Angel of Mercy in Washington: Josephine Griffing and the Freedmen, 1864–1872," *Records of the Columbia Historical Society of Washington, D.C.* (1963–65): 243–72.

ing urgently to her mother, "You must not let your Society die out. There is poverty enough in the south to claim your attention for years."[13]

The decline in Northern interest in the former slaves followed astonishingly soon after the war ended. "Our school exists on charity, and charity that is weary," reported Laura Towne in 1870. Less than one year later, she reported the demise of the Pennsylvania Freedmen's Relief Association, one of several organizations upon which her work depended. Various kinds of devices were used to convince churches and local societies to raise money. But even the promise that "any church [that] will guarantee this Association fifty dollars per month, . . . will be at liberty to send a teacher of its own denomination" only briefly stirred the public. Others met similar frustrations in trying to raise funds and enthusiasm. "The claims of the Indians—so long injured & cheated & wronged in so many ways," wrote Lucretia Mott in response to a plea for funds, "seem now, with many of our Friends, to take the place of the Freedmen, so that we can hardly collect money eno' to pay our 8 or 10 teachers [in the] South." Six months later Mott reported that people excused themselves from giving money for the freedpeople by asserting that "if this individual effort were discontinued, the Governm$^t$ or Authorities of Washington would take charge of these poor, suffering people."[14] To a greater extent than in the past, the perception that the government was playing a role in relief was accurate; the belief that its impact was sufficient, however, was not.

The very nature of their work in the federally controlled South with newly emancipated slaves (as well as their intense interest in the status of the federal constitutional amendments) brought these women into a close relationship with the federal government. That relationship became the closer with the decline of support from private Northern charities. However limited the federal government's commitment to aiding the freedpeople, the new explicit partnership between itself and benevolent workers could not but affect activists' own relationship to

13. 27 February 1866, in Jaquette, *South after Gettysburg,* p. 219. On the difficulty of getting Northerners to fund work among freedpeople see Joe M. Richardson, *Christian Reconstruction: The American Missionary Association and Southern Blacks, 1861–1890* (Athens: University of Georgia Press, 1986).

14. Letters, 29 May 1870 and 6 July 1871, in Holland, *Letters and Diary of Laura M. Towne,* pp. 220, 222; Women's Central Branch of the Pennsylvania Freedmen's Relief Association, "Circular," dated 20 November 1865, Historical Society of Pennsylvania; Mott to Josephine Griffing, 25 December 1869 and 17 May 1870, in Josephine Sophia White Griffing Papers, Rare Book and Manuscript Library, Columbia University.

politics and, especially, to the vote. Julia Wilbur, the agent in Washington, D.C., for several relief associations, warned in 1866 that Southern whites would not hesitate to take away blacks' new freedoms if Northerners failed to support the Freedmen's Bureau: "Until the negro has the ballot," she wrote, "some other protection is necessary." Her own and her co-workers' faith in the power of voting became even stronger by the next year, when the society hoped that "with the extension of Suffrage, we may hope for a radical change in many respects." Like countless others Wilbur, through her close association with urgent political matters, came to wish for a greater political role for herself. When black men could first vote, she looked on with interest ("although I had no vote to deposit"), noted that most of the men were unable to read, and confessed "to feeling a little jealous—the least bit humiliated." But, she went on, she

> rejoiced that I had lived to see so much progress, knowing that the rest will come in time. . . . Well, the sun rose as usual the next morning; no earthquake followed these proceedings, and I presume no convulsion of nature would have occurred, had white *women* and black *women* increased that line of voters. To quote Sojourner Truth, "It doesn't seem to be very hard work to vote. I believe I could do it myself."[15]

The postwar South probably witnessed the most explosive partisan loyalties in United States history, as the victorious Republicans sought to maintain their own ascendency through black men's votes and the Democratic party slowly sought to regain its own—and Southern white—dominance. Not surprisingly, then, Northern teachers and agents in the South formed strong party identities as Republicans during the Reconstruction years, attending meetings, organizing voters, seeking to balance the needs of blacks with those of poor whites, and demanding a stronger federal presence to protect blacks' fragile independence. "All the old rebels are earnestly trying to get our coloured men to vote for Greeley," wrote Sallie Holley from Virginia. "I hold regular monthly Republican meetings in our schoolhouse, and don't mean a single man shall vote for Horace Greeley."[16] Increasingly mar-

15. Rochester Ladies' Anti-Slavery Society and Freedmen's Aid, *Fifteenth Annual Report,* p. 16, and *Sixteenth Annual Report,* pp. 4, 22.

16. Sallie Holley to Mrs. Porter, 20 July 1872, in Chadwick, *Life for Liberty,* p. 221. The Philadelphia Female Anti-Slavery Society claimed simply that "the triumph of the Republican Party in the October and November elections was hailed by every liberty-loving soul as a triumph for Humanity": *Thirty-fifth Annual Report* (Philadelphia: Merrihew and Son, 1869), p. 5.

ginal to Northern benevolence, women who worked among the ex-slaves nonetheless forged an unprecedented, if short-lived relationship between the federal government and activists themselves.

In contrast to the federal government, Northern states energetically and unhesitatingly undertook the coordination of postwar benevolence. The increase in state aid to the families of soldiers during the war as well as the ideology of wartime relief encouraged state governments to assume administrative responsibilities for some forms of relief. State boards of charity, operating under a variety of titles, proliferated. In 1863 the Massachusetts legislature established the first such board, hoping to fill "a fatal want of harmony between the administrative elements . . . and a want of centralized authority injurious to the interests of the state." It was soon imitated by New York (1867), Rhode Island and Pennsylvania (1869), Connecticut (1873), and numerous other Northern states; all sought to infuse the coordination of publicly funded institutions with efficiency, rationalization, and central administration.[17]

From the start, benevolent women formed alliances with these public boards, seeking to join them in becoming "the moral eye of the State."[18] Some accepted positions that actually gave them official status. In 1870 Elizabeth Buffum Chace was appointed by Rhode Island governor Henry Lippitt to the Women's Board of Visitors to the Penal and Correctional Institutions of the State; she later resigned on the grounds that the position conferred "no power to decide that any improvement shall be made in the government or workings of these institutions." In a comment that showed just how changed was the legacy of female benevolence from the antebellum era, Chace insisted that in order to be effective and efficient, "the influence of women . . . must be obtained by placing women on the Boards of direct control." Apparently the governor found it expedient to make some concessions and Chace accepted reappointment several months later, devoting more and more time to acquiring power for women on state boards.[19] Abby Hopper Gibbons,

17. Report of the State Legislature's Joint Standing Committee on Public Charitable Institutions, quoted in Walter I. Trattner, *From Poor Law to Welfare State: A History of Social Welfare in America* (New York: Free Press, 1974), p. 79. On the various state boards, see David M. Schneider and Albert Deutsch, "The Public Charities of New York: The Rise of State Supervision after the Civil War," *Social Service Review* 15 (March 1941): 1–23. For a longer treatment of the subject, see Schneider and Deutsch, *The History of Public Welfare in New York State, 1867–1940* (Chicago: University of Chicago Press, 1941).

18. This expression referred to the New York Board of State Commissioners of Public Charities itself; see its *Fifth Annual Report* (Albany: Argus, 1872), p. 9.

19. Elizabeth Buffum Chace to Governor Henry Lippitt, March 1876, in Wyman and Wyman, *Elizabeth Buffum Chace*, 2:65–66.

no novice to political activity, lobbied for prison reform, in addition to becoming a leader in the emerging "purity crusade" against prostitution. Both she and Chace lobbied successfully to get police matrons placed in female prisons and asylums. Beginning in the mid-1870s, they and other prison reformers would focus on the establishment of separate women's prisons throughout the nation. The postwar focus on governmental activity also operated on the local level; there too it took on an increasingly formal character. Some women and men set up organizations to provide women and the poor with legal assistance. Others worked with new municipal boards of health in enforcing housing and health legislation.[20] Women who had gained political and administrative experience in benevolent organizations before and during the war accepted their expanding relationships with governments as a matter of course.

In 1876 Governor Samuel Tilden appointed thirty-two-year-old Josephine Shaw Lowell to the New York State Board of Charities. ("I woke up next morning and found myself famous," reported the governor.) Although Lowell was the first woman to hold that position, she did not describe—and probably did not view—her appointment as an advance for womankind. On the contrary, the work represented a continuation of her previous activity in the context of expanded state functions: she investigated public institutions, proposed and secured legislation, and wrote reports, which, circulated as state papers, received greater visibility and influence than they might otherwise have done.[21]

If Lowell seemed indifferent to the implications for women of her new status, several older women viewed her appointment to the state board as a victory for the cause of woman's rights. "All honor to our Governor, that he has given a woman a place among men!" exulted Abby

20. On prison reform, see Estelle B. Freedman, *Their Sisters' Keepers: Women's Prison Reform in America, 1830–1930* (Ann Arbor: University of Michigan Press, 1981). As a member of the N.Y. State Board of Charities, Josephine Shaw Lowell worked with the State Reformatory for Women: Stewart, *Philanthropic Work of Josephine Shaw Lowell*, pp. 87–114. On local efforts see, e.g., the following publications of the Working Women's Protective Union: *A Report of Its Condition and the Results Secured after Thirty-one Years of Activity, 1863–1894* (New York, 1895); *Plain Facts about Working Women: . . . the Fifteenth Anniversary of the W.W.P.U.* (New York: The Union, 1879); and *Twenty-Five Years' History* (New York, 1888).

21. Tilden, quoted in *Woman's Journal* 7:28 (8 July 1876): 224; Stewart, *Philanthropic Work of Josephine Shaw Lowell*, p. 52. Lowell served on the board until 1889. The first women to hold public office in Michigan served on the board of a girls' reformatory, which the legislature approved in 1879; two members of the Woman's Christian Temperance Union served on the board, an indication of the W.C.T.U.'s strength in the Midwest: Ruth Bordin, *Woman and Temperance: The Quest for Power and Liberty, 1873–1900* (Philadelphia: Temple University Press, 1981), pp. xiii–xiv.

Hopper Gibbons, who added, "He shall have my vote now and always." Seventy-four-year-old Lydia Maria Child wrote Lowell's mother, Sarah Shaw ("My Darling"), that she was "delighted with Mrs. Lowell's appointment. The manner in which she will discharge the duties of her important trust, will do more good for the Woman Cause, than a dozen conventions."22 These sentiments about Lowell's appointment were probably shared only ambivalently by the leaders of the woman's movement, who reported it briefly in their newspapers. Lowell's position, after all, represented her prior access to the state and underscored most women's limited access to the political tools necessary to performing society's work. To leading woman's rights activists, it was the vote, not the entry of a few women into particular positions, that would ensure women's greater authority in postwar society, that was in fact "the key which unlocks every door."23

The history of the woman's rights movement immediately following the war has been discussed in detail elsewhere.24 In simple terms, activists had by 1870 divided over whether to support black male suffrage, embodied in the Fifteenth Amendment, or to work only for truly universal suffrage. Those willing to postpone woman suffrage in order to work for black male suffrage formed the American Woman Suffrage Association. Women who insisted on immediate universal—and therefore woman's—suffrage joined Elizabeth Cady Stanton and Susan B. Anthony in the smaller National Woman Suffrage Association in New York. In their anger toward and sense of betrayal by longtime colleagues in the abolitionist movement (who, according to historian Ellen Du-

22. Abby Hopper Gibbons to John Bigelow, 3 May 1876, in Emerson, *Abby Hopper Gibbons,* 2:189; Lydia Maria Child to Sarah Shaw, [August?] 1876, in Milton Meltzer and Patricia G. Holland, eds., *Lydia Maria Child: Selected Letters, 1817–1880* (Amherst: University of Massachusetts Press, 1982), p. 537.

23. *Woman's Journal* 1:47 (26 November 1870): 373. For reports of Lowell's appointment, see, e.g., *Woman's Journal* 7:19 (6 May 1876): 149, and 7:20 (13 May 1876): 160.

24. See Ellen Carol DuBois, ed., *Elizabeth Cady Stanton, Susan B. Anthony: Correspondence, Writings, Speeches* (New York: Schocken Books, 1981); DuBois, *Feminism and Suffrage: The Emergence of an Independent Women's Movement in America, 1848–1869* (Ithaca: Cornell University Press, 1978); Eleanor Flexner, *Century of Struggle: The Woman's Rights Movement in the United States* (New York: Atheneum, 1974), pp. 142–55; and Elizabeth Cady Stanton, Susan B. Anthony, and Matilda Joslyn Gage, *History of Woman Suffrage* (New York: Fowler and Wells, 1882), vol. 2 (1861–76). Those interested in the postwar movement should also see *The Revolution,* Stanton and Anthony's woman's rights newspaper (New York, 1868–71), and the *Woman's Journal* (Chicago and Boston). Other relevant accounts of the politics of the immediate postwar years include David Montgomery, *Beyond Equality: Labor and the Radical Republicans, 1862–1872* (New York: Alfred A. Knopf, 1967), and Amy Dru Stanley, "Conjugal Bonds and Wage Labor: Rights of Contract in the Age of Emancipation," *Journal of American History* 75 (September 1988): 471–500.

Bois, saw "antifeminism as a strategy for ensuring the victory of black [male] suffrage"), some N.W.S.A. members, particularly Stanton, turned to a racist defense of white women's suffrage.[25] In other respects, particularly in their insistence that suffrage was only one facet of a struggle for woman's rights that included women's economic and sexual autonomy, the National Woman Suffrage Association represented the most radical of postbellum middle-class reformers.

The dispute among suffragists, often treated exclusively as a chapter in the struggle for woman suffrage, also needs to be viewed in the context of the transformed social and political landscape of the postwar years, as well as the changing class awareness of reformers themselves. In resorting to a fundamentally racist argument for enfranchising women, Stanton and others were turning their backs on their abolitionist roots and so on the legacy of moral transformation out of which the woman's rights movement had originally developed. The appeal to moral justice and to the transformative power of womanhood did not fade entirely from woman suffrage rhetoric, but the goals and language of the movement became increasingly secular and framed in terms of the political rights of competing groups. Indeed, one of the sources of greatest bitterness between the rival suffrage organizations was Stanton and Anthony's apparent defection from the party of emancipation, the Republican, to the Democratic party.[26]

In fact, woman suffragists were deeply involved in partisan politics. If the National Woman Suffrage Association turned to the federal government for total suffrage and the American, more moderately, to local governments, the difference in part reflected women's dissimilar access to politicians and parties. In Massachusetts, for instance, the stronghold of the American Woman Suffrage Association, it seemed quite possible to activists that woman suffrage would pass in the state in the early 1870s. The *Woman's Advocate* reported as early as 1869 that a committee of the state legislature had reported in favor of woman suffrage. That the legislature time and again voted down such proposals failed to discourage the Massachusetts suffragists, virtually all of whom were

25. DuBois, *Feminism and Suffrage*, p. 89.

26. For discussions of woman suffrage leaders' relationship to the major political parties and the tension between black men's suffrage and woman suffrage, see ibid., pp. 93–104, and Kathleen Barry, *Susan B. Anthony: A Biography* (New York: New York University Press, 1988), chap. 7. In a revealing incident in 1868, Susan B. Anthony apparently used Abby Hopper Gibbons' name in a way that implied that she was, as Gibbons herself put it, "hitched on to the Democratic party." What is most intriguing is the vehemence with which Gibbons' family insisted on a public disclaimer: Gibbons to Sarah Hopper Emerson, 7 July 1868, Emerson, *Abby Hopper Gibbons*, 2:151–52.

staunch Republicans, from believing that their partisan allies would soon grant suffrage to women. Indeed, in Massachusetts in the 1870s, the greatest opposition to woman suffrage came from the Democrats, who may have shared Lucy Stone's belief that "three fourths of the women of Massachusetts are Republicans." Certainly those associated with benevolent endeavors in that state were. In New York, in contrast, the Republican party held less sway. Offering "Thirteen Reasons Why Women Should Vote in 1876," "A Granger" noted that "with the present voting population New York is hopelessly Democratic." "A Granger" suggested that woman suffrage be adopted as a tactical move by the Republicans, comparable to their endorsement of black male suffrage: "Whichever party enfranchise Woman, in any closely contested State, will make a brilliant strategical stroke and secure its electoral vote," this writer stated confidently.[27]

Postwar activists acted openly on closely held partisan loyalties. When Mary Livermore was sent by the voters of her district to the 1870 Republican party convention, the *Woman's Journal* responded indignantly to reports that she had also attended the Democratic one, "for she is a Republican and not a Democrat." Elsewhere, noting that prohibition activist Judith Ellen Foster opposed the formation of a prohibition third party, D. Leigh Colvin argued that Foster was not nonpartisan (as she had apparently claimed) but pro-Republican, as "indicated by the fact that in 1888 [she] was elected by the Republican National Campaign Committee as the Chairman of the Women's National Republican Committee." Only after years of frenetic partisan activity followed by disappointment did the American Woman Suffrage newspaper, the *Woman's Journal,* announce that "our long clinging to the Republican party . . . is at an end." Susan B. Anthony, in contrast, proudly attended the Democratic national convention of 1868, a "new and unlooked-for sensation" that, Stanton and Anthony insisted, bespoke the Democratic party's greater commitment to woman suffrage—and foreshadowed these reformers' greater willingness to explore the possibilities of third parties throughout the rest of the century.[28] More was

27. *Woman's Advocate* 1:6 (June 1869): 326; *Woman's Journal* 1:42 (22 October 1870): 332, and 7:8 (19 February 1876): 60.

28. *Woman's Journal* 1:45 (12 November 1870): 359; D. Leigh Colvin, *Prohibition in the United States: A History of the Prohibition Party and of the Prohibition Movement* (New York: George H. Doran, 1926), p. 289; *Woman's Journal* 7:38 (16 September 1876): 300; on National Woman Suffrage Association leaders and the Democratic party, see Stanton et al., *History of Woman Suffrage* 2: 319–44 (quotation is on p. 340). For another reference to Livermore's party loyalties see "Woman Suffrage in Massachusetts," *Woman's Journal* 1:45 (12 November 1870): 359.

at stake in the contest for women's enfranchisement than simply competing ideologies or politics internal to the movement itself.

Closely tied to these partisan concerns—and, as we shall see, to the growing respectability of the woman suffrage movement—was the call for partial, or municipal, suffrage. The demand for partial suffrage was, as it is generally described, an ideologically conservative offshoot of the suffrage movement because it involved only piecemeal rights: the right to vote in municipal or school board elections, say, or on temperance referenda. Temperance women, for example, asked for the ballot only to abolish the liquor traffic, not to add to "their own individual rights and privileges": "Nobody has any inherent right to suffrage," insisted the Woman's Christian Temperance Union newspaper, the *Signal,* in 1882.[29]

The demand for partial suffrage must also be understood as a class issue, for it signified that relatively well-connected women, who expected to work in harmony with local political leaders, increasingly felt the sting of their own disfranchisement in a political era. The older, less formal channels that had once allowed women involved in local benevolent efforts to exercise political power were now increasingly ineffective. Elizabeth Buffum Chace was quite explicit about this when she protested the limited powers granted to Rhode Island's board of women visitors to prisons. Noting that the women's request to be appointed to "act as joint commissioners with men" on local committees had received "utter disregard," she concluded that "until equal rights in the government itself are guaranteed to all without regard to sex, we will henceforth make use of this treatment we have received as a new argument in favor of the emancipation of women." Frustrated at not having "even the privileges which would enable them to look after the welfare of the destitute and the suffering, with any power or authority to improve their condition," some women—among them many who in the antebellum years would have shunned so radical a cause—thus noted that suffrage, rather than an abstract or "natural" right, was a tool they needed to continue the work of benevolence.[30]

In some instances both supporters and detractors construed the issue of partial suffrage in explicitly class terms. Partial suffrage referred

29. *Signal* 3:14 (13 April 1882): 7; 3:21 (1 June 1882): 6. For a further defense of municipal suffrage see Mary A. Livermore, "The Ballot for Woman, a Temperance Measure," in the *Union Signal* 9:10 (8 March 1883): 2–3. On campaigns for partial suffrage see Flexner, *Century of Struggle,* pp. 176–77, and the *Woman's Journal.*

30. *Woman's Journal* 2:22 (3 June 1871): 175. The dispute continued in 1876, when the women resigned. See ibid. 7:17 (22 April 1876): 133.

not only to the permission to vote only in certain *elections* but also to granting that permission only to certain *women*. Some states, for example, experimented with bills that granted partial suffrage to women who owned a certain amount of property: "Well Done Connecticut!" cried Lucy Stone, when such a bill passed the house in that state. In 1882, indicating her interest in what certain women's votes might obtain rather than in all women's natural right to a ballot, Frances Willard proposed a restriction of woman suffrage to exclude illiterate women, women who drank, and prostitutes. In the final decades of the century a large number of states passed woman suffrage for school board elections or permitted propertied women to vote on tax-related issues.[31] No one understood the link among class, partisanship, and partial woman suffrage better than the opponents of the cause; as one Republican writer ted, an antisuffrage legislator in Massachusetts had framed the issue "a case of aristocracy against democracy, of diamonds against At-ucboro' jewelry, silk against calico, women's club against working-women's association" in a speech "calculated to give the impression that the amendment . . . did not allow poor women to vote."[32]

With the introduction of the demand for partial suffrage into local politics, more conservative women joined the cause. Although Thomas Wentworth Higginson claimed that "society" bore the same relation to woman suffrage that it had to antislavery, the acquisition by the movement of a growing number of wealthy women—and, indeed, the greater prosperity and social dominance of the children and grandchildren of antebellum activists—assured the growing respectability of the cause. The wealthy Julia Ward Howe, who had struggled to live both in fashionable society and in her husband's world of reformers, was finally able to do so. For Howe, middle age and the Civil War brought about a conversion, as "in an unexpected hour a new light came" to her and she joined the American Woman Suffrage Association, lending it a new legitimacy in the public eye as an increasingly respectable cause.[33] Another suffragist, Lillie Devereaux Blake, explicitly viewed as her mission the task of making woman suffrage more appealing to fashion-

31. Ibid. 7:26 (24 June 1876): 204; *Signal* 3:16 (27 April 1882): 4. See also "Woman Suffrage in Minnesota," *Woman's Journal* 7:8 (19 February 1876): 61; "Connecticut against Cincinnati," ibid. 7:28 (8 July 1876): 224; and *Signal* 3:17 (4 May 1882): 12. See, too, Morton Keller, *Affairs of State: Public Life in Late Nineteenth-Century America* (Cambridge: Harvard University Press, 1977), p. 442.

32. *Woman's Journal* 1:18 (7 May 1870): 138.

33. Julia Ward Howe, *Reminiscences, 1819–1899* (Boston: Houghton, Mifflin, 1899), p. 372; on her earlier conflict between the worlds of fashion and reform, see pp. 145–55.

able women. A product of the elite, Blake might seem an unusual advocate of so unpopular a cause. During the war, after the death of her first husband, she supported herself and her two children by writing articles from Washington, D.C., for New York newspapers. Blake joined the growing woman's movement when she happened to see the women at the National Woman Suffrage Association office and, amazed, cried, *"They're ladies!"* Apparently they were not lady enough, for Blake prided herself on having brought a tone of gentility and femininity to the cause. "She changed the whole method of the suffrage campaign," recalled one admirer, "by bringing the beauty and grace and charm of loveliest womanhood to aid the arguments and logic of the rather unattractive advocates who had been most conspicuous." Other activists also openly advocated gaining suffrage through appeals to "the conservative class of women." Remonstrating against Lucy Stone's suggestion that women boycott the centennial celebration of the Declaration of Independence until they too were declared created equal, one letter writer to the *Woman's Journal* opined, "When a sufficiently large proportion of the better class of women ask for the Suffrage they will obtain it and not till then."[34]

The entrance of more socially prominent women into the suffrage cause reflected their perception that partial suffrage would assist in concrete ways their ongoing pursuit of access to local officials in behalf of immediate ends. "We never so much really covet the ballot as at a school election," admitted the *Signal*. Successful campaigns for local suffrage, often tied to municipal appointments, were waged by clubwomen, temperance workers, and others who increasingly experienced the frustrations of votelessness and who felt that they now needed the vote to work efficiently.[35] Yet even without the franchise these women continued to exercise greater political authority than did poorer or more radical women—and they increasingly wielded that authority in quite formal ways. In 1869 two women from Worcester, Massachusetts, were elected to their local school committee. One of them, Ann B. Earle, had long been active in a number of charities; her husband, Edward, was a member of the State Board of Charities. In 1873, abolitionist and Civil War relief worker Abby May was elected along with three other women to the

34. Katherine D. Blake and Margaret L. Wallace, *Champion of Women: The Life of Lillie Devereaux Blake* (New York: Fleming H. Revell, 1943), pp. 74, 85; C. P. G. Pope to *Woman's Journal* 7:4 (22 January 1876): 28.

35. *Signal* 3:12 (30 March 1882): 8. On clubwomen's ambivalent response to the issue of woman suffrage, see Karen J. Blair, *The Clubwoman as Feminist: True Womanhood Redefined, 1868–1914* (New York: Holmes and Meier, 1980), e.g., chap. 3.

Boston school board amid some furor over their eligibility. The follow-ing year, legislation was enacted that permitted six elected women to serve on the board, although May lost reelection in 1878 due to "party action." In 1879, a full decade before Massachusetts women became eligible to vote in school board elections, she accepted an appointment by the governor to the State Board of Education; others served on the Massachusetts Prison Commission. In the mid-1880s, Grace Hoadley Dodge and Mary Nash Agnew were appointed to the New York City Board of Education, and in 1883 Woman's Central Association of Relief worker and nurse Georgeanna Woolsey Bacon received an appointment to the State Board of Charities from the governor of Connecticut.[36] Women thus served in positions for which they were not eligible to vote, a point not lost on Theodore Tilton's newspaper, the *Independent,* which suggested that woman suffrage might ultimately be achieved through this method: "Not from the ballot-box to the offices; but from the offices to the ballot-box." Frederick Douglass, too, acknowledged the significance of some women's political access when he informed suffragists that "I should like to attach myself to you ladies in the efforts that I make for liberty and progress, for I see that you have the inside track. You have ways of attaching yourselves to the governing power which we have not." Douglass averred somewhat snidely that the wom-en acquired access by their "faces [which] have a charm to the govern-ing power"; yet both he and the women understood that the disen-franchised differed in what they might ask of government—and that the work of society increasingly required that they demand a vote.[37]

Many of the female leaders of the Civil War relief organizations, who were as a group more socially prominent than woman suffrage

36. On Earle's appointment see *Woman's Advocate* 1:30 (March 1869): 127, and *Woman's Journal* 1:4 (27 January 1870): 27; and Lucia Peabody in Ednah Dow Cheney, *Memoirs of Lucretia Crocker and Abby W. May* (Boston, 1893), pp. 29–34, 41 (quotation on "party action" on p. 32). See also Julia A. Sprague, *History of the New England Women's Club from 1868 to 1893* (Boston: Lee and Shepard, 1894), pp. 75–77. The Massachusetts Prison Commission, unlike that in New York, legally required female members: Freedman, *Sisters' Keepers,* p. 38. On Woolsey, see Austin, *Woolsey Sisters,* pp. 156–57.

37. "Woman in Politics," *Independent* 21:1065 (29 April 1869): 4; Douglass in *Woman's Advocate* 1:2 (February 1869): 115. I can find little information about Mary Nash Agnew. Three letters by Abby Hopper Gibbons to New York Mayor H. J. Grant urged Dodge's and Agnew's reappointments. See those of 8, 19, and 22 November 1889, in Emerson, *Abby Hopper Gibbons,* 2:277–79. In the third letter, Gibbons remarks that she was particularly pleased with Agnew's reappointment: "I am glad the vacancy is filled by a married woman, as it should be." Agnew's husband, Dr. Cornelius R. Agnew, had been a Sanitary commissioner and was active in many of the activities discussed in this chapter. On Lucretia Crocker and Abby May see Cheney, *Memoirs of Lucretia Crocker and Abby W. May.*

activists, expressed little desire for the vote but no hesitation in working with governments; their war experience had encouraged them to view themselves as members of a class entitled to guard the efficiency of the state itself. Heirs to a benevolent tradition that had forged ongoing relationships with government officials, these women went further, founding organizations that depended for their very existence on a formal and explicit relationship with the state and on the rhetoric and values popularized during the Civil War. They severed their own benevolent work from its traditional moorings in the ideology of gender difference even as they eschewed suffragists' concern for undermining that ideology; indeed, they seemed to free themselves entirely from awareness of their sex, demonstrating instead a newly explicit loyalty to their class.

Louisa Lee Schuyler returned from Europe in 1871 ("after six years of health-hunting," in her words) eager to enlist her old Sanitary Commission co-workers in a new endeavor. She read the reports of the New York Board of State Commissioners of Public Charities (later the State Board of Charities) and personally investigated conditions in public institutions. Finding herself thwarted by officials—an experience almost relished by Civil War relief workers—she undertook the formation of an organization, the State Charities Aid Association, which would supervise and coordinate local visiting committees to the fifty-six public poorhouses and some half-dozen city almshouses in the state.[38] In the diary that she kept briefly at the start of her postwar career (even though, she wrote, "Anything I may write about this work can never interest me as one or two pages about the war would"), she detailed how she presented her proposal to Frederick Law Olmsted's scrutiny: "And then he put me through a cross-examination of several hours, rigourous, searching, imagining all sorts of contingencies. . . . It was delightfully exciting. I felt like my old self again—brain alive and responsive. . . . But not a word of commendation. I felt it was all right, but I did not know—not until midnight when my sister came into the room, & Mr. Olmsted turned to her: 'I have been trying to pick flaws in your sister's plan all evening, but without success.' Then I drew a long breath." In every way, Louisa Lee

38. See Walter I. Trattner, "Louisa Lee Schuyler and the Founding of the State Charities Aid Association," *New-York Historical Society Quarterly* 51 (July 1967): 233–48, and Robert D. Cross, "The Philanthropic Contribution of Louisa Lee Schuyler," *Social Service Review* 35 (September 1961): 290–301. The number of institutions is from State Charities Aid Association [of New York] (doc. no. 24), *Address from the S.C.A.A. to Its Local Visiting Committees* (New York, 1880), p. 4.

Schuyler undertook her postwar work with the Sanitary Commission stamp of approval.[39]

The central coordinating committee of the State Charities Aid Association stressed all that the Sanitary Commission had fought for: it represented the "best people" of the state, advocated experts' intervention between government and the people, employed associate managers and local visiting committees, and called for the efficient and independent administration of investigative work. In style and purpose it served as the benevolent arm of the emerging movement for civil service reform, which, according to George Fredrickson, "aimed not at the extension of democratic or humanitarian ideas, . . . but at . . . the creation of an efficient and disciplined administrative elite, an elite which would be relatively free of popular and political pressure and immune from the temptation to initiate basic social reforms."[40]

The leaders of the State Charities Aid Association in general, and Schuyler in particular, identified passionately with wartime benevolence. At the simplest level, they appealed to the bonds of affection and respect that the war had developed. "Many of the members of the State Charities Aid Association have worked together before," Schuyler noted in the organization's first report. "When our country was bleeding, in the great war of the rebellion, for four years they stood shoulder to shoulder in the ranks of the Sanitary Commission. . . . We believe they are ready to stand by us in memory of those old war-days when we worked together for our soldiers and our country." The next year Schuyler again evoked wartime memories to report: "In Brooklyn, a large, earnest, and influential organization has recently been effected, and we look now for the same active co-operation that is associated with the record of our sister city throughout the Rebellion." Seven years later, she still viewed the Civil War as her point of reference in greeting ex-associate manager Mary Wead. Pleased to find that Wead was president of the Franklin County visiting committee of the association, Schuyler

39. Louisa Lee Schuyler diary, 7 and 18 October 1871, Misc. Mss. Collection, Manuscript Division, Library of Congress.

40. Fredrickson, *Inner Civil War,* p. 209. Schuyler's 1878 eulogy of S.C.A.A. vice president Theodore Roosevelt listed as Roosevelt's first goal "the introduction of Civil Service Reform in the management of our Public Charities": quoted in S.C.A.A. (doc. no. 17), *Sixth Annual Report* (New York, 1878), p. 100. On civil service reform, see Ari Hoogenboom, *Outlawing the Spoils: A History of the Civil Service Reform Movement, 1865–1883* (Urbana: University of Illinois Press, 1968). An excellent account of postwar (male) liberals that includes information on civil service reform is John G. Sprout, *"The Best Men": Liberal Reformers in the Gilded Age* (New York: Oxford University Press, 1968).

(who had never met Wead but recalled her handwriting) wrote, "Naturally I have a peculiar feeling about our old Sanitary Commission fellow-workers, & care very much indeed to have them working with me again, in the work of today."[41]

The leadership of the State Charities Aid Association was virtually identical to that of the Woman's Central Association of Relief and the Sanitary Commission. The association's first annual report listed Louisa Lee Schuyler as vice president and chair of the executive committee. Other members in the first years included Frederick Law Olmsted, Georgina Schuyler, Ellen Collins, Jane and Abby Woolsey, and Emily Blackwell, as well as a few leaders of the New York branch of the Christian Commission. Individuals changed roles on the various committees, but the same names appeared year after year, including steadfast Sanitary Commission workers Catherine Nash, Christine Griffin, Gertrude Stevens Rice, Julia B. Curtis, Henry Bellows, and Josephine Shaw Lowell. Longstanding ties among Sanitary Commission colleagues extended to other cities as well. In Philadelphia, the Society for Organizing Charity was directed in part by Hugh Lenox Hodge, Jr., who had married Harriet Woolsey in 1869. Its second annual report (1880) listed as corresponding members the representatives of wartime benevolence throughout the Northern states; Louisa Lee Schuyler, Lowell, Charles Loring Brace, and George I. Chace (whose wife, "A. W.," had been the W.C.A.R.'s associate manager for Providence) worked with their Philadelphia counterparts in continuing the effort that they had undertaken during the war.[42]

The war also furnished the organizational structure for the State Charities Aid Association. Defending a system of private investigation with government support, Georgina Schuyler, Louisa's sister, compared current needs with those of wartime. "During the war the work of the Government in caring for the sick and wounded needed the supplementary aid of the Sanitary and Christian Commissions, and other outside agencies," she insisted, "—now, in time of peace, our public charities need the co-operation of patriotic and benevolent private citizens, both men and women, to make these charities what they intended to

41. S.C.A.A. (doc. no. 2), *First Annual Report* (New York: Cushing, Bardua, 1873), p. 25; S.C.A.A. (doc. no. 5), *Second Annual Report* (New York: Slote and Janes, 1874), p. 8; Louisa Lee Schuyler to Mary K. Wead, 29 June 1881, Wead.

42. See Philadelphia Society for Organizing Charity, *Second Annual Report of the Central Board of Directors* (Philadelphia: Globe Printing House, 1880). At the time of its *First Annual Report* (1879) the organization was called the Philadelphia Society for Organizing Charitable Relief and Repressing Mendicancy.

be." Like the Sanitary Commission, continued Schuyler, the S.C.A.A. required "systematic and organized work."[43]

In imitation of the Woman's Central Association of Relief's office in New York, the State Charities Aid Association's central committee performed primarily administrative work, depending for much of its information on local visiting committees, appropriately run by associate managers. Here too the names were familiar. Lydia Stranahan of Brooklyn, Mary Wead of Franklin County, New York, Elisa B. Culver, Katherine Wormeley, Emily Barnes, and other ex-Sanitary associate managers moved easily into new positions in the S.C.A.A.

The work of women and men in the State Charities Aid Association epitomized the changes that had come to characterize benevolence. They associated closely with the state government, sought the aid of New York's most elite Protestants, called for systematic work, established institutions, and welcomed conflict with the "bogie" of professional privilege in the name of independent benevolence. "The efficiency of all associated effort depends largely upon good organization, the enforcement of discipline and the thoroughness of the work performed," wrote Louisa Lee Schuyler as she continued to advocate virtues learned in wartime; she stressed in particular the "obedience to rules," the *"esprit de corps,"* and other "soldierly qualities, so essential to volunteer work, which may be developed by firm discipline and an earnest interest in a common cause."[44]

The Bellevue Hospital visiting committee reflected each of these characteristics early in its history. Formed even before the central committee of the State Charities Aid Association, the committee consisted of dozens of members of New York City's elite ("the very best class of our citizens, of enlightened views, wise benevolence, experience, wealth and social position," recalled Elizabeth Hobson), including Abby Woolsey, who visited Bellevue's wards weekly and who drafted the plan for the Bellevue Training School for Nurses. According to Hobson, the committee's chair, "a stronger or more influential committee for the purpose could scarely have been named in the City of New York, . . . all bending their energies to the reformation of that hospital, a hospital, be it remembered, dominated by political influences, and only to be regenerated through the force and backing of a powerful public opin-

---

43. Georgina Schuyler, in S.C.A.A., *Address . . . with Constitution and By-Laws [Local Visiting Committee for the Westchester County Poor House]* (New York, 1872), p. 15.
44. S.C.A.A., *Sixth Annual Report,* p. 3.

ion."[45] By September 1872, the committee had the "reluctant consent" of the New York State Board of Charities to start the nursing school. Within six weeks they raised $23,000 and by May 1873 hired a matron and established their training school with six female students. That year also saw the establishment of two other nursing schools, one at the Massachusetts General Hospital and the other at the General Hospital of Connecticut in New Haven, among whose organizers was former W.C.A.R. worker and nurse and Abby's sister, Georgeanna Woolsey Bacon.[46]

The plan for the Bellevue nursing school, although never expressing doubt that the nurses would be women, explicitly followed the lessons of wartime by repudiating any sentiment for nurses' "womanly care." Theirs were to be professional standards. "There is an idea prevailing among certain classes," complained the first State Charities Aid Association document, that "the work of nursing can best be done by persons who receive no pay. . . . Why should not Christian women receive proper remuneration for their services as well as Christian men?"[47] The visitors to Bellevue sought to implement the standards of efficiency that they had acclaimed during the war. As founders of a training school for female nurses they publicly emphasized the benefits of professional standards at the expense of traditional conceptions of female benevolence.

The State Charities Aid Association also challenged older images of female benevolence in defining its relationship with the State Board of Charities. In 1873, local officials expelled several "lady visitors" from the Westchester County poorhouse. Self-righteously, the association helped secure for the state board the authority to confer access to public institutions, with an understanding that the board would appoint visitors from the S.C.A.A. In 1878 the board cut off the association's access, provoking protest and lobbying by the S.C.A.A., which saw in this action a partisan effort to deny to "independent citizens" the right to

45. S.C.A.A. (doc. no. 1), *Report of the Committee on Hospitals,* rev. ed. (New York: G. P. Putnam's Sons, 1877; orig. 1872), p. 6; Elizabeth Christophers [Kimball] Hobson, *Recollections of a Happy Life* (New York: G. P. Putnam's Sons, 1916), p. 88.

46. Hobson, *Recollections,* pp. 94–100 (quotation on p. 94). Anne Austin, *Woolsey Sisters,* describes the Woolsey sisters' roles in civilian nursing after the war. On Jane's role as the "directress" of the new Presbyterian Hospital, see pp. 123–29; on Abby in the S.C.A.A., pp. 132–41; on Georgeanna's contribution to the founding of the Nursing School at the General Hospital of Connecticut, pp. 147–60.

47. S.C.A.A., *Report of the Committee on Hospitals,* pp. 26–27.

inspect institutions for which their taxes paid. The association appealed for its own "right of entrance law," which passed easily in 1881.[48]

Although the State Charities Aid Association's attack on partisanship was reminiscent of an earlier era of reform, in arguing for the new law the association explicitly rejected traditional rhetoric about benevolent agencies that were staffed by women. First, the association insisted that the fact that state commissioners were unpaid did not prevent even them from acting from political interest. "Public officers may receive no salaries," stated one report, mirroring the Sanitary Commission argument that pay in itself did not imply impure motives, "and yet must be bound by the limitations of the statutes which create them." Furthermore, S.C.A.A. member Joseph Choate argued before a committee of the state senate that the association merited official status for its work in part *because* it had repudiated older notions of benevolent activism. "Now, it may be supposed by some that the State Charities Aid Association is a mere gathering of sympathetic women," admitted Choate, "who go to these institutions to condole with the paupers and carry them gingerbread and tracts, and lavish a little weak sentiment upon them." Not so, he continued: the S.C.A.A. had proved itself free from "weak or sickly sentimentality."[49] A barely veiled contempt for the womanly virtues celebrated only decades before pervaded efforts at making state aid more efficient and more responsive to the benevolent elite. It is somewhat more surprising that the attacks on female virtues extended to turf that women and men had long declared most susceptible to those very traits: the field of private benevolence.

As the State Charities Aid Association coordinated its investigative efforts on behalf of the New York State Board of Charities, the Charity Organization movement implemented the values of Civil War relief in

48. The history of this legislation as well as the conflict between the boards can be found in S.C.A.A., *First Annual Report*, pp. 15–20; S.C.A.A., *Address to the Local Visiting Committees;* S.C.A.A. (doc. no. 25), *Argument of Mr. Joseph H. Choate before the Senate Committee on Miscellaneous Corporations, in Behalf of the S.C.A.A.* (New York, 1881), pp. 4–8; S.C.A.A. (doc. no. 26), *Final Report of the Special Committee in Charge of the Bill of the S.C.A.A.* (New York, 1881); Schneider and Deutsch, "Public Charities," pp. 12–13; passage and advantages of the law mentioned in S.C.A.A., *Second Annual Report*, pp. 11–12, and *Third Annual Report*, pp. 14–15. The 1881 "right of entrance law" specifically granted S.C.A.A. visitors the right to enter and inspect state charitable institutions, county poorhouses, town poorhouses, and city almshouses. See S.C.A.A., *Final Report of the Special Committee*, pp. 5–6. This document includes the final version of the bill (pp. 15–16).

49. S.C.A.A., *Address before the Local Visiting Committees*, p. 11; idem, *Argument of Choate*, p. 9.

systematizing private benevolence. Historians as well as contemporaries have viewed this movement as the dawn of the modern age. "It seemed that philanthropy at last had emerged from the sloughs of sentimentality and alms-giving, and achieved scientific status," begins Roy Lubove's book on the professionalization of charity work, expressing a sentiment widely held by the reformers themselves. Out of frustration with the chaos of relief during the national depression of 1873–77, charity workers established the first citywide Charity Organization Society in the United States in Buffalo in 1877; advocates of scientific charity quickly followed suit in numerous Northern cities. Complying with repeated calls by the State Charities Aid Association for such a society in New York City, Josephine Shaw Lowell, who had been authorized by the State Board of Charities to investigate the possibility of coordinating private charity, founded the New York Charity Organization Society in 1882.[50]

Charity Organization Societies dispensed little or no material aid, as signs outside the organizations' offices proclaimed proudly.[51] Unlike previous organizations, the Charity Organization Society focused primarily on the administration of a city's charitable resources—coordinating disparate charities, keeping records of all recipients of aid (to avoid duplicity and duplication, according to the leaders of the movement),

50. Roy Lubove, *The Professional Altruist: The Emergence of Social Work as a Career, 1880–1930* (New York: Atheneum, 1980), p. 1. Charity Organization Societies modeled themselves after the London Charity Organization Society (founded 1869). The main statement of Charity Organization's rationale is Stephen Humphreys Gurteen's *A Handbook of Charity Organization* (Buffalo: privately printed, 1882). Societies were founded in New Haven and Philadelphia in 1878, Boston, Brooklyn, and Cincinnati in 1879: Lubove, *Professional Altruist*, p. 2. Trattner writes that there were 138 C.O.S.'s by the turn of the century: *From Poor Law*, p. 84. See also Frank Dekker Watson, *The Charity Organization Movement in the United States: A Study in American Philanthropy* (New York: Macmillan, 1922), and Kathleen Woodroofe, *From Charity to Social Work in England and the United States* (London: Routledge and Kegan Paul, 1962). On the relationship between the C.O.S. and the New York State Board of Charities, see Stewart, *Philanthropic Work of Josephine Shaw Lowell*, pp. 122–26. On the depression itself and the C.O.S., see Schneider and Deutsch, *Public Welfare*, pp. 35–38. Eventually the C.O.S. and the New York Association for Improving the Condition of the Poor merged and became the Community Service Society. See [Community Service Society], *Frontiers in Human Welfare: The Story of a Hundred Years of Service to the Community of New York, 1848–1948* (New York: C.S.S., 1948).

51. Trattner, *From Poor Law*, p. 84; Robert H. Bremner, "Scientific Philanthropy, 1873–93," *Compassion and Responsibility: Readings in the History of Social Welfare Policy in the United States,* ed. Frank R. Breul and Steven J. Diner (Chicago: University of Chicago Press, 1980), pp. 197–202. Historians frequently quote the sign outside the Buffalo C.O.S., which said NO RELIEF GIVEN HERE. See, e.g., Bremner, "Scientific Charity," in *Compassion and Responsibility,* ed. Breul and Diner, p. 199.

and administering a vast system of direct visiting by wealthy volunteers. This system of "friendly visiting," staffed largely by women, was intended to educate people toward self-sufficiency, thus, the organizers claimed, eliminating the causes of poverty. Volunteers were expected to "enlarge [their] circle of friends" by interacting with those whom they visited.[52] In the meantime, the movement's advocates hoped to diffuse the dangers implicit in the growing distance between the classes essentially by having the wealthy keep an eye on the poor.

In some respects, friendly visiting seemed to hark back to the more sentimental benevolence of the prewar period; yet to those observers who longed for an older style, charity organization seemed cold. Josephine Shaw Lowell, who identified with and aggressively disseminated the organization's message, was attacked for being stern and for expressing pride that the Charity Organization Society distributed "not one cent!" Because of their emphasis on efficiency, the C.O.S.'s "tended to emphasize the detective and repressive aspects of their work," as they sought out impostors among the needy. "So important a business as the administration of charity . . . ," asserted Lowell in a plea for organized charity, "requires to be carried on on business principles, if the great evils of wasted funds and corrupted and pauperized citizens are to be avoided." The C.O.S., according to historian Walter Trattner, reflected the middle-class virtues of "rationality, efficiency, foresight, and planning," which were central to business as well as philanthropic goals.[53]

The Charity Organization Societies as well as the state boards of charity adopted business rhetoric for their work, thus expanding on the model celebrated during the Civil War. A corporate rhetoric pervaded the new charity work as it did that of the Gilded Age itself, and charity organization was likened to "trustification and amalgamation in business." According to historian Kathleen McCarthy, "for Chicago's feminine stewards, the Gilded Age was an era of expanding managerial and monetary opportunities, while the masculine leitmotivs were centralization and control. Businessmen, rather than women, were accorded the

52. Quoted in Watson, *Charity Organization Movement*, p. 150. The New York C.O.S. published a series of charitable directories that are tremendously useful for students of late nineteenth-century charity. See, e.g., C.O.S., *A Classified and Descriptive Directory to the Charitable and Beneficent Societies and Institutions of the City of New York* (New York: G. P. Putnam's Sons, 1883).

53. Trattner, *From Poor Law*, p. 86; Bremner, "Scientific Philanthropy," p. 200; Stewart, *Philanthropic Work of Josephine Shaw Lowell*, p. 124; Trattner, *From Poor Law*, p. 85. The movement's founder agreed: "There must be no sentiment in the matter. It must be treated as a business scheme": Gurteen, *Handbook*, p. 123.

central role in the Social Darwinist scenario." Not surprisingly, charity organization leaders were attacked as corporate magnates in a period of corporate dominance. One minister advised the Cleveland C.O.S. that if they truly believed in charity they would end the twelve-hour day and increase wages; the members were apparently unruffled by the challenge or the criticism.[54] To the extent that benevolence acquired a businesslike rhetoric, it adopted other aspects of the emerging corporate mentality: ever stronger class identification, a rejection of calls upon women to overcome class differences in the interest of sisterhood, and hostility toward those who urged dramatic social change.

Charity Organization Societies' emphasis on science and business helped transform the discourse over benevolence from one about gender to one about class at a time of growing conservatism and class awareness on the part of the Protestant middle and upper-middle classes. No longer something to transcend through virtue, class standing was now understood explicitly by the benevolent as something to protect. In contrast to the antebellum period, when middle-class women articulated an ideology of virtue that identified their own social status as preferable to that of elites, their daughters asserted, through their benevolent and reform work, a class identity that sharply distinguished between themselves and the poor. More economically secure than their parents, urban upper-middle-class activists evinced little concern that they be distinguished from a leisured aristocracy, that only virtue lay between themselves and the fallen. The connections between benevolent organizations and corporate leaders became visible in the 1870s and 1880s, a time when "the industrial bourgeoisie were primarily sons of Protestant laymen who had been active in church work." People's understanding of the link between benevolence and class interest deepened accordingly. "It is a truism to say that this Charity is an outgrowth of Capital, and could not exist without it," blandly stated a report of the New York Association for Improving the Condition of the Poor in 1872. Nor were charity organizers loath to discuss "the money value to the community of our work." Josephine Shaw Lowell unambivalently sought out "business & professional men" in founding the N.Y.C.O.S., appealing to their interests to fight inefficiency: "The whole business of outdoor relief in this City is carried on independently by each separate

54. Lubove, *Professional Altruist*, p. 6; Kathleen D. McCarthy, *Noblesse Oblige: Charity and Cultural Philanthropy in Chicago, 1829–1929* (Chicago: University of Chicago, 1982), p. 72; Trattner, *From Poor Law*, p. 88.

organization and the result is a constant increase of pauperism, imposture &c," she insisted.[55]

The parallels between postwar charitable enterprises and those operating for private profit were numerous and explicit. "Some one has said that the supreme test of the great executive is that when he dies the corporate machine he has created goes on without the slightest pause, . . ." asserted Ellice Alger on the death of Louisa Lee Schuyler, "without its stock selling off in the market or any other suggestion of loss of public approval or confidence. If that be true of the great business executive, it was eminently true of Miss Schuyler."[56] Schuyler herself would not have objected to this characterization; she sought to imbue benevolence with precisely those qualities that she had observed in the corporation building undertaken by the men of her class.

Grace Hoadley Dodge, born in 1856, experienced firsthand the benefits of this new professionalism. Her father, William (himself the son of the "Christian merchant"), was a founder of the Young Men's Christian Association, the Christian Commission, and the Union League Club, organizations that reflected the declining moral hopefulness of the era. Her mother, Sarah Hoadley Dodge, was a member of the visiting committee of the State Charities Aid Association to Bellevue Hospital. Grace was a descendant of a long line of the benevolent elite, a family of whom Josephine Shaw Lowell remarked that "you can depend on every time, [for] being all rich . . . they have time to work."[57]

55. Gregory H. Singleton, "Protestant Voluntary Organizations and the Shaping of Victorian America," *American Quarterly* 27 (December 1975): 558; N.Y.A.I.C.P., quoted in Marvin E. Gettleman, "Charity and Social Classes in the United States, 1874–1900, I," *American Journal of Economics and Sociology* 22 (April 1963): 318; Charles Kellogg, quoted in New York Charity Organization Society, *Third Annual Report* (New York, 1885), p. 19; Josephine Shaw Lowell to Charles Fairchild, 28 November 1881, box 1, no. 122, Fairchild Papers, Manuscripts Division, New-York Historical Society. S.C.A.A. secretary Susan M. Van Amringe noted that visitors and the committee "all agree as to the fact that improved hospital accommodations, and a system of paid nursing in the poor-houses of the State are demanded, not only by humanity, but by a regard to the principles of sound public economy as well": S.C.A.A. (doc. no. 30), *Tenth Annual Report* (New York, 1882), p. 29. Lubove and others argue convincingly that Charity Organization was "an instrument of social control for the conservative middle class": *Professional Altruist*, p. 5.

56. Ellice M. Alger, "Louisa Lee Schuyler: Her Executive Ability," in National Committee for the Prevention of Blindness, *Louisa Lee Schuyler, 1837–1926* (New York: N.C.P.B., 1926), p. 18.

57. Sarah H. Dodge's membership noted in Hobson, *Recollections*, p. 89 fn.; Josephine Shaw Lowell to Anna Haggerty Shaw, 23 May 1882, in Stewart, *Philanthropic Work of Josephine Shaw Lowell*, p. 129.

Dodge's biographer, Abbie Graham, argues that Dodge's career should be viewed alongside those of the businessmen of her class. Dodge was a "merchant" who sought to invest in the "invisible commodities of the spirit, of which her generation stood in need." Dodge's apprenticeship and career greatly resembled those of her corporation-bound male counterparts. In the late 1870s Dodge's father stopped in at the S.C.A.A. office of his friend and co-worker, Louisa Lee Schuyler. There he sought Schuyler's advice about his daughter, who had expressed a desire to work with the poor. Schuyler agreed to give the young woman work on the Committee on the Elevation of the Poor in their Homes. In 1881 Grace Hoadley Dodge became the chair of that committee, studied the condition of tenements and of citywide charities, and thus undertook a full-time career which would include initiating coal clubs, working girls' clubs, kitchen gardens, loan associations, Teachers' College at Columbia University, and other early Progressive Era institutions.[58]

The postwar language of corporatism and scientific charity was a significant challenge to the rhetoric of antebellum female benevolence even though the organizational lessons learned earlier persisted into the postwar world. Whereas the ideology of benevolence had permitted some antebellum activists to express their best hopes for a moral society, the postwar generation evinced a far more pessimistic and insulated perspective about human nature and the limits of reform; composed of the most elite of a city's benevolent upper-middle class, Charity Organization Societies were only the most extreme manifestation of this transformation. In a postwar urban society characterized by the growing rigidity and seeming permanence of class boundaries, many of the women who had launched their careers during the Civil War almost never used an imagery of gender in their public work. In fact, the new administrators of charity denied that women were better suited for benevolent work: they demanded professional—not gender—standards.[59] To

58. Abbie Graham, *Grace H. Dodge: Merchant of Dreams* (New York: Womans Press, 1926), pp. 15, 58–61. See also Robert D. Cross, "Grace Hoadley Dodge," in *Notable American Women*, ed. James and James, 1: 489–92. In many respects Dodge's activities bridged her parents' generation with a later one, for they signaled the reemergence of a benevolent concern with gender-related issues and rhetoric.

59. I have been aided by Thomas Haskell's definition of professionalism in understanding the new benevolence: "Professionalization is understood to be a measure not of quality, but of community. A social thinker's work is professional depending on the degree to which it is oriented toward, and integrated with, the work of other inquirers in an ongoing community of inquiry": *The Emergence of Professional Social Science: The American Social Science Association and the Nineteenth-Century Crisis of Authority* (Urbana: University of Illinois Press, 1977),

them, it was the very absence of traditional female traits that marked a woman as a good benevolent worker. "Gertrude [Stevens Rice] is a most satisfactory person to work with," wrote Josephine Shaw Lowell of her ex-W.C.A.R. and now Charity Organization Society colleague, "very efficient and full of sense and no personal feelings to interfere." One C.O.S. New York district report stated: "We have found quality more important than quantity in Friendly Visitors," as it proceeded to argue that volunteers be screened and only those accepted who had sufficient skills and who demonstrated "their ability and willingness to carry out the principles of the Society." Annie Fields of the Boston Charity Organization Society agreed, explaining that in charity, as in government, expertise should carry greater weight than simple willingness to do the work.[60] "In spite of sentimental notions, women are no more born nurses than men are born chemists and engineers. Nursing is serious business," stated the State Charities Aid Association. Its volume, *A Century of Nursing,* went on to make brutally clear what it thought of the traditional conflation of nursing with feminine sensibilities: "The thrusting of persons, without previous education for the duties, into such responsible positions is trifling with human life and suffering."[61] Charity organizers learned the lessons of the Civil War too well, as they sought to make charity work efficient at the risk of making it uncharitable.[62]

These benevolent activists, by their very silence about a female identity (even ignoring occasional remarks from the men to the effect

p. 18. The ties between the A.S.S.A. and the new charity work were numerous. Franklin Sanborn, e.g., was both secretary of the Board of Charities of Massachusetts and general secretary of the A.S.S.A. The National Conference of Charities and Corrections developed from these two movements. For a discussion of the links between professional social science and what he calls postwar "feminism" see William Leach, *True Love and Perfect Union: The Feminist Reform of Sex and Society* (New York: Basic Books, 1980), chaps. 11 and 12. See also Geoffrey Blodgett, "Reform Thought and the Genteel Tradition," in A. W. Morgan, ed., *The Gilded Age,* rev. ed. (Syracuse: Syracuse University Press, 1970).

60. Josephine Shaw Lowell to Annie Haggerty Shaw, 28 March 1882, in Stewart, *Philanthropic Work of Josephine Shaw Lowell,* p. 128; N.Y.C.O.S., *Third Annual Report* (New York, 1885), pp. 33–34 (Report of District Committee number 13); Mrs. James T. [Annie] Fields, *How to Help the Poor* (Boston: Houghton, Mifflin, 1884), p. 26.

61. S.C.A.A. (doc. no. 11), *A Century of Nursing, with Hints toward the Organization of a Training School* (New York: G. P. Putnam's Sons, 1876), p. 112.

62. Clifford Clark, Jr., in a biographical essay on Henry Bellows, writes: "Unfortunately, . . . Bellows' success on the Sanitary Commission had set too persuasive an example": "Religious Beliefs and Social Reforms in the Gilded Age: The Case of Henry Whitney Bellows," *New England Quarterly* 43 (March 1970): 75.

that the "ladies" did most of the work),[63] helped effect the emergence of an ideology of gender sameness in the interest of class unity. "So far as I know she had no particular interest in what so many women have considered the 'great cause,' the emancipation of her sex," mused Ellice Alger after Louisa Lee Schuyler's death. "I do not think women interested her more or less than men and I do not suppose she ever in her life felt handicapped because she had not a personal vote, though much of that life was spent in work which was essentially political." When these women did refer to gender, it was to the skills acquired in the process of performing "women's work," not to traits inherent in or shared by all women. The Bellevue Hospital committee, for example, reported that the wards were visited weekly "by ladies whose experience in the supervision of their own households has made them experts as regards washing, the care of linen, cooking, nursing the sick, etc. . . . The Commissioners [of Charities] have themselves told us there were many household details in a large hospital only understood by women." Their emphasis on a desexualized professionalism assured that these benevolent women would repudiate the traditional ideology of peculiarly female characteristics, as they sought a professional community based solely on class and career. It also assured that they would reject the conflation of womanhood with the ideology of Christian benevolence.[64]

In light of the vitality of a language of reform that explicitly rejected earlier benevolent values, we need to understand how those movements that did use rhetoric reminiscent of antebellum benevolence nevertheless signaled the altered landscape of postwar reform. Both the Woman's Christian Temperance Union and the social purity (antiprostitution) crusade sustained older notions of female benevolence, arguing that only through the protection of women and, most especially, the home,

63. D. B. Eaton, e.g., called the success of the S.C.A.A. "a striking illustration of the moral power of a few refined women, guided by a noble spirit": "Notes and Recollections" (1875) in Sophonisba R. Breckinridge, ed., *Public Welfare Administration in the United States: Selected Documents* (Chicago: University of Chicago Press, 1927), pp. 355–56. See also the Reverend Dr. Adams' speech in the S.C.A.A., *Third Annual Report,* pp. 46–47, and speech of Charles O'Conor, in idem, *Fourth Annual Report,* pp. 93–94. This is not of course to suggest that there were no differences between the women and men in terms of authority or options.

64. Alger, "Louisa Lee Schuyler," in *Louisa Lee Schuyler,* p. 18; S.C.A.A., *First Annual Report,* pp. 11–12. On those interested in professionalizing housework see Hayden, *Grand Domestic Revolution,* pp. 124–31. Other groups, notably the woman's club movement, participated in this trend toward professionalization without sacrificing a consciousness of women's shared social experience. See Blair, *Clubwoman as Feminist.*

could society's virtue be saved. These activists employed the ideology of women's moral superiority to seek to control male behavior, in particular sexual activity and drinking, by demanding "public recognition of women's values."[65] The very slogan of the W.C.T.U.—"Home Protection"—reveals the importance of the rhetoric of female values and interests to many Protestant women. Yet these movements, which took up struggles in which earlier activists had tested the radical implications of the ideology of female benevolence, nevertheless also reflected the pessimism characteristic of their time and the growing sense of the improbability of the moral transformation of society.

The social purity crusade, organized by the New York Committee for the Suppression of Legalized Vice (founded 1873), was led by former abolitionists such as Abby Hopper Gibbons, Elizabeth Neall Gay, Elizabeth Blackwell, Aaron Powell, and Susan B. Anthony, as well as conservatives like Anthony Comstock.[66] Labeled the "new abolitionists," the purity crusaders claimed to have inherited the moral agenda of the campaign against slavery.[67] Nevertheless they worked in a wholly different context. The purity crusade was conceived almost entirely in political terms, as reformers demanded strictly enforced age of consent, or statutory rape, laws and fought police efforts to regulate, and therefore implicitly condone, prostitution. These reformers bypassed attempts to convert individuals away from their immoral behavior; alerted to sin in their midst, they appealed directly to the state to limit its effects. The "restraining force of old religious feelings" was disappearing, warned Dr. Elizabeth Blackwell: "the 'Repressive System' . . . in reference to municipal action" was the only "righteous method" for controlling male sexual transgressions.[68] With a sexually mixed leadership, purity reformers blended a rather perfunctory concern for female innocence with an outraged emphasis on protecting social institutions from the "vicious."

65. Barbara Epstein, *The Politics of Domesticity: Women, Evangelism, and Temperance in Nineteenth-Century America* (Middletown, Conn.: Wesleyan University Press, 1981), p. 90.

66. The essential history of the movement is David J. Pivar's *Purity Crusade: Sexual Morality and Social Control, 1868–1900* (Westport, Conn.: Greenwood Press, 1973). On similar efforts in England see Judith R. Walkowitz, *Prostitution and Victorian Society: Women, Class, and the State* (New York: Cambridge University Press, 1980). The related censorship movement is discussed by Paul S. Boyer, *Purity in Print: The Vice-Society Movement and Book Censorship in America* (New York: Charles Scribner's Sons, 1968).

67. Pivar, *Purity Crusade,* p. 7. Ednah Cheney believed that the purity reformers "inherit[ed] the mantle of the heroes of anti-slavery": *Reminiscences,* p. 169.

68. Elizabeth Blackwell, *Wrong and Right Methods of Dealing with Social Evil* (New York: A. Brentano, 1883), pp. 6, 43.

The all-female Woman's Christian Temperance Union illustrates the persistence of the traditional conflation of women and morality; in many ways it dedicated an older rhetoric to a new style of benevolent work. Based largely in small-town churches, the W.C.T.U. gathered the largest number of women of any nineteenth-century organization; clearly the appeal to a shared female benevolence rang a chord of sympathy in many Protestant women.[69] Nevertheless, the W.C.T.U. plunged into political activism, seeking to infuse electoral politics with the goals of "Home Protection." In the organization's first year, its president, Annie Wittenmyer, a politically cautious ex–Civil War nurse and relief worker, organized a petition campaign to Congress pleading for the establishment of a committee to investigate the evils of drink. By 1875, Frances Willard, who would become the president in 1879, was pushing for "broader political programs," among which would ultimately be the demand for suffrage as the only means to protect the home.[70]

The W.C.T.U. did not shrink from entering presidential politics, endorsing Republican James Garfield for president in 1880. Disappointed with Garfield's unfulfilled temperance promises, they organized the Home Protection party in 1881, the first national political party composed of women. One year later the party merged with the National Prohibition Reform party, which included support for woman's suffrage in its platform and which for two years agreed to be called the Prohibition Home Protection party. Moving beyond the political activities of the 1850s (men were to sign a voters' pledge in lieu of the once ubiquitous temperance pledge), both women and men had become unabashedly partisan in the interests of a benevolent cause. "Your memorialists do respectfully set forth that they are an organization of women citizens of the State . . . ," began a W.C.T.U. petition to a political convention, which went on to "modestly remind our political leaders of the historic testimony of American politics, that the people do not long adhere to a party which does not listen to its expressed desire."[71] Even

69. Local boards of the W.C.T.U. counted their members from among the various Protestant denominations in a given city or town: Bordin, *Woman and Temperance,* pp. 9–10. There were more than 176,000 members by the end of the century: Epstein, *Politics of Domesticity,* p. 115. See also Anna A. Gordon's rather glorified biography, *The Beautiful Life of Frances E. Willard* (Chicago: W.C.T.U., 1898), and Willard's *Glimpses of Fifty Years: The Autobiography of an American Woman* (Chicago: Woman's Temperance Publication Association, 1889).

70. Bordin, *Woman and Temperance,* pp. 49–50; the campaign resulted in more than 40,000 signatures. Also see pp. 51, 55–56.

71. See Epstein, *Politics of Domesticity,* p. 122; Ernest H. Cherrington, *The Evolution of Prohibition in the United States of America* (Westerville, Ohio: American Issue Press, 1920),

an article on "The Church and Prohibition" defined a role for religious institutions that was decidedly political: "If every pulpit and religious paper in the land would constantly and openly urge all Christian and temperance people the sacred duty of supporting only that political organization which stands pledged to the suppression of the liquor traffic, we should witness its overthrow." The article went on to describe the importance of women to such a party.[72]

The Woman's Christian Temperance Union tried to insist on the importance of female values for social policy; in contrast to earlier activists, however, postwar temperance workers essentially counted on women to adhere to that standard and on men to obey laws designed to limit their behavior. "Any influence . . . which will tend to restrain the evil passions of men, and to make them more amenable to law, is . . . a practical matter, and one worthy of the State's consideration," the organization insisted. Frances Willard's proposed partial suffrage for women did provoke an impassioned response from a woman who insisted that the same standard for citizenship be set for women as for men: "Immorality does not disqualify a man for any political honor," she pointed out. True enough, the editor of the *Signal* responded, but proclaimed, "Let there be one standard of morality, and let women conform to it, no matter what men may do."[73] Men could be expected to follow their "evil passions" and still rule society; women, in contrast, might be denied future—and very concrete—privileges unless they adhered to a middle-class standard of morality.

Both the Woman's Christian Temperance Union and the purity reformers used the apparatus of government to "protect" women from male excess.[74] Their political and partisan activity, which has signaled to historians their entrance into a male arena, was as we know far from

---

pp. 167–74. See also Willard, *Glimpses of Fifty Years,* pp. 371–402, and Colvin, *Prohibition,* pp. 132–33. Colvin also prints the Prohibition party platforms, which included woman's suffrage (pp. 124–27). Quoted petition and voters' pledge are in Judith Ellen Foster, *Constitutional Amendment Manual . . . for Constitutional Prohibition* (New York: National Temperance Society and Publication House, 1882), pp. 67, 87.

72. *Signal* 3:12 (30 March 1882): 6.

73. Ibid. 3:8 (2 March 1882): 6; 3:16 (27 April 1882): 4.

74. The debate about female sexuality took a new turn in the 1870s and 1880s with the growing acknowledgment of female sexual feeling: Linda Gordon, *Woman's Body, Woman's Right: The Birth Control Movement in America* (London: Penguin Books, 1974), pp. 95–115. For a new interpretation of the relationship between antiprostitution campaigns and women's perception of their own sexual vulnerability see Linda Gordon and Ellen DuBois, "Seeking Ecstasy on the Battlefield: Danger and Pleasure in Nineteenth-Century Feminist Sexual Thought," *Feminist Studies* 9 (Spring 1983): 7–25.

unprecedented. But if they were following in their mothers' footsteps in focusing on politics, these activists exhibited a more pessimistic view of human and, especially, male nature than that which characterized their mothers' generation. The legislation that they sought can only be described as repressive: the 1873 Comstock law; the enforcement of criminal codes against prostitutes; and, of course, prohibition. Epitomizing the most conservative tendencies of state-linked religious reform, an 1863 coalition formed from eleven Protestant denominations proposed and lobbied for a constitutional amendment that would establish Christianity as the national religion. On a local level they sought and won Sunday blue laws, censorship, and other Christian legislation. Frances Willard, in many ways the most radical leader of the W.C.T.U., supported this institutionalization of religious belief.[75]

Although those postwar benevolent movements that adopted the rhetoric of female values are difficult to classify, their visions reflected the growing conservatism of the world in which they worked. As in the 1850s, the increased emphasis on governmental activity in the 1870s and 1880s coincided with a less optimistic faith in social change than that held by a previous generation. Certainly the demand for the vote was a radical step for many women. Still, in their reliance on legislative solutions to social ills, reformers demonstrated their weakened conviction that an intrinsic human morality could provide the engine for a fundamental transformation of society. If religion had lost much of its controlling power, the state had gained: the descendants of moral reformers and temperance activists increasingly sought the state's assistance in enforcing the restraints of Christian morality.

Even for those postwar workers who adopted the mantle of Christian benevolence, there was nothing in their rhetoric to suggest the millennial enthusiasm of the 1830s and 1840s. The postwar decades were not a hopeful time. The Charity Organization movement, for example, bluntly aimed to "separate philanthropy from religion and bring it into harmony with the principles of political economy."[76] Indeed, what is striking about the changing context of benevolence is how like our own times the relationship of morality to social change had become. Liberals and radicals, those concerned with ameliorating or transform-

75. Dubois, *Stanton, Anthony,* pp. 185, 198 fn. 47; Stow Persons, *Free Religion: An American Faith* (New Haven: Yale University Press, 1947), p. 114. The Prohibition party platform of 1867 included calls for the national observance of the Christian sabbath and the use of the Bible as a textbook in public schools: Colvin, *Prohibition,* p. 110.

76. Bremner, "Scientific Philanthropy," p. 200.

ing societal conditions, turned to the state—and to a secular rhetoric— for their legitimacy and appeal. When those who adopted the evangelical voice appealed to government, they did so with the intent of institutionalizing religious control over an increasingly secular nation.

The 1870s and 1880s were a conservative period, as middle- and upper-middle-class reformers engaged in a backlash against both prewar utopianism and the radical possibilities of the immediate postwar years. "Many persons who have been Radicals all their lives," wrote the *Nation*'s editor E. L. Godkin in 1871, "are in doubt whether to be Radical any longer." Middle-class Protestantism became increasingly defensive of privilege, insensitive to the poor, and harsh toward efforts to change from within. A small group of liberals and former abolitionists found the Free Religion movement in Boston and Liberal Leagues throughout the Northeast more conducive to their thinking than the established churches. Only these free thinkers worked for "a Republic built *wholly* independent of the Church," but even they struggled over such issues as whether to oppose the Comstock law, which forbade the mailing of "obscene" materials.[77] Many ministers came to endorse a corporate defense of property and expressed hostility to labor organizing; nowhere, writes Sidney Fine, "did the business spirit find greater favor than in the Protestant church." The Gilded Age, writes historian Paul Carter, "was a time when the gospel of Christ was felt to be in full harmony with the Gospel of Wealth." Henry Beecher's brand of Protestantism, as harsh in its demands on the poor as it was gentle with the well-to-do, increasingly dominated a complacent middle class.[78]

The middle and upper-middle class seemed to be becoming, in part as a result of its wartime experience, less sensitive to the suffering and hardship of the poor. As Eric Foner writes, the new liberal view of reform "helped to crystallize a distinctive and increasingly conservative middle-class consciousness." The movement for scientific charity was but one manifestation of this less empathetic age; the vociferously elitist

77. Godkin, quoted in Montgomery, *Beyond Equality,* p. 335. The Free Religion movement was a reaction against Henry Bellows' purge of the Unitarian conference of 1865: Persons, *Free Religion,* pp. 12–17; Clark, "Religious Beliefs," pp. 72–73. On the dispute over the Comstock law, see D. F. Underwood to Elizur Wright, 10 September 1879, and Josephine S. Lilton to Elizur Wright, 12 September 1879, both in Wright.

78. Sidney Fine, *Laissez-Faire and the General Welfare State: A Study of Conflict in American Thought, 1865–1901* (Ann Arbor: University of Michigan Press, 1956), p. 117; Paul A. Carter, *The Spiritual Crisis of the Gilded Age* (DeKalb: Northern Illinois University Press, 1971), pp. 136–37. See also Clifford E. Clark, Jr., *Henry Ward Beecher: Spokesman for a Middle-Class America* (Urbana: University of Illinois Press, 1978).

Union League clubs (whose leaders wished "to establish the fact that there is an 'aristocratic class'") and hostility toward labor organizing were others. The Paris Commune of 1871 and the 1877 national railroad strike fortified the middle class's own class consciousness. The age did not nurture the kind of humanitarian sympathy prevalent in the 1830s and 1840s. "You do not like *'the people'* as I did and do," Abby Hopper Gibbons wrote her daughter Sally Emerson in 1869. "I like every side of life where there is no clerical hypocrisy and find among the poorer classes more humanity than among the rich." Her daughter's generation, in contrast, felt that their experience had justified a more pessimistic approach to poverty, social change, and human nature itself.[79]

The myriad of organizations and movements that emerged in the postwar decades fit no single category: activists no longer shared even the rhetoric of Protestant benevolence. Woman suffrage and labor activists, philanthropists, civil service reformers, advocates of professionalism or prohibition—all sought diverse and often contradictory goals, reflecting the interests and ideologies of disparate constituencies. Several patterns did, however, differentiate these groups from their prewar and, especially, pre-1850 counterparts. These patterns give some insight into the conservative atmosphere of the postwar period, as well as the generation that had organized and been hardened by the war.

First, benevolent organizations that developed directly from the Civil War experience had boards composed of both women and men. The board of the State Charities Aid Association, the Charity Organization Societies, and, increasingly, municipal and state agencies mixed both sexes in various capacities. It was largely political activism on behalf of women that employed single-sex organization for its work. The National Woman Suffrage Association, for example, insisted on a woman-only leadership despite its roots in the abolition cause.[80] Similarly, the Woman's Christian Temperance Union, which emphasized women's vulnerable status, sought social authority in all-female organi-

79. Eric Foner, *Reconstruction,* p. 489; Frederick Law Olmsted, quoted in Henry Bellows, *Historical Sketch of the Union League Club of New York* (New York: Club House, 1879), p. 12; Abby Hopper Gibbons to Sally Hopper Emerson, 29 July 1869, in Emerson, *Abby Hopper Gibbons,* 2:157; also 5 November 1870, 2:159–60.

80. On the debate about mixed leadership see DuBois, *Feminism and Suffrage,* pp. 191–92. Theodore Tilton did serve as president from 1870 to 1871: Theodore Stanton and Harriot Stanton Blatch, *Elizabeth Cady Stanton as Revealed in Her Letters, Diary, and Reminiscences* (New York: Harper and Brothers, 1922), 2:129 fn.

zations and communities. In contrast, women who worked in state-related benevolent organizations repudiated an ideology based on a peculiarly female identity as they sought to create an efficient charitable elite with the men of their class.

Second, a new standard for behavior and values pervaded efforts for charity and social change as a passion for professionalism overtook the middle and upper-middle class. Rather than calling on all people to adhere to a single female ethos, postwar liberalism encouraged a few women to aspire to the standard represented by men. The new women's colleges demanded that young women perform academically and professionally like men.[81] Women's clubs also offered a new, professional status for women reformers. Charity workers and women who were tied to the apparatus of government, as well as the founders of training schools for female nurses, advocated professionalism, thus undermining the notion that a truer standard of social virtue and status would be based on female, or Christian, values. Just as, in the context of antebellum America, the emphasis on sexual difference had contained strong conservative implications, in an increasingly class-stratified and class-conscious society the new emphasis on sexual sameness could bespeak a conservative middle and upper-middle class closing ranks.

Woman suffrage activists, whose very ideological underpinning was a consciousness of women's shared social experience, also aspired increasingly to male models for social change. Because of the growing centrality of the vote in their work, these radicals had long before eschewed their commitment to moral suasion. Increasingly from the 1850s and almost universally by the postwar period they called on women to enter the world of electoral politics and to participate in the struggle for male forms of power. Although the emphasis of these activists on women's potential sameness as, not difference from, men constituted a radical challenge to the ideology of gender, in the context of the 1870s and 1880s it seemed to have neither necessarily changed the power structure underlying that difference nor recognized as honorable the female virtues that most women still valued.

81. See Roberta Frankfort, *Collegiate Women: Domesticity and Career in Turn-of-the-Century America* (New York: New York University Press, 1977). In contrast to this postwar view, the evangelically based college at Oberlin had urged men to adhere to the standards of "benevolent femininity": Lori D. Ginzberg, "The 'Joint Education of the Sexes': Oberlin's Original Vision," in *Educating Men and Women Together: Coeducation in a Changing World,* ed. Carol Lasser (Urbana: University of Illinois Press, 1987), pp. 67–80.

Third, groups turned to governments not only for money, legal status, and legislation but for their very identity. Disgusted with the apparent futility of transforming the moral basis of society, the benevolent relied on shortcuts to far more modest reforms. As in the 1850s, woman suffrage groups appealed to both the federal and state governments for aid whereas charity workers sought the alliance of local and state officials, among whom were members of their social networks. By the 1880s a system of state charitable aid and inspection had provided new sources of authority for a few elite women. Even movements on behalf of a moral cause, such as the campaign for social purity, defined themselves explicitly in relation to laws and legal bodies rather than in terms of an abstract morality apart from political goals. The same was true of the woman suffrage movement, which increasingly defined itself in terms of the narrow goal of obtaining the vote and which, building on its growing association with wealthy and relatively conservative women, demonstrated a willingness to exclude some women from the suffrage in order to achieve practical political goals.

Finally, the ideology of Protestant benevolence no longer served the array of charitable and reform causes. Ultraists had become, as their work in the 1850s had anticipated, political activists in a secular society. They advocated science and the rule of secular law over religious doctrine. Benevolent workers had become liberals who, according to David Montgomery, "sought to bring under the sway of science the management of the social order itself." This group—in Eric Foner's words, a "newly self-conscious intelligentsia determined to redefine the meaning of 'reform' "—worked in close alliance with state governments to create institutional settings for the social welfare programs that would be the focus of a later generation.[82] Similarly, the women grouped around the Woman's Christian Temperance Union, still loyal to the rhetoric of female benevolence, increasingly turned to repressive legislation that they hoped would protect women from the men whom they no longer expected to change.

By the postwar period the genteel Protestant reformers of antislavery heritage were no longer on the radical cutting edge of United States society. Organizations such as Josephine Shaw Lowell's Charity Organization Society, with its emphasis on science and business principles, helped recast benevolent discourse from a potentially radical call for the

82. Montgomery, *Beyond Equality,* p. 382; Foner, *Reconstruction,* p. 469.

moral transformation of society into a conservative defense of the class privilege of benevolent leaders. "Outraged respectability" found an outlet in the new journal the *Nation,* which, founded by abolitionists James Miller McKim and William Lloyd Garrison, Jr., "opposed nearly all the political economic movements of that period." One of the *Nation*'s primary goals was to find "means of checking the popular passions, which it felt were largely manifestations of ignorance and sin" and which were increasingly defined in class terms.[83] Human nature, according to the once benevolent middle class, had not been amenable to salvation; with the help of the state, it could perhaps be restrained. Like Abby Hopper Gibbons' daughter, Sarah, the postwar generation did not share their parents' respect for and faith in "the people." Their rhetoric replaced a fervent faith in the possibilities of human change with a passion, nurtured in wartime, for controlling human inadequacies.

Workers' and farmers' organizations came to represent the radical voice of United States society after the Civil War. Laying claim to the utopianism that the wealthier classes had rejected, they often adopted the ideals of earlier reformers. "The Christian perfectionism of pre–Civil War evangelical and reform movements . . . ," asserts Herbert Gutman, "lingered on among many discontented postbellum workers." Middle-class liberals, in contrast, found themselves defending a distasteful "pro-corporation credo." Depressions, strikes, corruption, and noticeably greater extremes of wealth—all played a role in transforming the context in which middle-class Protestants had once sought a grand moral change in society.[84] Slavery no longer provided an issue around which ultraists could rally their moral forces. Battles between classes and regions cornered the middle class in a defense of privilege based on a growing conviction of human nature's imperfectability. Even the de-

83. Eric Goldman, *Rendezvous with Destiny: A History of Modern American Reform* (New York: Alfred A. Knopf, 1952), p. 20; Alan Pendleton Grimes, *The Political Liberalism of the New York Nation, 1865–1932* (Chapel Hill: University of North Carolina Press, 1953), pp. 25, 52. Interestingly, E. L. Godkin had edited the *S.C. Bulletin* before becoming editor of the *Nation:* William Quentin Maxwell, *Lincoln's Fifth Wheel: The Political History of the United States Sanitary Commission* (New York: Longmans, Green, 1956), p. 223. Morton Keller notes that other liberal editors, including Henry C. Bowen, Lewis Tappan's son-in-law, moved from antislavery to "a racism in the 1880s that was part of their more general distaste for the course and character of American life": *Affairs of State,* p. 448.

84. Herbert G. Gutman, "Protestantism and the American Labor Movement: The Christian Spirit in the Gilded Age," in *Work, Culture and Society in Industrializing America* (New York: Random House, 1966), p. 85; see also Goldman, *Rendezvous with Destiny,* p. 40. On the "politics of depression," see Foner, *Reconstruction,* chap. 11.

mand for woman suffrage was losing its radical associations as more conservative women became convinced of the value of the vote in their own work.

The ideology of women's unique moral calling, exemplified by the Woman's Christian Temperance Union, also seemed to have lost much of its radical potential. Virtue came to be treated as solely, even biologically, women's responsibility rather than as a model to which men should aspire. The belief that human perfectability was possible through female benevolence was as anachronistic in the postwar decades as the utopian impulse that had inspired it. The rhetoric of postwar society focused on class rather than gender as the source of social change or, to the middle class, social control.

Elizabeth Cady Stanton could recall a time when the rhetoric of female benevolence had served a radical cause. She had seen the context for what constituted a radical or conservative position come full circle. Nevertheless, Stanton had always been suspicious of the double-edged promise of moral rhetoric and feared that its radical possibilities did not balance the dangers of religious conservatism. Unlike many other former abolitionists, therefore, she was appalled by the conservative turn that organized Protestantism took in the postwar years and spent much of the remaining decades of her life fighting its effects. In the mid-1890s Stanton wrote a fascinating set of essays in which she confronted head-on the issue of Christian women's loyalties to religion instead of to the "great public questions" of the state.[85]

Stanton believed that the state provided the only route to radical social change, and she called on women to defend a secular society. "Woman's education has been left too much to the church, which has . . . train[ed] her sentiments and emotions at the expense of her reason and common sense," she wrote. "The state must now open to her a wider field of thought and action." Stanton did not object to religion solely because of what she considered its stunting effect on women themselves. Painfully aware that religious women had never hesitated to join in political activity, she believed that "in their present religious bondage, the political influence of women would be against the secular nature of our government." Her fears were specific—and well founded:

85. Elizabeth Cady Stanton, *Bible and Church Degrade Woman* (Chicago: H. L. Green, [1896?]), p. 4. See also Stanton's *The Woman's Bible,* published in 1895, "a feminist commentary on the Old Testament." For an excellent summary of Stanton's almost solitary attack on organized Christianity in the latter years of her life, see DuBois, *Stanton, Anthony,* pp. 182–93 (quotation p. 188).

"They would, if possible, restore the Puritan Sabbath and sumptuary laws, and have the name of God and the Christian religion recognized in the National Constitution. . . ." Stanton claimed: "We must turn the tide of her enthusiasm from the church to the state," for it was that enthusiasm "on which depend the stability of the republic and the elevation of the race."[86]

Elizabeth Cady Stanton had experienced a lifetime of attacks from those who utilized the ideology of benevolent womanhood in the name of conservative causes. She had been involved, albeit ambivalently, in efforts to use moral suasion to transform society. Unlike most nineteenth-century woman's rights leaders, however, she believed that the ideology of female moral superiority could ultimately benefit only those who opposed their cause. She was willing, as were few women then or now, to argue that only in the rejection of the ideology of female difference lay the possibilities for the broadest vision of social change and for a true benevolence, based not on sex but on justice.

86. Stanton, *Bible and Church,* pp. 4, 3, 4.

# Afterword

❧ ❧

In her rejection of religion and her insistence that morally expressed gender differences were both ideological and fundamentally dangerous, Elizabeth Cady Stanton placed herself in a small minority of nineteenth-century women. And yet in her discussion can be found virtually all the threads of one of the most complex debates faced by historians and feminists: how to reconcile the radical and conservative implications of two very different ideologies of gender—one, that the sexes are fundamentally different, the other that they are potentially the same. It is a debate that emerged in the nineteenth century in the context of struggles over political, class, and gender identities in the United States. It remains today submerged in, indeed obscured by, those struggles.

This study has argued that the conflation of the ideologies of morality and gender played a central role in the emergence of middle-class identity in the nineteenth century. It did so both by adapting revolutionary era rhetoric about virtue to an expanding, industrializing, and urbanizing society and by obscuring the interests and identities that informed women's benevolent work. In addition, women's belief in appropriate female behavior undermined radical challenges—ranging from abolitionism to the woman suffrage movement—to the developing class- as well as gender-based authority structure in American society. Finally, the nineteenth century witnessed the emergence of the competing ideologies of gender to which we are the heirs, with many middle-class women persisting in the notion that so-called female traits should set a standard for superior moral behavior and with more urban, elite women participating in a process in which an assumption of gender sameness characterized efforts on behalf of their class.

214

Particular contexts evoked both the radical and the conservative possibilities of these ideologies. During the 1830s and 1840s, the belief in gender difference in general and female morality in particular provided some women with the language with which to support fundamental social change. To these women, anything was possible: even men could change, becoming more like women. Indeed, the ideology of female benevolence and of a shared female sensibility informed the earliest critiques of men's dominance over women. That same belief in female morality, however, always sustained an opposite view, one that emphasized the continuance of a social hierarchy based on women's subordination to men. Both views assisted the development of a middle-class identity based on the notion of virtue. It was an identity by which the middle class opposed itself to the supposedly nonvirtuous upper class, evoking revolutionary rhetoric in an effort to establish its own prerogative to define social status as a moral condition. To have opposed overtly the conflation of female benevolence with morality and, therefore, with social virtue would have been not only "immoral" but, to use a more modern phrase, "un-American."

By the 1850s, the belief in a peculiarly female form of social change—moral suasion—had lost much of its credibility, or at least its universality, as the growing interest in electoral results underscored the powerlessness of a nonvoting position. At the same time, more conservative and socially prominent women focused their benevolent work on institutional settings, increasingly working alongside men to consolidate the business of benevolence in a new context. Building on these transformations, the Civil War made possible the emergence of a class-based ideology that seemed to disregard gender and, therefore, encouraged a secular ideal of gender sameness. The rhetoric of the post–Civil War period, an era in which, according to Mari Jo Buhle, radicalism had lost its "moral vigor," evoked the most conservative connotations of the two related beliefs about the supposed difference or sameness of the sexes.[1] Increasingly, the radical potential of the belief in female values faded into an insistence on either inherent (and, with the advent of science, increasingly biological) gender differences or an equally conservative insistence on some women's sameness to men. As the founders of postwar charity showed, the insistence on sameness—in the now familiar form of the thoroughly professional woman—denied both power

1. Mari Jo Buhle, *Women and American Socialism, 1870–1920* (Urbana: University of Illinois Press, 1981), p. 70.

215

differences between the sexes and the radical possibilities of organizing to transform those inequalities. Not until the Progressive decades would elite Protestant women such as Grace Hoadley Dodge and Jane Addams again infuse social reform with the rhetoric of female virtue and moral righteousness.

One of the lessons in all this is that ideologies about gender serve broader purposes than either describing or enforcing supposed differences between women and men. It is necessary, in the interest of both historical study and social change, to understand the uses to which those ideologies are put. The nineteenth-century ideology of women's benign, indeed nearly heavenly, influence and the purposes of charity itself, for example, were closely connected. The success of charitable and benevolent endeavors depended upon this belief in women's invisibility and lack of self-interest. Charity, like welfare in the twentieth century, was a necessary component of economic growth; it mediated the most blatant harshness and dislocation of nineteenth-century capitalism and urbanization. Charitable enterprises provided some cushion for the poor in the form of material goods, temporary shelter, small subsidies, and the care of children even as the benevolent urged the poor to conform to the tenets that would ostensibly raise them from their current condition. Thus the control of services to the poor and outcast was a key element in the dominant groups' control of resources and of standards of behavior.[2] Charity cannot be wholly invisible if it is to make these lessons clear. Women or, more accurately, the belief in women's moral superiority perfectly fit the requirement that charitable endeavors appear unmotivated by self- or class interest. As members of a group that seemed to be defined exclusively by gender, women could have no interest other than to fulfill their benevolent destiny; they could be applauded and recognized without calling into question the purity of their motives.

Clearly we have inherited, not resolved, this century-long debate over gender difference and sameness as well as the relationship of those ideologies to charity, social change, and class. We too have experienced the radical potential of the "bonds of womanhood," although we refer to those bonds as "sisterhood," reject the suggestion of female asexuality, and squirm at the language of morality. We have also witnessed the advent of what the media smugly call the "postfeminist generation." At the risk of greatly oversimplifying, I want to suggest that what we are

2. See Frances Fox Piven and Richard A. Cloward, *Regulating the Poor: The Functions of Public Welfare* (New York: Random House, 1971), esp. chap. 1.

experiencing today resembles in several important respects the post–
Civil War period. Like Josephine Shaw Lowell and Louisa Lee
Schuyler, the archetypal professional women of today have benefited
greatly from the feminist movement to the extent that they have under-
taken activities once exclusively male. Nevertheless, they disdain sis-
terhood, often on the grounds that they have not needed to ally with
women to achieve their own goals. Nor do they acknowledge the need
for broader social change that would include a rejection of gender roles
to the extent of demanding that men, too, change. As was the case one
hundred years ago, the adherents of this view adopt liberal categories—
equality under the law, moderate social reform, and individual achieve-
ment—to express their analysis of social ills as well as their own class
identity.

At the same time, we have experienced a resurgence of both the
repressive and the potentially radical uses of the ideology of morally
expressed gender difference. As both Andrea Dworkin and Barbara
Ehrenreich have shown, right-wing women have appealed to women's
(especially housewives') sense of their own vulnerability in demanding
that society protect females. As Dworkin puts it, "The Right promises
to put enforceable restraints on male aggression, thus simplifying sur-
vival for women." If in the 1830s and 1840s this argument was phrased
in terms of morality, our own focus is on the equally malleable construct,
the "family." Unlike moral reformers in the 1830s, the creators of this
rhetoric lay no claim to radical change, in part because of the defen-
siveness of their position in its twentieth-century context. Men cannot
change, so the argument goes, therefore we must insulate ourselves
from them all by seeking—and keeping—the protection of one. This
view is as depressing as it is dangerous.[3]

In addition to playing on women's very real—and reasonable—
fears, the New Right has captured the terms of morality as its own.
"Once again," writes Carol Pohli, "conservative Protestants have sancti-
fied political activism." In the name of morality, the Right has appropri-

3. Andrea Dworkin, *Right-Wing Women* (New York: Perigee Books, 1983), p. 21. See
also Barbara Ehrenreich, *The Hearts of Men: American Dreams and the Flight from Commitment*
(Garden City, N.Y.: Doubleday, 1984), chap. 10. Insightful accounts of the New Right's
antifeminism include Zillah R. Eisenstein, "The Sexual Politics of the New Right: Under-
standing the 'Crisis of Liberalism' for the 1980s," *Signs* 7 (Spring 1982): 567–88, and
Rosalind Petchesky, "Antiabortion, Antifeminism, and the Rise of the New Right," *Feminist
Studies* 7 (Summer 1981): 206–46. Ehrenreich, *Hearts of Men,* pp. 152–61, contains a useful
discussion of the connection between the New Right's antifeminism and its conservative stands
on issues such as communism, unions, and racial integration.

ated the issue of sexual (especially homosexual or poor or young people's heterosexual) behavior as its most powerful weapon.[4] That this weapon has been effective indicates just how much has remained unchanged in the past one hundred years. If the charge of unfemininity no longer works as efficiently as it once did to regulate radical activity on the part of women, activists still cower under the attack either that they are lesbians or that they reject "life." Like the frightened abolitionist Juliana Tappan, women continue (unsuccessfully) to defend themselves against such attacks on the attackers' own terms. They thus prove that the terms themselves still matter and that the ideology of appropriate female behavior persists.

In our own time, some feminists have reasserted the radical potential of the ideology of women's peculiar morality. In her pathbreaking study, *In a Different Voice,* Carol Gilligan countenances this view by arguing that there are important differences between girls' and boys' "moral development," differences that, contrary to prior psychological assumptions, would seem to give girls the "edge" in a world based on feminist values; in any case, a hierarchy of gender differences persists. Following Gilligan, numerous theorists and activists have argued for a feminist "ethic of care," tracing, for example, women's supposed pacifism to the social experience of being female, and asserting women's greater moral strength in the face of a troubled world and their own subordination. Some indeed argue that an ethic of care and nonviolence lies at the core of a feminist politics—that the very experience gained from subordination will in turn empower women.[5]

A feminism that celebrates female culture, implying strongly that female traits are either intrinsic to or shared by all women and, further-

4. Carol Virginia Pohli, "Church Closets and Back Doors: A Feminist View of Moral Majority Women," *Feminist Studies* 9 (Fall 1983): 534. See also John D'Emilio and Estelle B. Freedman, *Intimate Matters: A History of Sexuality in America* (New York: Harper and Row, 1988), pp. 344–60.

5. Carol Gilligan, *In a Different Voice: Psychological Theory and Women's Development* (Cambridge: Harvard University Press, 1982). See in particular the work of Jean Bethke Elshtain, including *Public Man, Private Woman* (Princeton: Princeton University Press, 1981), "Feminists against the Family," *Nation* (November 1979): 497–500, and "Feminist Discourse and Its Discontents: Language, Power, and Meaning," *Signs* 7 (Spring 1982): 603–21; Adrienne Rich, *Of Woman Born* (New York: W. W. Norton, 1976); and Joyce Treblicot, ed., *Mothering: Essays on Feminist Theory* (Totowa, N.J.: Littlefield Adams, 1983). For critiques of this view see Mary G. Dietz, "Citizenship with a Feminist Face: The Problem with Maternal Thinking," *Political Theory* 13 (February 1985): 19–37. Excellent essays on the question appear in Eva Feder Kittay and Diana T. Meyers, eds., *Women and Moral Theory* (Totowa, N.J.: Rowman Allanheld, 1985).

more, that gender constitutes women's only or most central identity, shares some of the depressing aspects of the reactionary belief in inherent moral differences between the sexes: namely, that men cannot change and, therefore, women must remove themselves from their (perhaps biological) danger. Ehrenreich claims that "the New Right psychology is marked, above all, by a profound contempt for men."[6] Feminist separatism, whether literal or ideological, also treats men as morally irresponsible beings even as it supposes the moral unity of women. There are important radical implications to separatism's emphasis on female independence and strength, and the state of the world certainly makes a desire for simple, safe solutions understandable. Nevertheless, this view ultimately perpetuates, even celebrates, a belief in gender difference without confronting the conservative uses which that ideology continues to serve.

A modern-day analysis that explores the radical possibilities of the ideology of female difference, therefore, like that of antebellum ultraists, has its appeal but also its dangers: What does it mean to women, or to any subordinate group, to stress an ethic based on their own morality and experience of subordination? Can the claim of moral superiority ever restructure power relationships in a society or does it simply sustain difference itself? Finally, how does this claim—like that of antebellum benevolent activists—obscure differences among women, reflecting, as one essay on moral theory puts it, an "elitist voice," even as it allows those who assert it to demand a form of authority?[7] The emphasis on women's unique moral status in the antebellum years may have represented, in the context of ultraist women's relative political powerlessness, a radical stance. At the same time, it obscured class and racial differences—and loyalties—among women that were intrinsic to the ideology itself: some women, after all, were more powerless than others and less likely to be considered among the truly moral. Then as well as in our own time, for those women who reject participation in a male-dominated society or according to male-defined standards, aloofness is perhaps not so much a sacrifice as a privilege.

Why do some women cling so strongly to their belief that gender difference transcends other differences among women, especially in the face of evidence that that ideology often undermines their efforts for

6. Ehrenreich, *Hearts of Men,* p. 162.

7. Mary Fainsod Katzenstein and David D. Laitin, "Politics, Feminism, and the Ethics of Caring," in Kittay and Meyers, *Women and Moral Theory,* p. 264.

social change? The ability of the ideology of female virtue to draw large numbers of women to political causes should by now be obvious: from radical abolitionists to late nineteenth-century temperance workers to the right-wing women of our own time, the ideology has attracted women of vastly different beliefs and interests. Nevertheless, attacks against women's femininity have served to undermine radical causes because of activists' own vulnerability to the charges of having betrayed "woman's nature."

Both feminists and women's historians have hesitated to sacrifice the assumption that gender forms women's primary self-identity. The very act of studying or writing women's history signifies a belief that gender is a powerful component in the organization of society and that socially constructed gender differences do exist. Further, the commitment to making central the experience of women in the past often evolves from a prior commitment to transforming the lives of women in the present. Women's historians have thus grappled implicitly with a contradiction which many of us experience in our own lives: that sisterhood and a sense of self-esteem based on womanhood are dependent on women's shared social experience, which is in turn created by the very belief in gender difference that perpetuates sexual inequality. In the struggle to abolish that and other inequalities, there is danger in romanticizing women's shared experience as well as peril in repudiating the radical possibilities of sisterhood.

# Index

Gibbons, Lucy, 108
Giddings, Joshua R., 130
Godkin, E. L., 207, 211n83
Government financial aid, 73, 74, 78, 79, 101, 123–24
Graham, Isabella, 39, 73
Grew, Mary, 28n44, 31, 113
Griffin, Christine, 147, 192
Griffing, Josephine, 178
Grimké, Angelina, 29, 30, 40, 56, 65, 67, 79, 84–85, 87, 105, 113
Grimké, Sarah, 30, 32n, 40, 65, 87

Hale, John P., 126
Hale, Sarah Josepha, 11–12, 14, 71–72, 126n
Hamilton, Elizabeth, 39
Hamilton, Mary, 143
Hamlin, Hannibal, 141
Hancock, Cornelia, 138, 146n29, 177, 178–79
Harrison, William Henry, 70–71
Hartford Female Beneficent Society, 50
Hartford Soldiers' Aid Association, 166
Hartley, Robert, 127
Haviland, Laura, 138
Hawkins, Mary A. Man, 7n, 62, 78, 113, 114
Health boards, 182
Higginson, Thomas Wentworth, 187
Hobson, Elizabeth, 193
Hodge, Caspar Wistar, 142n21
Hodge, Hugh Lenox, Jr., 192
Hoffman, Sarah, 39
Hoge, Jane Currie Blaikie, 159–60, 167
Holley, Sallie, 103, 140, 177, 180
Home for Aged Women, 160
Home for the Friendless and House of Industry, 121, 122
Hospital for Women and Children, 160
Hospital transport ships, 147–48, 157–58
Howe, Julia Ward, 187
Howland, Eliza Woolsey, 147
Howland, Emily, 103, 177

Industrial School for German Girls, 120
Industrial schools and houses of industry, 60–61, 108, 120, 121–22, 128, 155
Ingraham, Sarah R., 29, 58, 113

James, L. R., 157, 170
Jordan, Julianna, 61
Juvenile Anti-Slavery Society, 103

Kelley, Abby. *See* Foster, Abby Kelley
Kinney, Hannah, 40, 53
Kirkland, Caroline, 128, 167n86
Knapp, Frederick, 147
Know-Nothing party, 125

Labor reform movement, 125, 207, 208, 211
Ladies Home Missionary Society, 121
Ladies' Industrial Aid Association, 155
Ladies' New-York City Anti-Slavery Society, 28, 31
Ladies' Relief Society, 74
Ladies Seamen's Friend Society of New Haven, 43
Lane, Caroline, 142
Leavitt, Joshua, 7n, 68, 99–100
Legislatures: range of women's involvement with, 69, 71–72, 77, 80–81; lobbied by women, 69, 74, 78–79, 100, 102, 120; and privileges accorded more conservative women, 72, 73, 76, 83, 96; addressed by women, 80, 84–85. *See also* Petitioning by women; Politics
Liberal Leagues, 207
Liberty party, 87, 92n, 98, 130
Lippitt, Henry, 181
*Little Women* (Alcott), 57–58
Livermore, Mary Ashton Rice, 151, 155–56, 159, 160, 167, 175–76, 185
Lobbying by women, 69, 74, 78–79, 102, 136; and institutionalization of benevolence, 120
Lovejoy, Julia, 116
Lowell, Charles Russell, 131
Lowell, Josephine Shaw, 104, 118, 130–31, 133, 134, 142, 175, 177, 182, 183, 192, 196, 197, 198–99, 201, 210, 217

McDowall, John, 11, 55–56, 77
McDowall, Phebe, 55–56
McKim, James Miller, 211
McKim, Lucy, 106, 139, 140
Maine law, 110n21, 117–18
Mann, Horace, 102

New York House and School of Industry, 45, 60, 121, 128
New York Infirmary for Women and Children, 140
New York Metropolitan Fair, 157
New York Orphan Asylum Society, 39, 73
New York State Board of Charities, 182, 190, 194, 195, 196
New York State Temperance Society, 56
New York State Woman's Temperance Society, 116
Northwestern Sanitary Commission, 159
Northwestern Sanitary Fair, 157
Nonresistance, 82–86, 88, 89–92, 97
Nurses, 193–94; during Civil War, 135, 138, 141n, 143–49, 157–58, 161, 165, 177; and professionalization of charity work, 199n, 201, 209

Olmsted, Frederick Law, 134, 147, 162, 190, 192
Olmsted, Mary, 163–64

Pacifism, 83, 138, 139, 218
Parker, Theodore, 16
Parrish, Joseph, 156–57, 159
Partial suffrage, 70, 186–89, 205
"Pastoral Letter" (1837), 30, 33
Pease, Elizabeth, 90, 92
Penitent Females' Refuge, 43
Pennsylvania Freedmen's Relief Association, 179
Petitioning by women, 66, 100; for corporate charters for female-run organizations, 51–53; and effort to separate morality and politics, 67–68, 79, 80, 82, 84–85, 92–95; and influence of voteless women, 68–69, 71, 74, 95–96; moral reformers', 77–78, 91; abolitionists', 80–82, 84–85, 88, 92–95, 136–37; and temperance movement, 111; for antislavery principles during Civil War, 136–37
Philadelphia Female Anti-Slavery Society, 72–73, 94, 112, 129, 130n65
Philanthropy, 61, 144, 206; and Sanitary Commission's assault on volunteerism, 134; and conservatism of postwar period, 208. *See also* Benevolence; Charity
Pickman, C. Gayton, 1

Pierce, Franklin, 126n
Pierpont, Reverend, 116
Pintard, Elizabeth Brasher, 37, 38, 44, 47
Pittsburgh Orphan Asylum, 159
Politics, 8–9, 66, 162, 212; and incorporation of benevolent and charity societies, 48–53; ideological division between morality and, 67, 68, 69–70, 79, 84–85, 89–92, 94, 96–97; abolition movement and, 67, 68, 71–72, 73, 76, 79–94, 98, 100, 110, 112; and nature of women's antebellum benevolent activism, 67–97; electoral, in antebellum period, 69–132 passim; growth of party organization, 70n5, 76; and changing makeup of city governments, 70n5, 76n19; growing importance of, 70–71, 76; and temperance movement, 71–72, 75–77, 81, 95–97, 99n, 110–11, 114–18, 204–06; and government financial aid to benevolent organizations, 73, 74, 78, 79; women's class-related access to men with political power, 73, 76, 77, 81, 83, 95, 96; and radical "no government" position, 82–86; growing association of voting with, 94–95; as focus of reformers in pre–Civil War era, 98–132 passim; postwar benevolence and, 176, 180, 182, 203–06, 208, 209; and social purity crusade, 203, 205–06; and the New Right, 218. *See also* Legislatures; Petitioning by women
Post, Angelina, 142, 151, 159, 169, 170, 171, 176
Powell, Aaron, 203
Powers, Eliza, 165
Prior, Margaret, 13, 20, 29, 31, 56
Prison Association of New York, 52, 120
Prison reform, 113, 182
Prisons, percentage of males and females in, 12–13
Professionalism, 176, 215, 217; development of, 142, 155–56, 193–209 passim; and "masculinization" of ideology of benevolence, 172–73; and conservatism of postwar period, 208, 209
Prohibition Home Protection party, 204
Prohibition movement, 176, 206, 208
Prostitution, campaign against, 19, 20, 21, 22–23, 26, 76n18, 120–21, 174; social purity crusade, 182, 202–03, 205, 210

what was happening in the so?
benevolence of any kind?